CONTENTS

INTRODUCTION
CAN'T GO BACK
CONDITION OF THE ARTIST
THE DREGS
EISELEY CARD
DELINQUENT DAZE
INK GALLERY 1
DETONATION
COMBO HERO
CARDBOARD SPACESHIPS
LETTERS TO THE EDITOR
MADAME T. TREATMENT
INK GALLERY 2
MONSTERVILLE DREAMERS
LESSON 13
IRRATIONAL PERSPECTIVES
REMARQUES
SUPERHERO RETROGRADE
INK GALLERY 3
TEN YEARS AFTER
ZACH'S BACK
WEIRD WORLDS REMARQUES
INK GALLERY 4
A CONVERSATION OVERHEARD
FLOODED BASEMENT
PENCIL PUSHINGS
HUNGER
PICKLED
INK GALLERY 5
BAD GIRL CRAZE
NIGHTMARE DAYS
SADHANA
SANTA COMIC
TITS FOR TATS
BUMPER STICKER
SINISTER 4

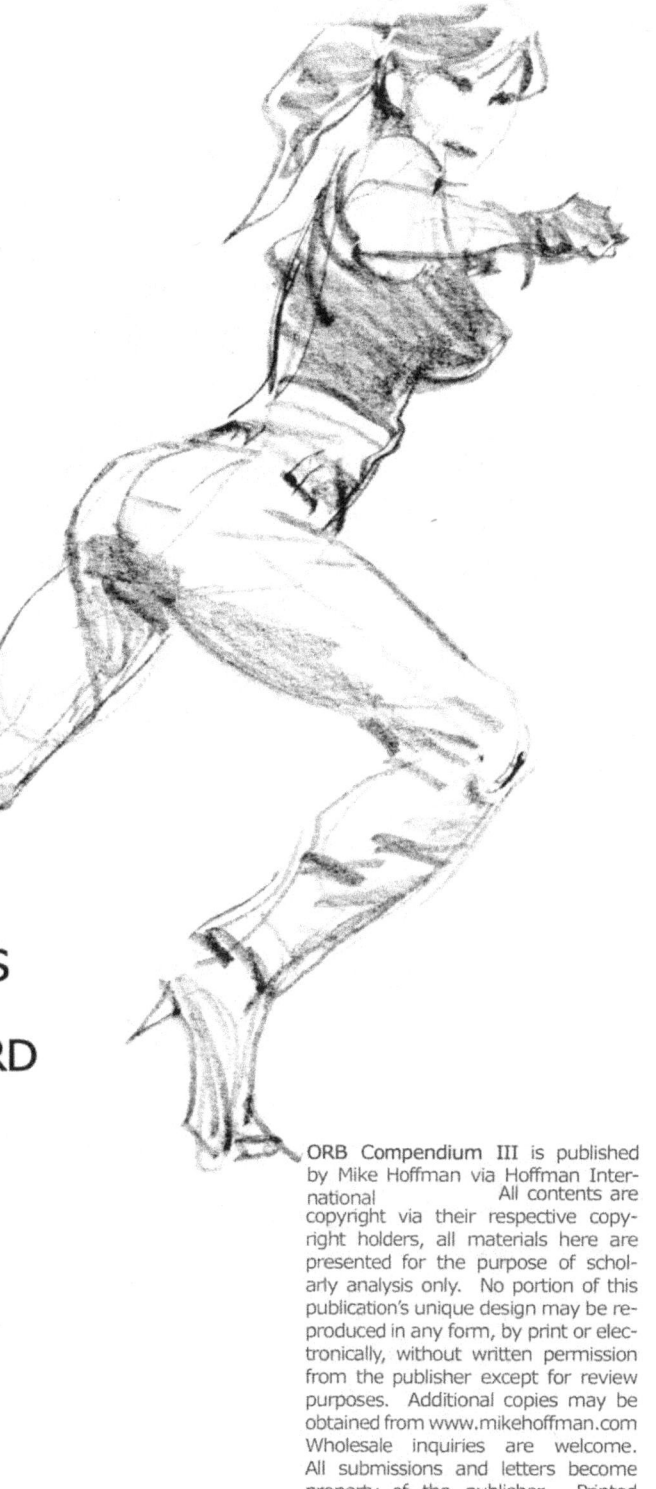

ORB Compendium III is published by Mike Hoffman via Hoffman International All contents are copyright via their respective copyright holders, all materials here are presented for the purpose of scholarly analysis only. No portion of this publication's unique design may be reproduced in any form, by print or electronically, without written permission from the publisher except for review purposes. Additional copies may be obtained from www.mikehoffman.com Wholesale inquiries are welcome. All submissions and letters become property of the publisher. Printed in the United States of America.

ISBN-13: 978-1542508827
ISBN-10: 1542508827

Introduction

"Doesn't that Hoffman guy ever get tired of talking about himself?" I've asked myself the same question, but due to the necessity of promoting and selling "me" there's really no way around it. But at least I'm not selling my soiled undies--yet.

My wife tells me I'm actually giving, so I feel better as she's usually right. Then again, I must like attention on some level or I'd be a hermit, so maybe she's wrong. Anyway, I'm not going to worry about it too much.

This is the third *ORB* compilation, but it's different from the first two in that I stuck it together at one go rather that doing it monthly and collecting it together later. This time I cheated.

I had been doing ink drawings all along, which have always been a staple in ORB, so there's a bunch of the best here since after *Orb Compendium II* left off. And in fact, that wasn't really long ago; the last edition was only around six months back.

Those ink drawings help pay the bills around here, but no matter how many I do I still always make time to to other stuff--Paintings and Comics. You've got to stay sane, and endless "pinups" for eBay is the road to insanity.

I mean, who'd want to be remembered as the Comic Book artist who never drew a comic book? There are a lot of those out there, you know.

I have to do Comics, and I have a lot of new ideas for and about them. You can read some articles and see features here that relates to the situation.

I'm especially pleased with my *Superhero Retrograde* essay, which came to me from out of nowhere but I think sums things up accurately. In fact, anti-corporate sentiments are all over these days, aren't they?

But then some people don't get alarmed until it affects them, but not me. As soon as the last war of U.S. aggression started, my first mental picture was dead women and children in a far-off foreign land. Some people don't ever get that far, it's all cascading red, white and bruised forever. Scars and Stripes of Blood.

But now Coporate hate is hip, and unemployed people have the spare time needed to attack the *moneybehemoth*. But would they bother just for their neighbor's sake? I wonder--I hope so.

Maybe this era of less Me and more You. That could be a good thing, but very bad for business.

An unused signature from an alternate universe.

All this relates to who you was and who you're going. I imagine that some people's signatures never change. In Art you want to be recognized, so you don't see a lot of name-changing. When it does happen, you might get ridiculed--like Prince did, although I hear he had a good reason.

The exotic me.

On wid da book.

Can't Go Back

Now honestly, why should you care about my family History when you have your own? Or, maybe you're adopted and are really in the dark. Anyway, being The Publisher means I can do what I like, and ORB is at least half for me. At least this issue is. And I own the Time Machine.

Turns out from a bit of very faded and aged scrap of paper that I lived in Golden, Colorado from July 1959 until September 1961. I was only born in '58, so that makes me a baby and toddler then. Here's a photo of the front of the house, undoubtedly taken by my Dad.

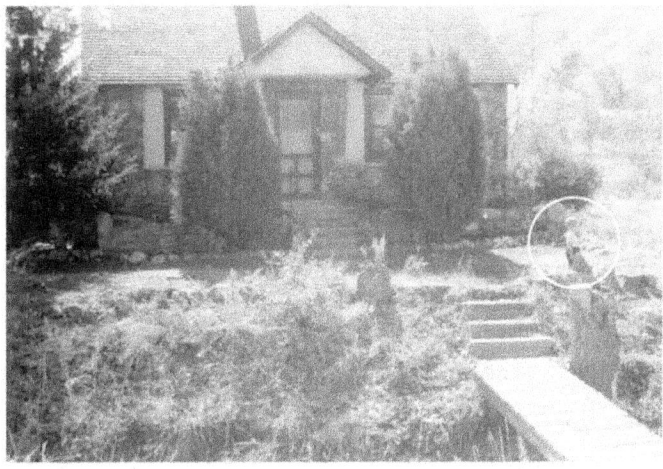

I've enlarged the small figure to the right in the above photo, below. Is is it me, or my brother? It feels like me.

It's not always true what they say that you can't go home again, but in this case I really can't. There is no charming, rustic house there anymore. In fact, there's nothing resembling this lanscape from a faded old photograph. In fact I even wonder if the mountain is still there.

You can't romanticize the Past much when it's been stomped flatter than a parking lot. Here's a photo of the back of the Lost House:

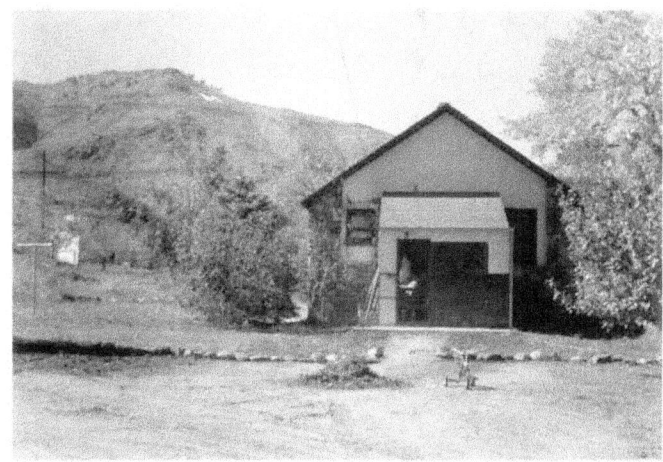

I should mention that due to the fading of these photos they have been digitally enhanced.

In true artistic fashion, my Father included a figure in this picture as well. It's hard to make out, but it must be my mother, perhaps holding something--a baby?

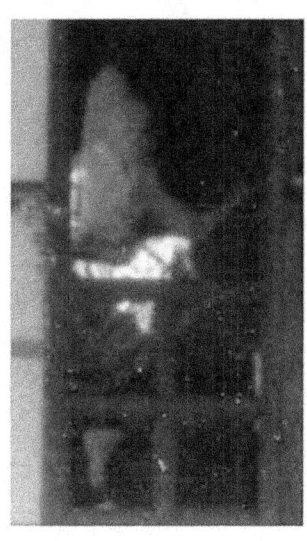

Condition of the Artist

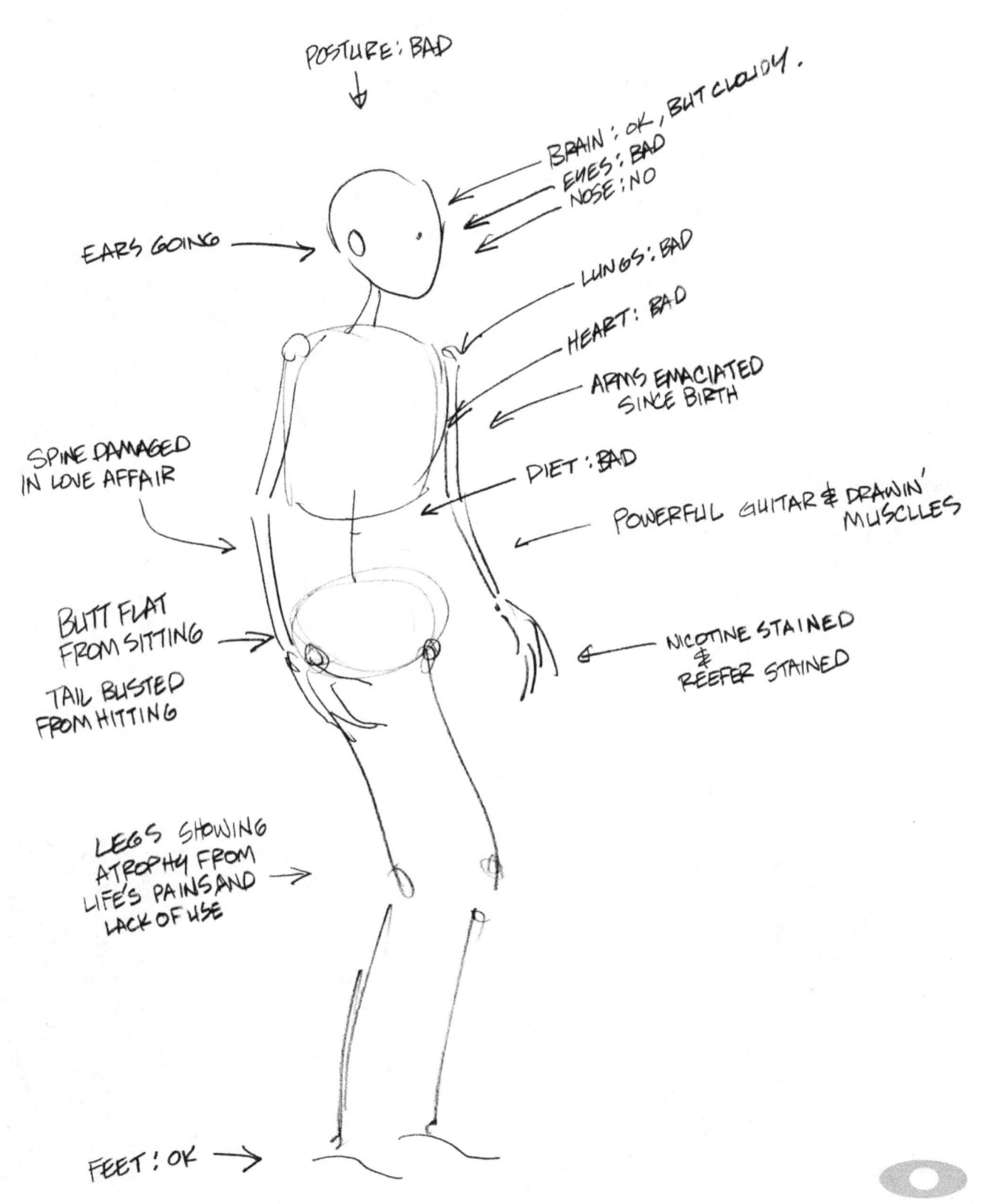

The Dregs

I can see why ageing authors and artists may look around at the boxloads of scribblings they've produced over a lifetime, and near the end of their lives than the beginning, have to figure out what to burn and what to keep. Usually, there's a lot of burning going on.

I already did one huge burning while in New Mexico around 2004 or so, the fireplace got so hot that candles on a far table began to melt. Now I'm at it again, for the last time, only now the wife wants me to recycle the paper. The heck with that.

The reason I won't need to purge again after this is that nowadays when I draw a real clunker it gets torn up right away, no years of waiting to decide as to its merit.

Looking back at my own baby steps I realize that artists never ever get slick, at least not to themselves. It is always crude on one level or another. Some like to say Art can't match Nature, but artistic arrangements sure do. It's the molecular biology stuff, those DNA replicator machines for example, that are "perfect". They have to be or we wouldn't be here.

So really it's the statement and not the technique. What happened early on with me is that I was making statements unintentionally. Only now can I look back and read them.

Much of my earliest work, the really weird stuff, already got published some years ago in the two *Secret Sketchbooks*. If those drawings were the *creme de la scum*, then some of these are just scum. But like scum on an ancient monument, or on some Roman bathroom wall, it's worthy of some study. Maybe.

An artist may get to some point mentally where they are actually aware of what the heck they are doing on Earth. Some say that the #1 task of being here is remembering why we came. Why did you come? Or did you just show up, not having asked to be born? I'm not sure I believe that's even possible, at the risk of sounding arcane and mystical.

This issue of ORB will contain--I promise--the last of the early works worthy of preservation, at least to me. We are at the bottom of the barrel, the emptying of the box, the very last sweepings and scrapings and scraps and crumbage. All the rest has been either published or incinerated.

You have to ask yourself, reliving all the gaffs and awkwardnesses, whether you'd like to have done anything differently. If you say "yes", you're sure to harbor regrets, and what's the practical point of that?

I won't say I have no regrets, although I used to be fond of saying it, but mine don't relate to my work but rather towards other people.

The work is me, my own growth, a path, and a direction I chose, and a step I took. Were years wasted going down undernourished garden paths? Who's to say, and why? Would Van Gogh have been better off with both ears intact?

No, because you come into the world to suffer like fuck and either come out of it laughing or crying. Or sometimes like those weird movies where you laugh and cry at the same time. Not many of those, are there? Maybe you could laugh, cry and puke at the same time for the right movie.

People were puking during *The Exorcist* way back in 1973, I remember that. Nowadays that would be considered so ultra-tame it'd be like "See Spot Run". I'm puking already.

Mainly the Old Fogies were barfing back then, and *we* were laughing. Nowadays I'm doing the puking at new movies and probably getting laughed at for it.

Well, here it comes...

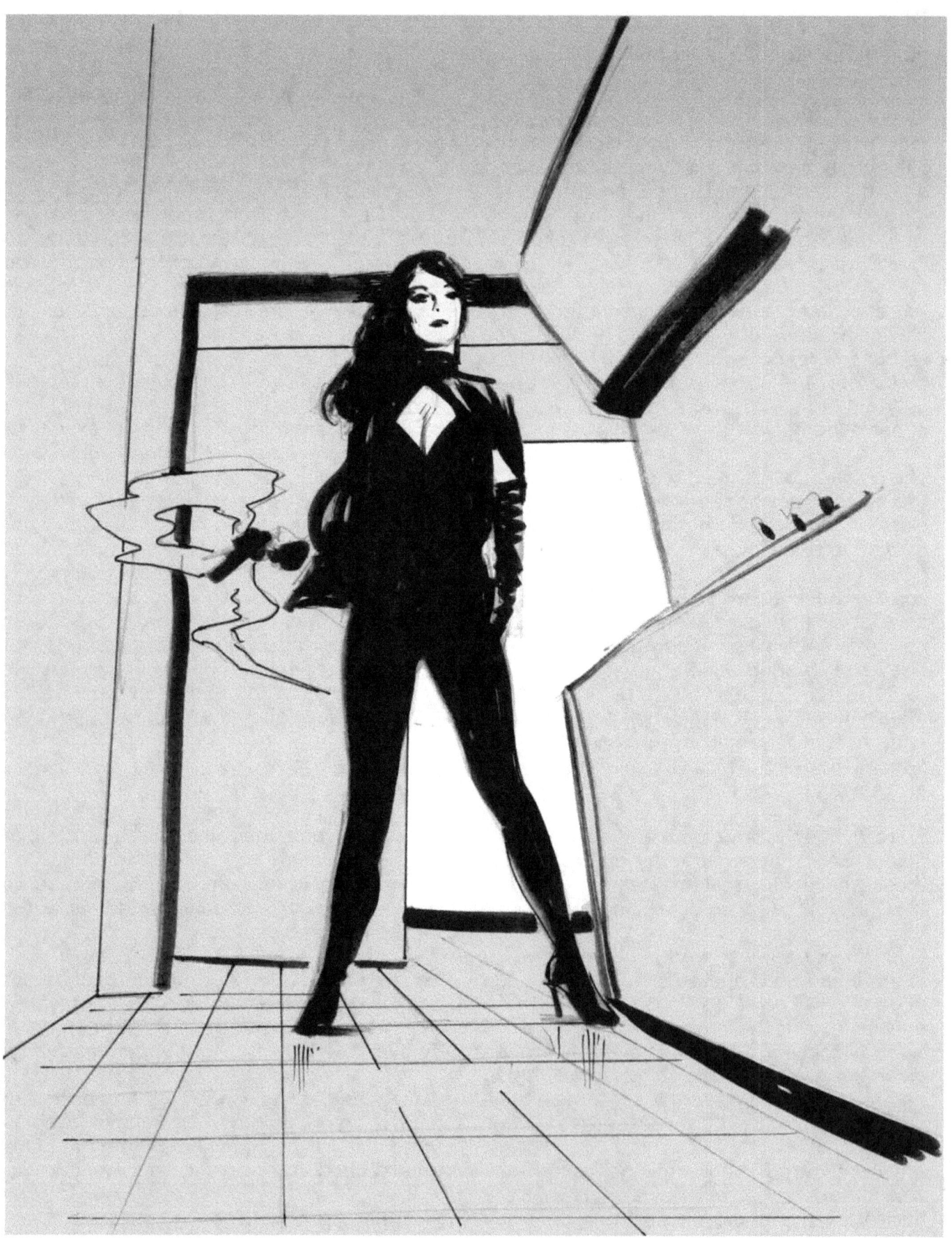

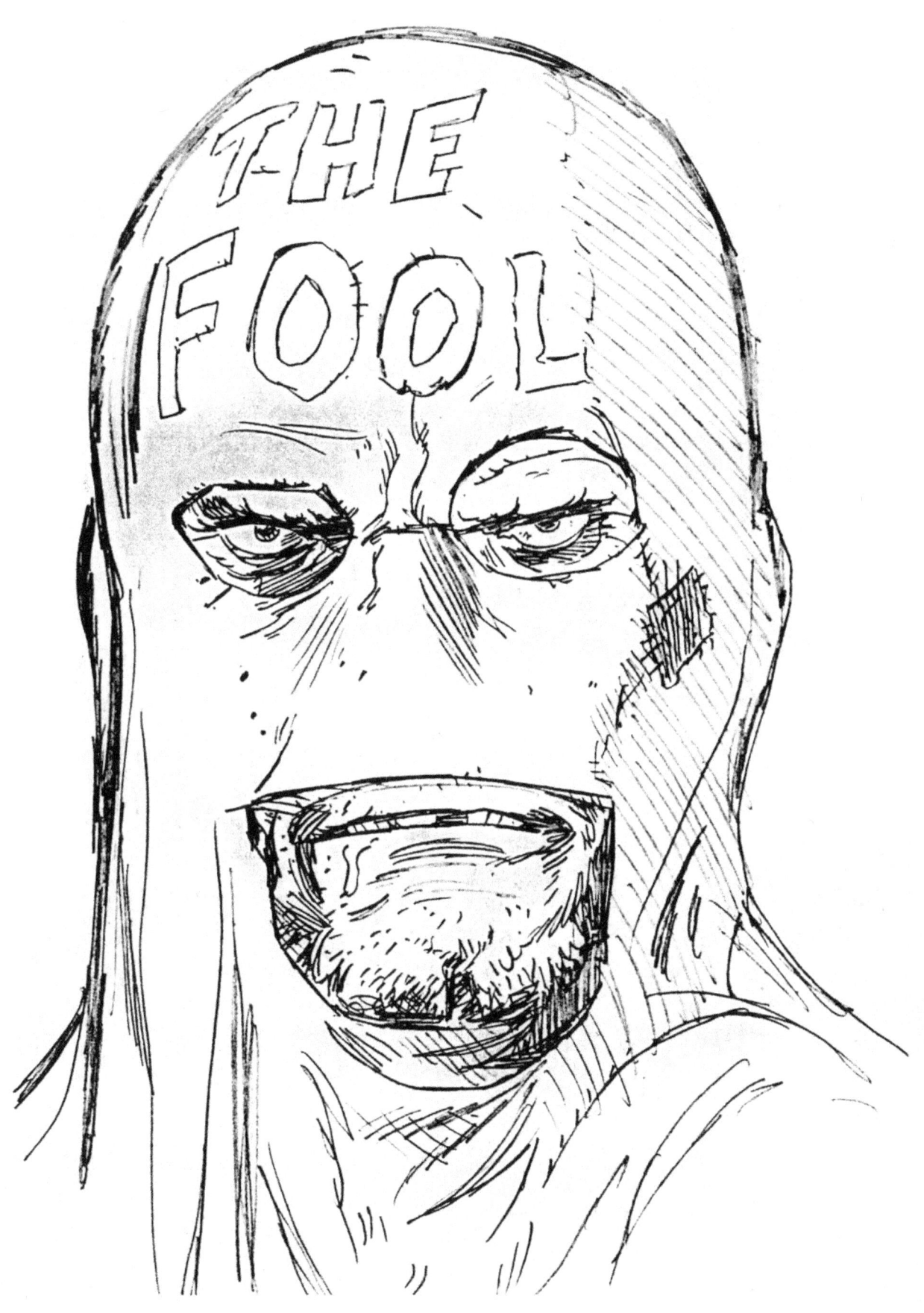

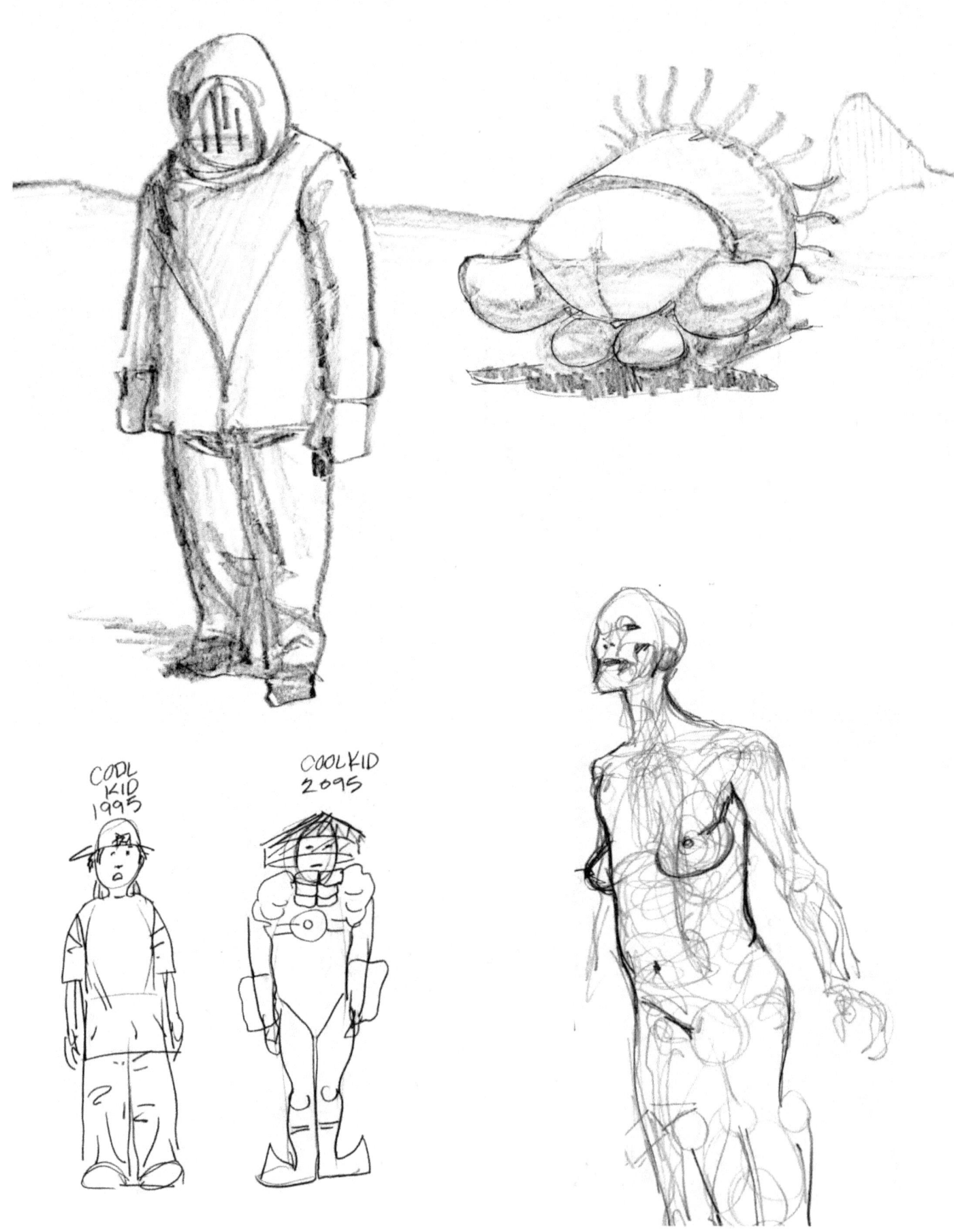

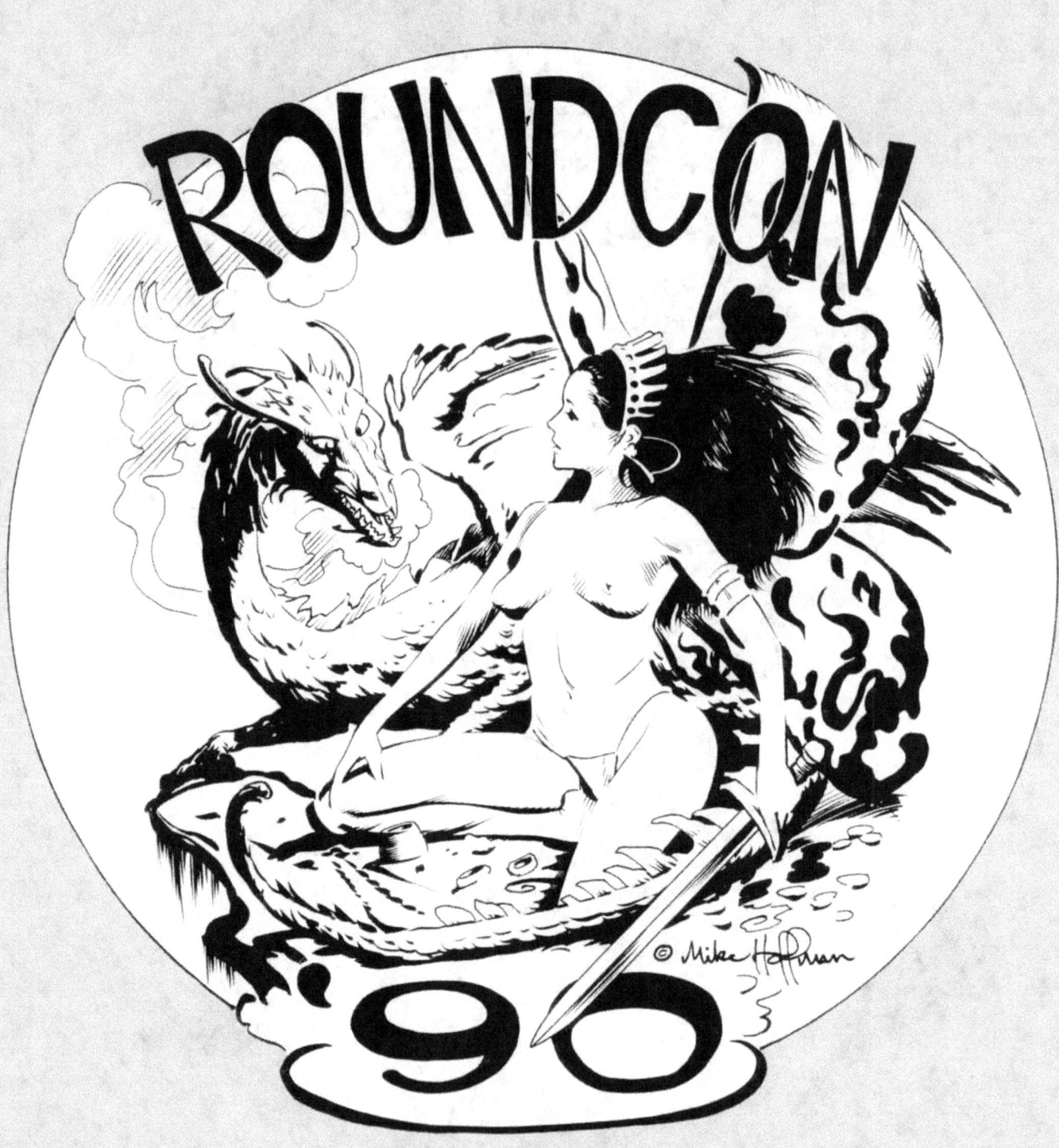

THE WISE ONE
AND TWO SERVANTS —

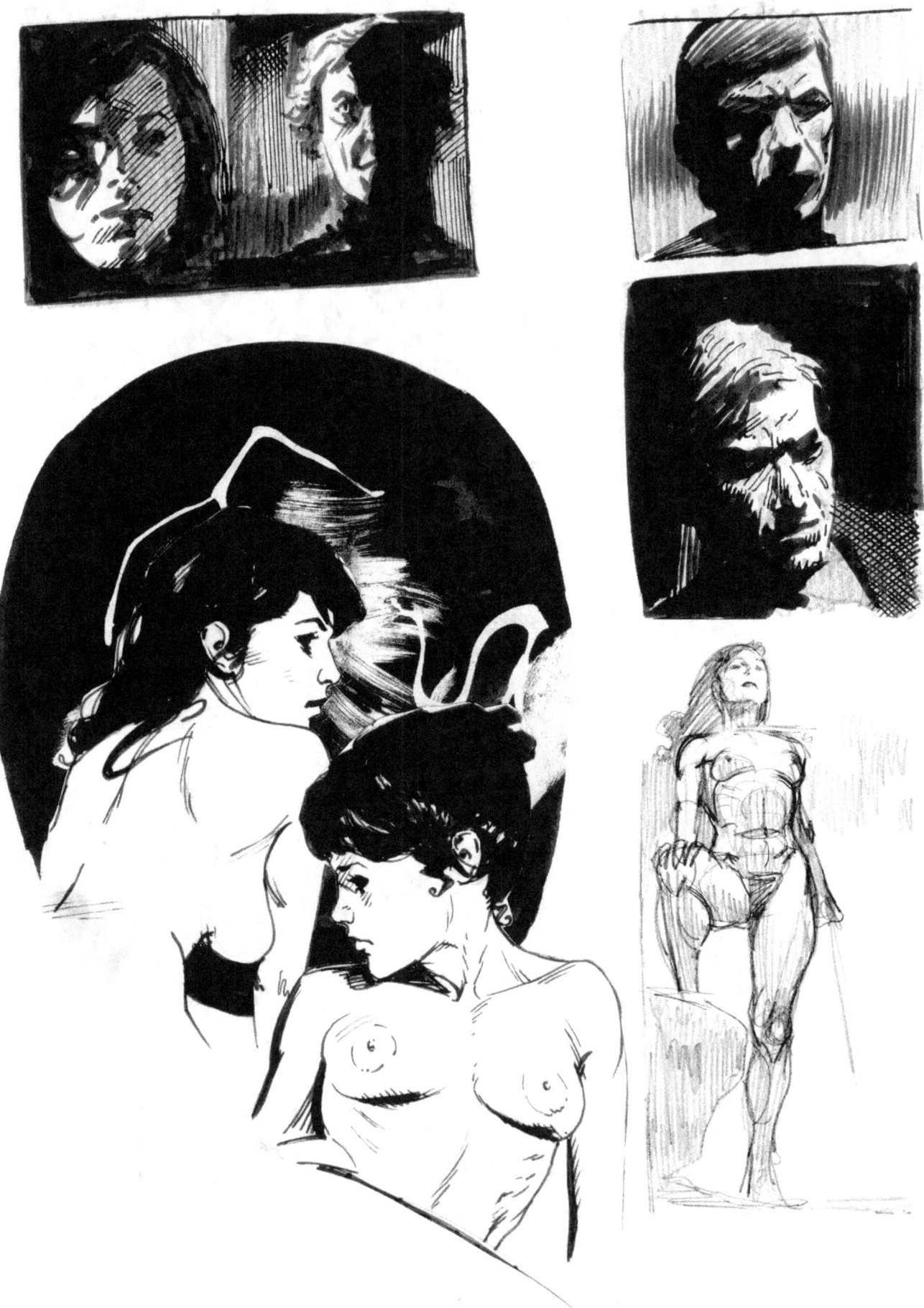

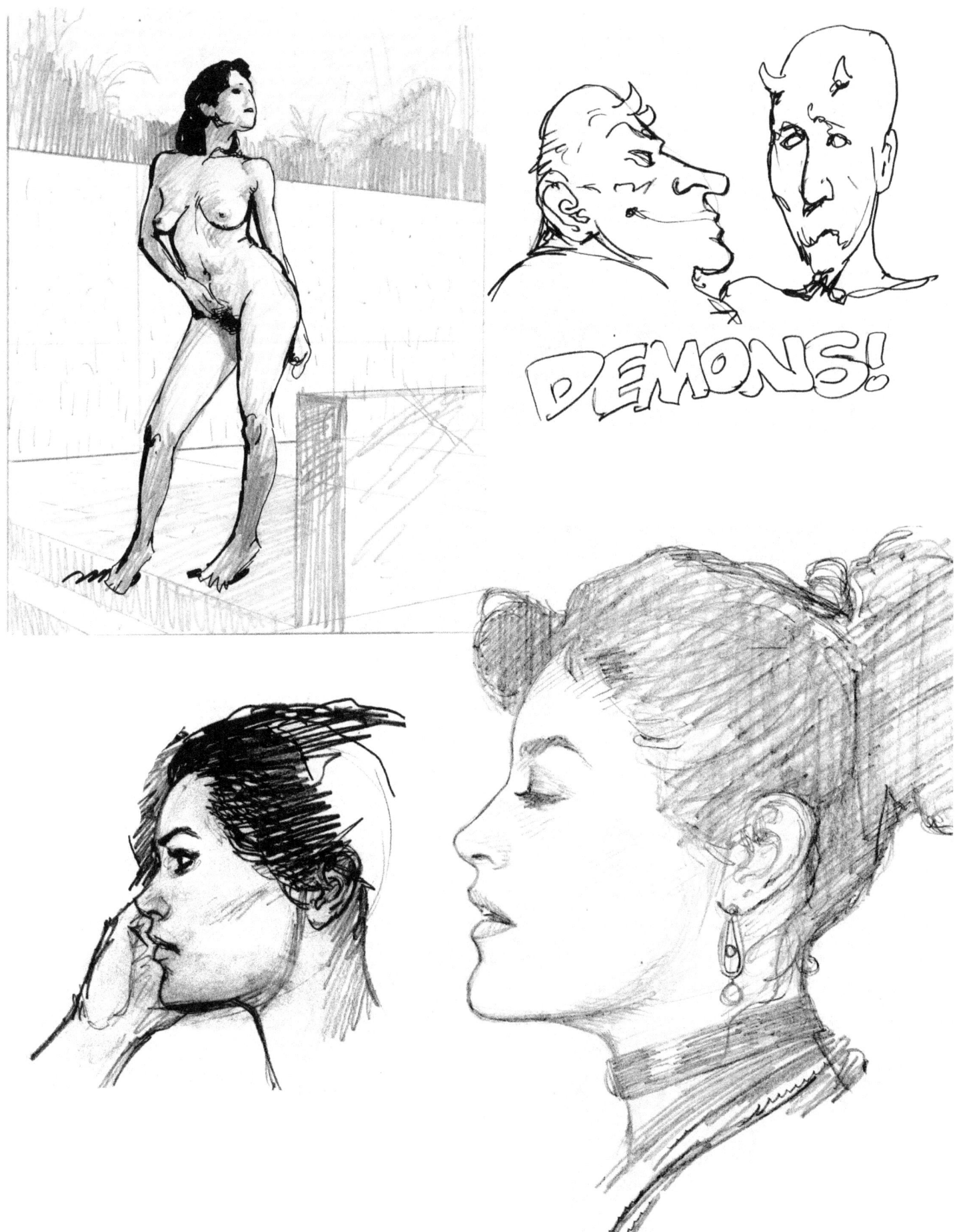

Our forefathers, who art on the bookshelves,
Forgotten be thy names.
The Cash-Kingdom nomes, Corporate will will be done
In the third world as it is in America
Give us this day our Media fix
and dliver us from thinking
For theirs is the Kingdom
of Power and Money
For ever and ever
Or until the Resources run out
Amen.

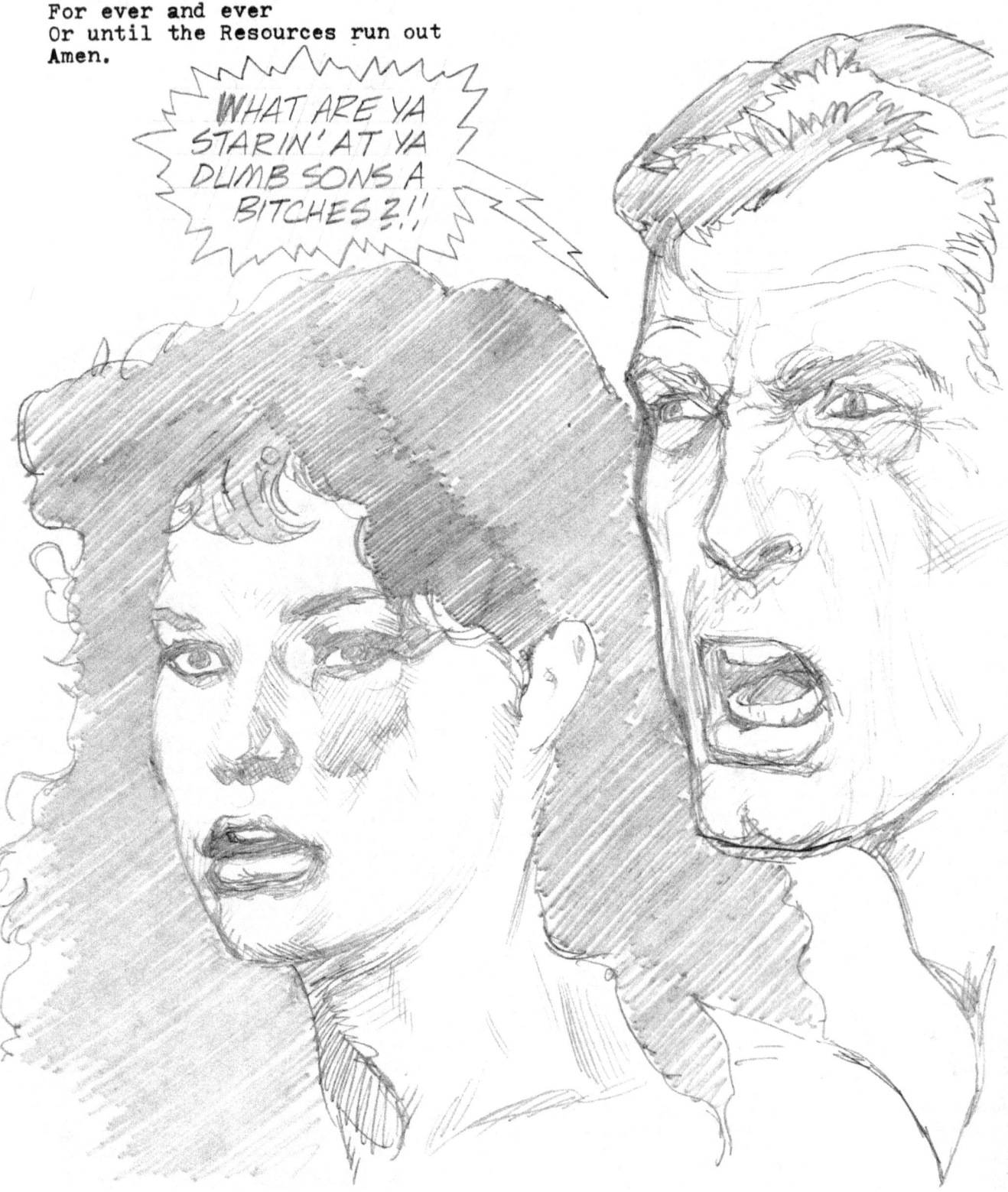

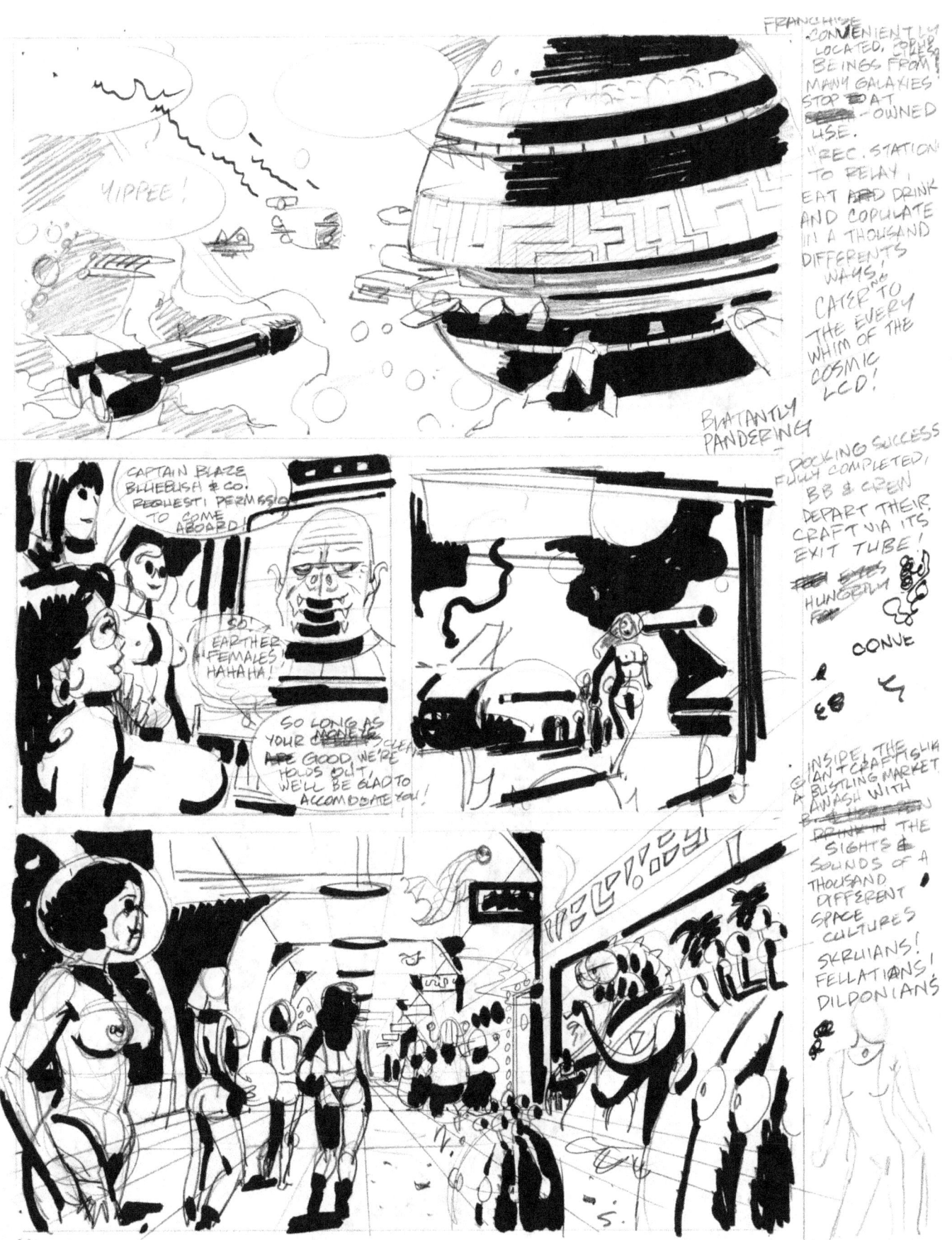

Layout for a sequel to my "Captain Bluebush" adult comic, featuring a descendant of the original character.

F.L.U.B. -- Fightin' Legion Of Underdogs And Bums

RIGHT: Octavia's very first original costume design; BOTTOM RIGHT: A High School era drawing showing a meticulous Franklin Booth influence.

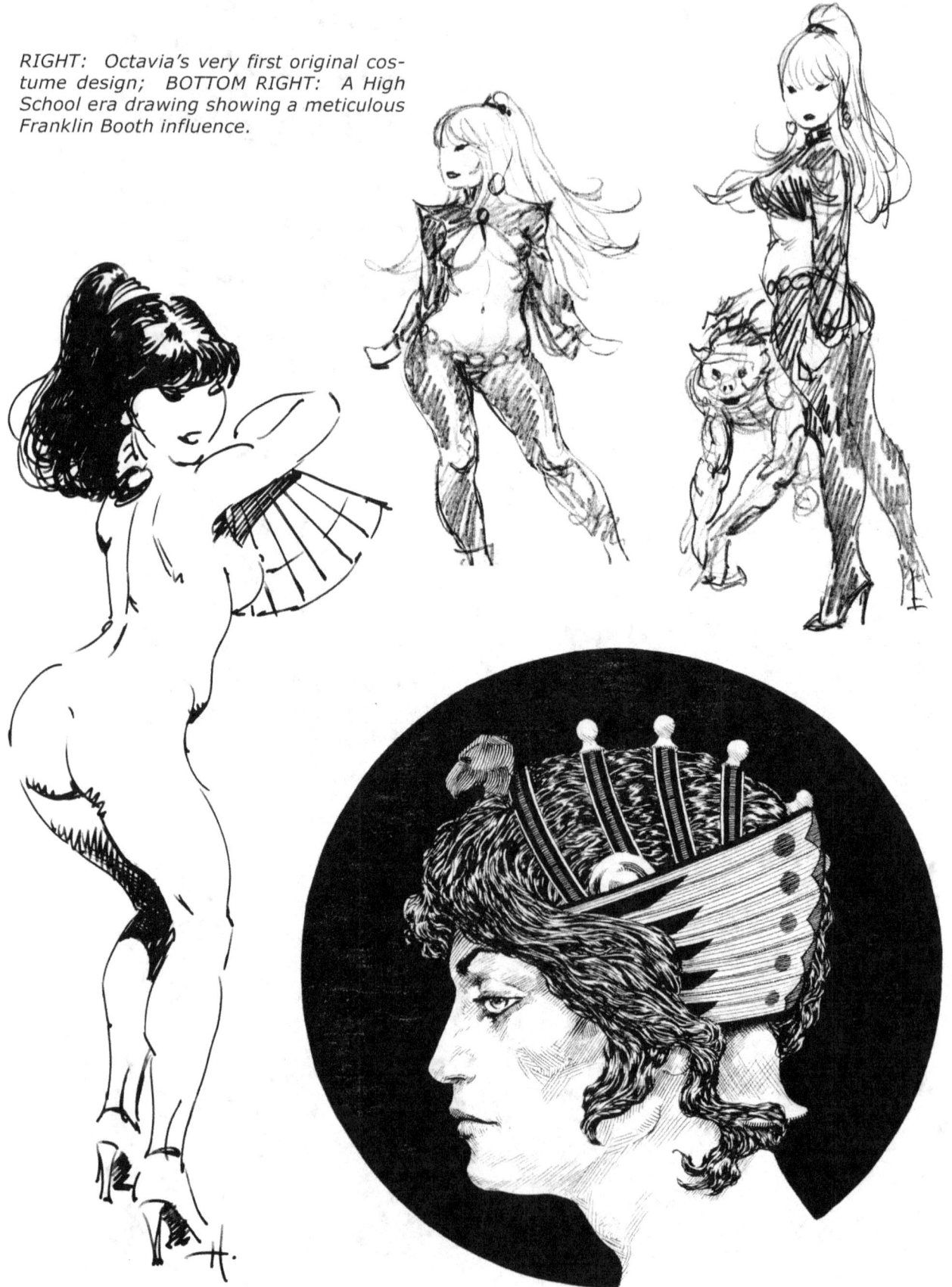

THIS PAGE: Character drawings for an unproduced comic story about a man who falls in love with a department store dummy.

NEW GUARD

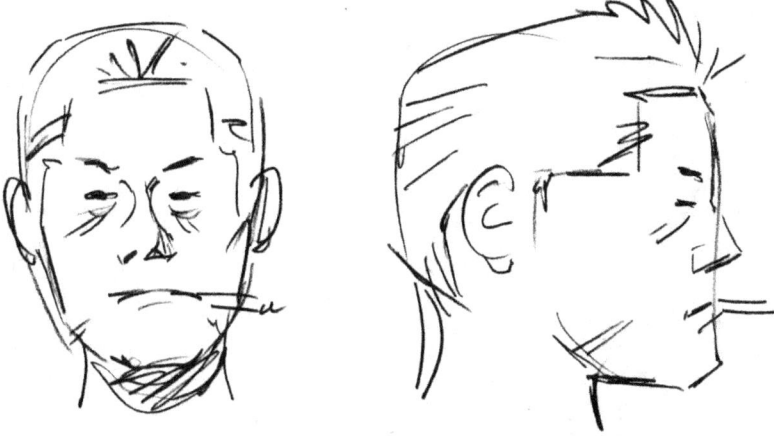

SMOKING KID

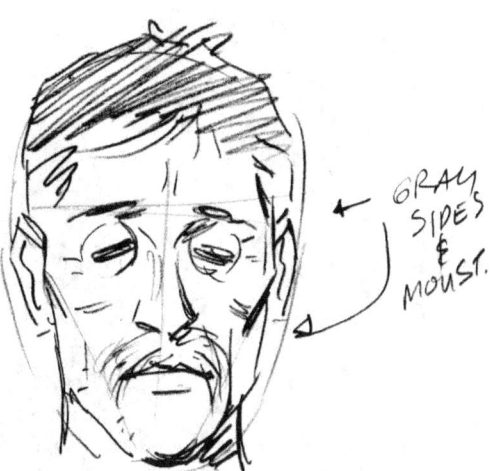

GRAY SIDES & MOUST.

FELDSTEEN (A LITTLE LIKE DICK VAN DYKE)

STALEY (LIKE A BULLDOG)

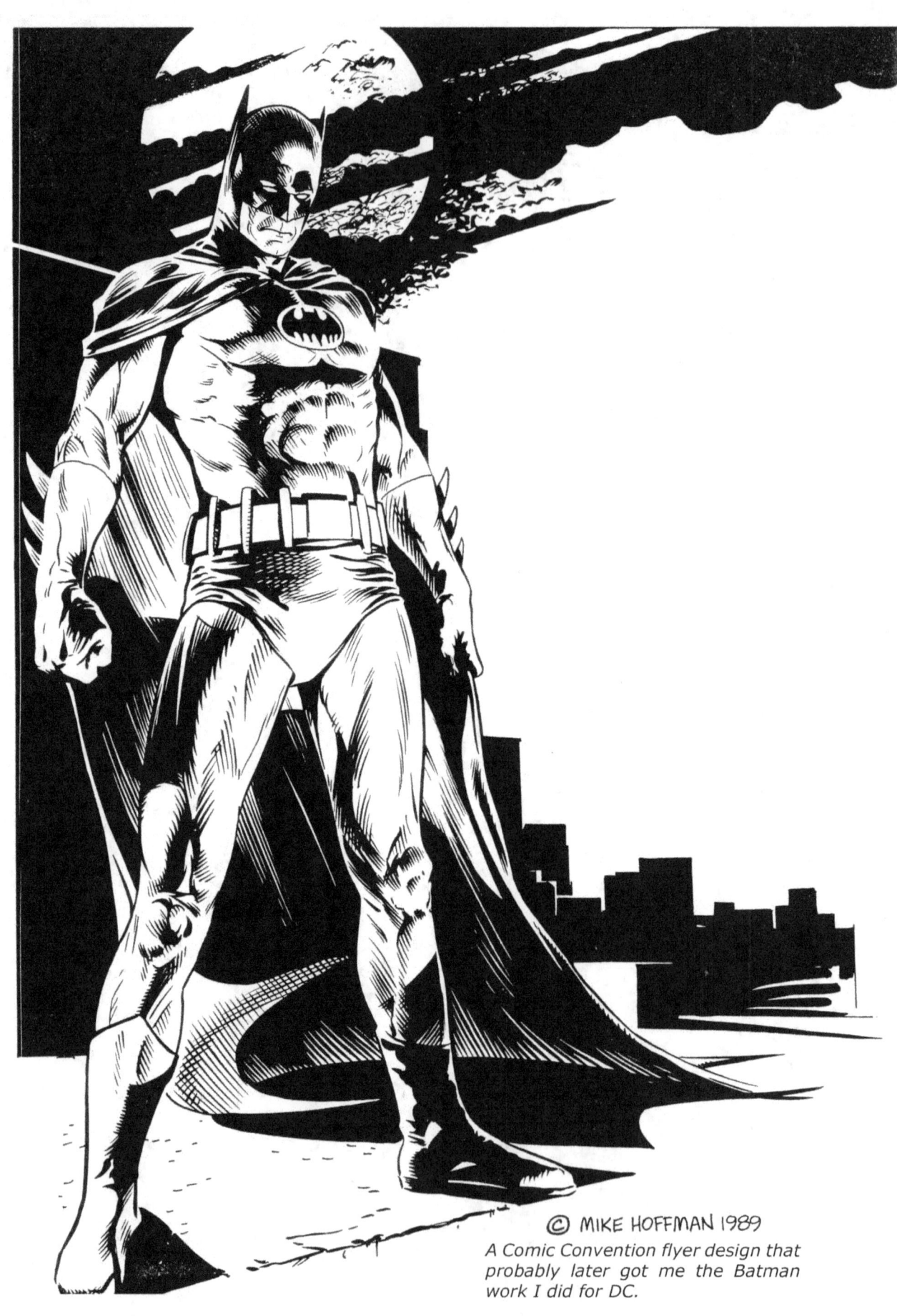

© MIKE HOFFMAN 1989
A Comic Convention flyer design that probably later got me the Batman work I did for DC.

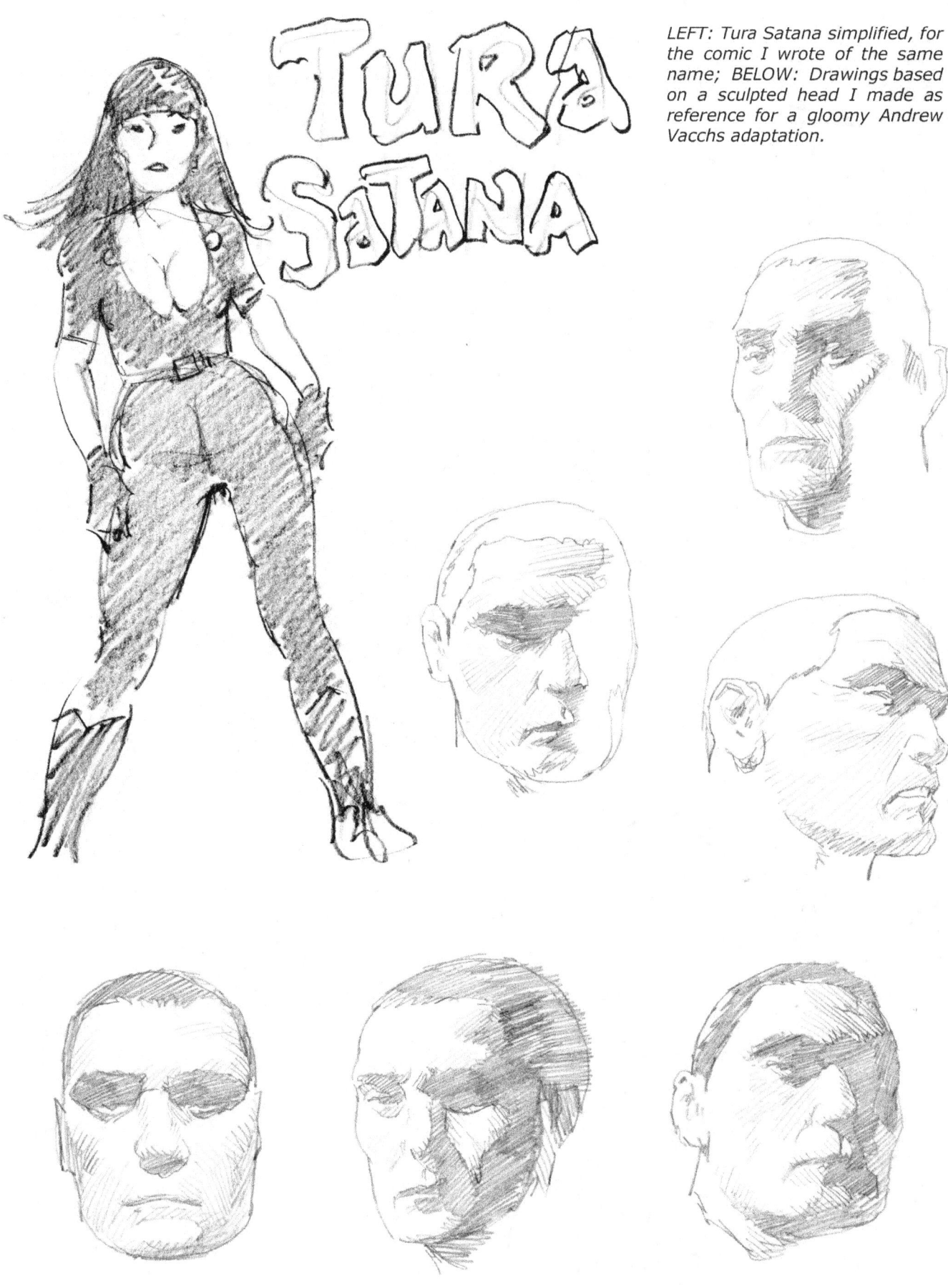

LEFT: Tura Satana simplified, for the comic I wrote of the same name; BELOW: Drawings based on a sculpted head I made as reference for a gloomy Andrew Vacchs adaptation.

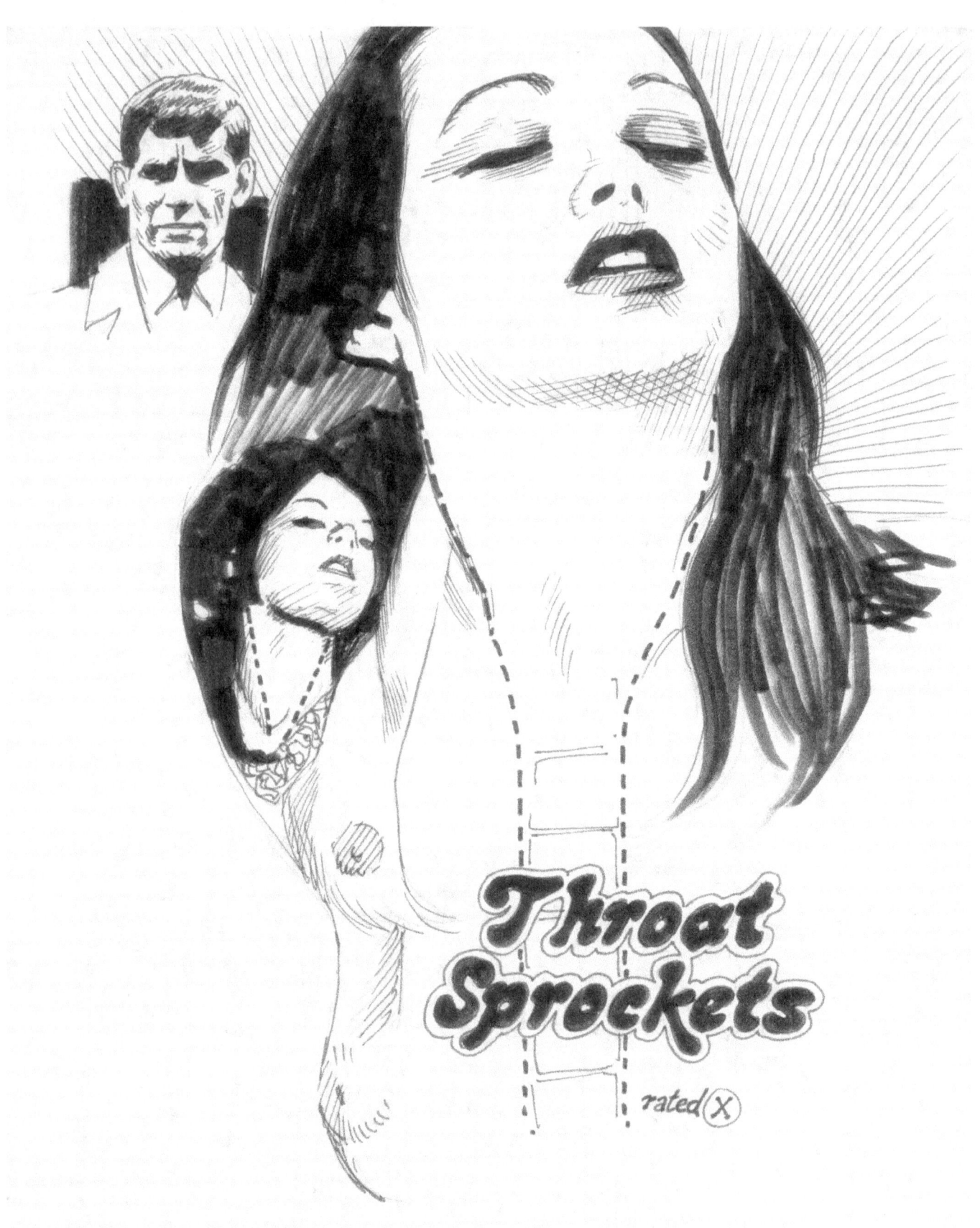

A mock movie poster designed to accompany the strip of the same name I drew for Steve Bissette's "Taboo".

ABOVE: a prime example of the Obsessive Meticulousness of Yesteryear; a drawing done to appear as a mural in the background of a comic panel. I used white-out and a sponge for some of the ink effects.

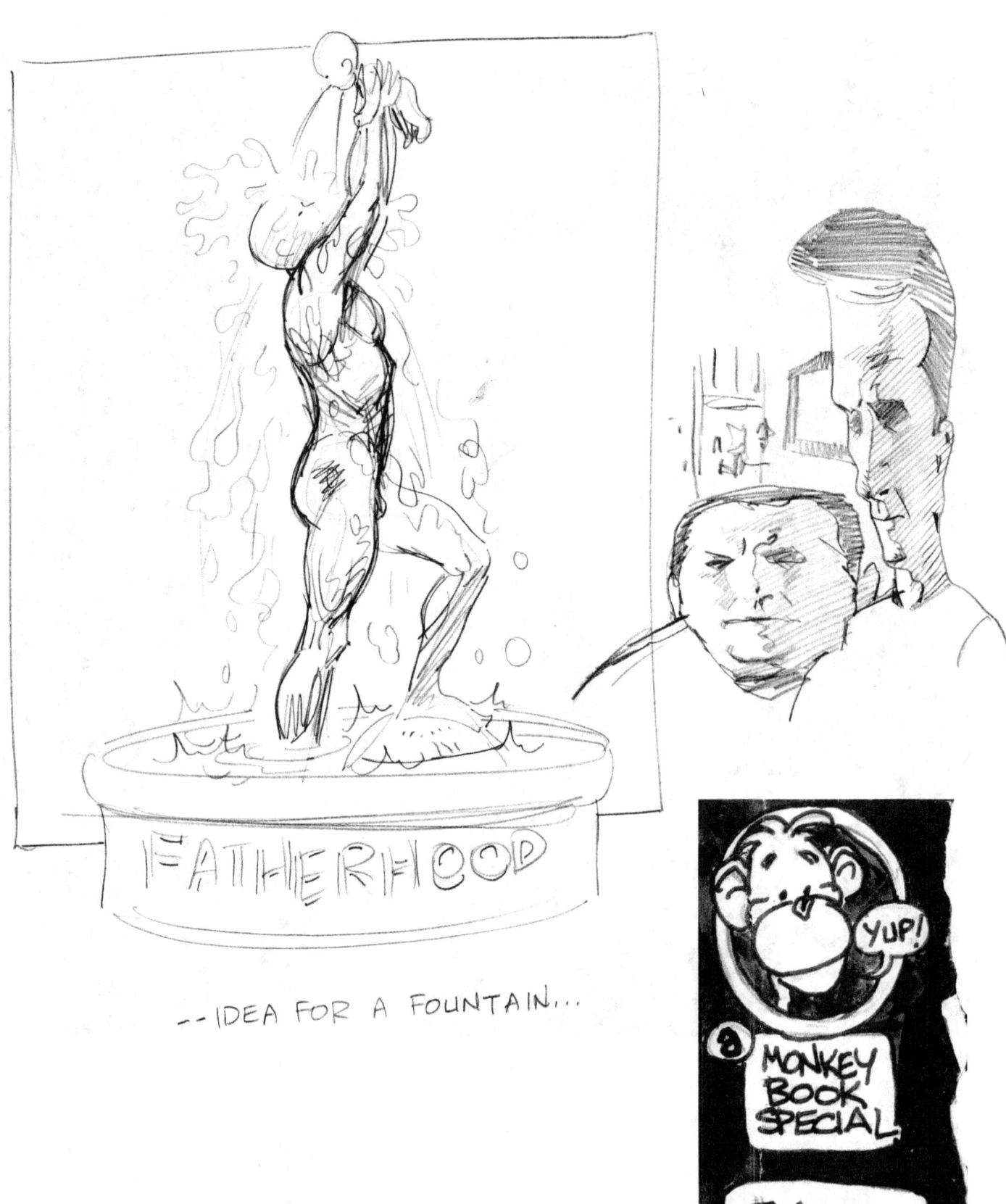

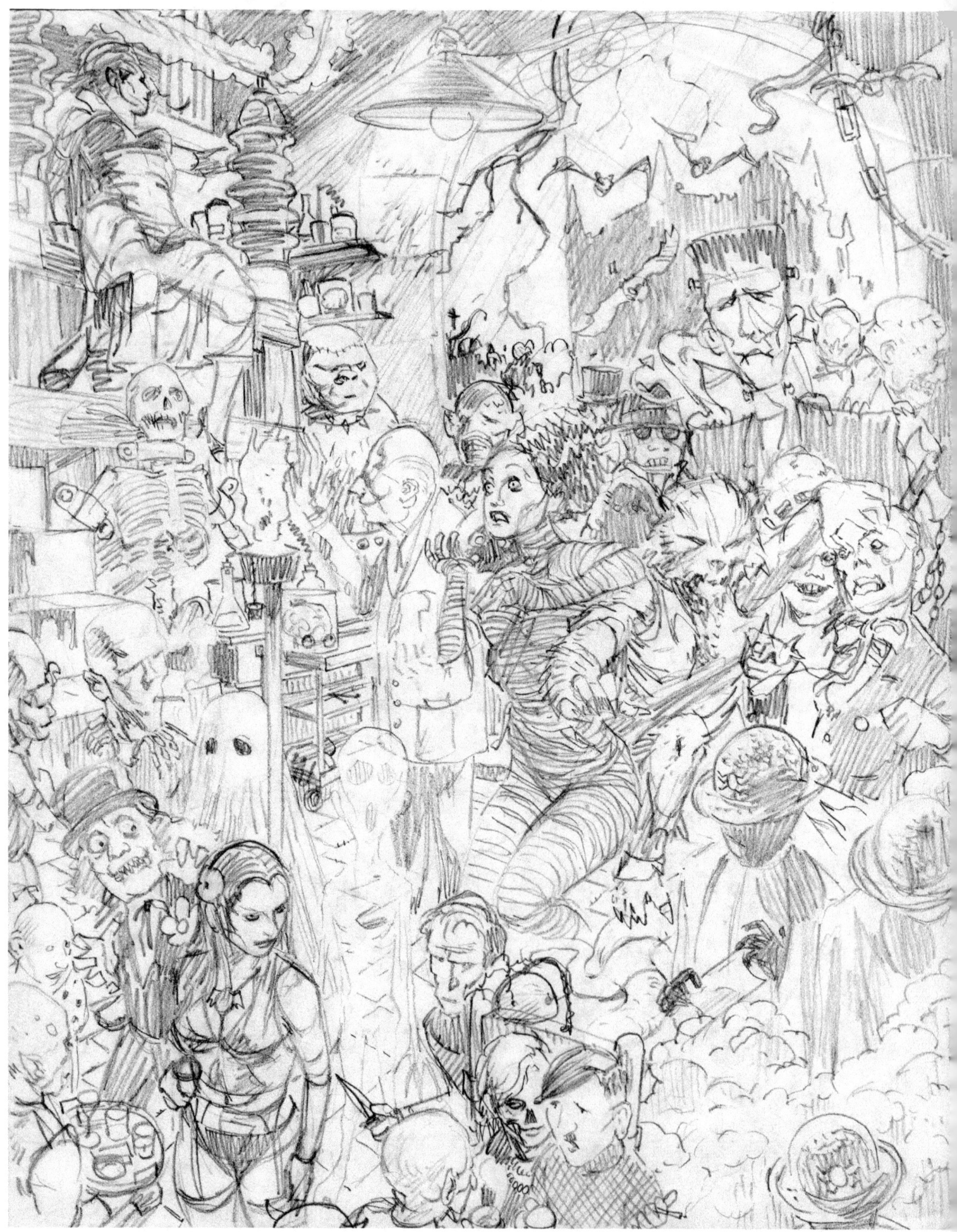

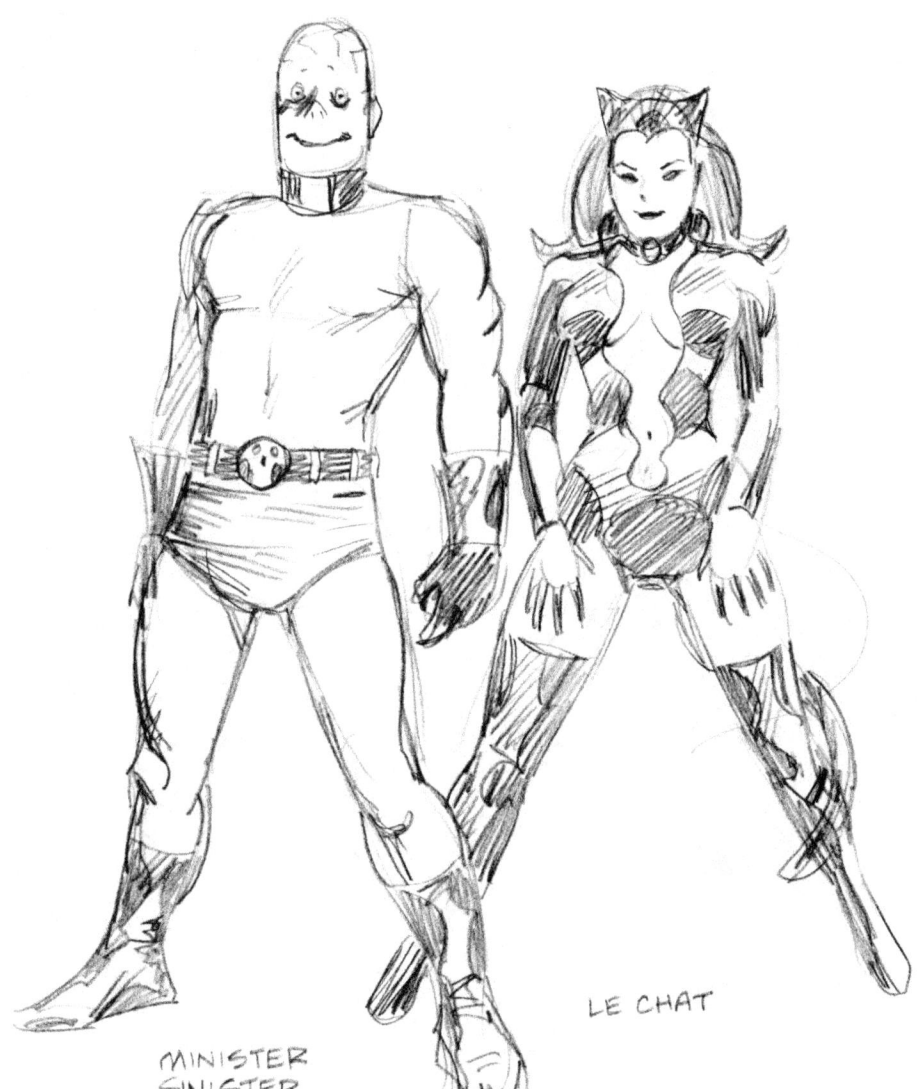

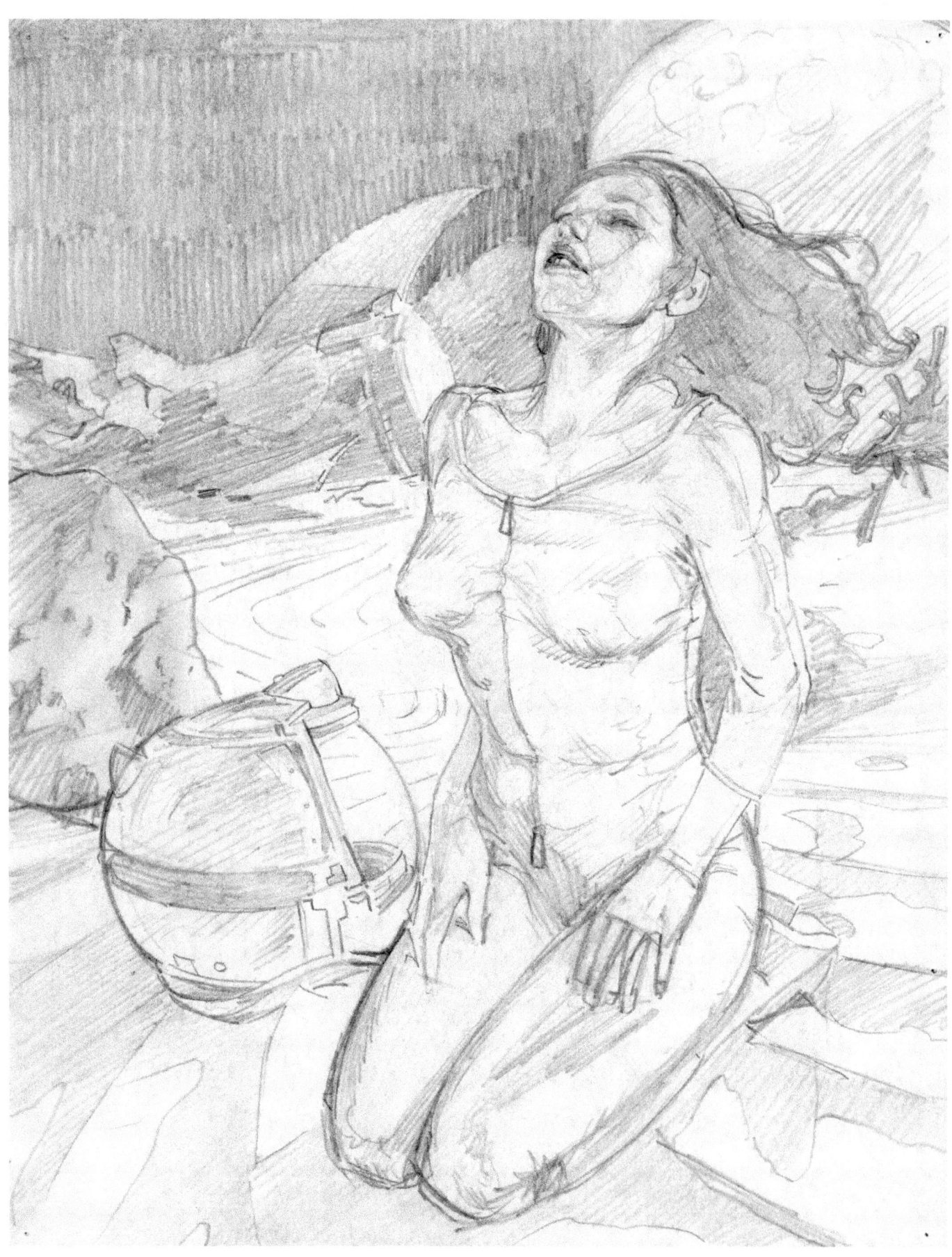

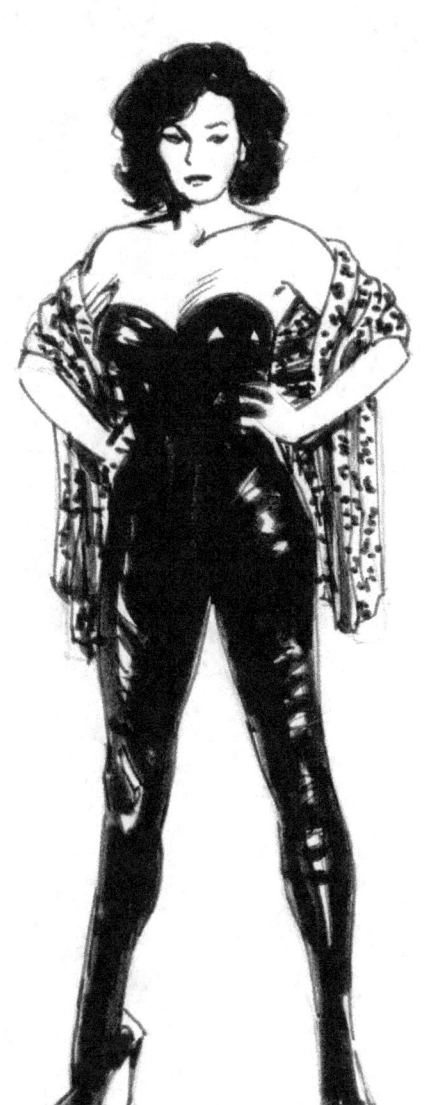

WAITING.... ALL OF THEM WAITING.

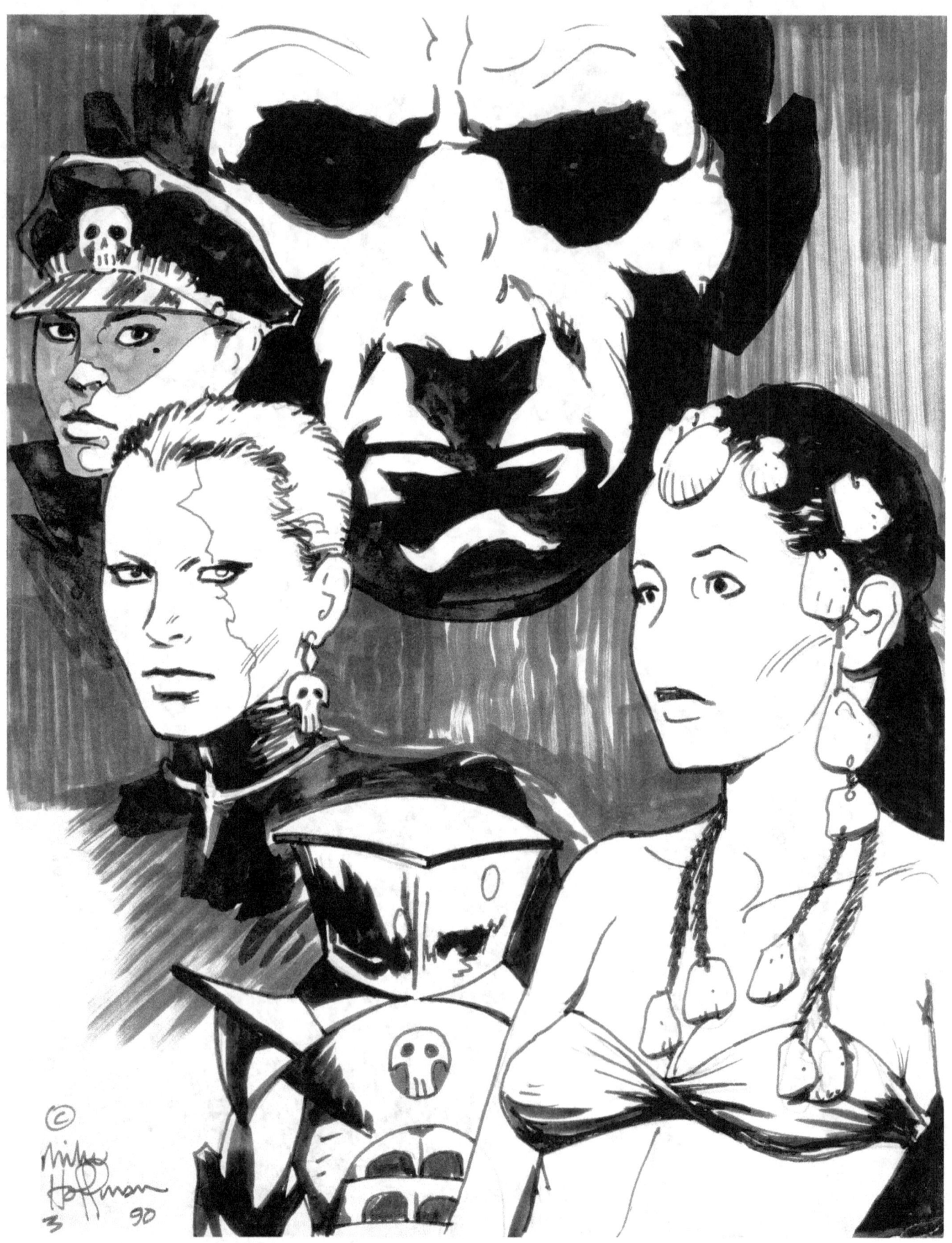

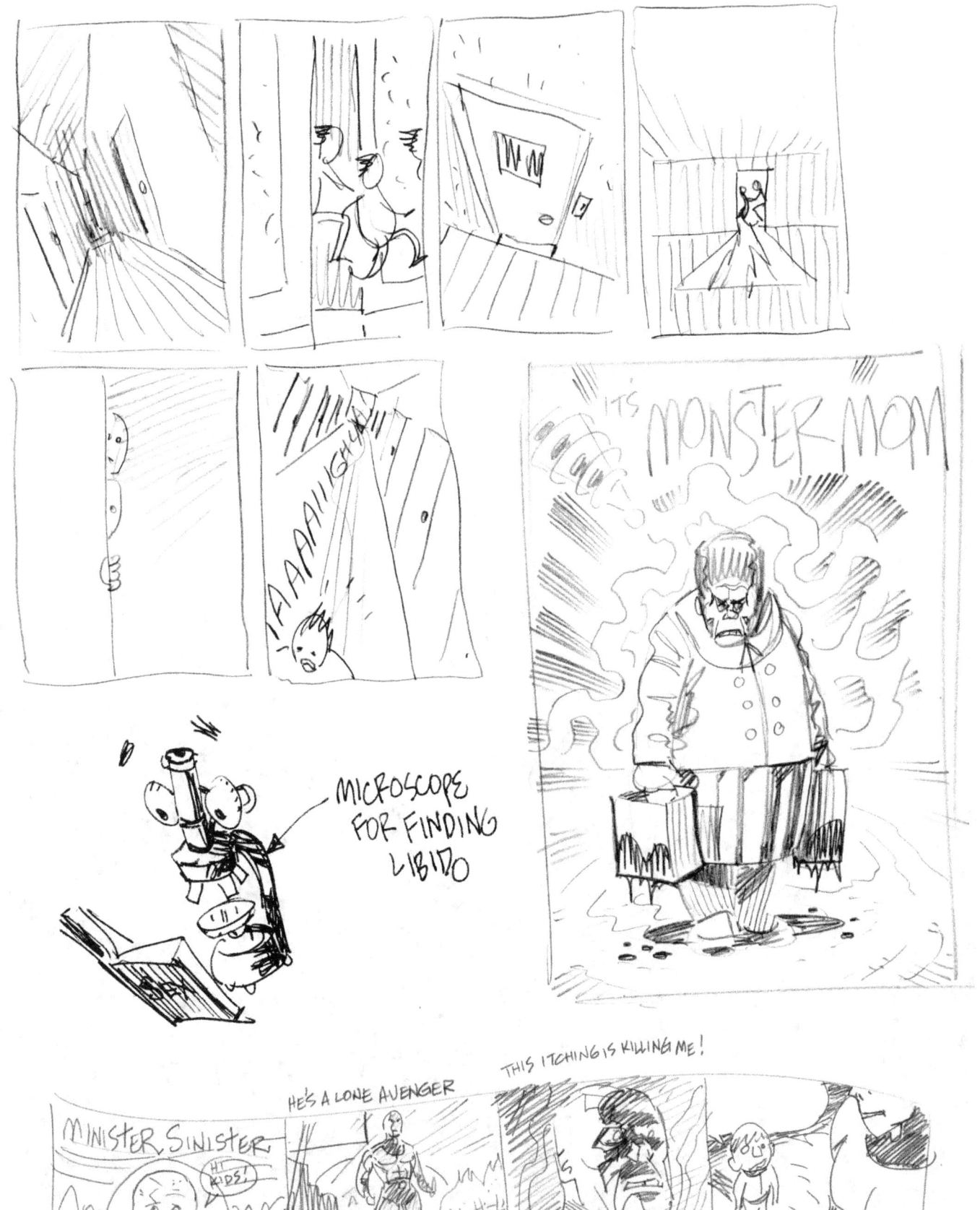

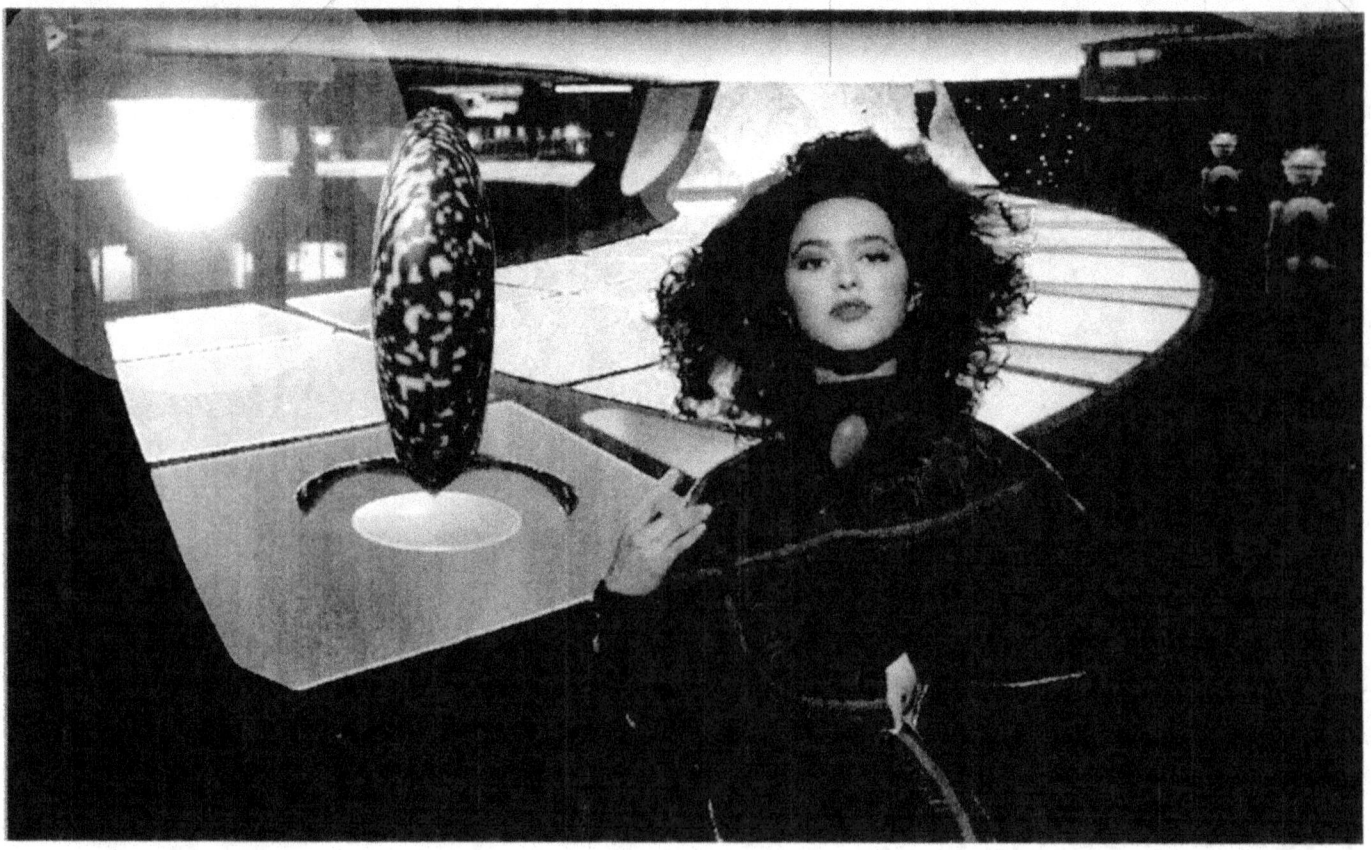

TOP: working out complex perspectives; BOTTOM: a collage made using one of the earliest extant versions of Photoshop and its antiquated "glass lens soft" effect. The background is an inverted photograph of an airport.

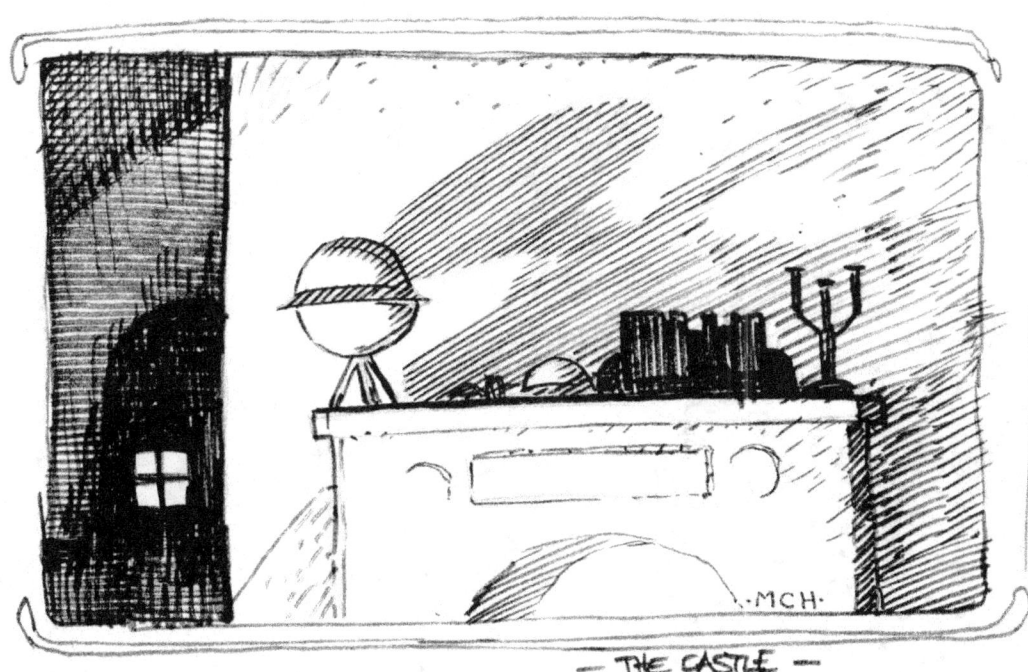

— THE CASTLE —

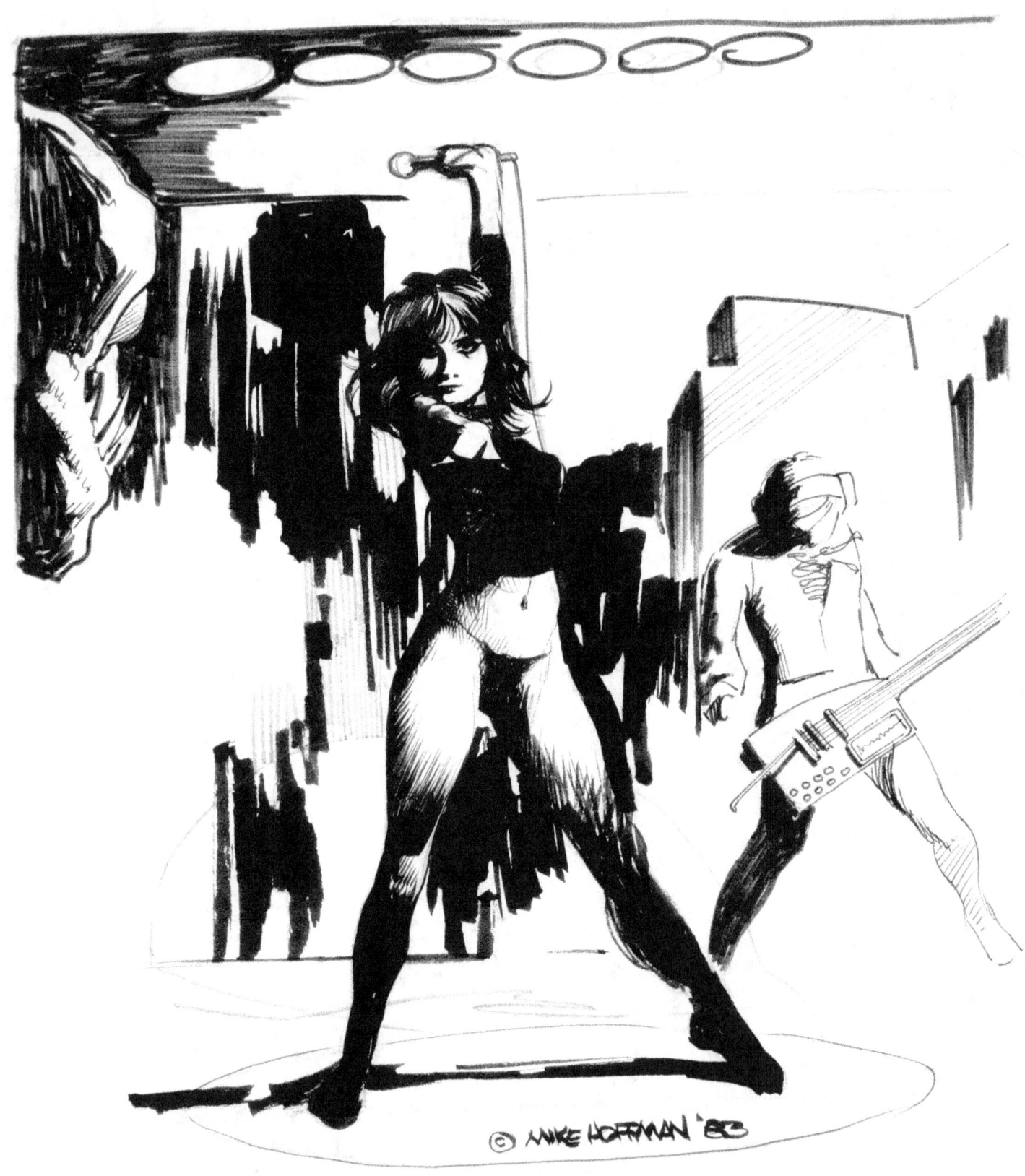

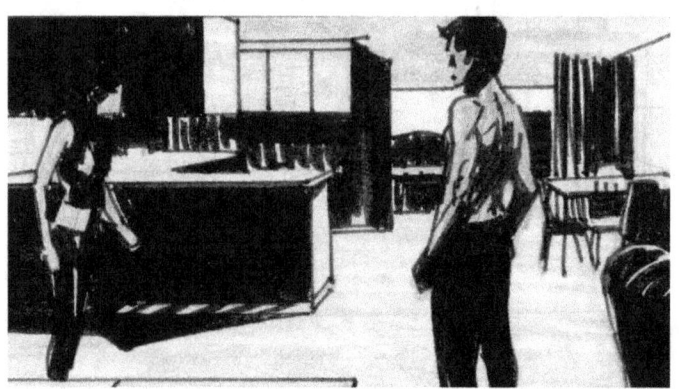

```
Michael:  Last night, I heard that noise
too!...It is definitely AN OWL!!!....
So don't worry, THEY have not come for
you yet.

                          Love, MOM
```

Eiseley Card

Made as a gift for a Unitarian Minister in Albuquerque, New Mexico. The quote is from Naturalist Loren Eiseley.

The evolutionists, piercing beneath the show of momentary stability, discovered, hidden in rudimentary organs, the discarded rubbish of the past. They detected the reptile under the lifted feathers of the bird, the lost terrestrial limbs dwindling beneath the blubber of the giant cetaceans. They saw life rushing outward from an unknown center, just as today the astronomer senses the galaxies fleeing into the infinity of darkness. As the spinning galactic clouds hurl stars and worlds across the night, so life, equally impelled by the centrifugal powers lurking in the germ cell, scatters the splintered radiance of consciousness and sends it prowling and contending through the thickets of the world.

— Loren Eiseley

Delinquent Daze

I could talk to you as one regular old flawed human being instead of some hot-shot artist, ha-ha, and I'm sure you could probably relate a little bit. We were all young once, I can readily assume. Maybe you still are, there's a lot of that going around.

One thing I recently discovered due some info from a Hoffman Insider is that my Poor Pop's life-long hardships came from a case of BPD, or Borderline Personality Disorder, that he was diagnosed with while under professional medical observation for 60 to 90 days in the 1960s.

I remembered nothing of all that, not the visit to a hospital with Mom and brother to see him in slippers and robe. The doctors must have said it could be treated, but it never was, except with alcohol. This, I finally discover, was where all the pain and aberrant behaviour came from. Or rather, not its origin but manifestation.

Those causes could be due to some childhood abuse or imply be inherited. What if there is a gene for violent, irrational behaviour that's passed down father-to-son? What if I have it? What if I just found this out, a few weeks past my 53rd birthday?

Am I not paying enough attention to Life, or not doing adequate research while travelling?

Going through a small mountain of papers here recently, I am struck by my "misspent", and I use the word with some misgiving, Youth. Common threads wind through the fabric, now visible from afar.

Heck, I was even drawing delinquent punks all the time; chronicling make-believe lives of nonexistent characters who smoked, greased and wore leather like some parody on the cover of a 1950s paperback novel "Reform School Punks".

Whether imaginary or not, the real world around me was an Ever-Ever Land of pot, ciggies, brewskis and acid, cast-off clothes and smoke-filled cars, and rosy-flushed doper chicks with soggy crotches

in the back seat. Am I clear on all this?

And lest we forget: vomit, tripping, pornography, theft & vandalism, the police, and a really shitty public school system.

And I really, really am not doing and saying this stuff to try and grab some pity, I am looking back at it and trying to understand some things.

The delinquency, for lack of a better term, went on for years and years and years. What exactly is it? The Dictionary says:

<u>Delinquency</u>

1. failure in or neglect of duty or obligation; dereliction; default: delinquency in payment of dues.
2. wrongful, illegal, or antisocial behavior. Compare juvenile delinquency.
3. any misdeed, offense, or misdemeanor.
4. something, as a debt, that is past due or otherwise delinquent.

See #2? Now we're on to something:

<u>Juvenile Delinquency</u>

behavior of a child or youth that is so marked by violation of law, persistent mischievousness, antisocial behavior, disobedience, or intractability as to thwart correction by parents and to constitute a matter for action by the juvenile courts.

That's better. I was in trouble with "the Law" constantly, although most offenses were comitted as a minor, or at least the ones I got caught at. I went through PTI, for example, "Pre-Trial Intervention".

The details of the many criminal activities of my youth are retold in my book called *Teenage Murder Bait,* although the names have been changed there to protect the guilty.

The Juvenile D. turned into Adult D. and is currently moving into Senile D. mode, and this realization has got me nonfused as to

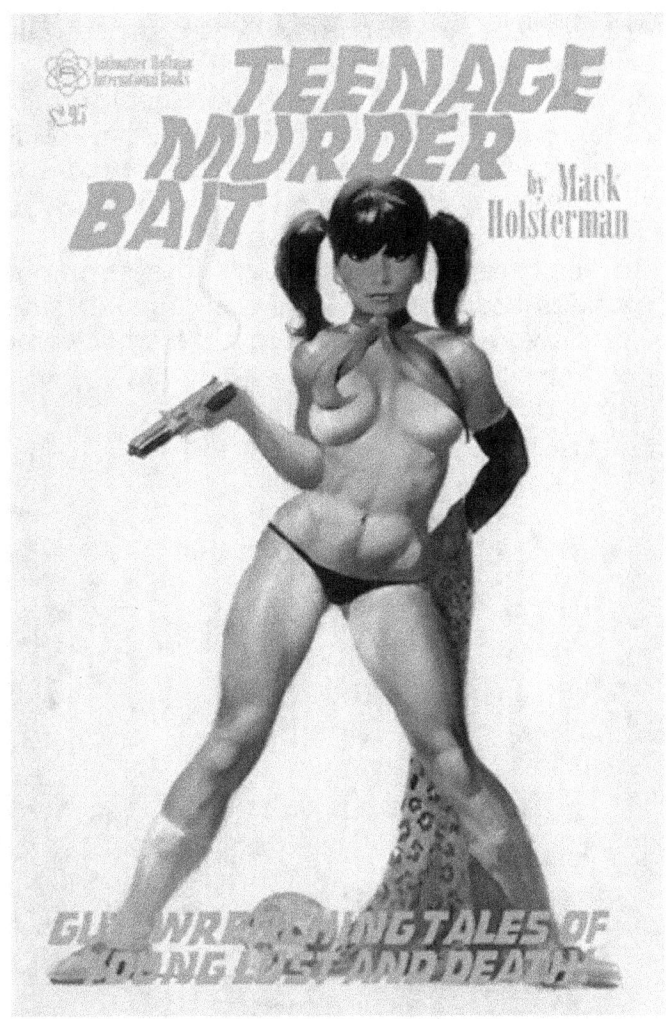

True tales of misspent youth in the Deep South.

whether I should apologize, try and hide it or not be concerned. On the other hand, maybe it is a cause for rejoicing.

I remember in the late 1970s when Punk Rock was all the rage, kids up to age 30+ everywhere were all bent on being rebellious, and it was a sort of carbon-copy rebellion.

I took part in it in that I was in a band, and I wrote some rather negative songs but also promoted the oldster stuff in the form of cover versions like *Smile, The Impossible Dream* and *Goldfinger.* Nowadays when kids go xerox they toss the baby with the bathwater.

I was very liberal back then with the Hedonism but very conservative about my underpinnings and creative substructure; I didn't pattern my musical creativeness on a Ramones album.

At any rate, the delinquency has prospered for so long around here it's become an established norm. Or perhaps better, The Establishment itself. Has it yielded much, or caused incurable stunting, with an impending geriatric *Lord of the Flies Rest Home?*

Our culture asks this every time someone parades their tattoos and piercings--it says "Aren't you ready to be a mature adult some day?" when the answer is obviously already "No".

But I never despised the adult world, the one I inherited from my folks and everyone else who made the World what it was before I came along. Who spits out their mother's milk, or spits in their father's eye?

I knew no one had hurt me intentionally, but the hurting just happened anyway, and what happened afterwards was the result.

No matter who you are, the Universe has a special paddle shaped just for your backside.

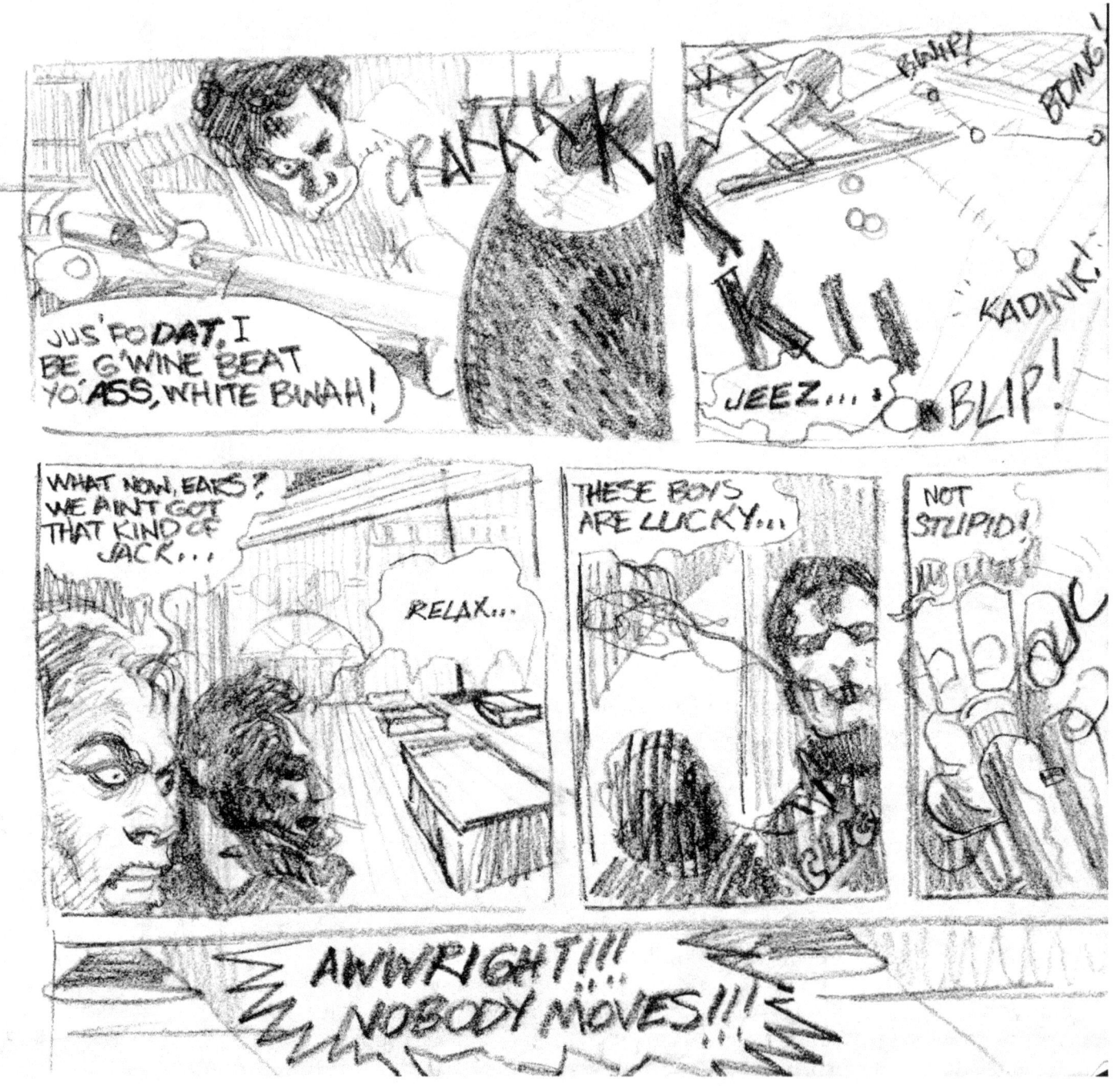

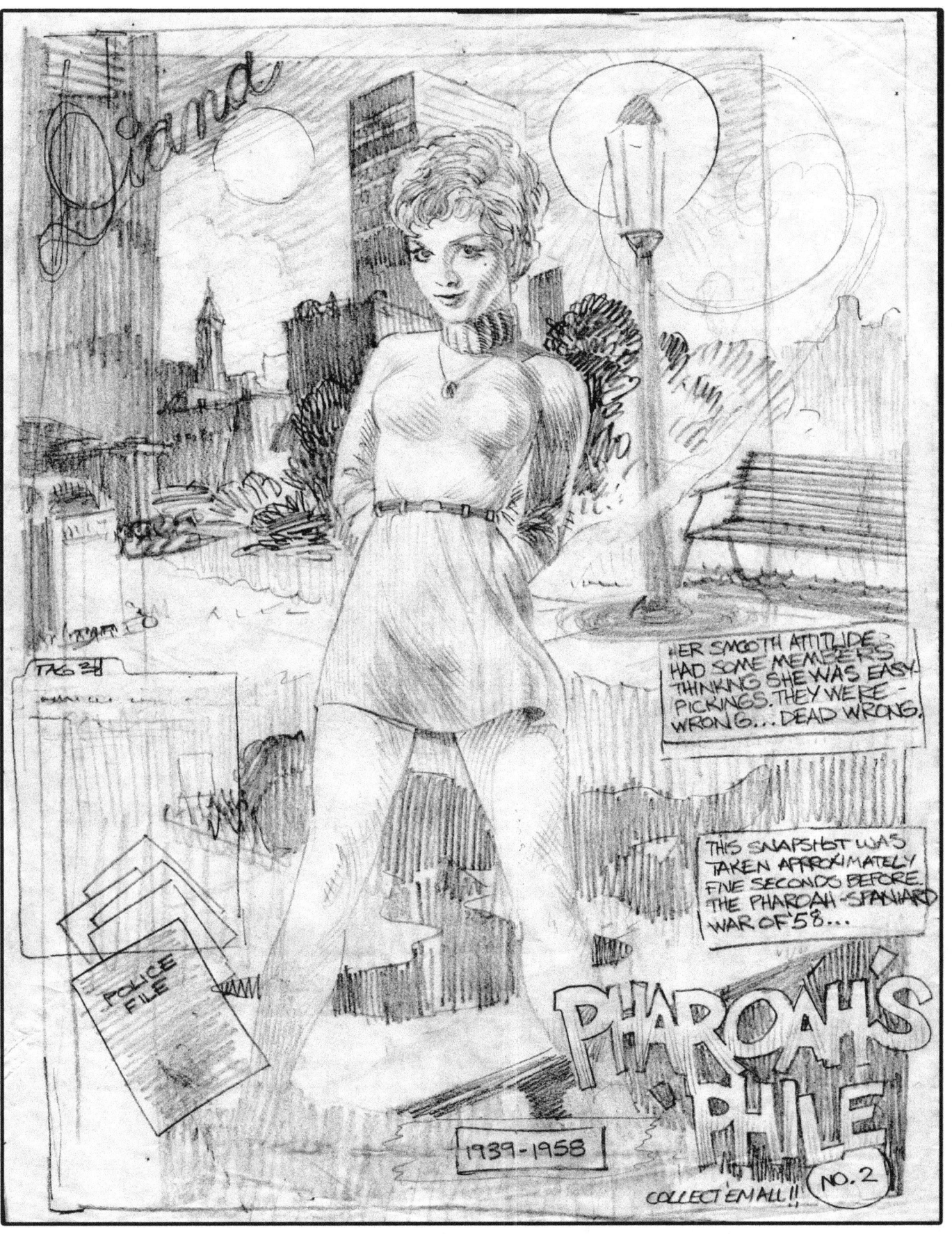

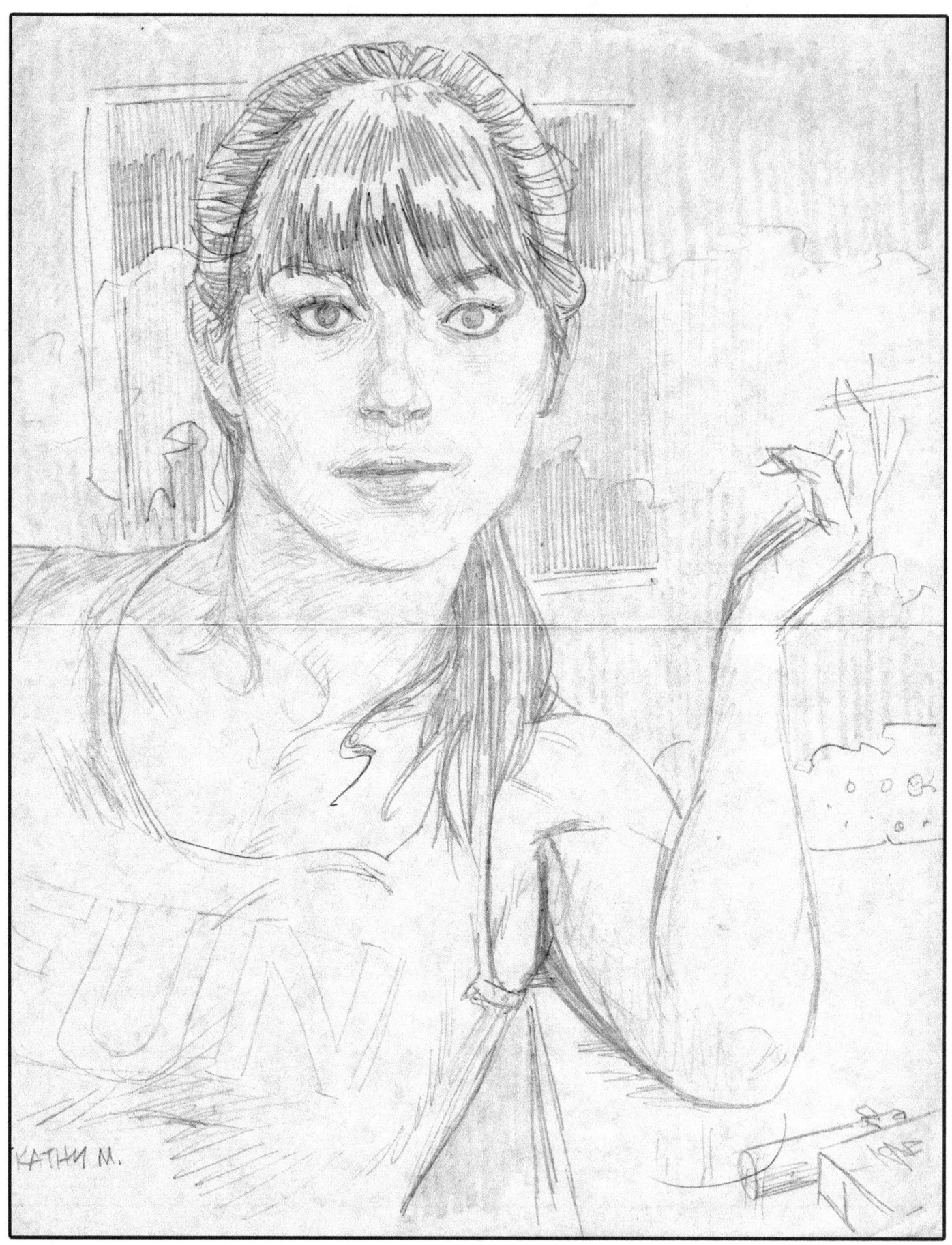

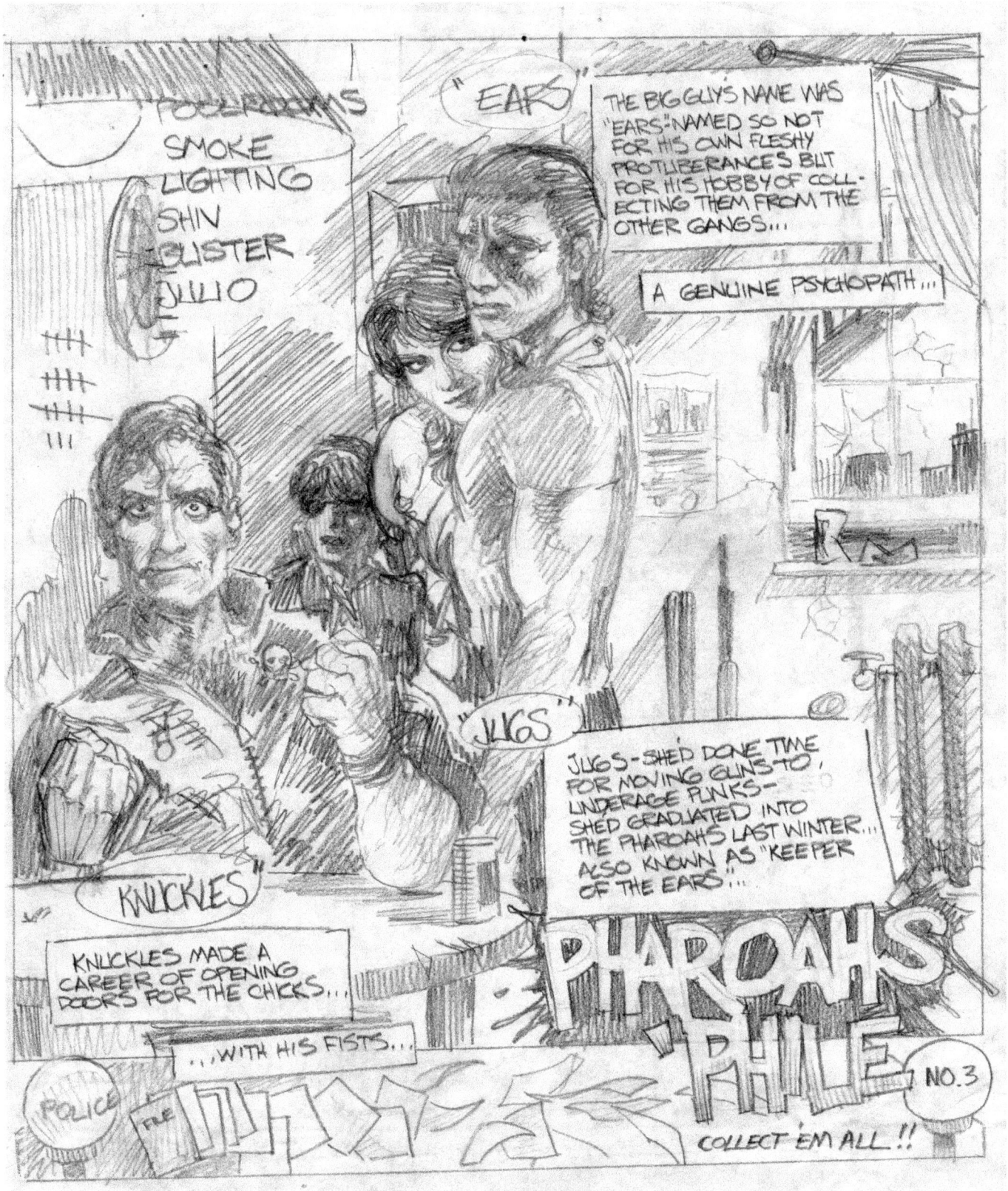

The kind of delinquency-based art that sprang effortlessly from deep in my tortured young psyche.

A "Film Noir" or hard-boiled detective-based drawing which was enlarged into an ink drawing.

Ink Gallery 1

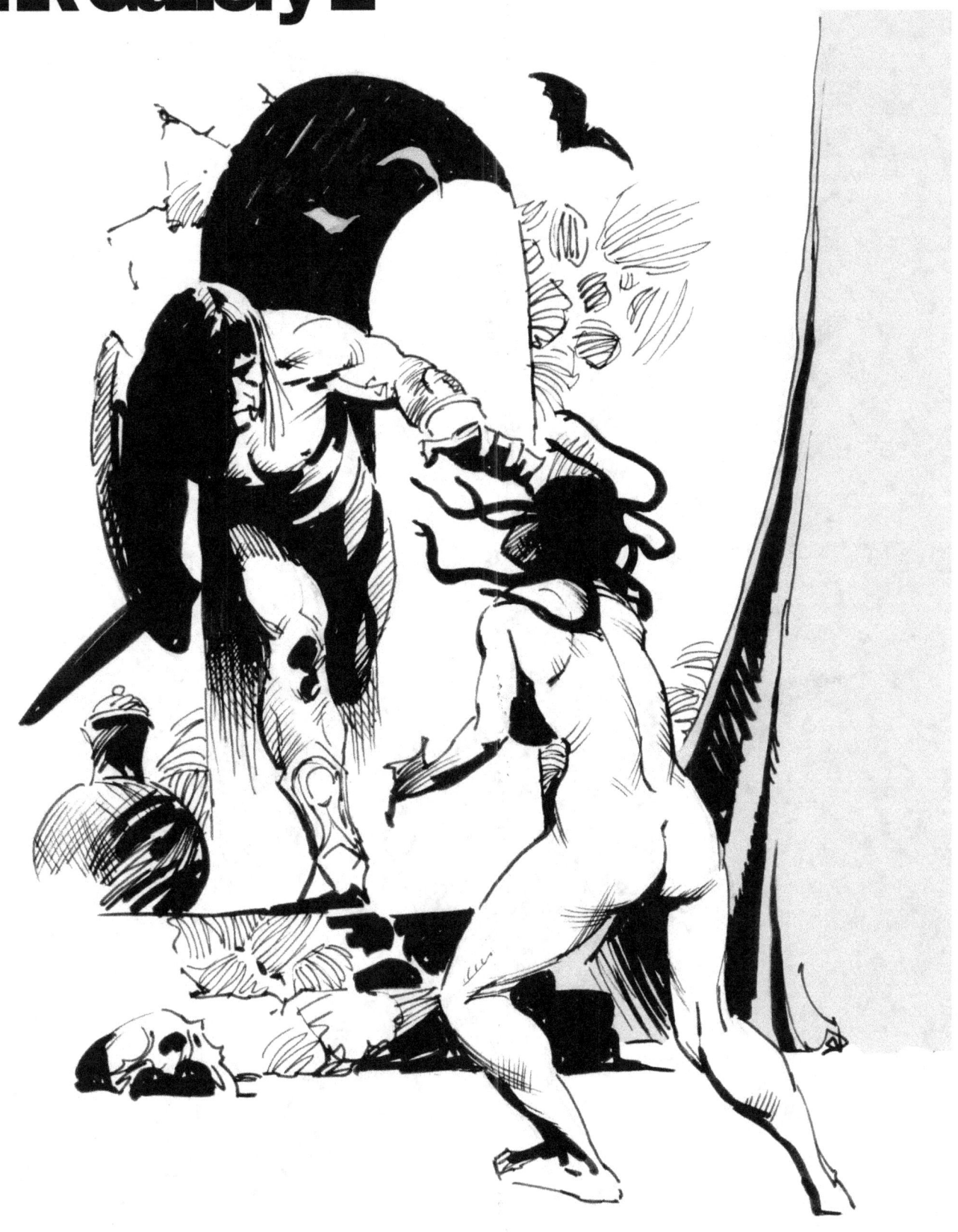

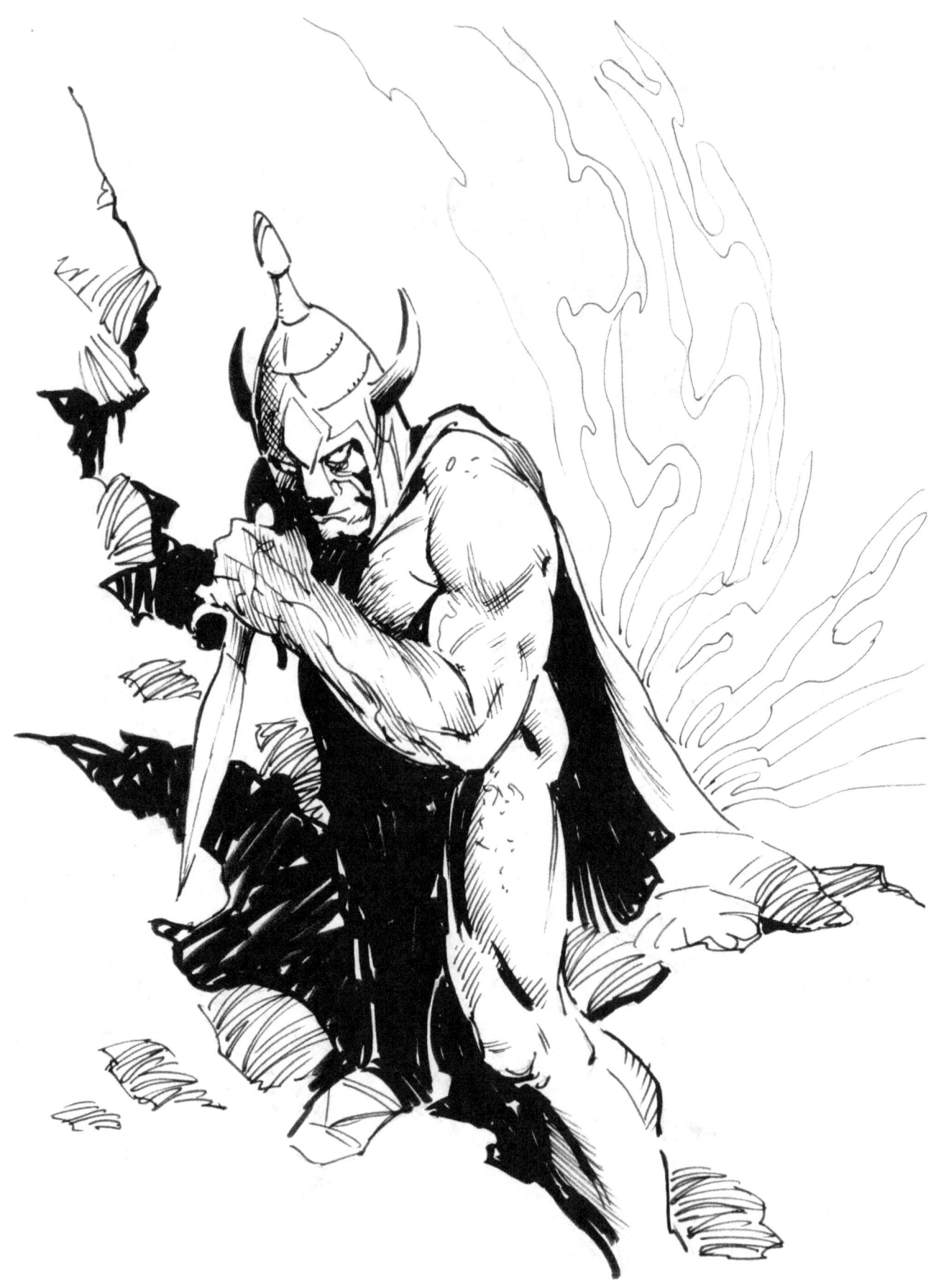

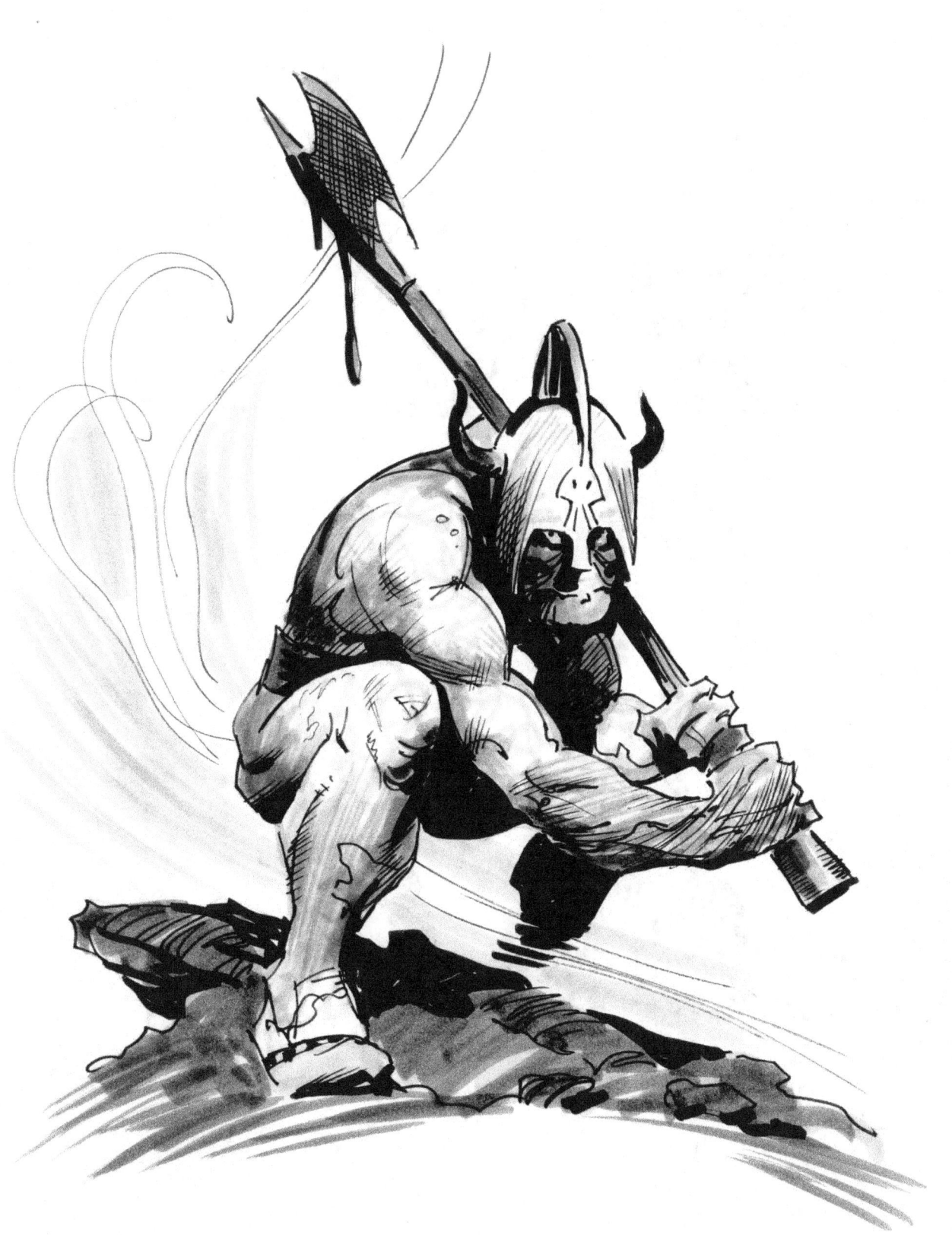

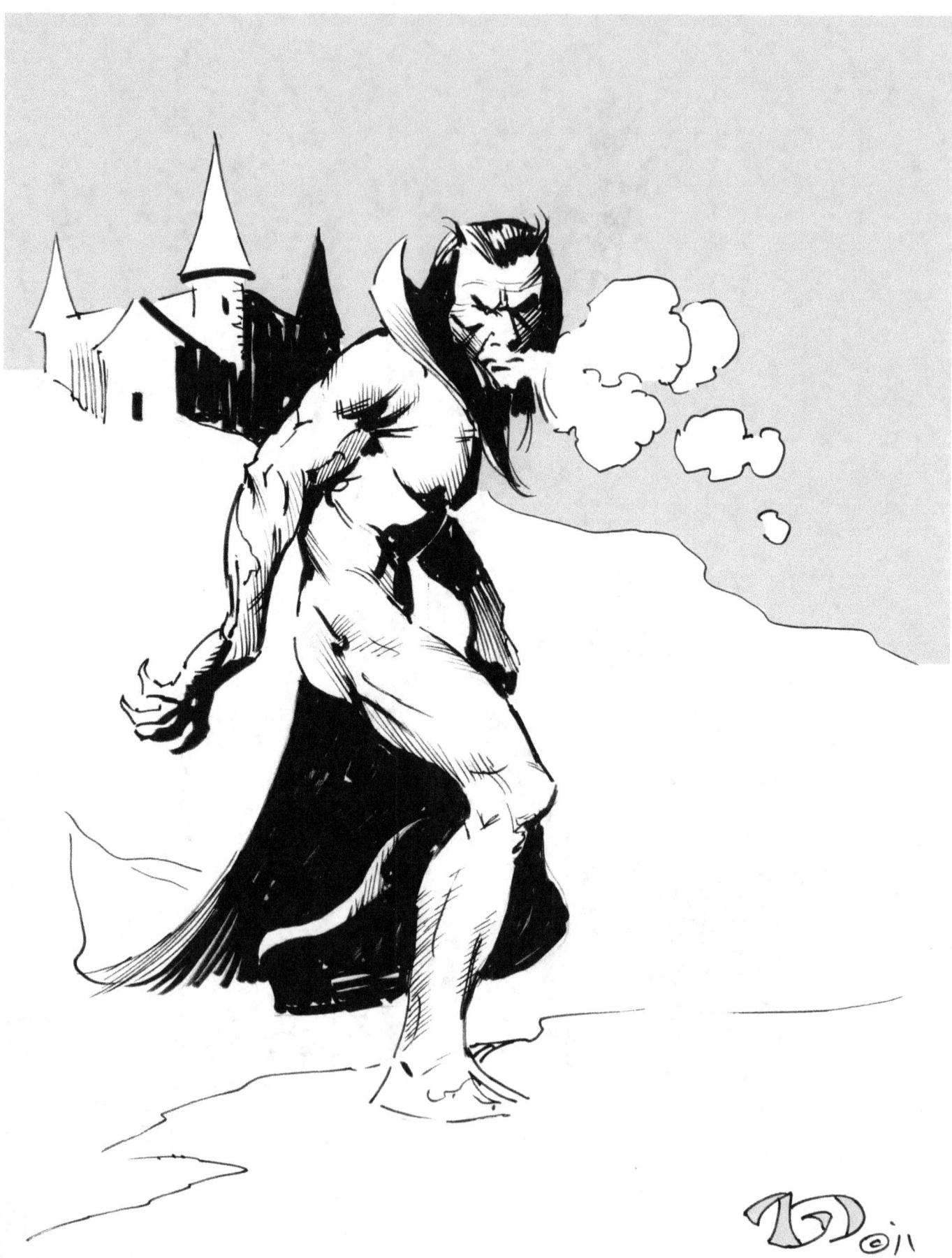

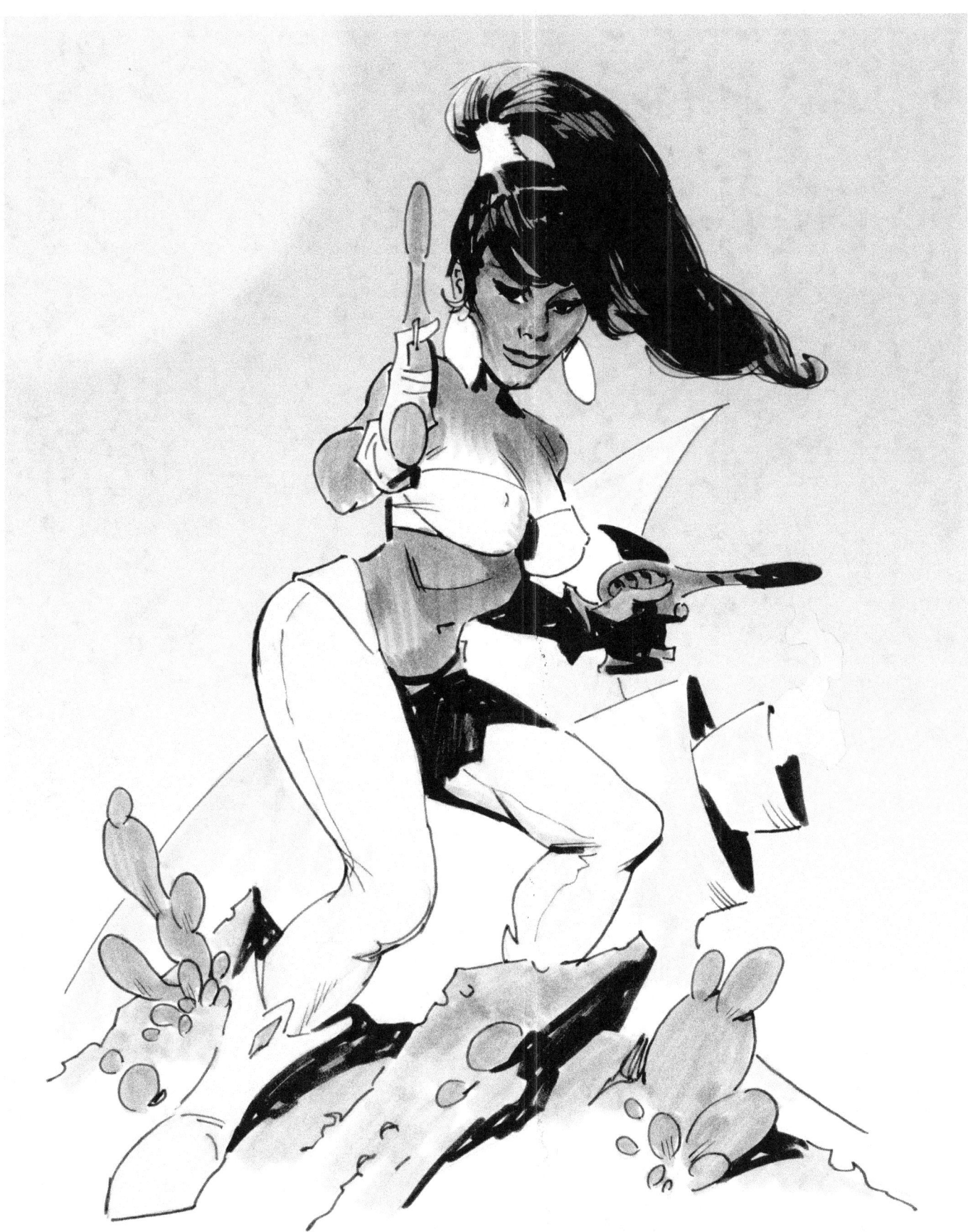

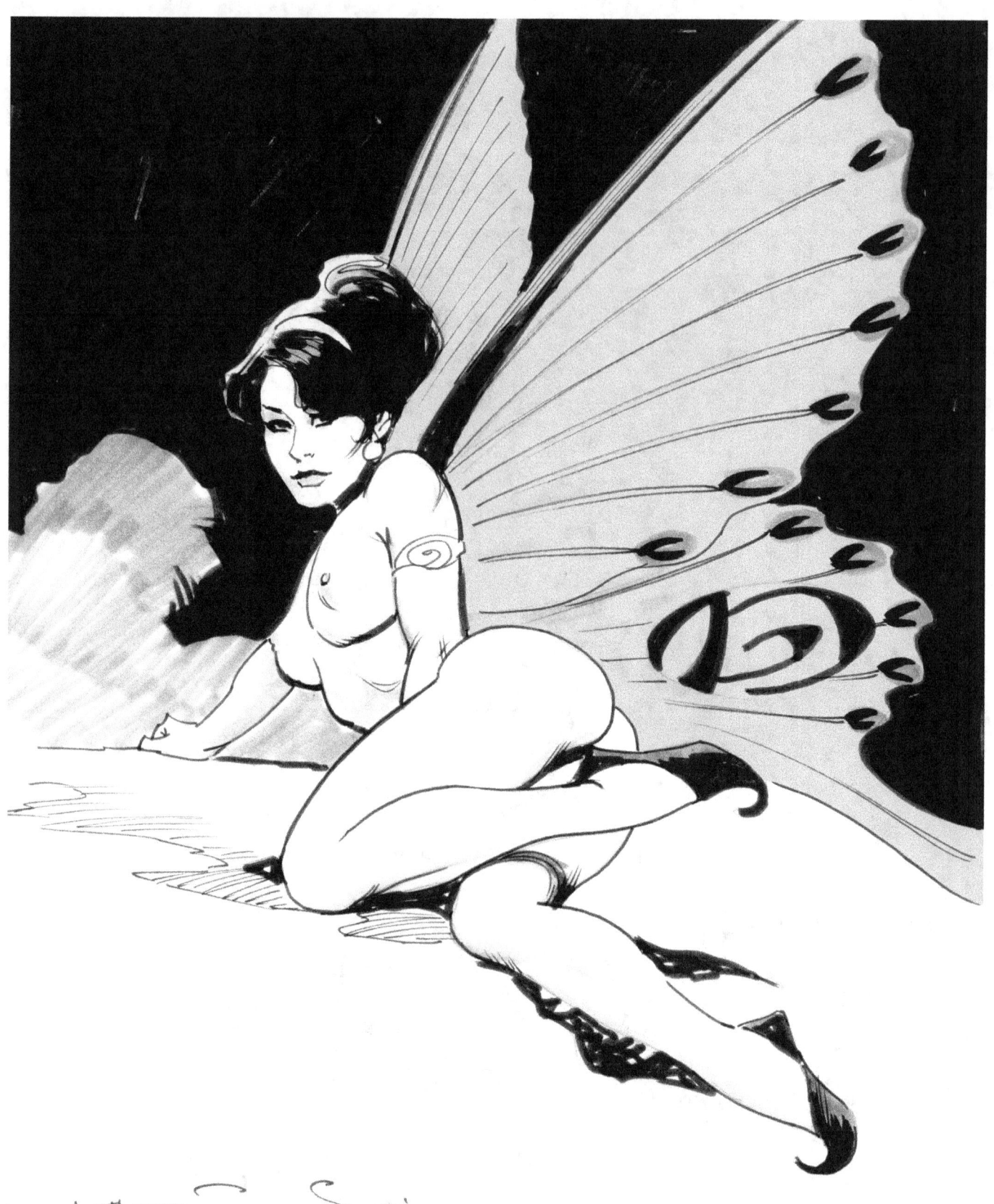

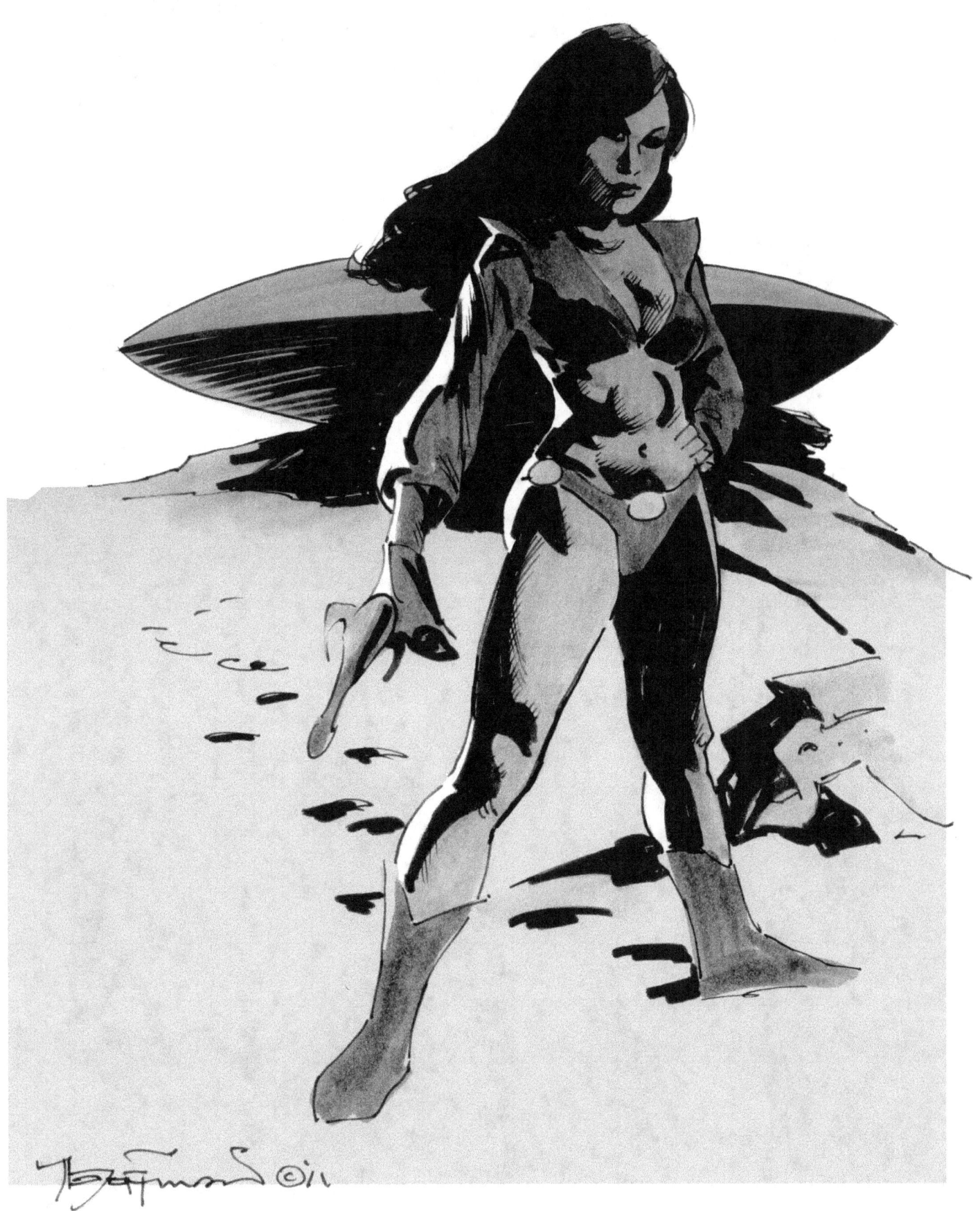

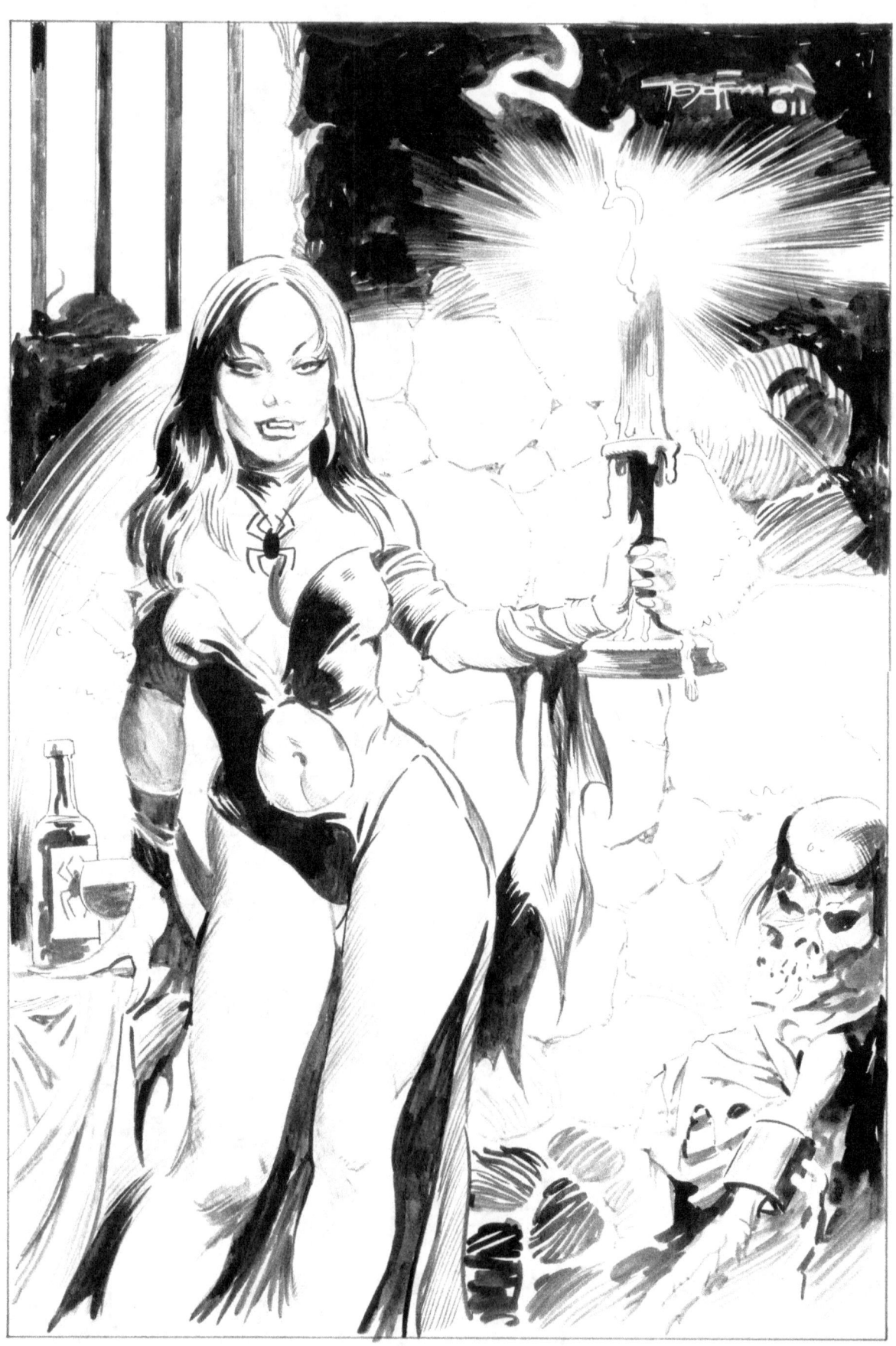

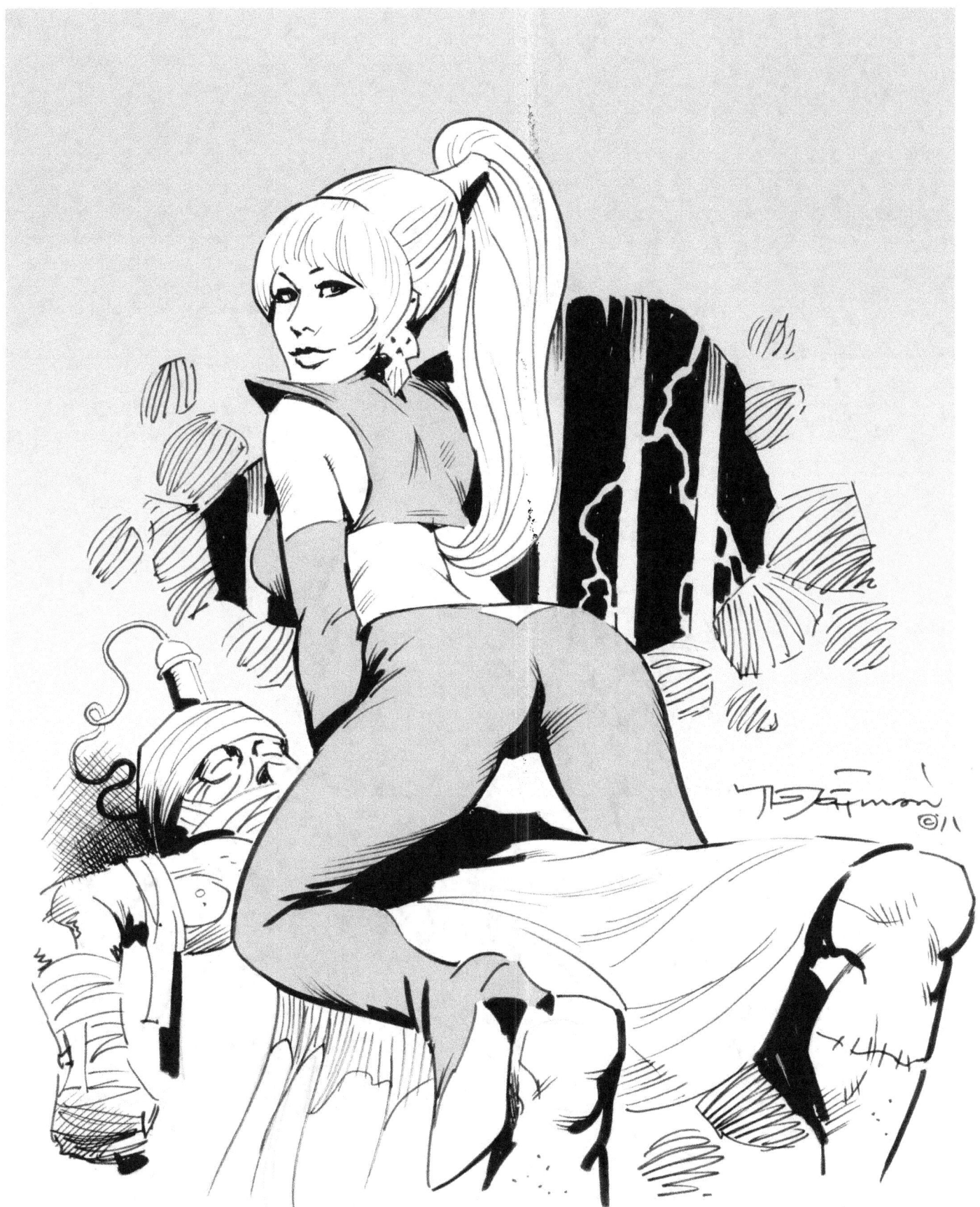

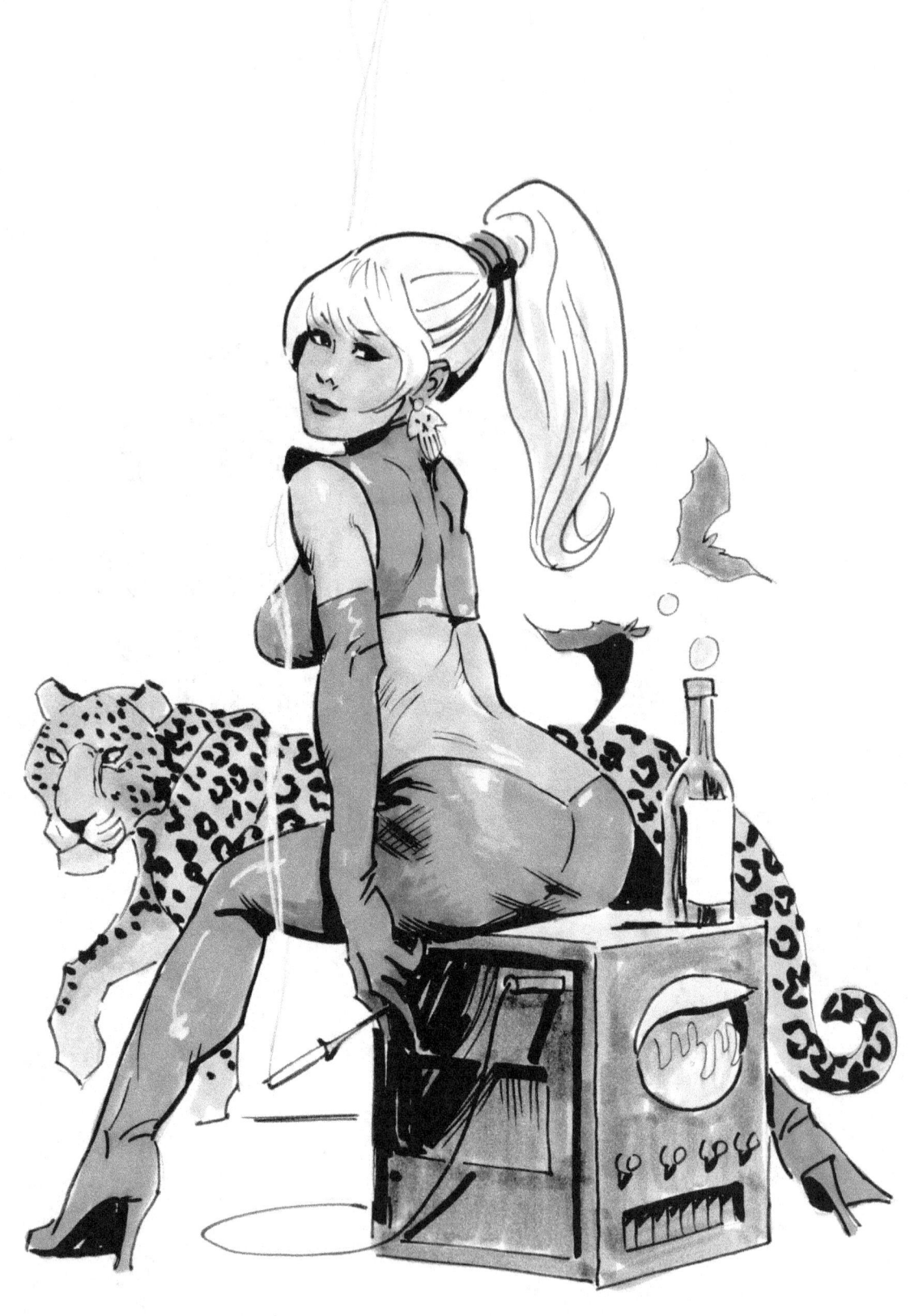

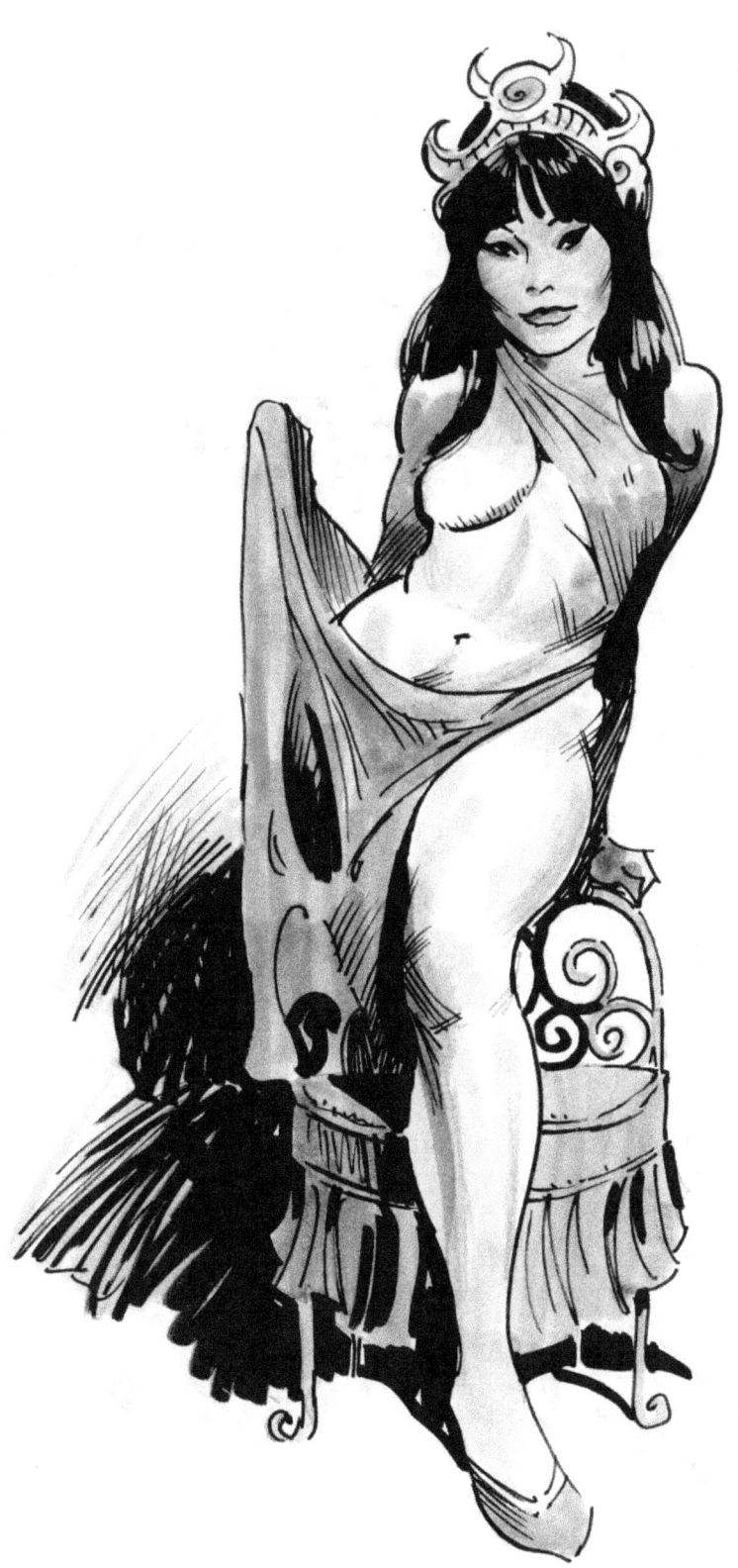

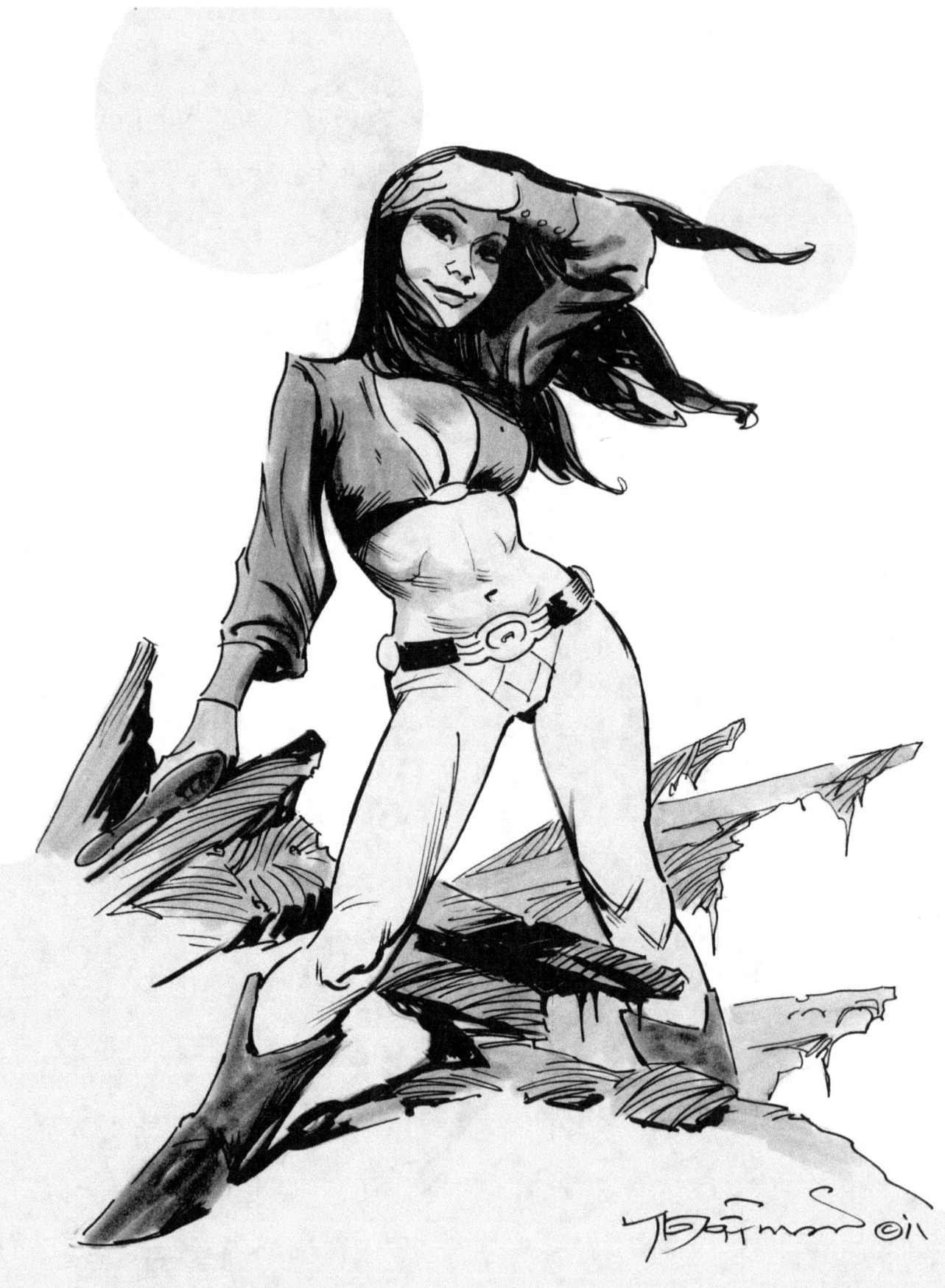

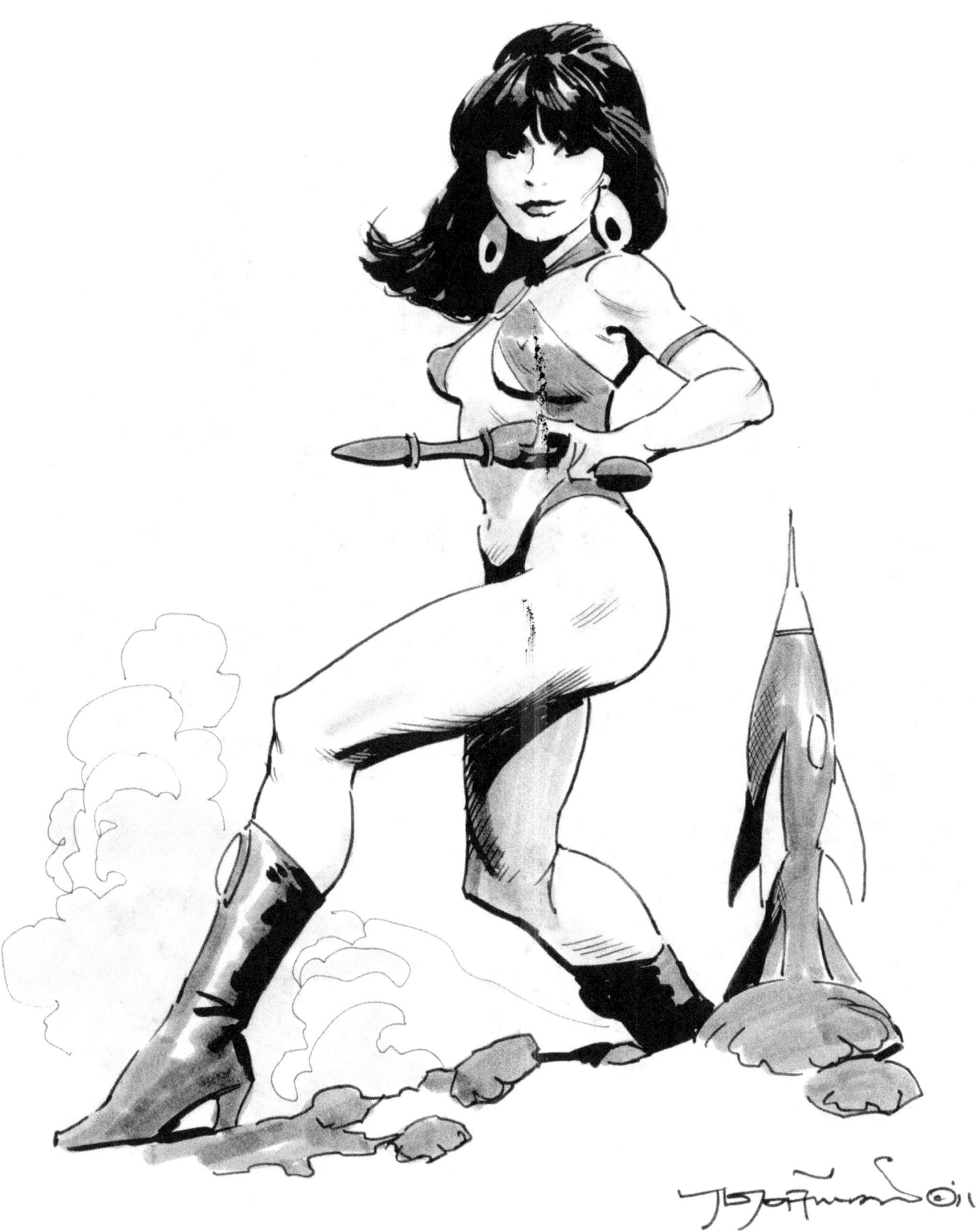

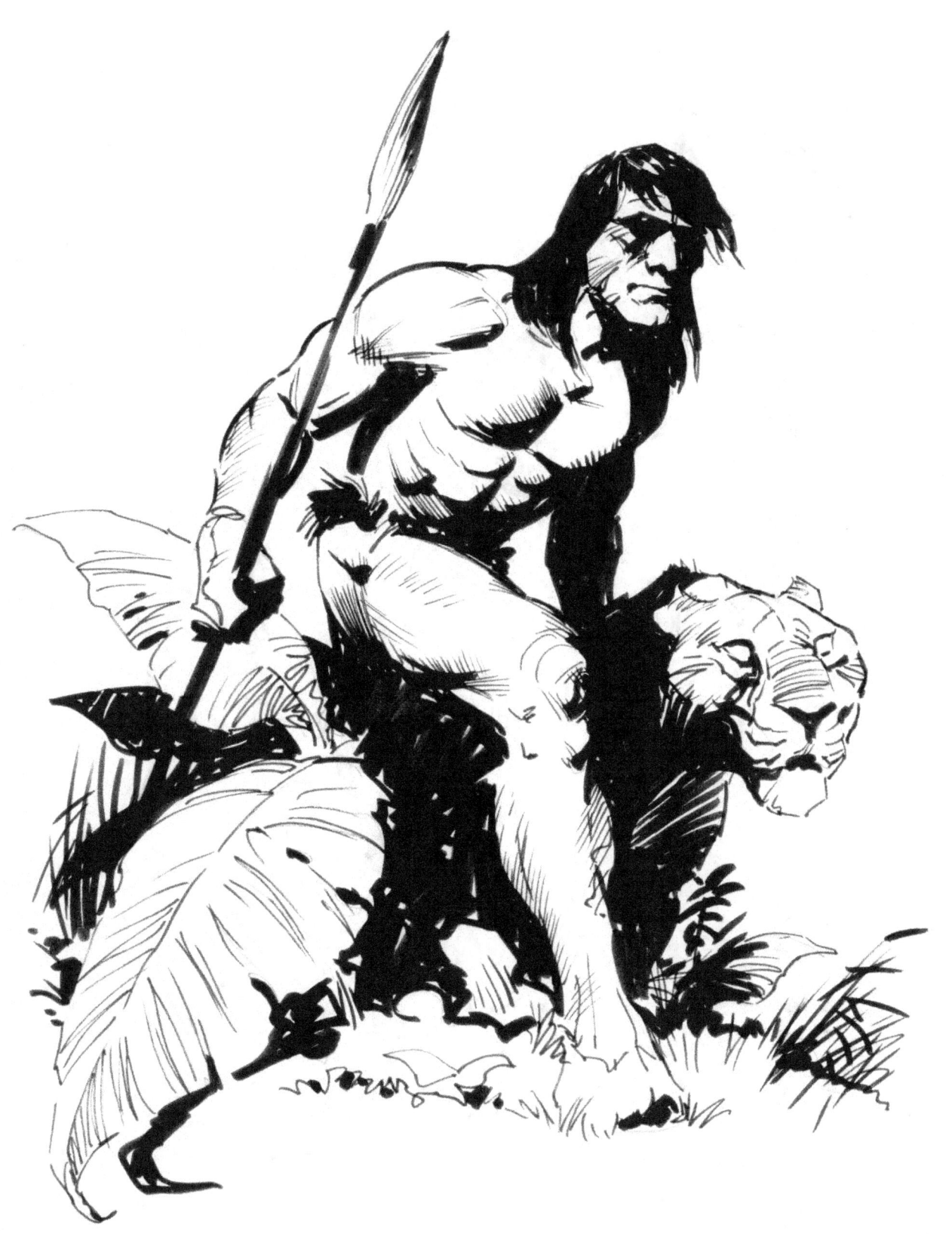

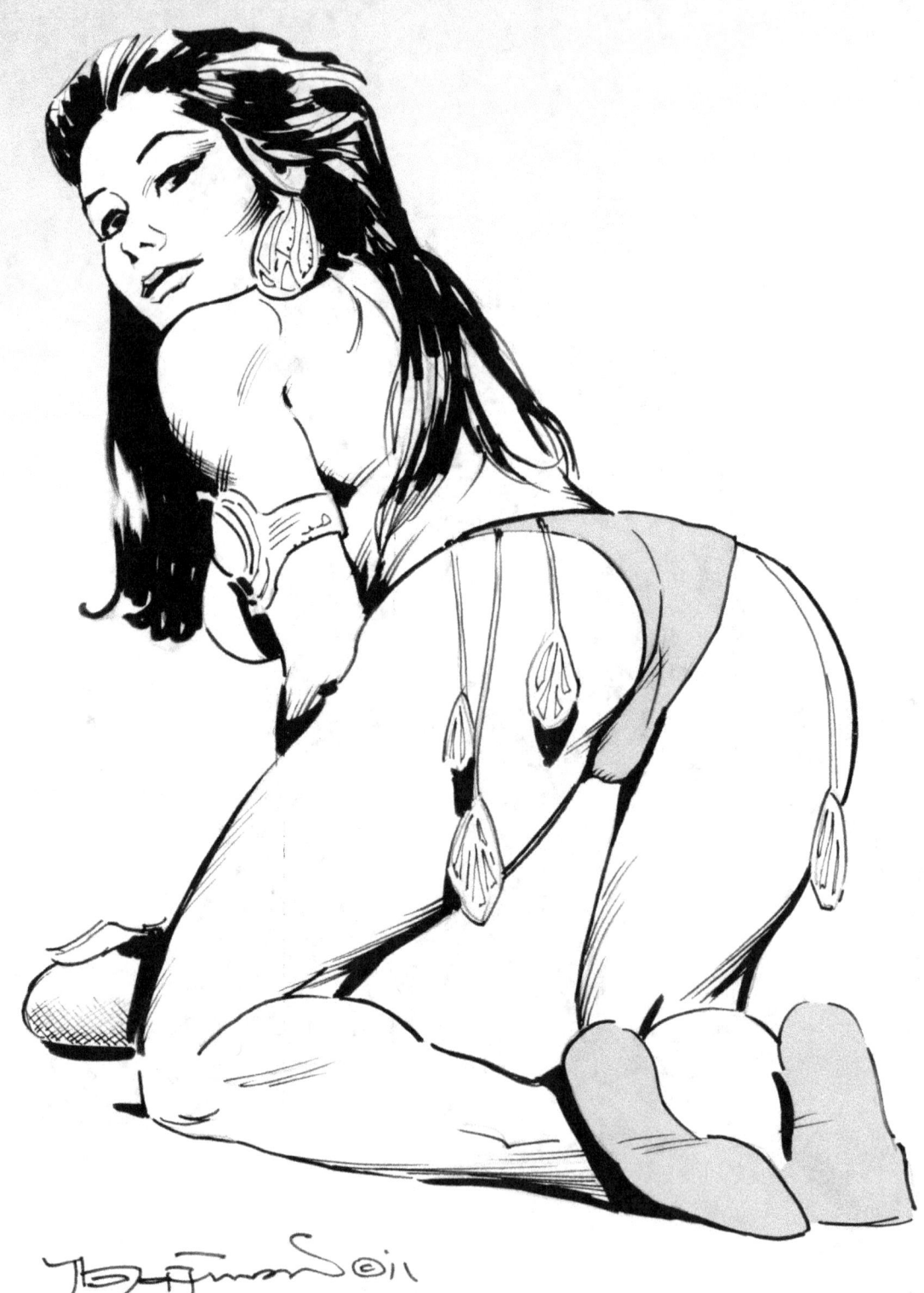

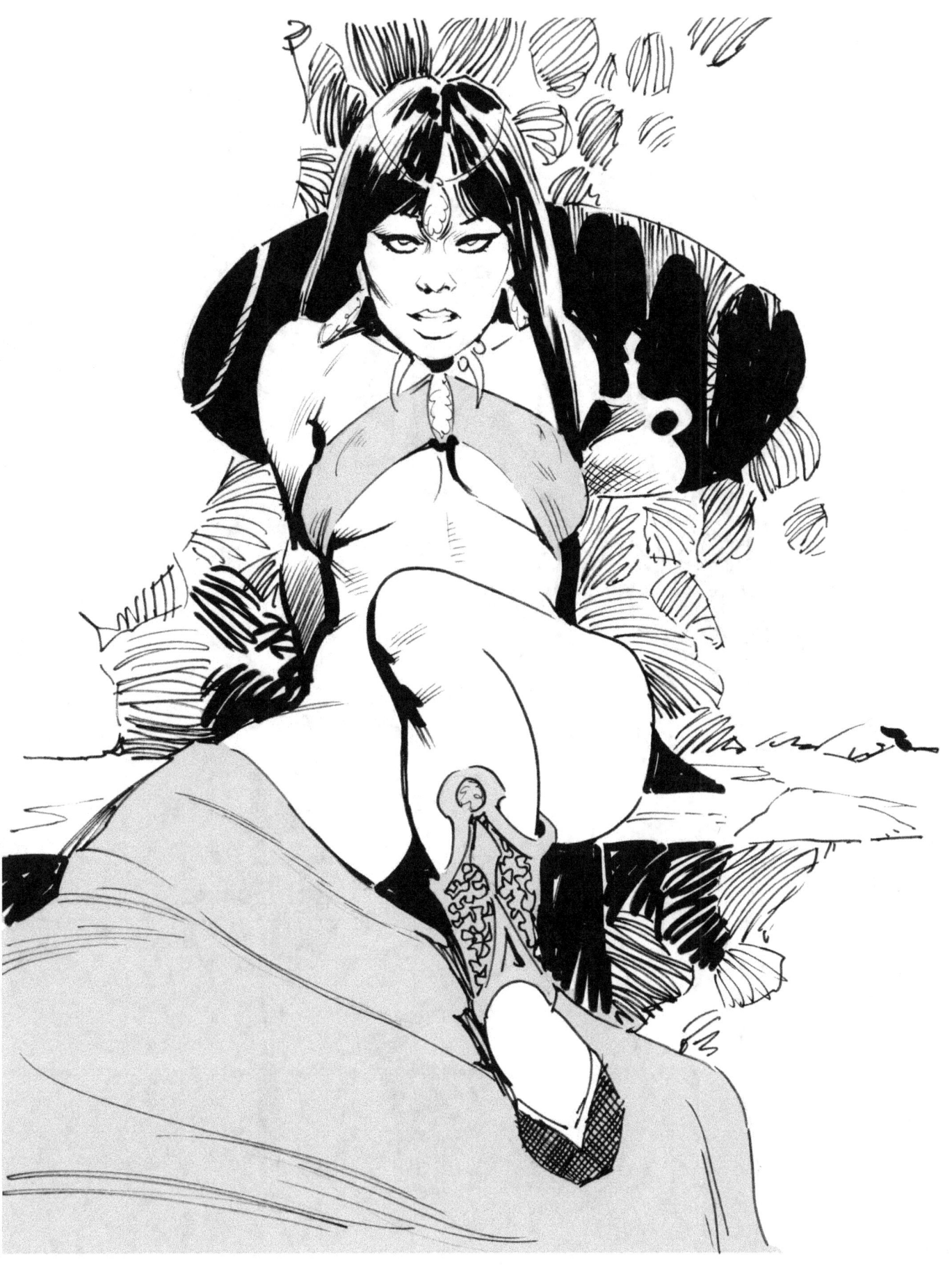

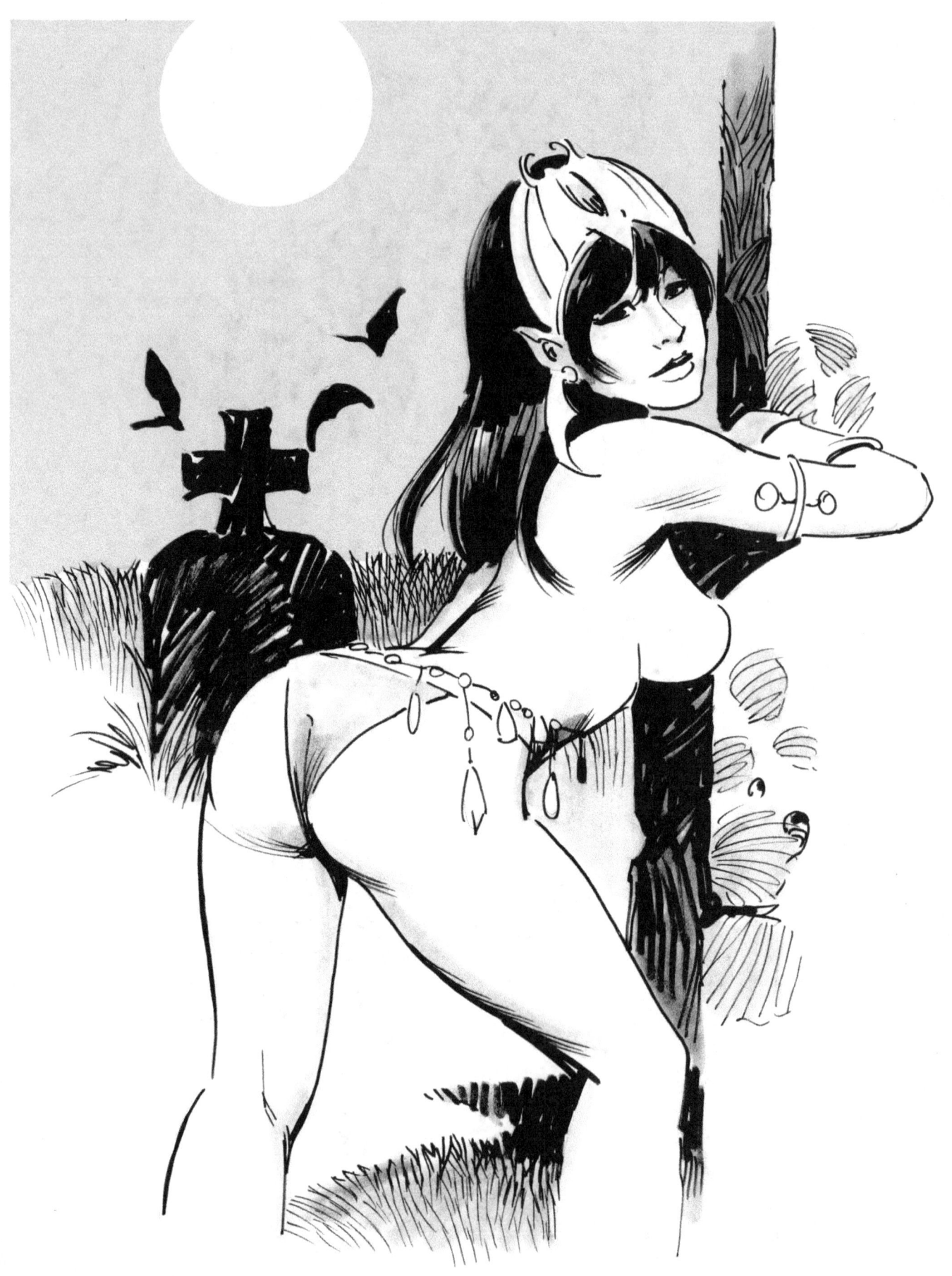

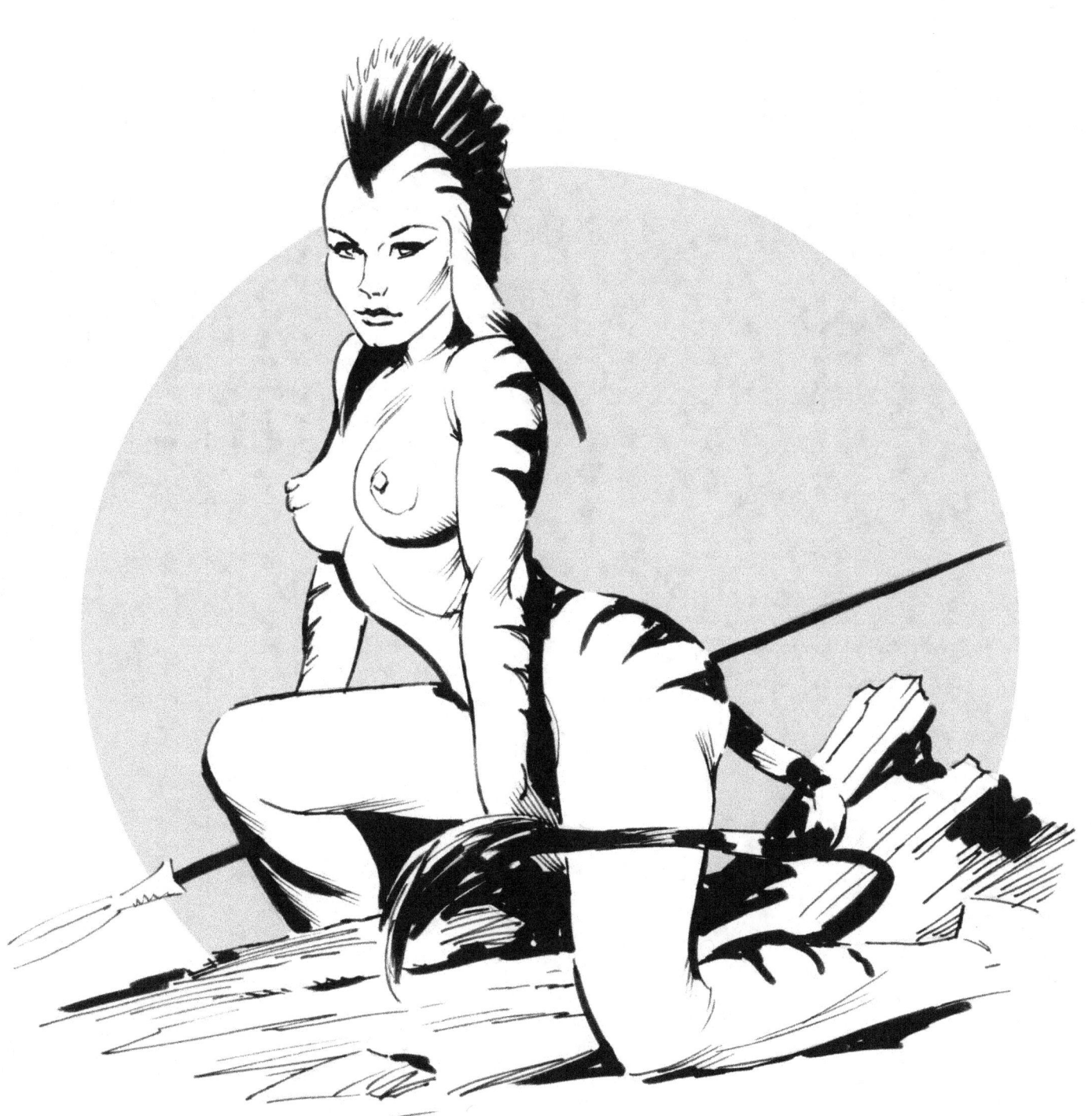

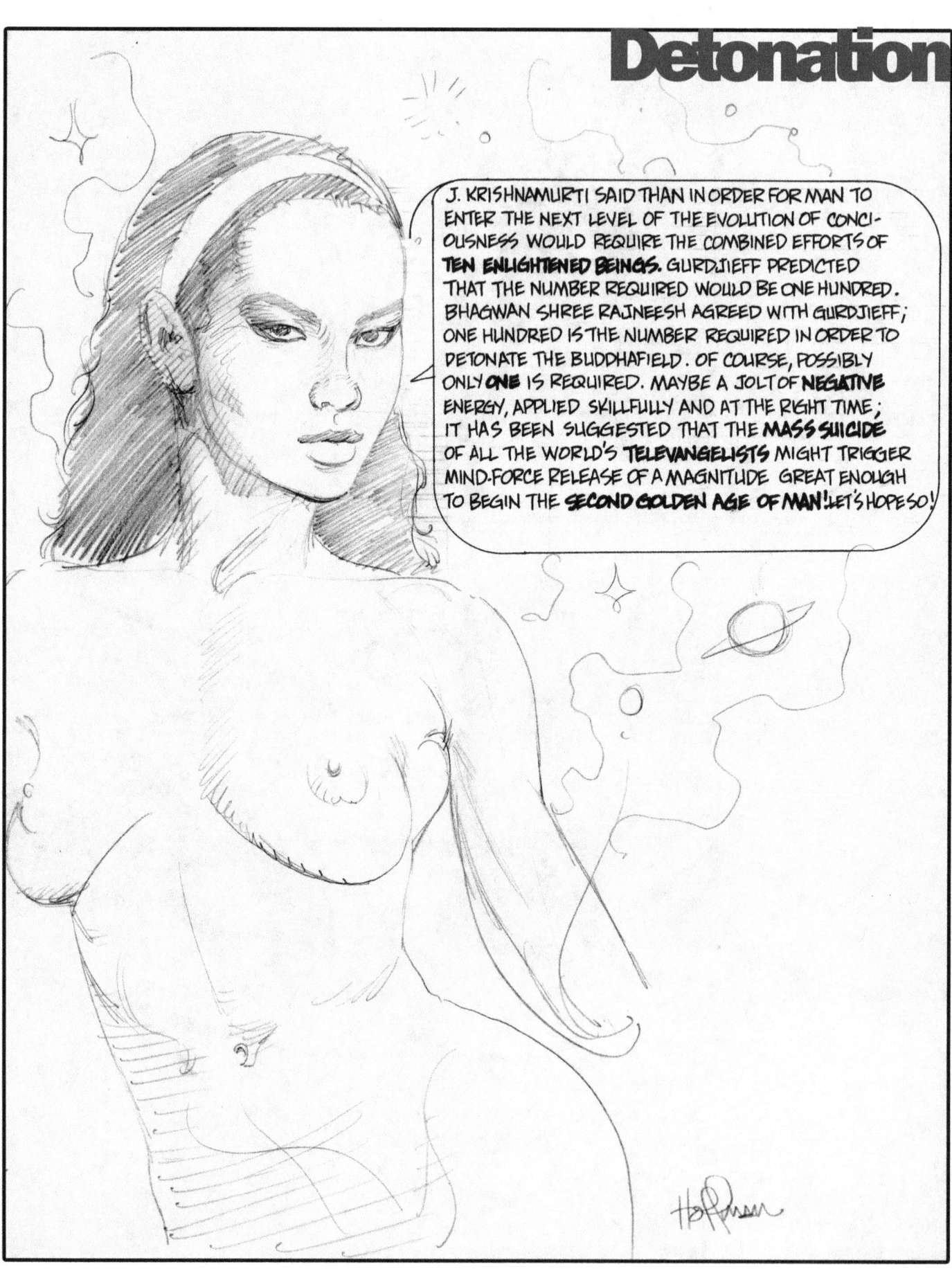

Combo Hero

This sketch is the result of combining two seemingly disparate drawing approaches: the fantastic and functional dimensionality of Jack Kirby's techniques plus the naturalistic anatomy of Frank Frazetta's.

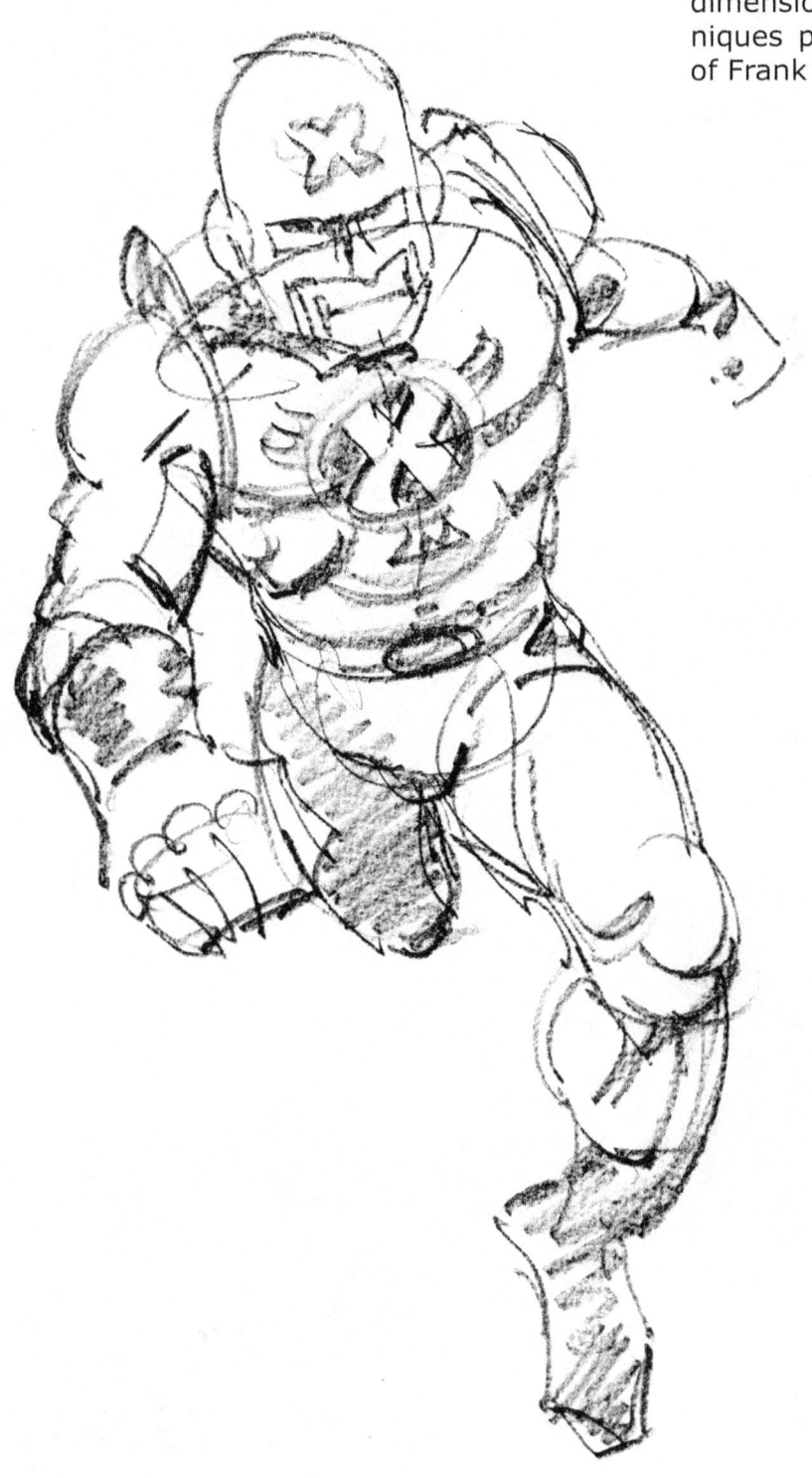

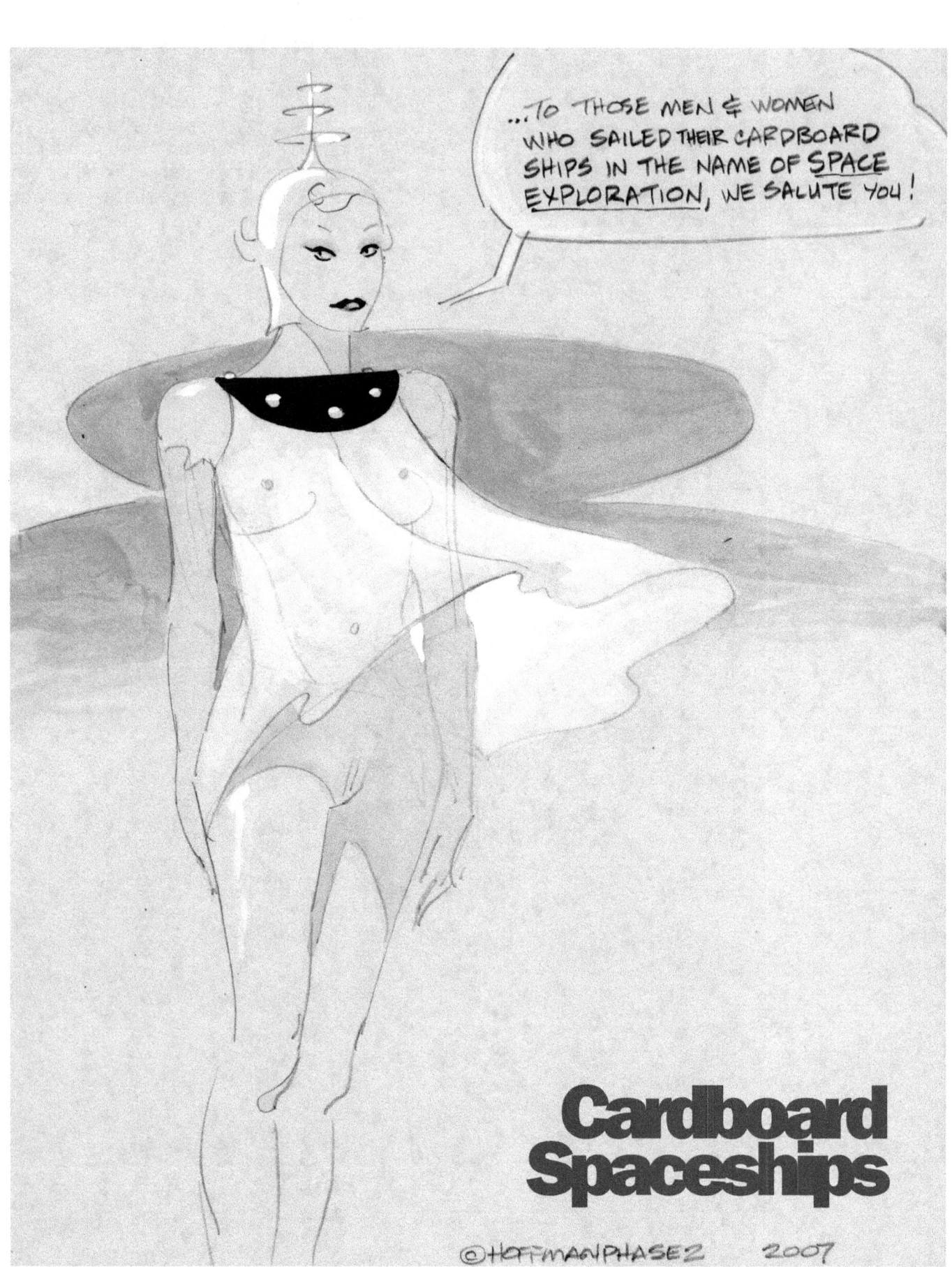

Letters to the Editor

Back around 1996 I was spending a good bit of time and effort writing these sorts of letters to *The State* newspaper in South Carolina. they'd been bought by Knight-Ridder, an out-of-state conglomerate, and became a vehicle for citizen squabblings. The new publishers even encouraged it by giving free column space to weird fringe groups like "The League of the South", who wanted to secede from the Union. Naturally folks got annoyed and wanted to talk back.

I had one letter per month, all that was permitted. I wouldn't waste the time these days, but being younger I apparently needed something to beat on. Or someone.

I think they're well-written, but I'm not especially proud of many of them. What writing them did accomplish, I feel, was to help me develop an economical writing style with precise and clear arguments.

Or maybe I already had that?

Attorney general's polemics unconvincing

■ Charlie Condon's argument (*The State*, April 20), comparing smoking to fast food and obesity fails. Scientists know nicotine is an addictive drug harder to quit than heroin.

Tobacco companies know that it's nearly impossible to get adults started smoking, so they target teen-agers.

Also, many smokers don't like being "hooked" but can't quit. Condon's simplistic perception of smokers as cheerful, adult pleasure-seekers shows that cigarette billboards work effectively on adults, just as "Joe Camel" ads work on kids (which Condon denies).

MIKE HOFFMAN
Columbia

Rejecting evolution limits related sciences

■ Fred Kerr's letter (March 10) mentions "evolutionist teachers" who "use their classrooms to proselytize captive student audiences." I'd like to point out that freedom of religion also means freedom *from* religion.

The problem with rejecting evolution is that we must then throw out atomic physics, carbon dating, genetics, paleontology, geology and, ultimately, all other sciences, as they represent an interconnected and interdependent body of knowledge. Perhaps we can do all that, but I don't think we can then call what's left "education."

MIKE HOFFMAN
Columbia

BOXING
Organized cruelty unworthy of society

■ Folks are chattering about Mike Tyson's recent encounter with Evander Holyfield's ears, and so is columnist Warren Bolton, who describes the act as "ludicrous" — a word that implies the mutilation was ridiculous enough to be laughable, that is, "funny."

I suppose Mr. Bolton didn't use a better adjective, like "barbaric," because it might fit the so-called "sport" too well. As to Bolton's praise of Holyfield's faith, I think that if the Christian God is the one who really decides the outcome of boxing matches, then he's undeserving of our worship.

Boxing reminds me of Roman gladiatorial combat: Vast sums of money were spent on these spectacles, and huge numbers of humans and animals were slaughtered for the "entertainment" of crowds of up to 50,000. The Coliseum in Rome was dedicated in A.D. 80 with 100 days of games. One day 3,000 men fought to the death, and on another, 9,000 animals were killed.

This sort of fun entertainment went on for over a hundred years and, not surprisingly, also had strong religious overtones. The difference between the Roman games and boxing is only a matter of degree: Organized cruelty is unworthy of a civilized society, regardless of how many line up to watch.

MIKE HOFFMAN
Columbia

Madame Tarantula Treatment

I've had interest from a film and TV producer concerning my character Madame Tarantula, and it's still up in the air as to what will or won't happen with it. In the meantime, here's the treatment I wrote at his request.

MADAME TARANTULA

A Treatment for Film by Mike Hoffman ©2011

In the year 7011 life on Earth is almost unrecognizeable as it has been overrun by synthetic flora and fauna born of Man's genetic engineering experiments in the late 20th Century. In addition to the bizarre animals and plants, there are also robots, androids, cybernetic beings and everything in between. The remaining "pure" humans are now an oppressed minority.

Stylistically the story is like A. a Spaghetti Western, with elements like extreme close-ups and guitar-based mood music, B. Tura Satana's character "Varla" from the cult film Faster, Pussycat! Kill! Kill! with similar violent tendencies and black leather garb, and C. the 1960s comic book Magnus, Robot Fighter in which a single lone hero, or in this case heroine, physically fights against non-human beings.

Thematically the story reflects the struggle between Man and the Frankenstein of Technology he has created. And, it is not so much character-driven as linear--a string of visually provocative events and non-stop action, the goal being to take the viewer somewhere new, exciting and strange--to show them things they've never seen before.

ACT ONE:

Introduces "The World" of 7011, which is a major character in itself, and the woman called Madame Tarantula, whose real name "Osimvah", which is Chinese-Indian for "Tarantula". We learn bits about her past from sketchy remembrances told in flashback: a little girl on the prairie, parents killed by bandits, rescued by Chinese "Indians" who crossed a land bridge centuries before and who care for her but eventually return her to "her own kind". Shown are the dangerous and violent patterns of daily life--eerily much like the Old West, with cattle, cowboys or robot vaqueros, prospectors, saloons, mining and ghost towns, gunfights, etc., but each time we're shown something familiar or recognizeable there is a novel new "twist" to it.

Osimvah's initial experiences in the town called Hades where the Indians have left her are disastrous, as she's maligned and cast out--but not before wreaking some revenge on a few bad types. The characters themselves meant as weird entertainment, partially recognizeable as stereotypes but each with unpredictable surprises (see Madame T.'s Rogues Gallery). Several unpleasant experiences in Hades demonstrate that she will probably always be an outcast, and a "half-breed Indian-lover". She tried to remain pacifistic, but when she finally leaves the town it's mainly destroyed from the fighting caused by her presence.

Back on the trail she encounters a gnarled old prospector "Pop" Small. Inside his crashed rocket trailer-home/lab, he educates her as to how and why the World had changed, explianing through the use of an antique technology called the "VHS tape". He explains how the American Inland Sea was formed, and how desperate families bought death-trap rockets to cross it to the promised land of the "New West", all of which we see by satellite view and grainy film-flashback.

When Osimvah confides in Pop Smalls that she can't recall her past, he runs some tests on her and concludes she has a progressive disease caused by little "spiders" in her blood that will one day kill her. Before he can say more, hybrid raiders, some flying hover-bikes, attack

them in the crashed ship. Smalls tosses her a set of strange silvery guns which fire deadly blasts.

But, they are overpowered, Smalls is left for dead and Osimvah is captured. Bound to a weird cactus-like tree, an ugly, dirty humanoid being called "Snake Eyes" wants to use her for target practice. He is able to grab rattlesnakes by the tail and "crack" them like a whip whereupon the become rigid like a spear, with jaws agape and fangs pointing out. He hurls several at her, they pierce her flesh, and ultimately she is left for dead in a crucified position.

While unconscious, Madame T. experiences mystical visions that may be due to the snake venom. She sees her own body as transparent, and as spinning chakras of pure energy, and the false machine energies that Man is in conflict with. She sees herself lying flat and a shaft of light emerging from her "third eye" between the eyebrows, it rises up and splits into eight "legs" and becomes a glowing mechanical spider.

She comes out of this Peyote-like experience when rescued and cut down by a band of human travellers who are on an Exodus to a "promised land" in Kal-49a which is what's left of California. She becomes involved with Merlin, a young man who's a "trickster", who says that their guru called "The All-Wise" can heal her body there in K-49a, so she at least considers following them there. Several others in the group are suffering from weird maladies as their bodies fight off strange new diseases and bizarre parasites.

Even though she is with humans, many are suspicious and still do not accept her as human herself due to her strange powers of self-healing, as the band of twenty or so journeyers saw the rattlesnake scars vanish after Merlin pulled snake fangs out. They are like Gypsy Hippies, claiming to "Love the Enemy" but full of self-righteousness and prejudice. Osimvah maintains that the synthetic beings aren't human and therefore don't warrant kindness, but some wonder whether she's all human herself. Although hypocritical, the band is grateful for her protection. "You got some bad energy, baby--and a good thing, too!"

ACT TWO:

Osimvah follows the band from a distance or scouts ahead, they don't trust her but she does intercede to protect them when needed. Many strange sights are witnessed in the long journey: a field of ancient sea-galleons run aground in a desert, fields of plants that eat flesh, robotic totem-poles, bars that serve baby urine, a robot who crawls through the desert begging for oil, dangerous trees that arc bolts of electricity, a giant eight-legged spider-robot similar to the one in her dream, various hangings, affluent robots playing golf and others comedically imitating human behaviours but continually missing the point, and all sorts of other dangers and oddities.

Madame T. battles most of these threats herself, including a radioactive, glowing "Gila-Woman", whose skin is patterned like the reptile, and she shows she is just as good with her fists as guns. And the "Twilight Agency", a bizarre machine-intelligence, possibly extra-terrestrial, that is fighting for dominance on Earth, is explored more fully through combat and Madame T.'s recurrent nightmares, which seem to be taking place on a different vibratory plane, and through her physical interaction with its various "enforcers", some hybrid, some robot, and the pure "gaseous" state of the individual Twilight Agents themselves, and inexplicable lifeform.

The middle section is mainly action and fast-paced adventure, a roller-coaster ride through this weird world of the "New West" while journeying towards K-49a. Further tension is added and Madame T.'s "progressive disease" first diagnosed by Pop Smalls seems to be spreading, as visible patches, and she begins to hope that upon reaching "The All-Wise" that she too will be healed. But time seems to be running out.

ACT THREE:

The surviving travellers make their final appoach to K-49a after many battles and struggles. The "temple" they seek is reportedly located deep within an abandoned "Radiumite" mine. On the way inside, they are stopped by the robots belonging to a pale, white-haired woman with one white cataract-clouded eye. She calls herself "Starfire Uranium", and announces to them that "This mine is MINE!"

A battle ensues between Starfire and Madame T., the dark against the light. A miner-bot, part coal-cart for use on underground train-tracks, suddenly crashes into her. She manages to grab the two rail-ends, one in each hand, as the 'bot clatters down the shaft where we see horrible, mutant star-nosed mole-things waiting at the bottom. Starfire Uranium smashes at Osimvah's hands alternately with a shovel--it's only a matter of time before she hits one and she tumbles to her death below. Hanging by one hand, Madame T. quickly snares Starfire Uranium around the throat with a bullwhip and yanks her down into the deadly mole-pit.

The miner-bots, now without a leader, obligingly ferry them on to a large underground chamber. In the center of the room is an idol--The All-Wise, which we only see from behind. Several Gypsies drop to their knees hoping to pray and be healed, but Madame T. is skeptical. She has heard the teachings of the All-Wise throughout the journey, commandments like "Be Not Cruel". Upon closer examination of the ancient statue we see that it is a cheap plaster bust of Elvis Presley, who over the centuries has been elevated to a Christ-like status. The teaching "Be Not Cruel" is an alteration of the song "Don't be Cruel". Heaven is where the faithful "Return to Sender".

A battle royale ensues as they return to the surface where the Twilight Agency is striking with full force and robotic and symbiotic beings the likes of which we've never seen thus far, and there's a dreamlike, symbolic quality to the conflict. After much fighting most of the Gypsies are decimated. Merlin is badly wounded, and Osimvah so utterly overwhelmed she cannot save him. He says he forgives her, even if she is "part machine", and just "save yerself!"

With a superhuman effort Madame Tarantula momentarily throws off her attackers and faces a giant robot the likes of which she's never seen. It advances rapidly and the humans scatter, many shouting apocalyptically "It is the End! THE END!" She faces the metal monster, ready to sacrifice herself, but Merlin tells her to run. The robot goliath picks her up with one hand and pulls her toward its opening jaws, and it appears to be really be "the end".

But as she looks into the gaping mouth she sees "Pop" Smalls, he is inside the giant robot's "cockpit" controlling it. "Looks like you could use some help, girl!" Now with the aid of the new ally the Twilight Agency forces are routed and withdraw. Merlin, however, is near death from his wounds. Pop says "If you love him, you better tell him now, like that old song says It's Now or Never".

Osimvah spontaneously enters her dream-state and earlier images of she and Merlin appear. The dream is like another plane of reality, and their figures appear there as energy and them merge in a final explosion of light and sound. Then the dream is over and she is back, collapsed by the immense effort. Pop crouches by Merlin "I--I think he's gonna be okay, don't know why or how, though..."

Later back at Pop Small's, he runs some medical tests on Madame T. and tells her she's going to have a child. This strikes horror in her heart as she now knows she's long been infected with nano-scale machines, like tiny eight-limbed spiders--or tarantulas--that restore her DNA, heal wounds and provide immortality, but also erase her memories. "How them Injuns knew to call yuh Osimvah I'll never know" he remarks.

She's told the operation will remove the Tarantulas and her child will be safe, but she'll no longer have the power of healing, of herself or others. Pop adds that "Y'might even

get yer memory back", and also that the down side might be that the process is fatal. Merlin says it's up to her. She takes the special injection.

We see a microcosmic internal war in Madame Tarantula's cells and tissues as the robot invaders are cast out. Finally she returns to consciousness but the worried onlookers don't know what to expect. The tension is palpable as she looks carefully at each one of them. Merlin asks desperately "Don't you know me?" She appears puzzled. She looks at Pop "I know you, I think". IHe replies "I'm yer Great-Great-Great Grandad, honey. You been on this here Earth for almost 400 years. But now you is gonna live and die like real human woman." She turns to Merlin and in flash knows him too and they embrace.

We leave the bedside to Pop's crashed ship and finally pull out to fully see this strange, barely recognizable American continent of "The New West" from Space, with a distinct feeling that there is hope for the future.

END

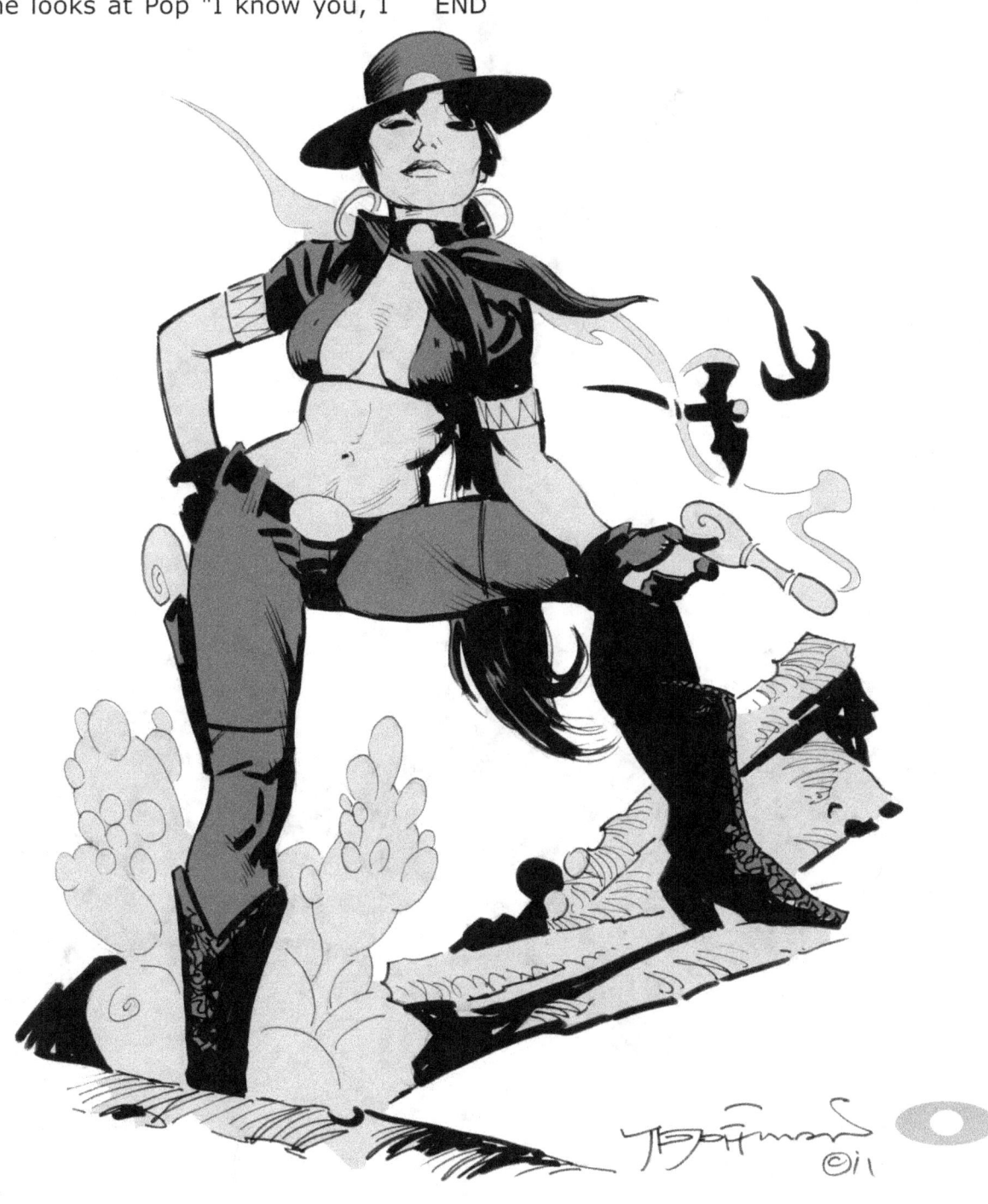

Ink Gallery 2

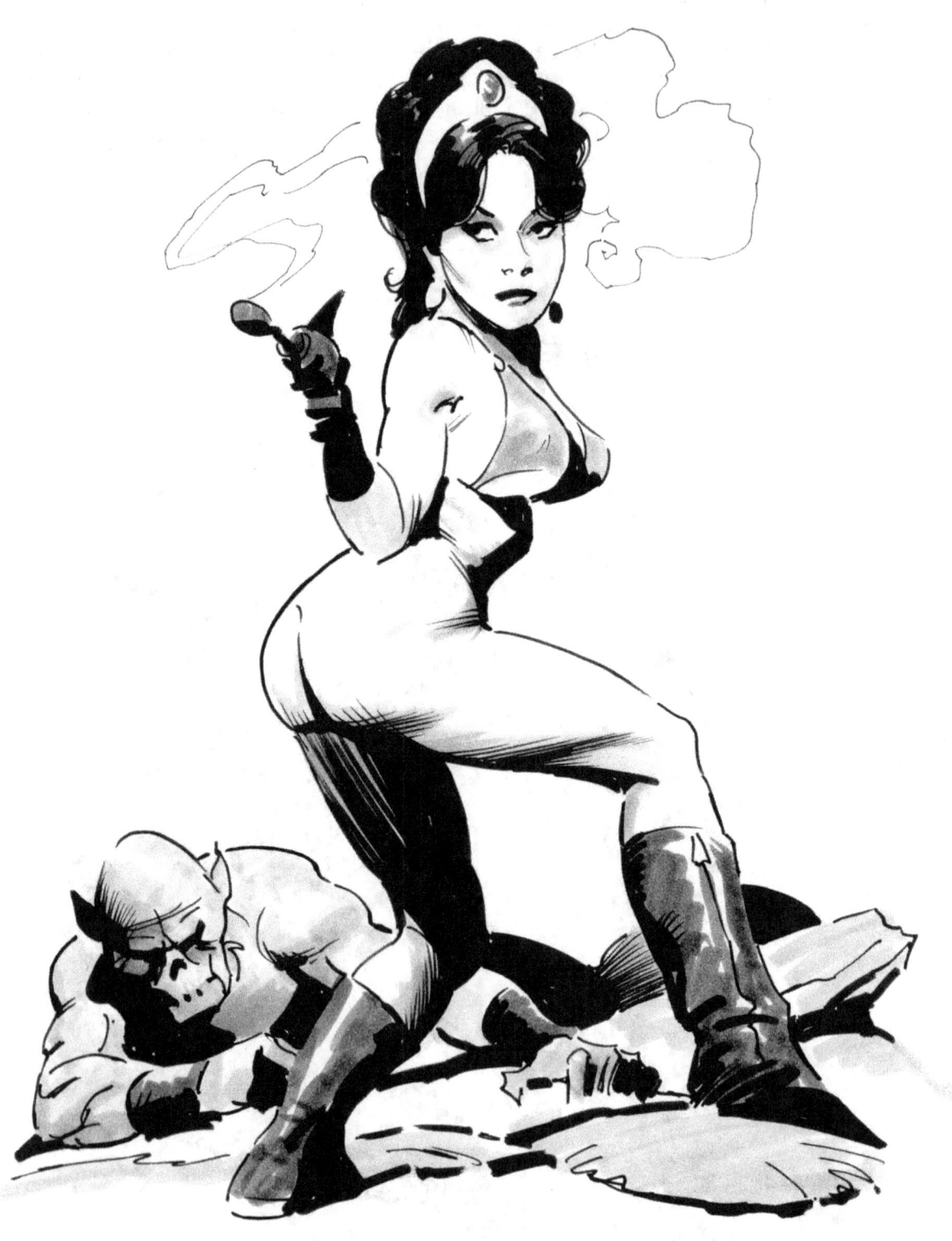

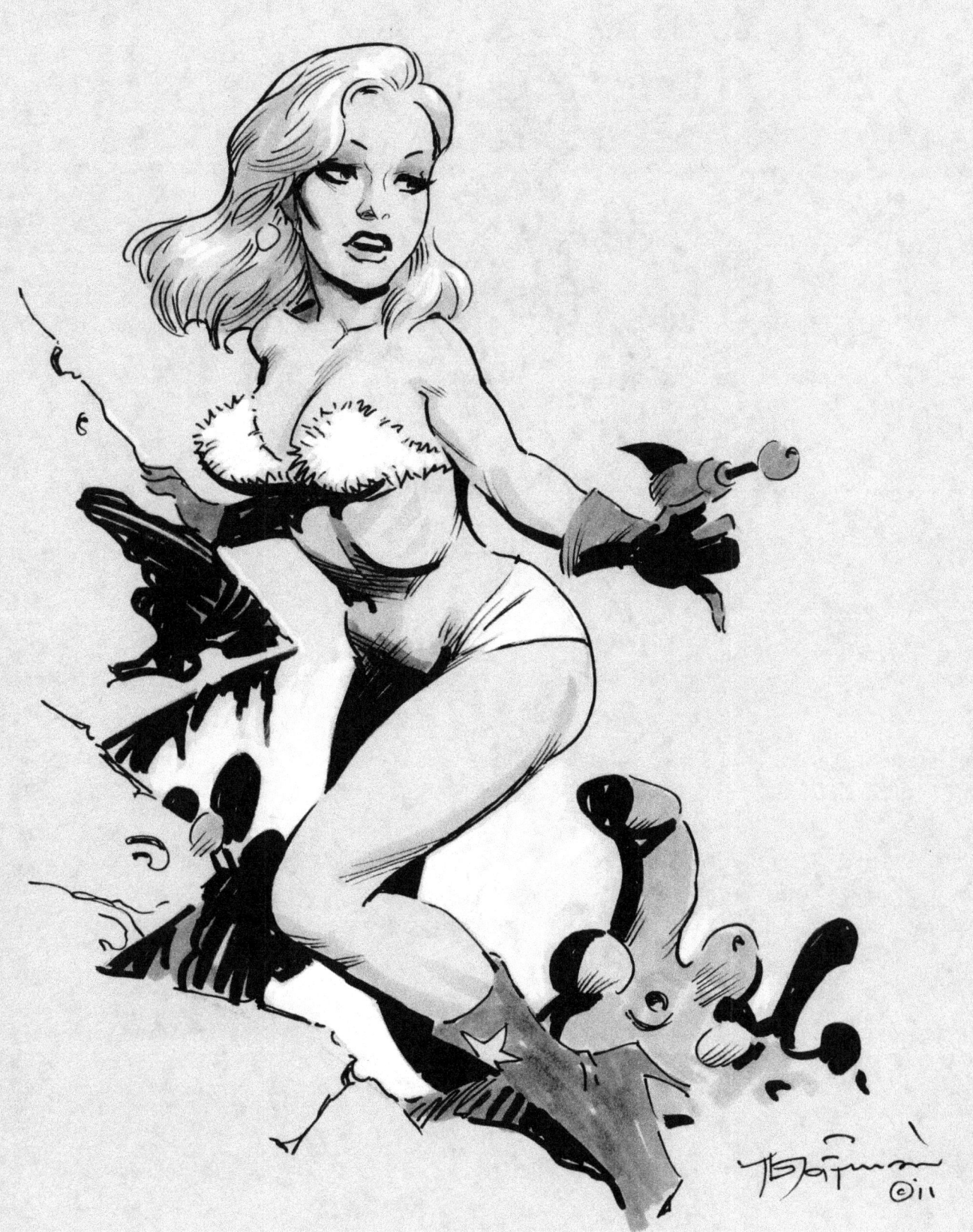

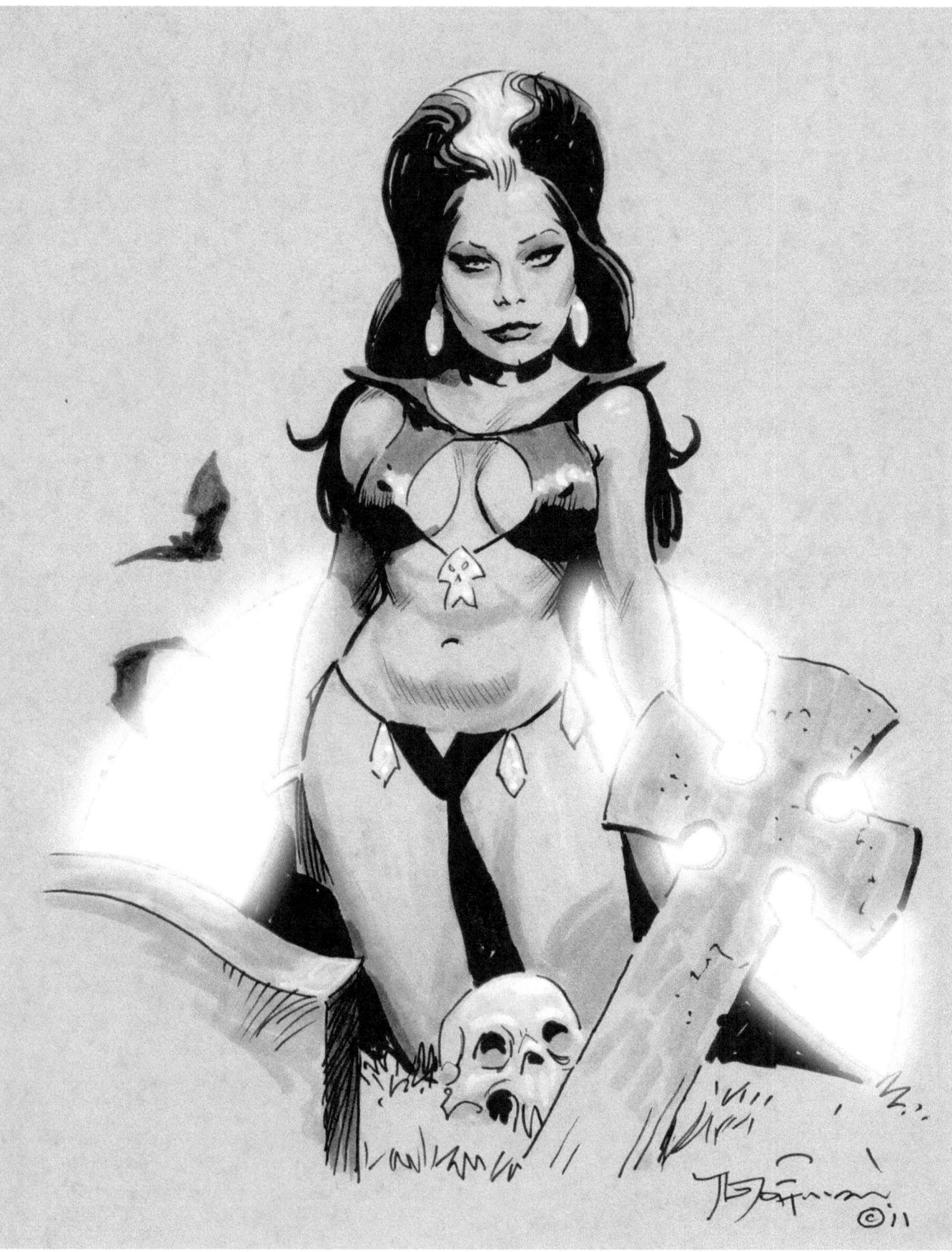

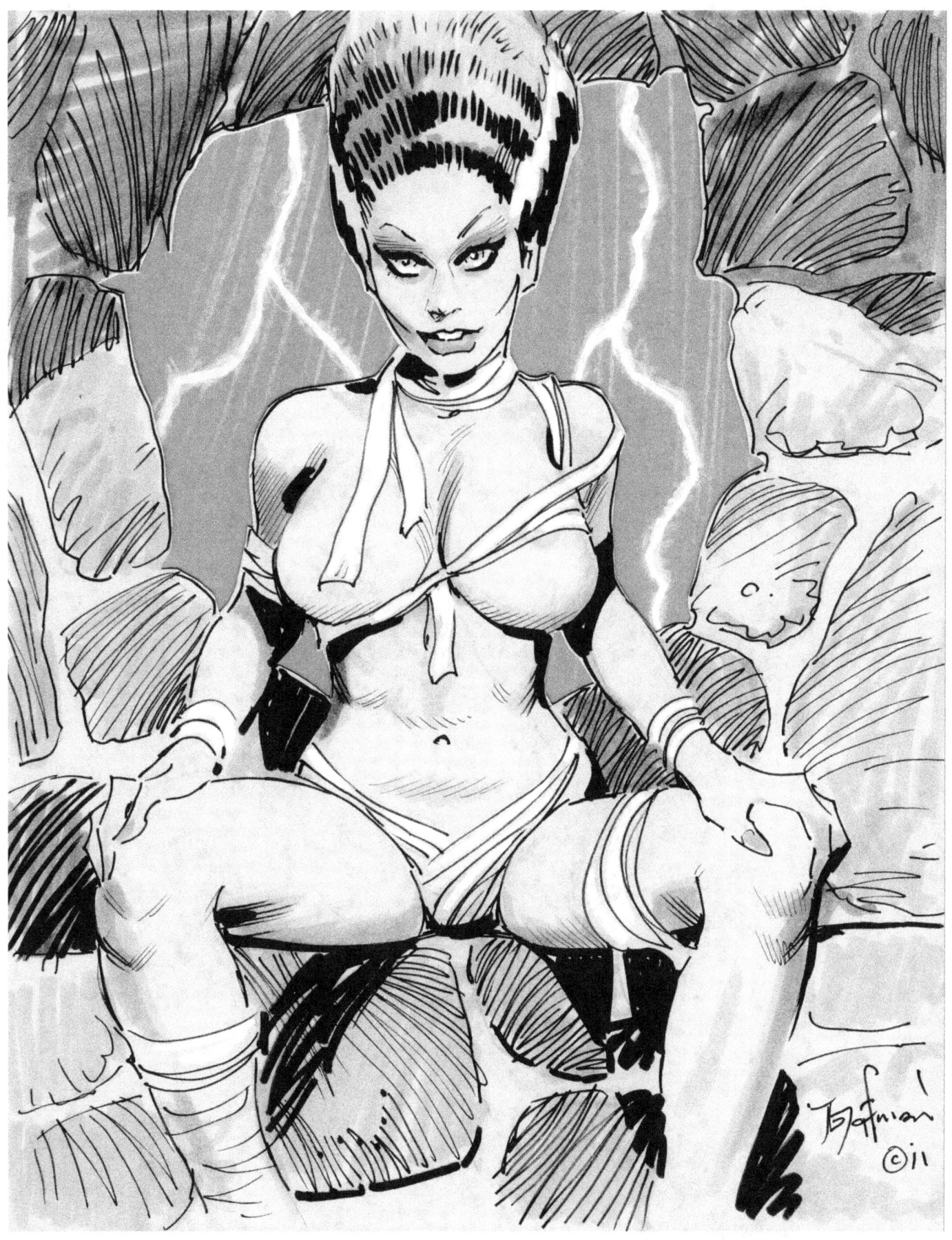

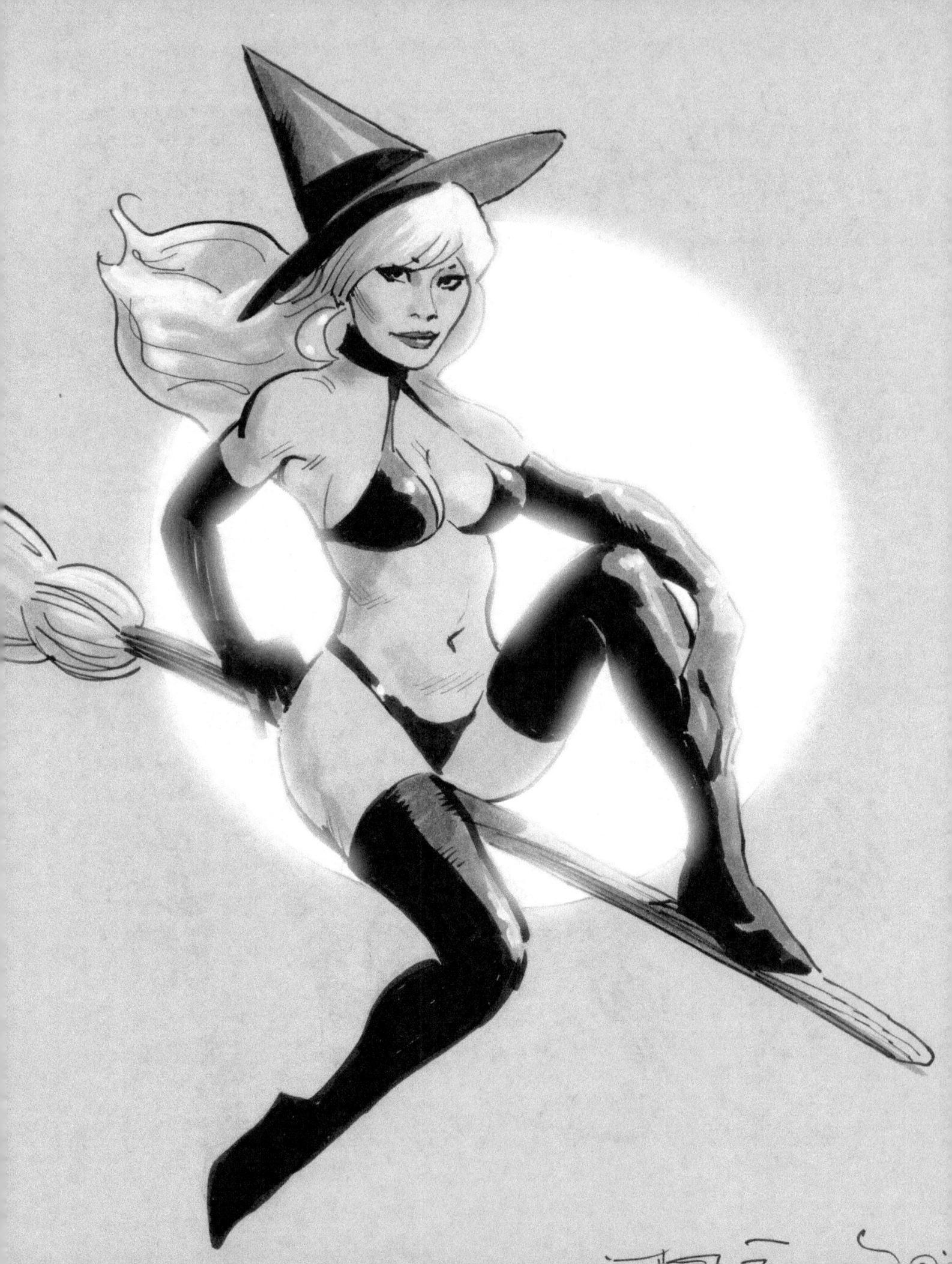

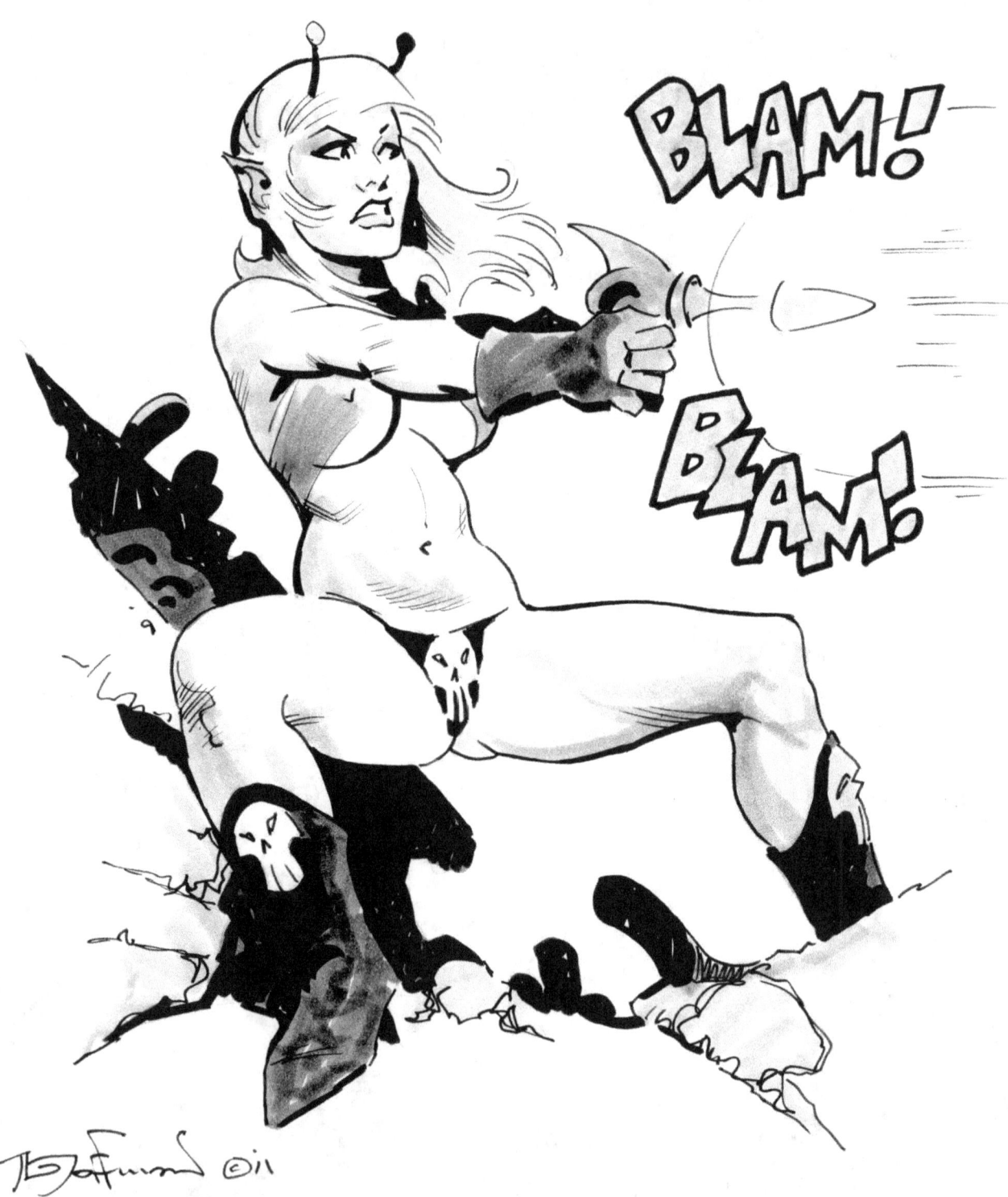

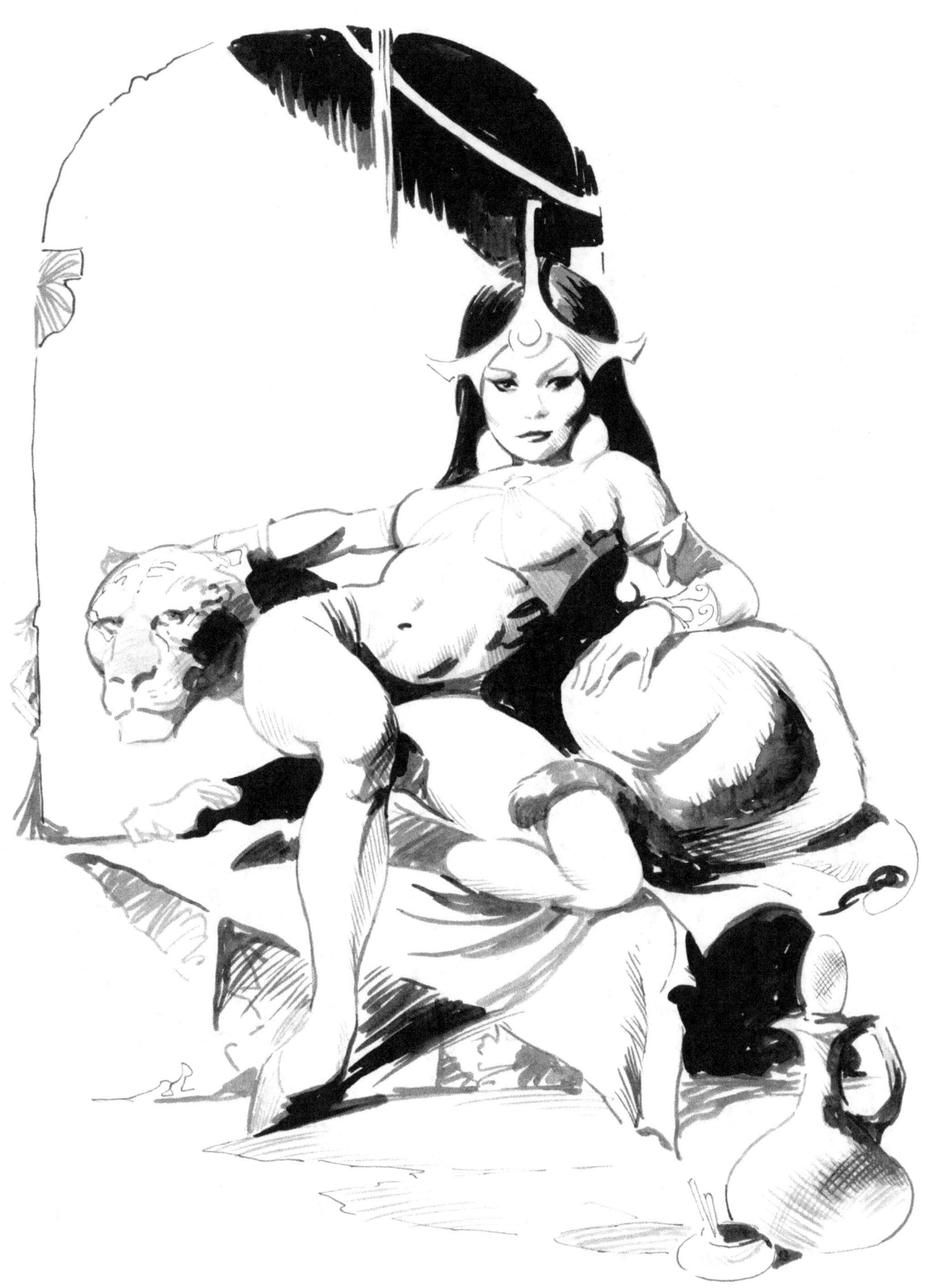

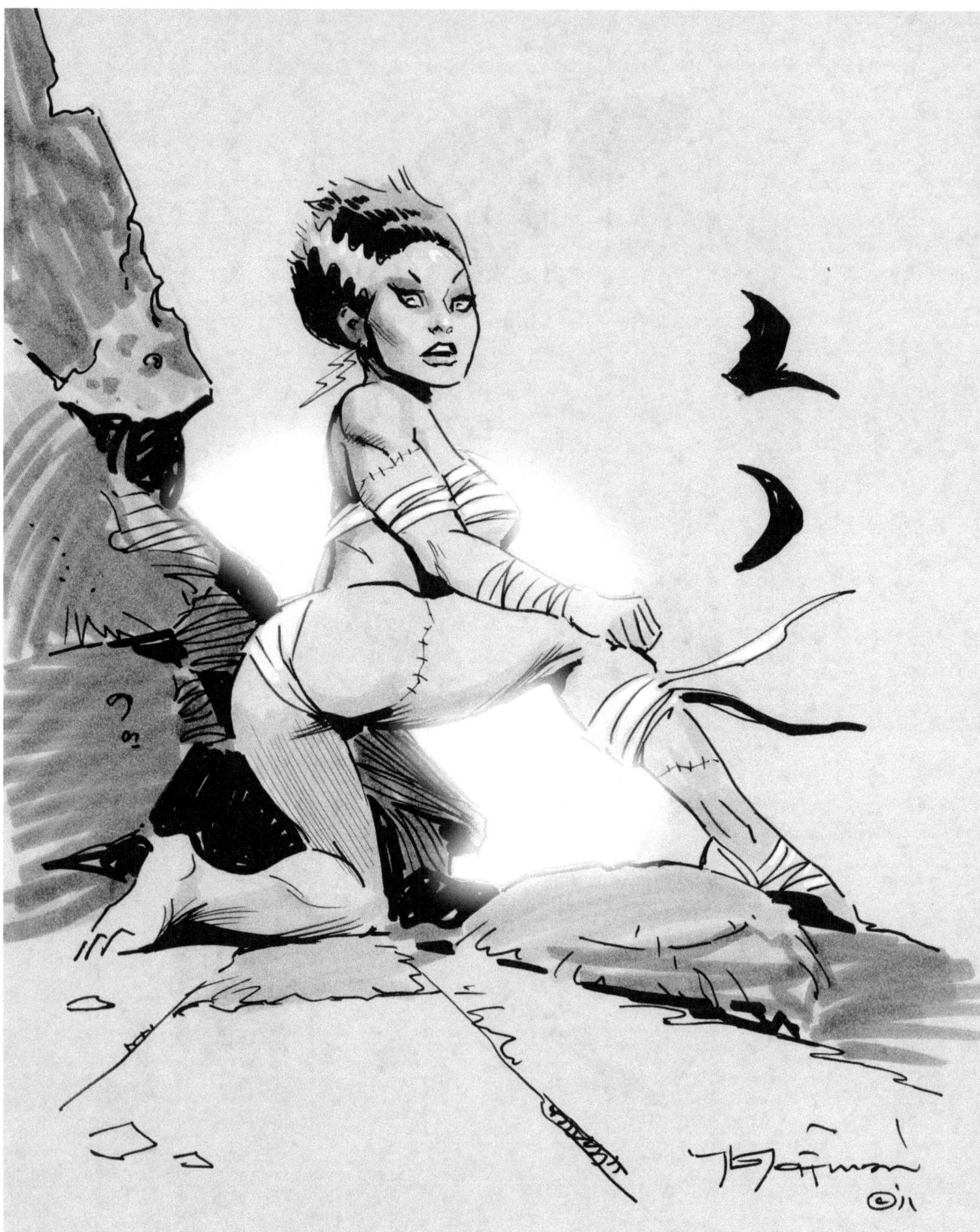

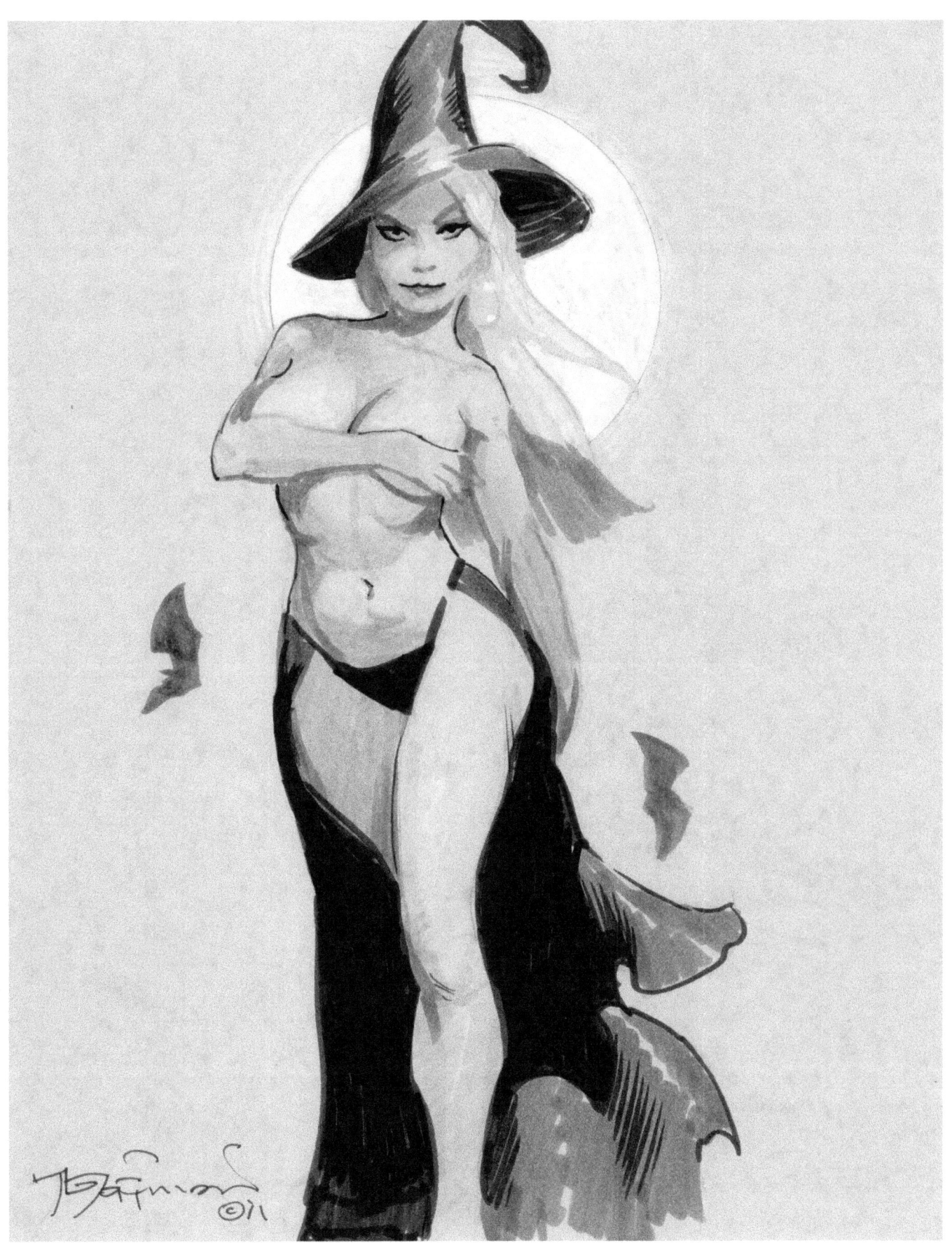

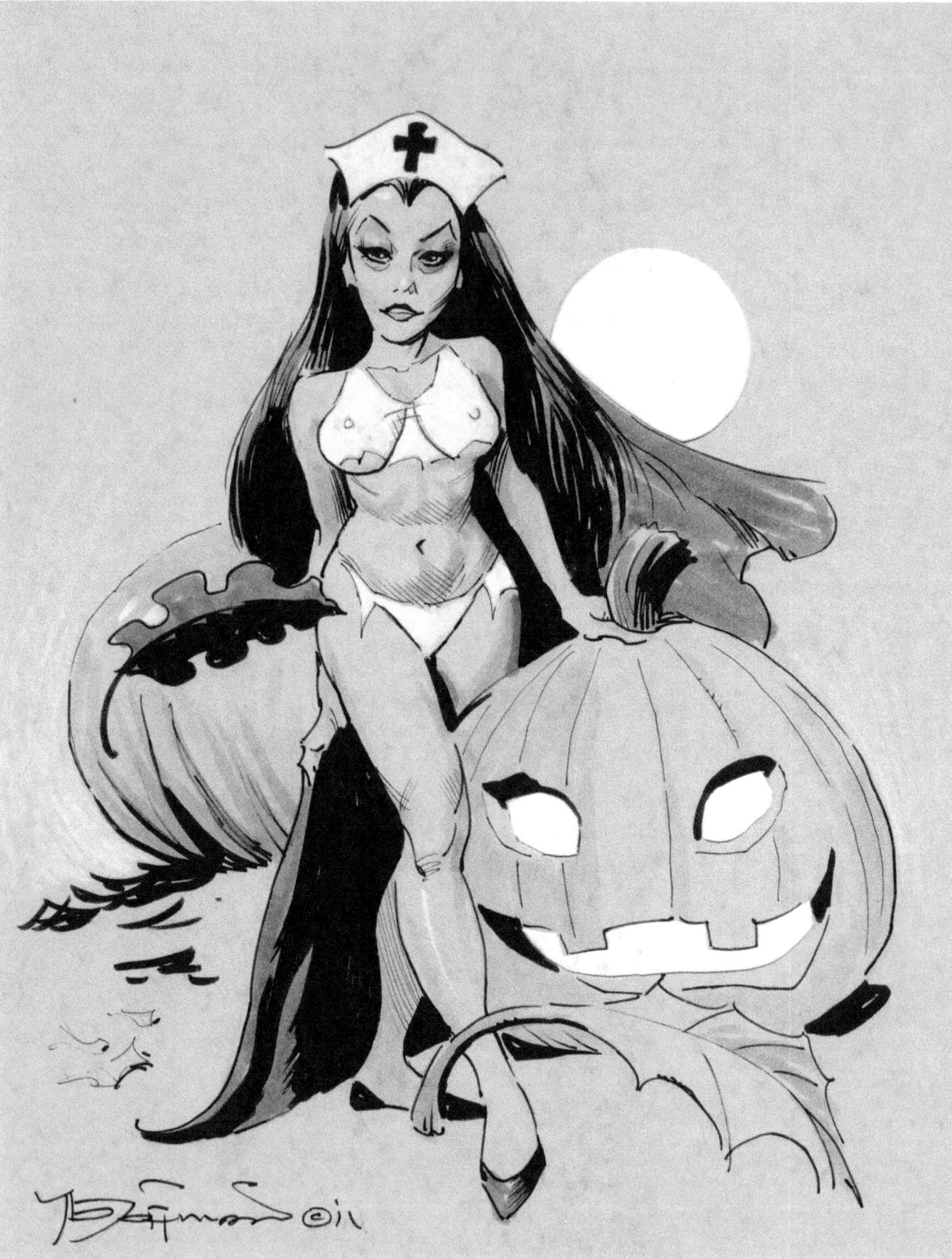

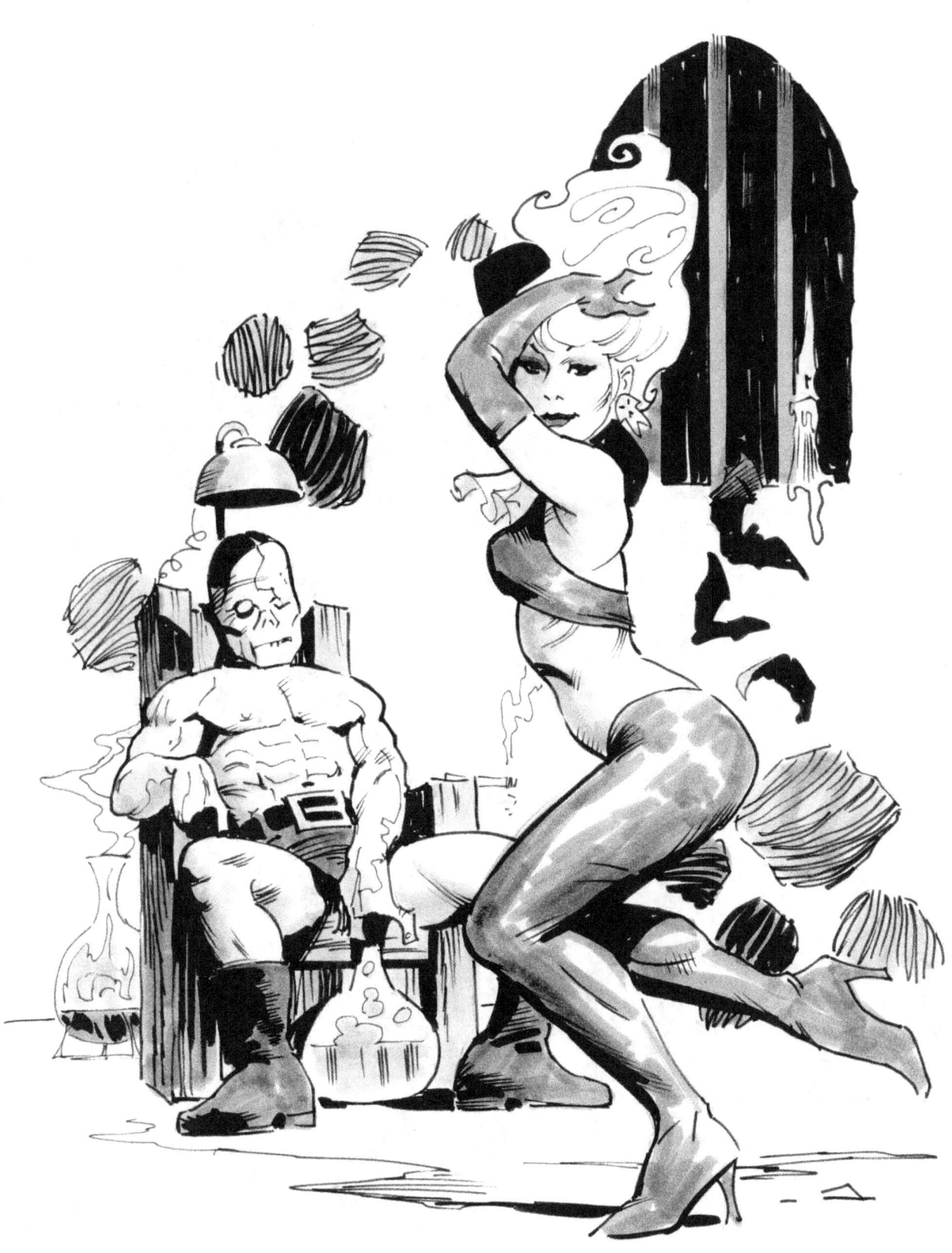

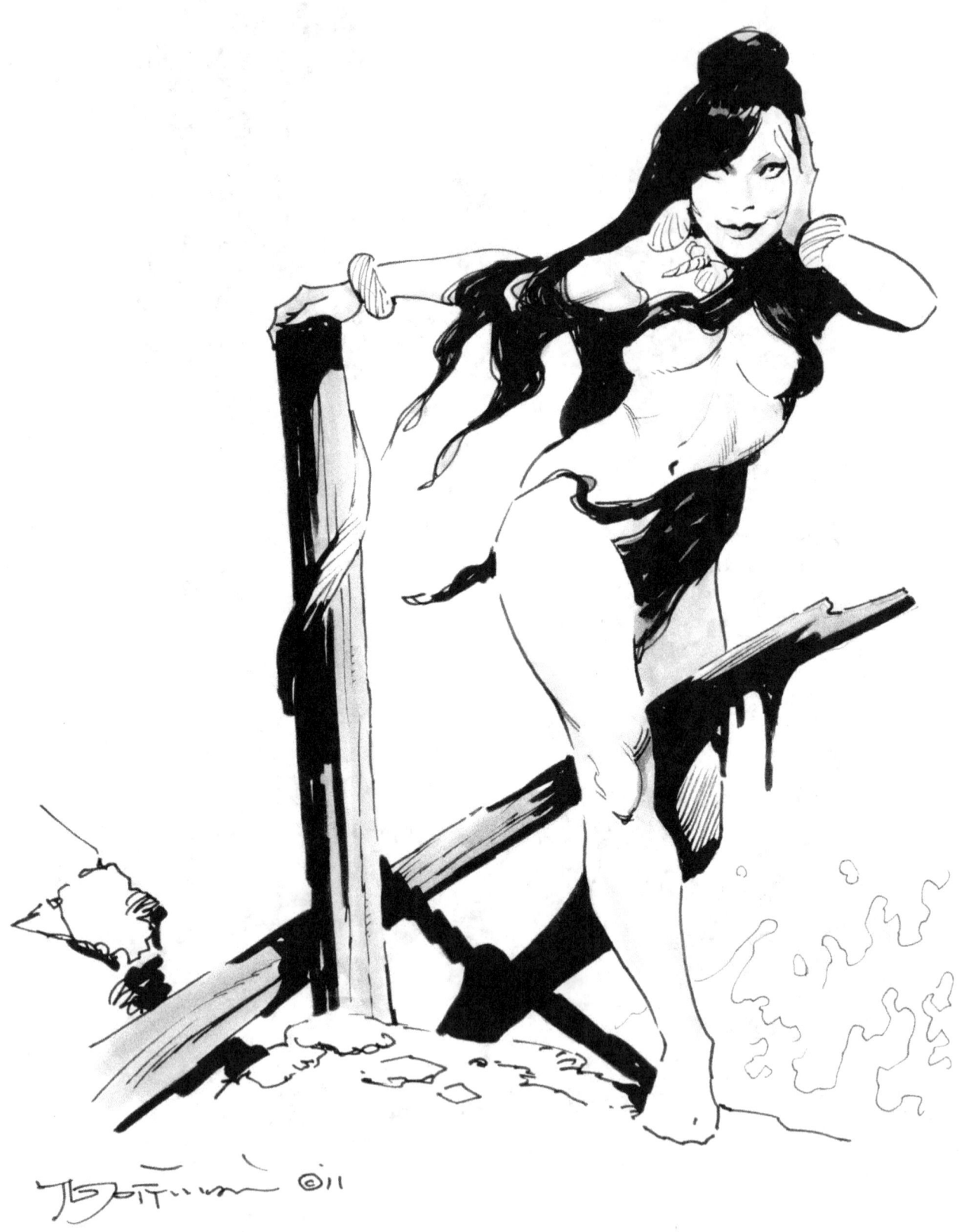

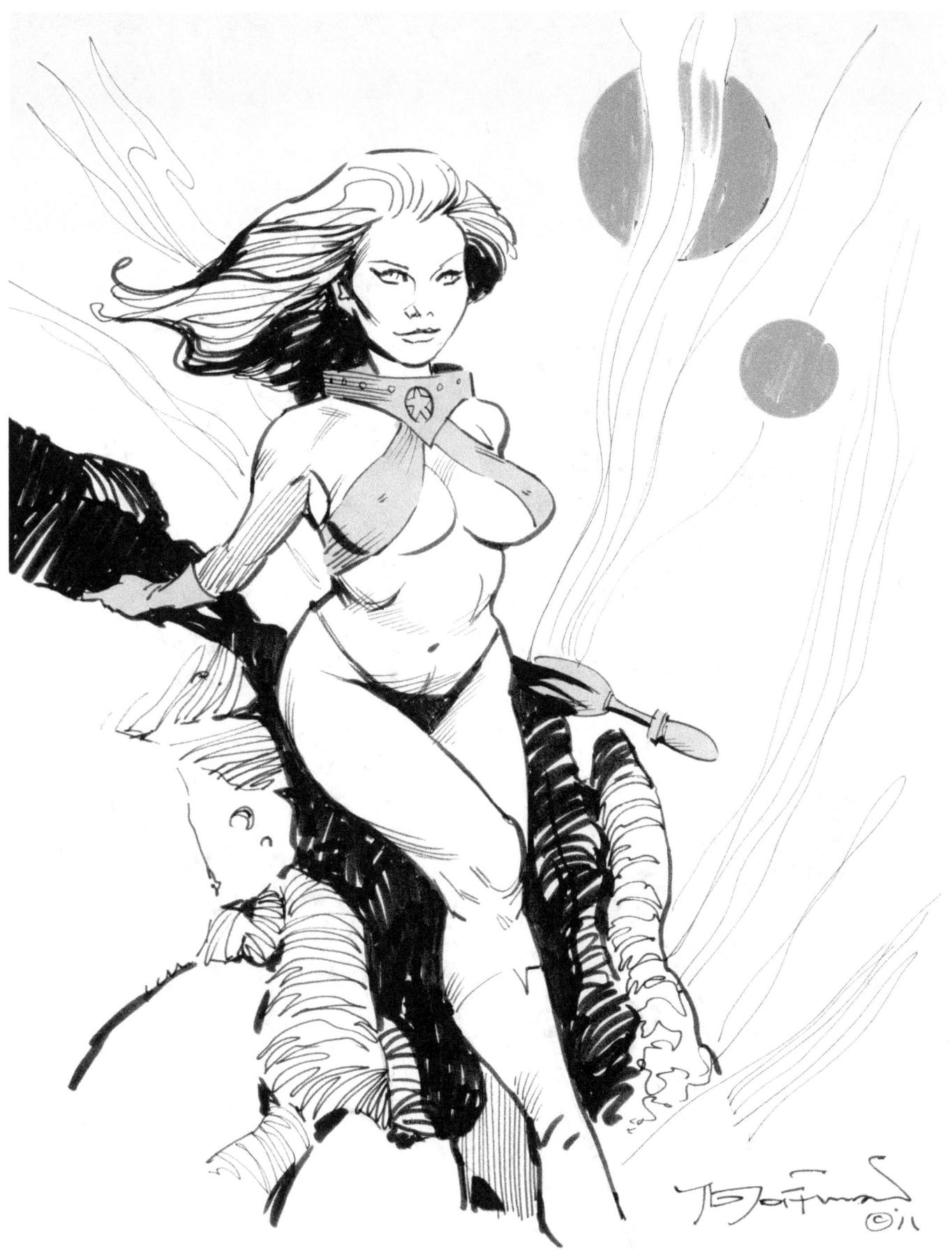

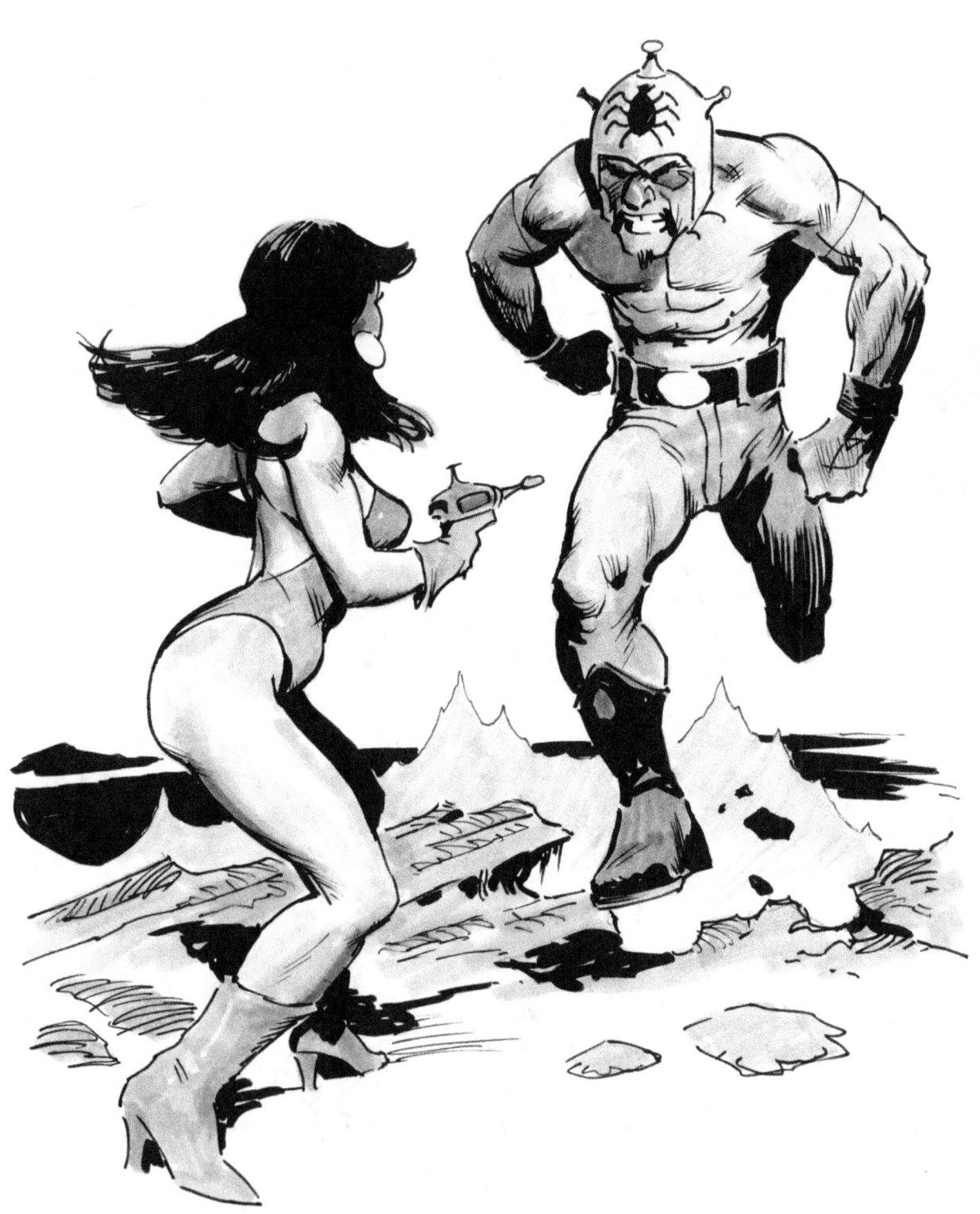

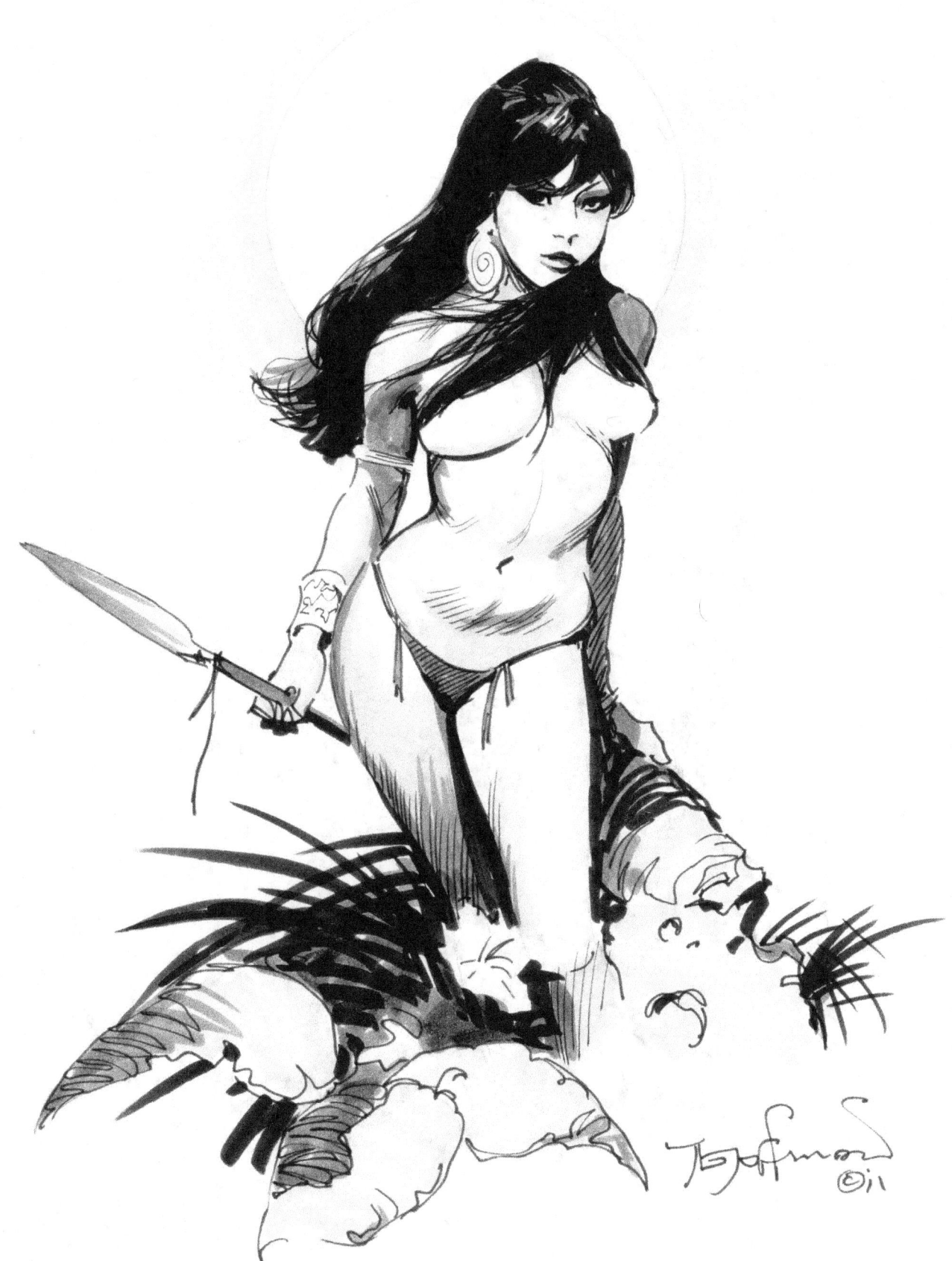

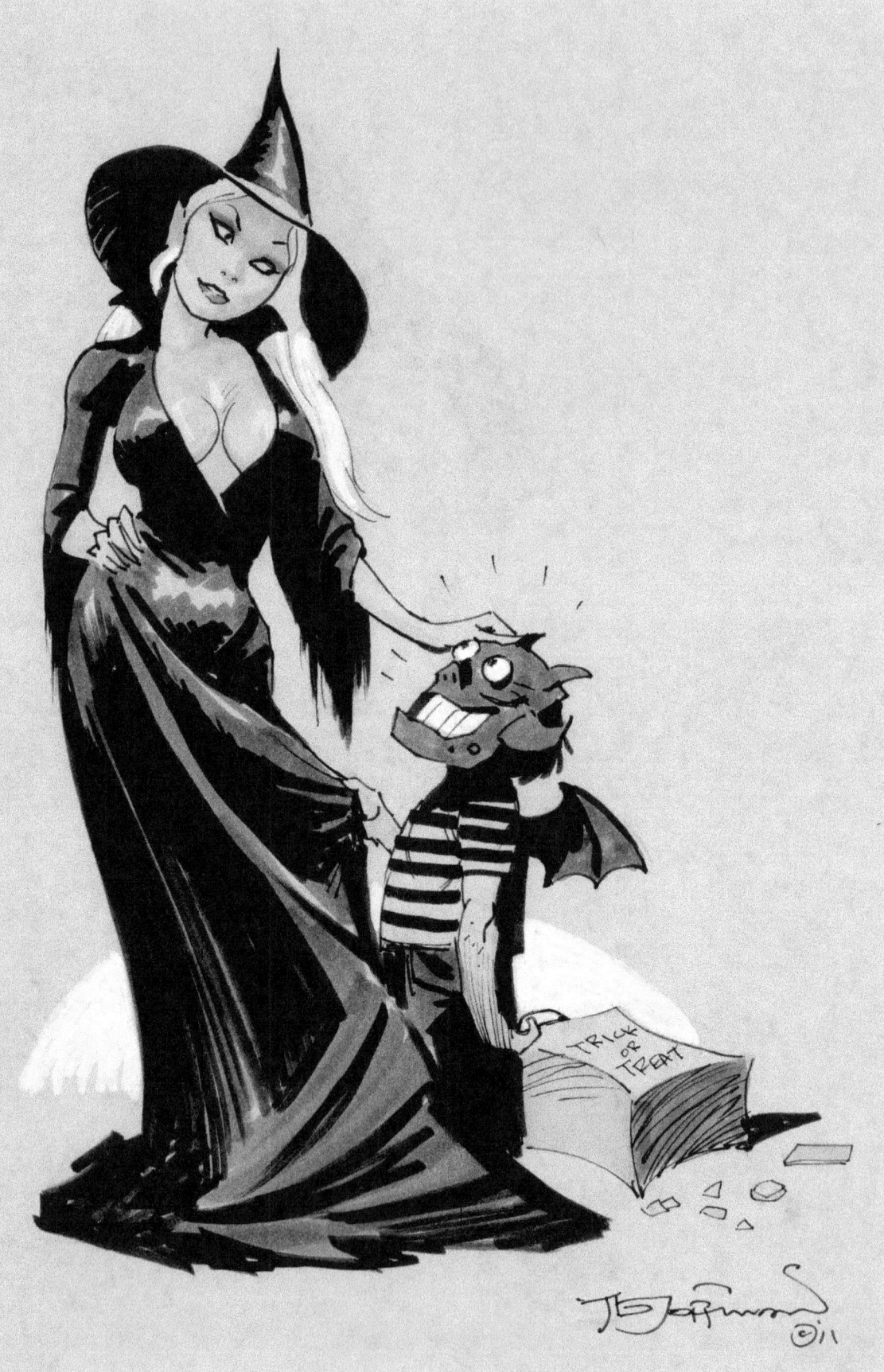

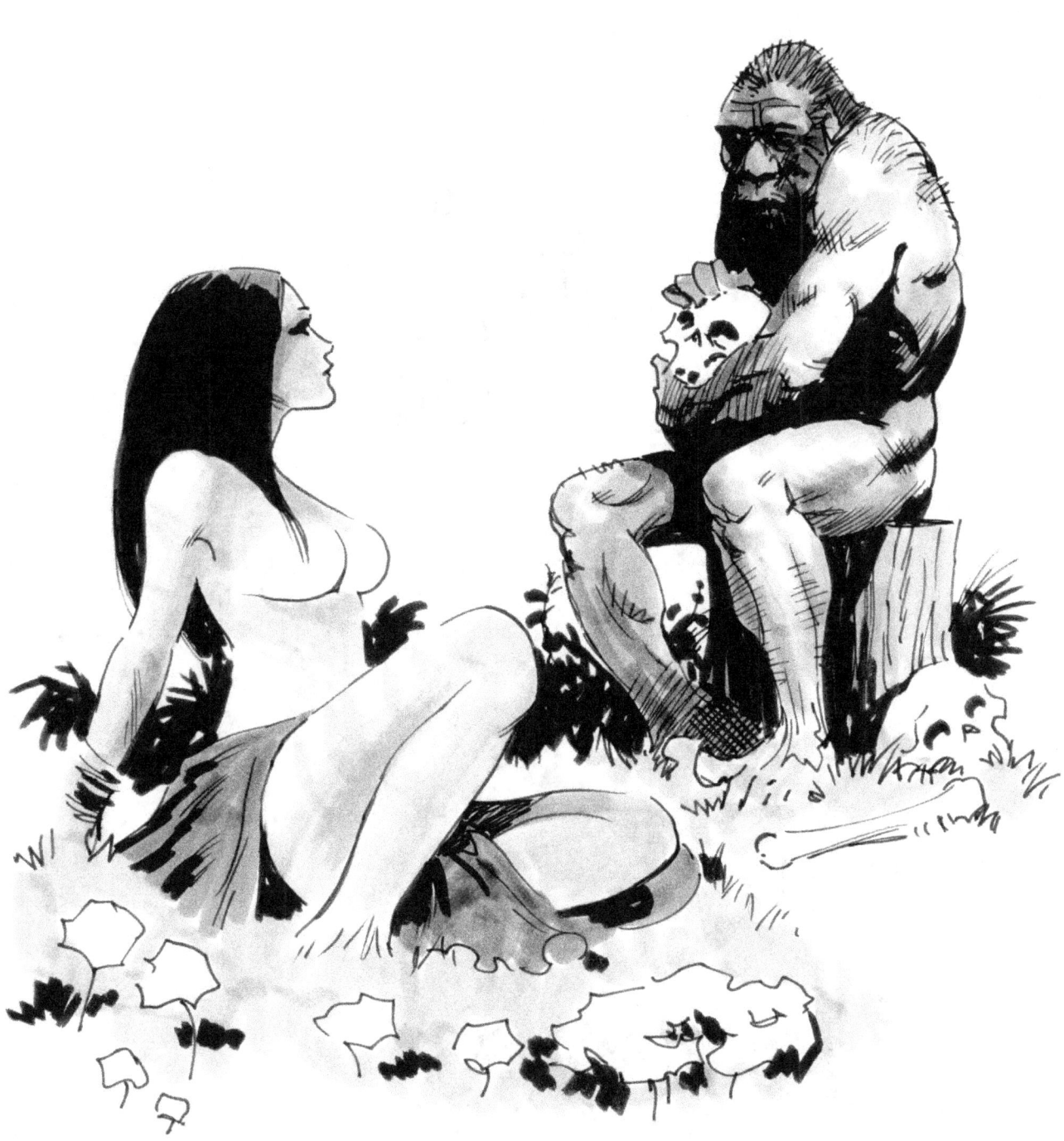

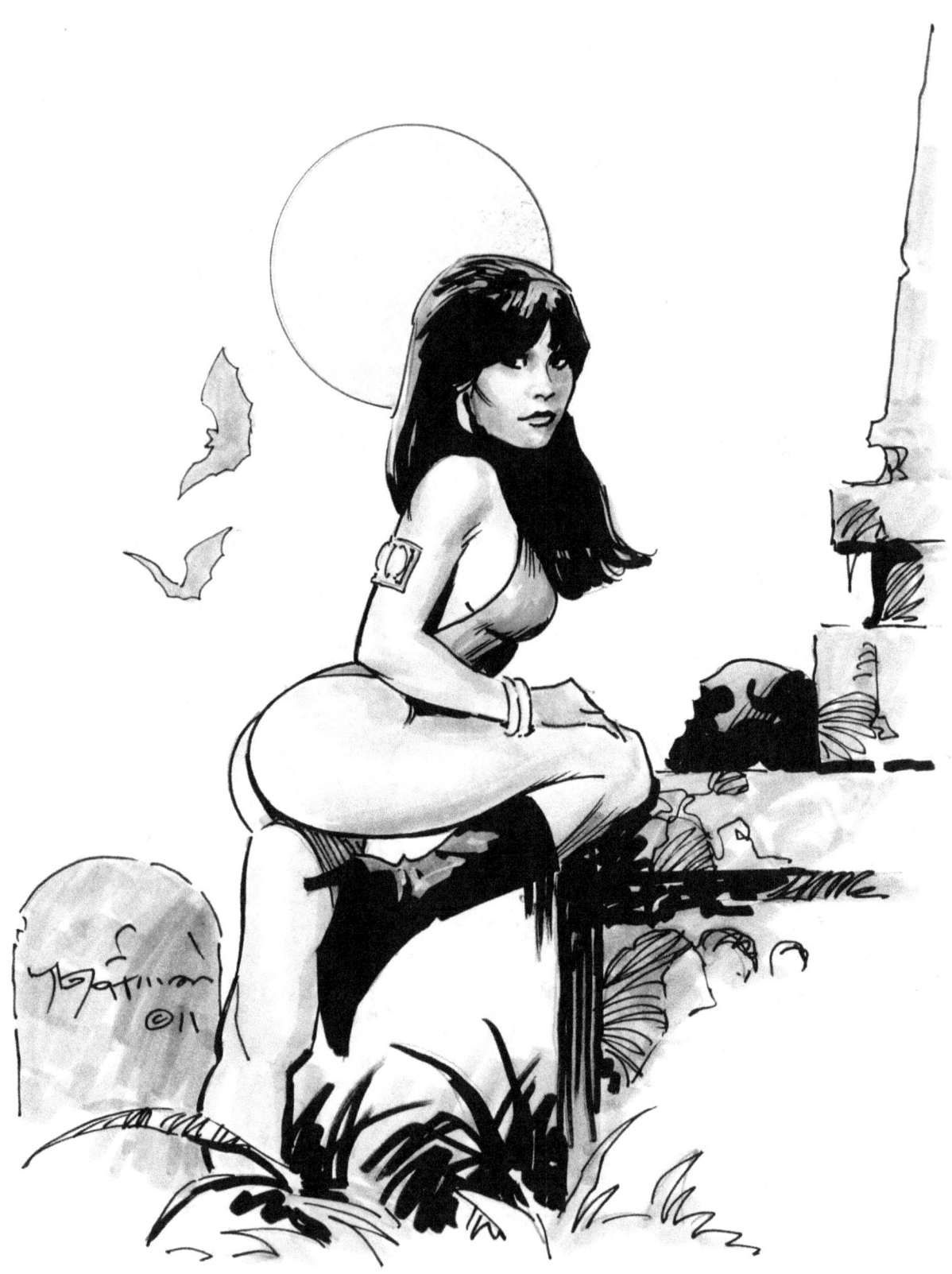

Monsterville Dreamers

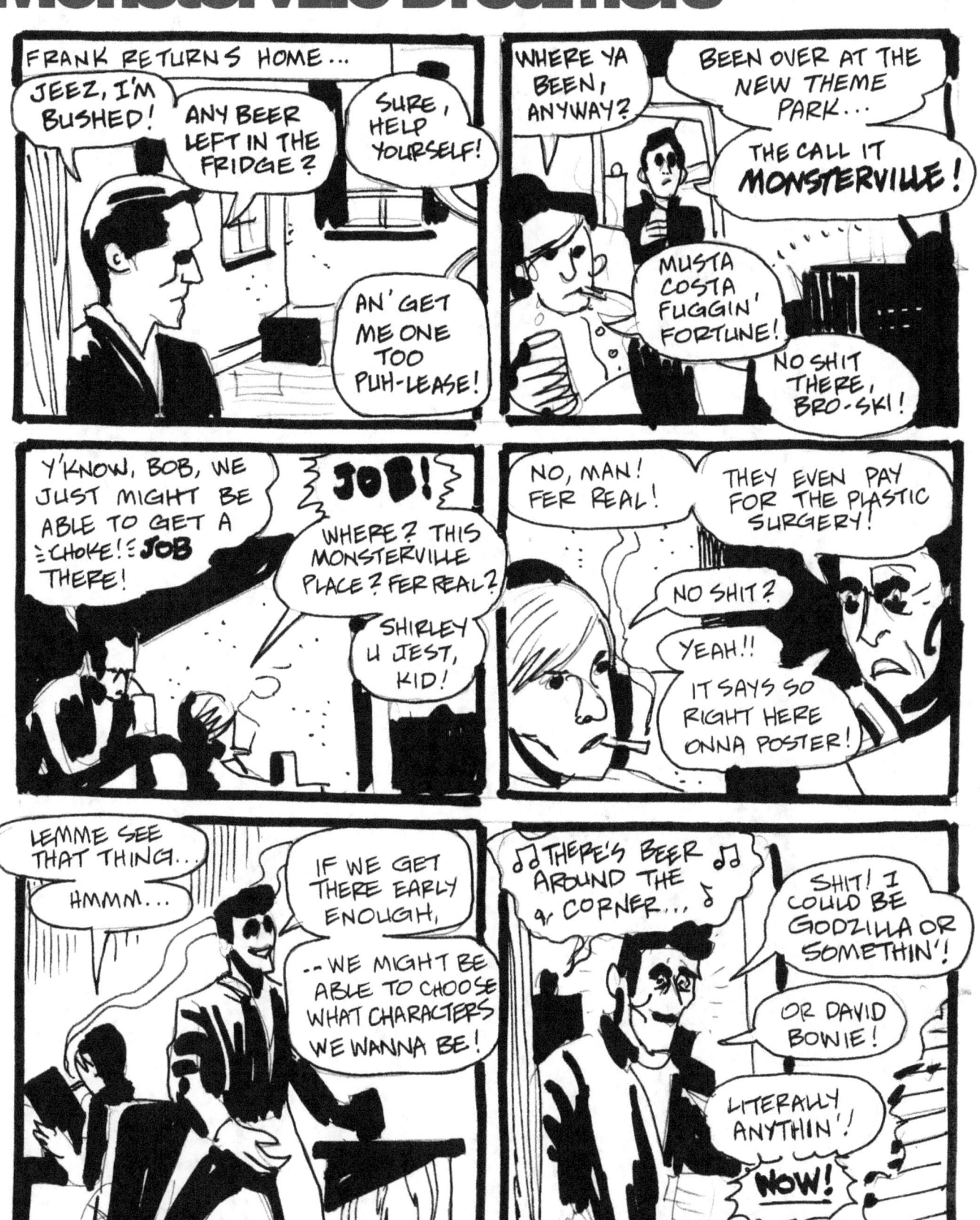

Lesson Thirteen

Drawing done in 1988 from an old edition of the "Famous Artists Course".

Irrational Perspectives

There was time when the obsessive-compulsiveness associated with my drawing training led me to try and solve in advance every technical problem that might one day arise.

This drawing explains the difference between artistic and photographic perspective.

I call it "irrational" because who else was crazy enough to do this kind of thing way back in the 1980s?

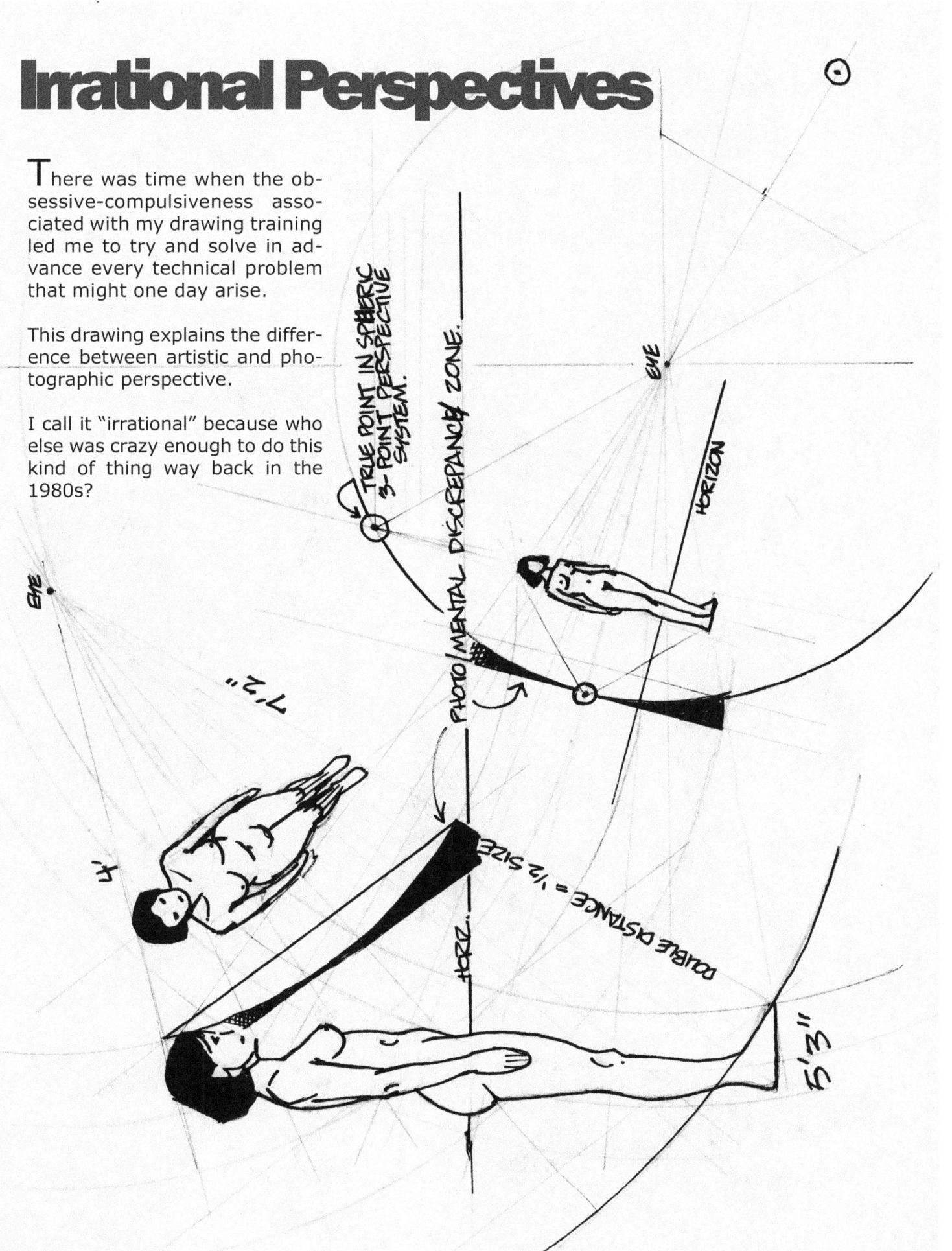

Assorted Remarques

Remarque drawings allow me to give something a little extra on books, comics and prints, although I will draw on almost anything. LEFT: His & Hearse Monster card remarques; CENTER & BOTTOM: remarques on untrimmed Art prints; RIGHT: a thank-you remarque to Australian artist Jason Paulos, contributor to TOMB magazine.

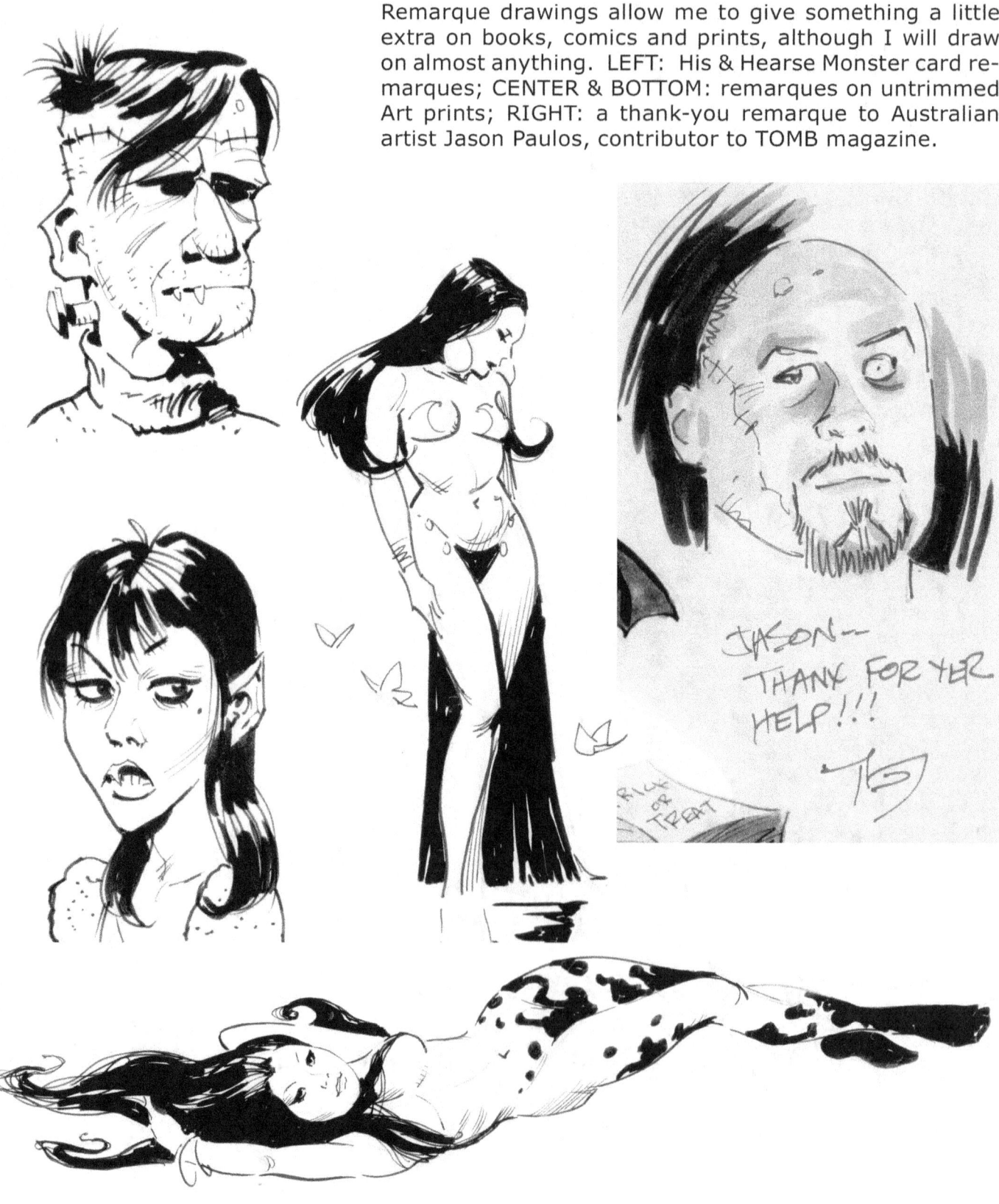

Superhero Retrograde

There's little argument out there that Jack Kirby single-handedly set the constellation spinning that would explode into the Marvel Comics Silver Age, influencing comics to this very day, or at least feeding it in its vampiric fashion.

And there is always plenty of talk meant to obscure the fact that all this crap was invented by someone else, and although you may have inherited it you sure the fuck weren't mentioned in the will. In fact, the will was never found.

And it's always said that these Old Heroes are out-of-date and therefore must be made more current, more relevant, and supposedly "more improved". Or, as people might say today, "more improveder". I'm not kidding, it's coming.

So we know why the Inheritors must monkey things up, but when asked precisely "how?" to do it there's always lots of answers. Or "Fanswers". But the standard one is "More Realism".

Superheroes are not and have never been "realistic". And in the Past they were no "realisticker", either.

The bottom line is that it's almost impossible to play around with something you didn't make and not bust it. Now, Corporate Comics--rather, corporate *media* companies own everything under the sun and bust them with regularity.

There are only two approaches out of this mess, and perhaps neither can challenge the Corpcomics total wedgie, but still some squirming is in order.

First, make up your own characters. If they die on the vine, or don't sell at all, that's okay, because you made up your own characters. We could call that dynamic MUYOC. I think it has a nice ring to it, kind of like a retching sound.

I should mention before going further that "retrograde" means travelling in the opposite direction than something else. All the smart chumps will know where this choo-choo of thought is heading.

Like some dumb Japanese movie, all Superheroes must be utterly destroyed before anything worthwhile, or honest, or real can emerge from the ashes like a big, flamin' boid.

Superheroes, at least my superheroes, have always been on a one-way downward trajectory towards a crash landing at absolute ground zero. I should put even more thrust behind them to get it over with more quickly and painlessly.

But no pain no gain, and pain you get from Corpcomics is a totally different kind--sorta like rusty staples under the fingernails. All the fancy computer coloring in the World can't hide it or begin to mask the stench.

They called them "Monkey Books" all through the Fifties because only a cretin or Gomer would actually read one. But what's a delinquent these days? Where are they? WHO are they? Do they even exist, or has everyone morphed into marshmallow Elois?

DOWN is the only thing that works, and its the only thing left to do. Hollywood must be stopped. Corpcomics must be killed and the movies with their endlessly resurrected hero-corpses swaying in that Ill Wind must be cut down and buried with any miniscule dignity they have left.

Don't let anyone tell you they need to be dug up and "reinvented" again. THEY ARE GHOULS. I didn't want the job, but it's a man's job. Remember, DOWN. The only way is DOWN.

To the bottom.

Ink Gallery 3

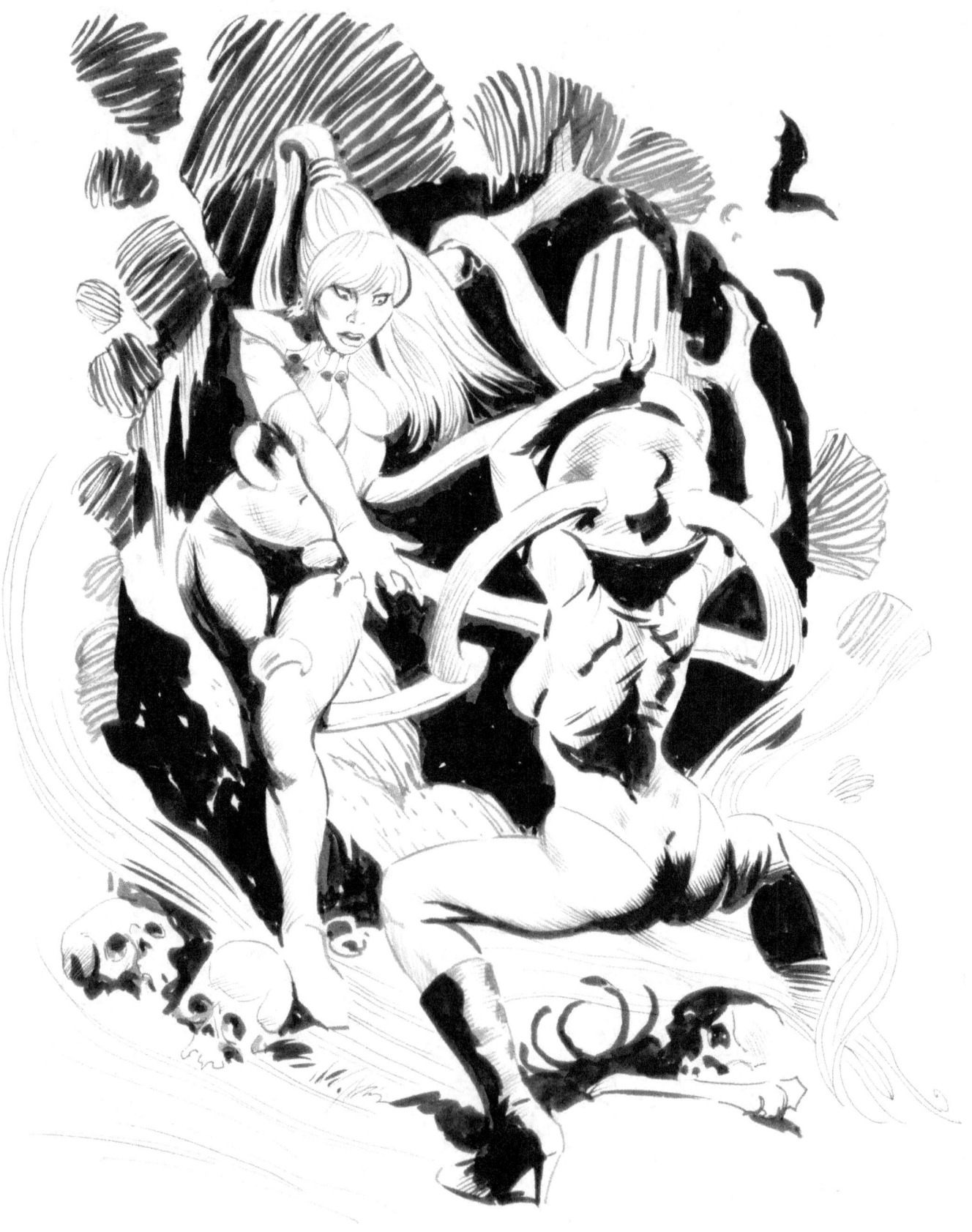

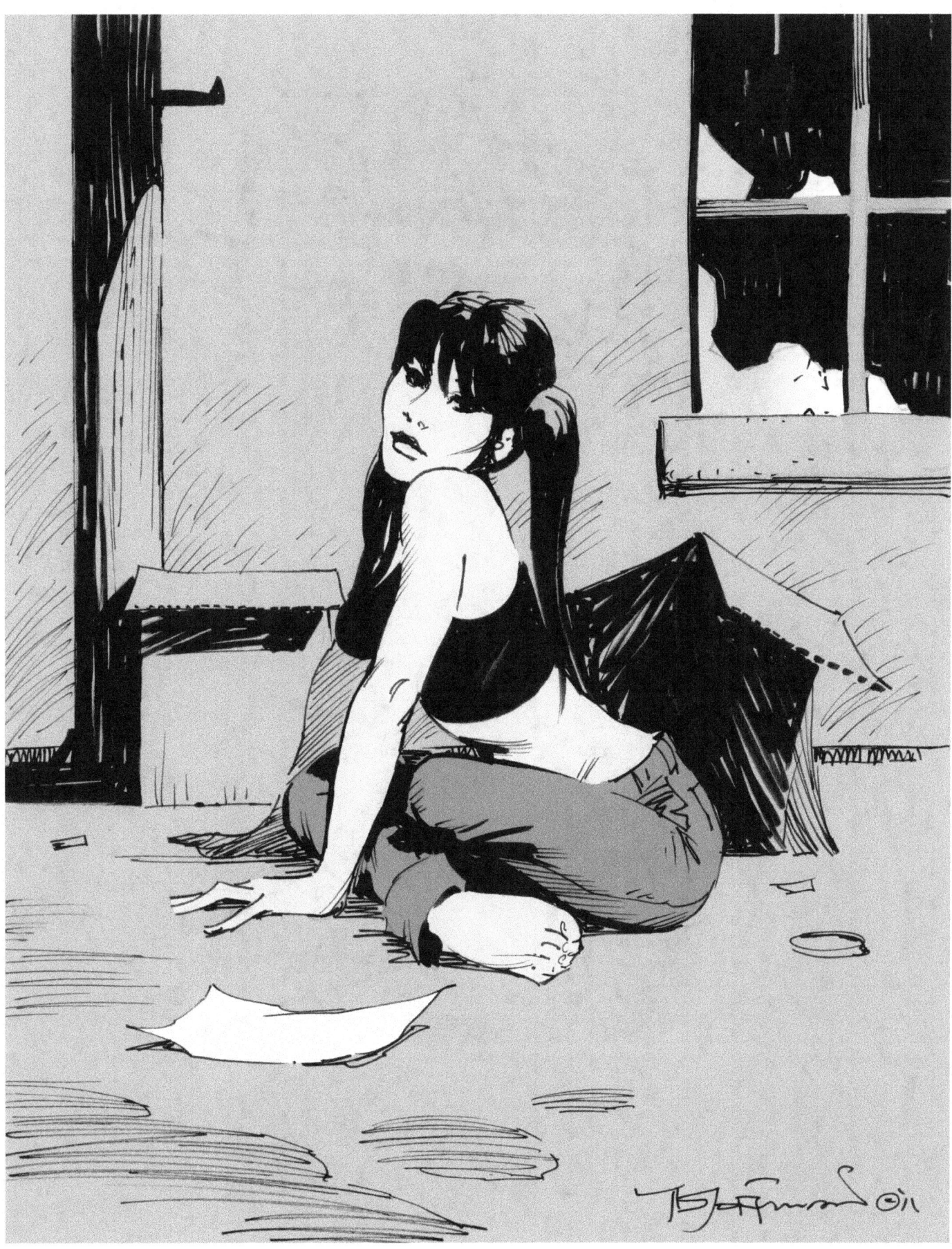

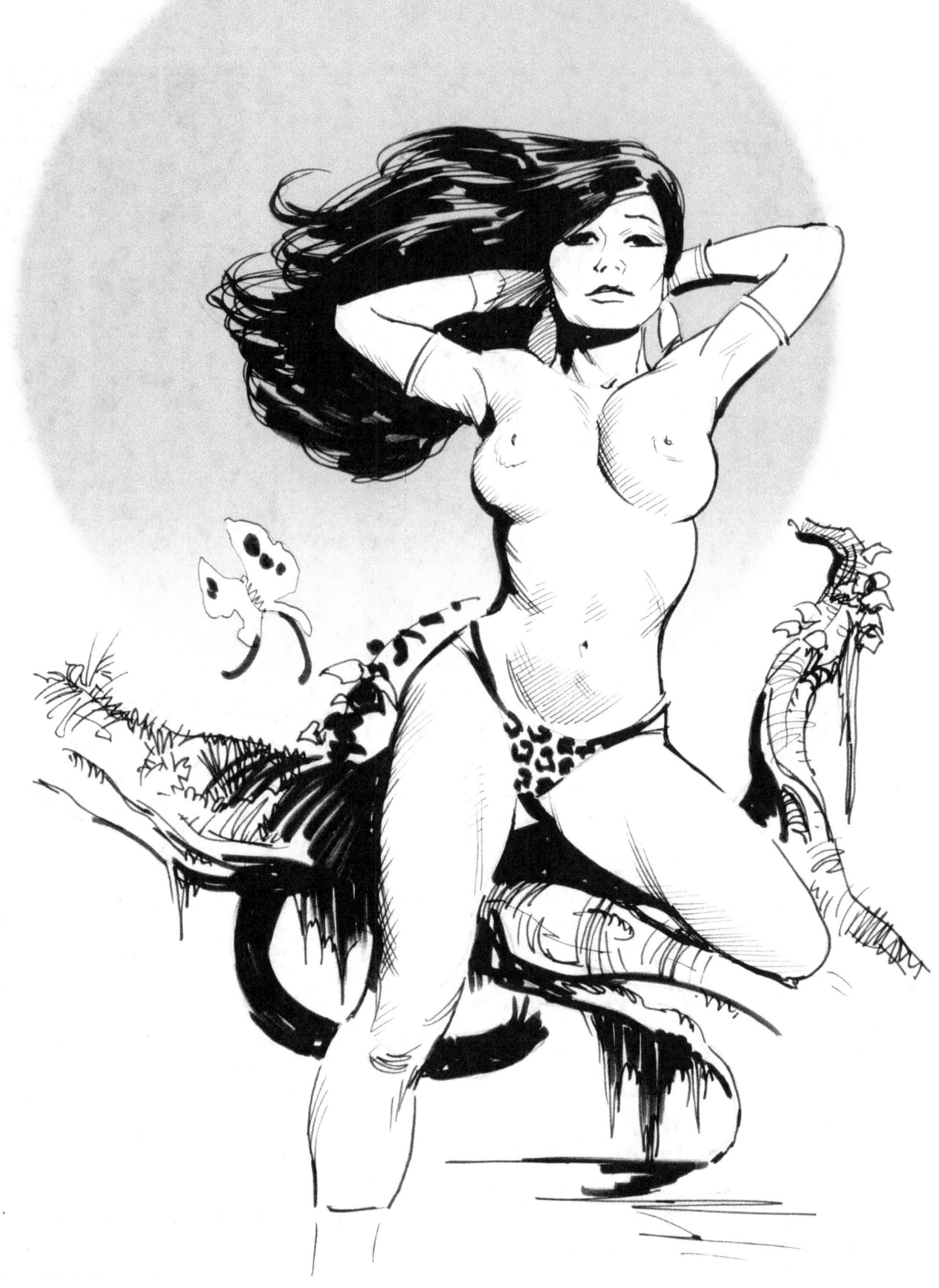

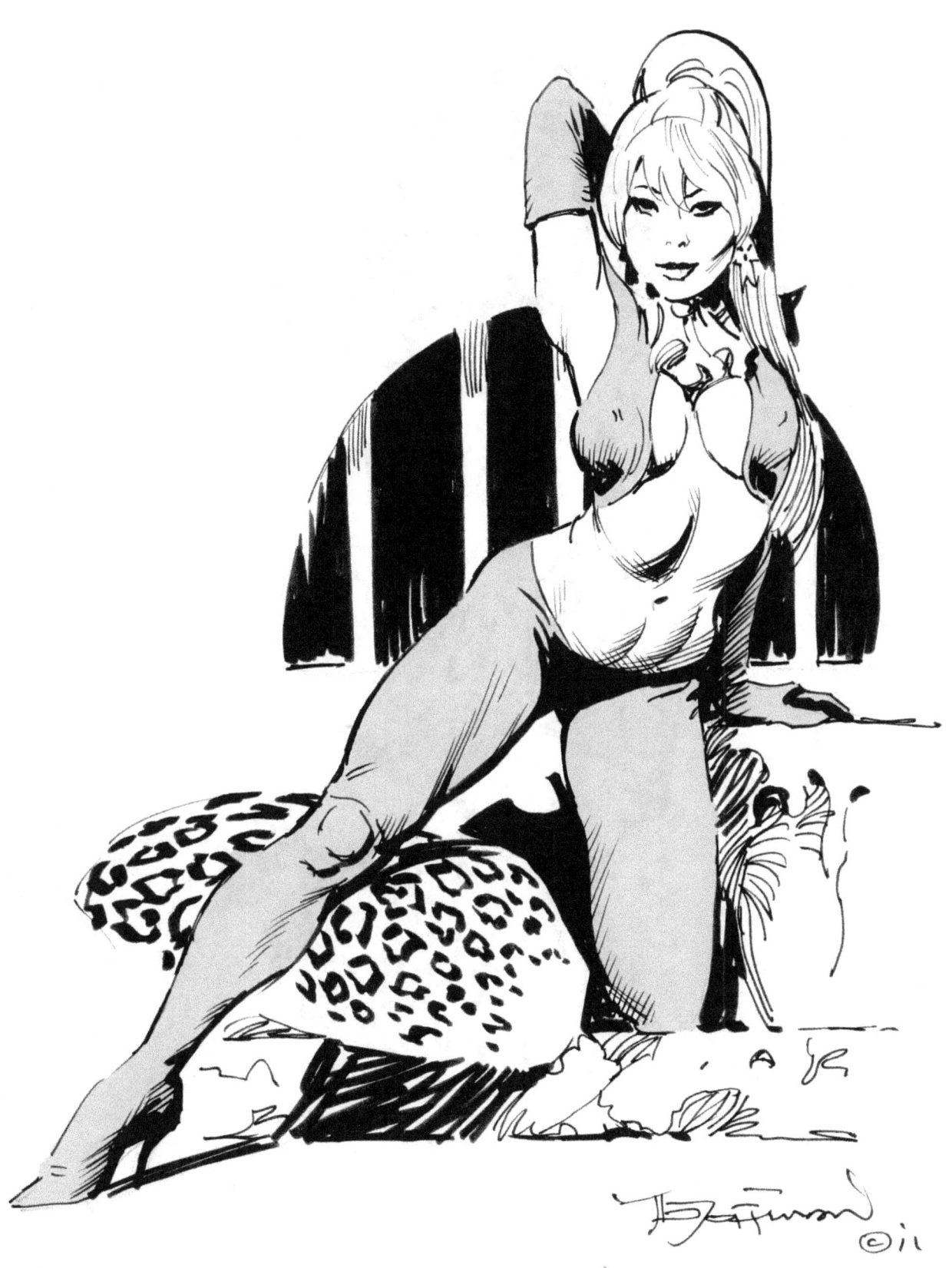

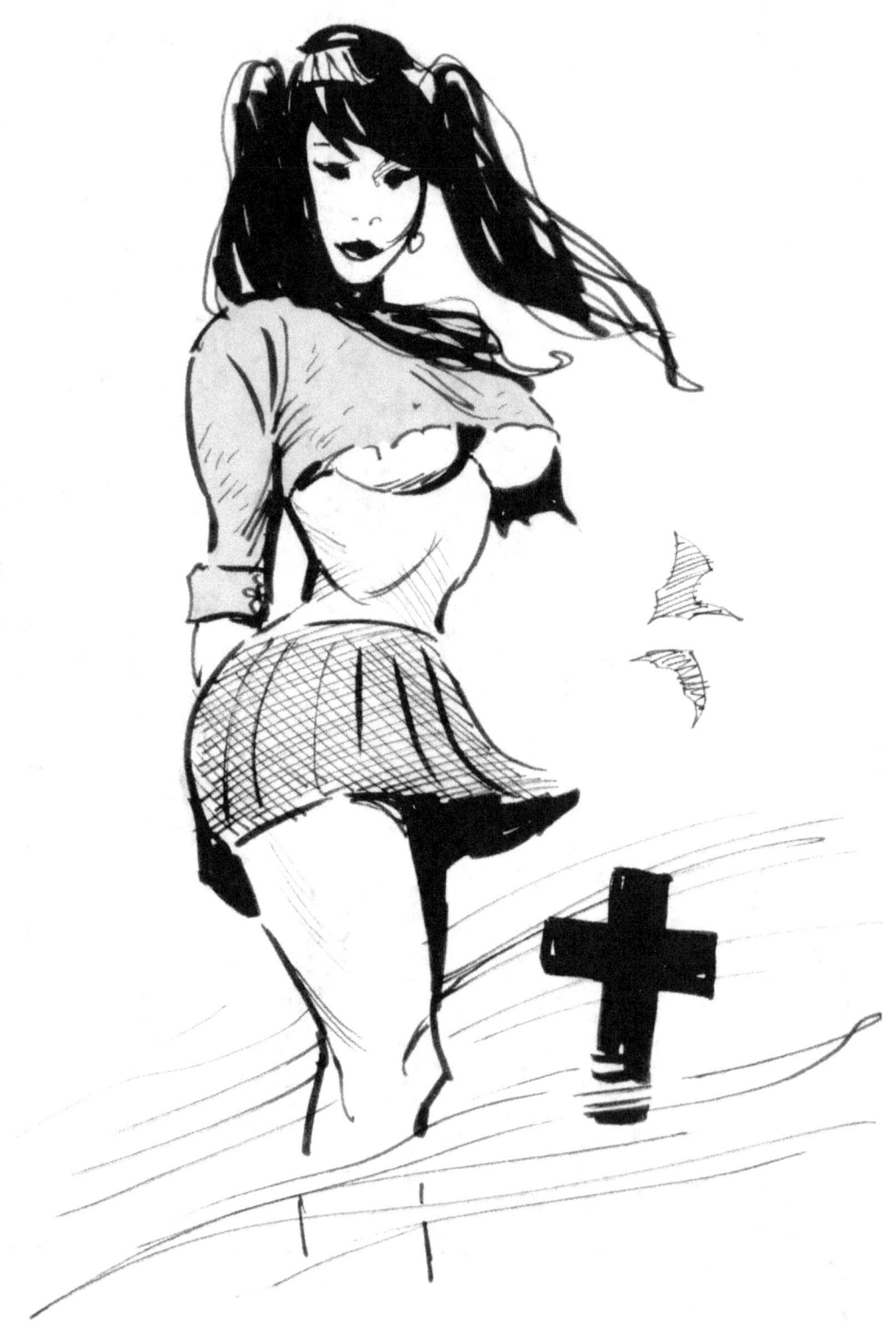

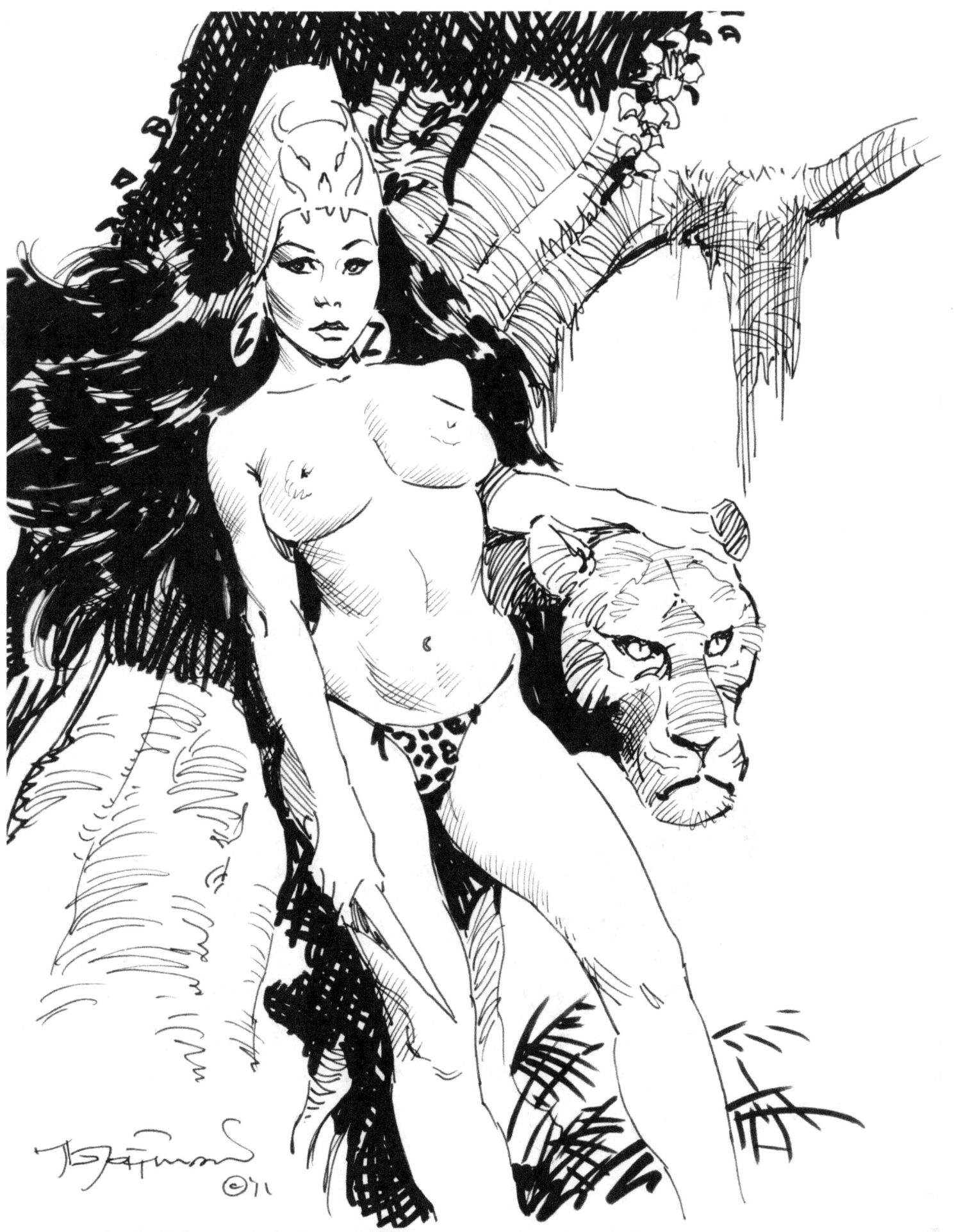

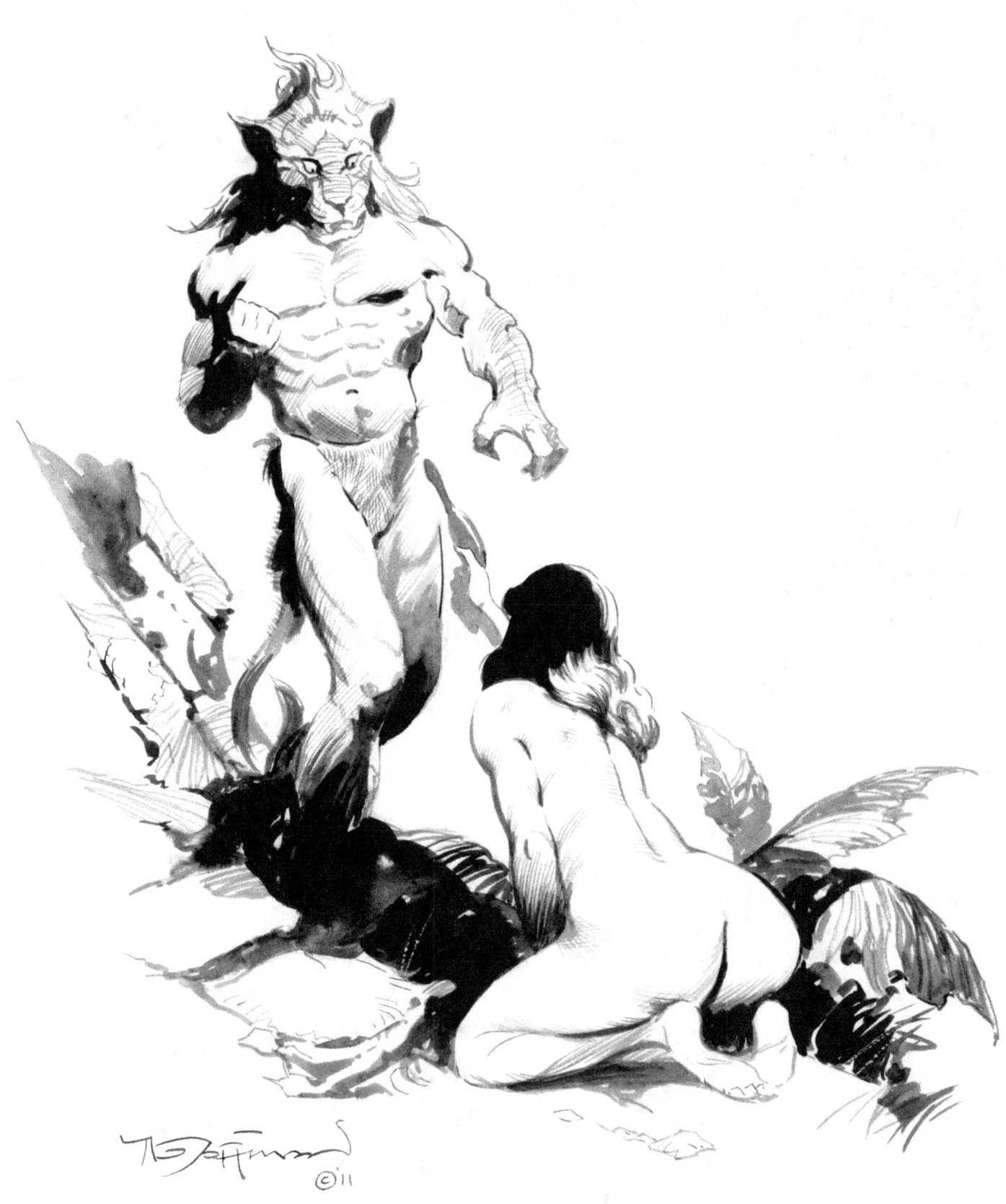

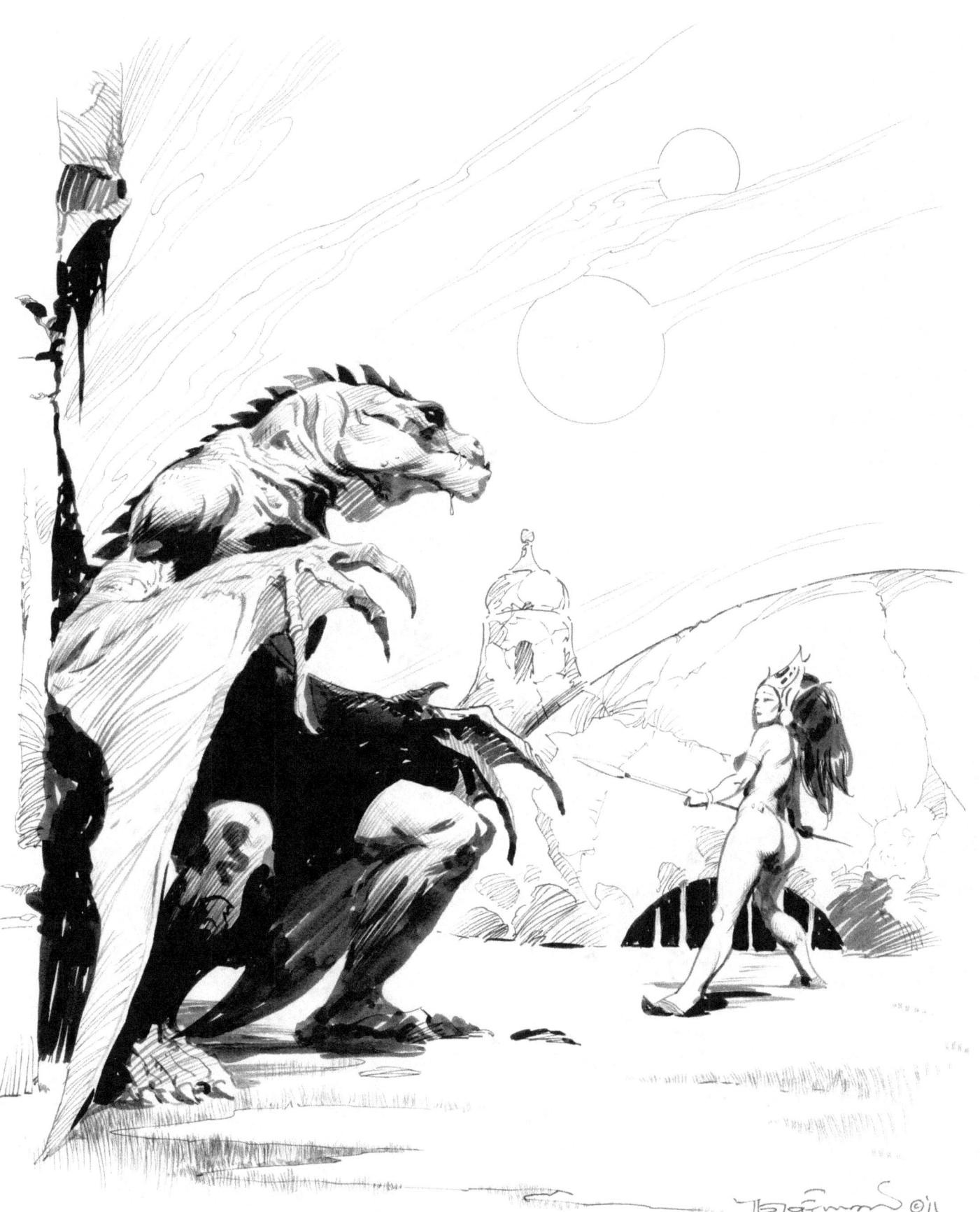

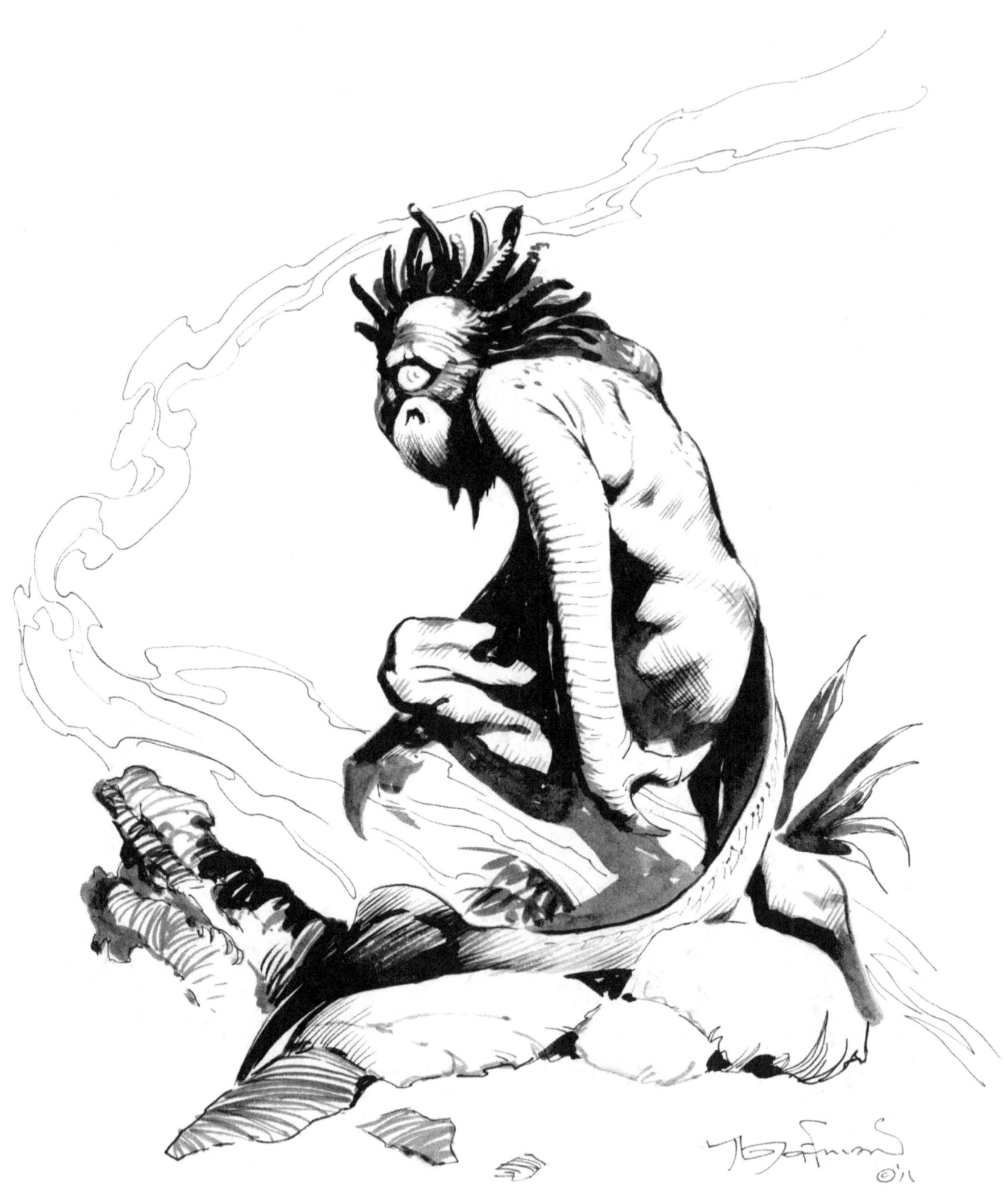

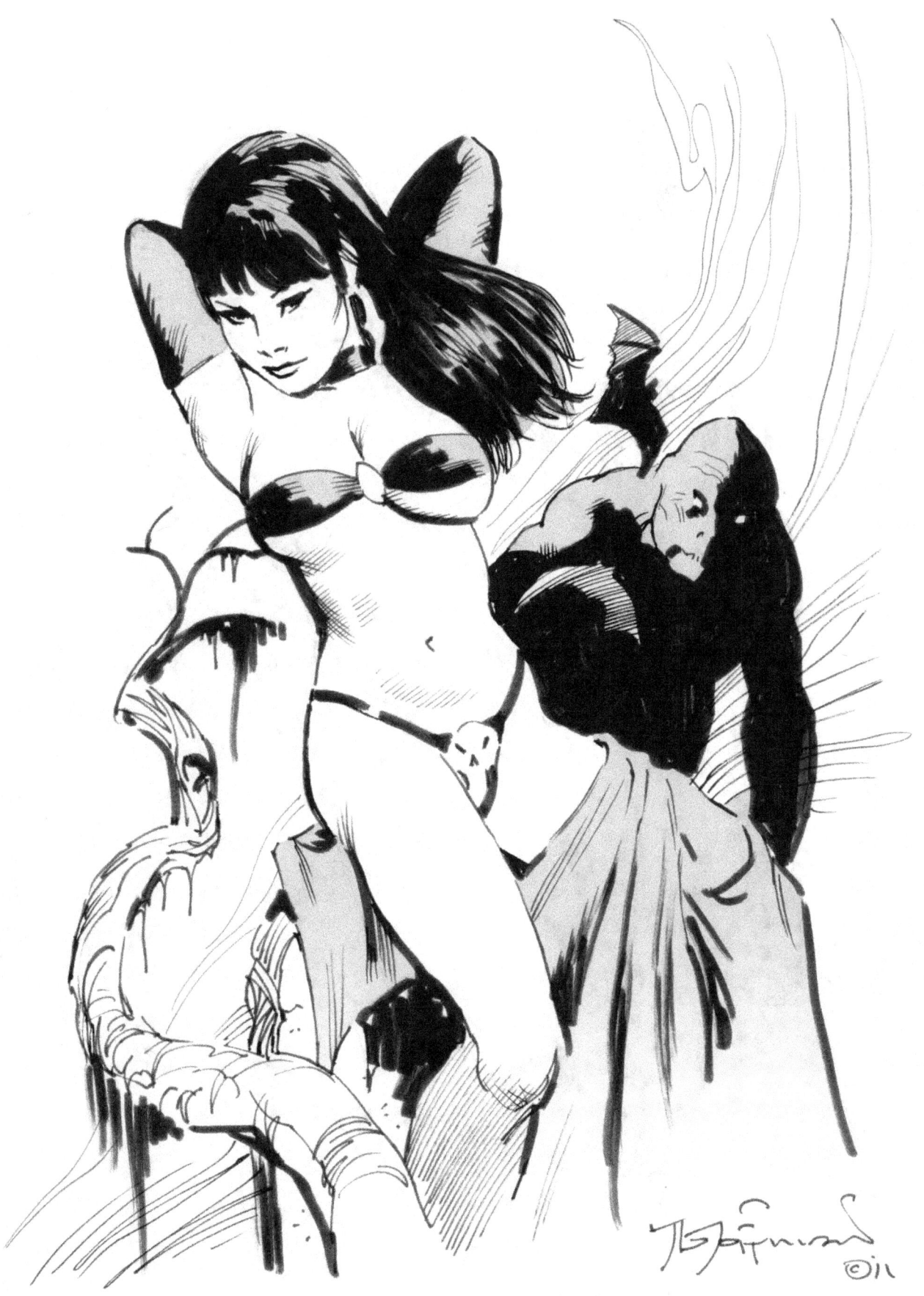

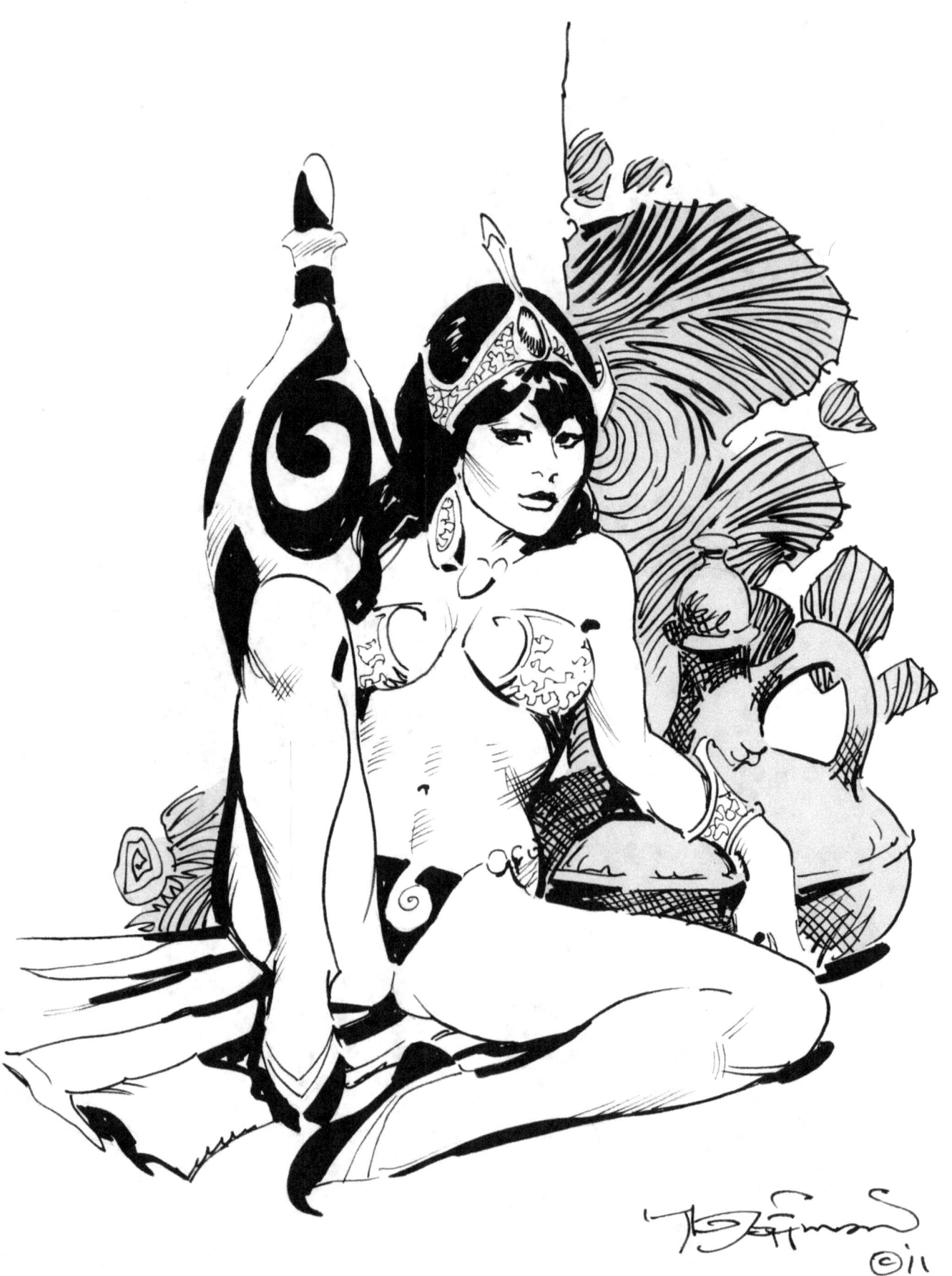

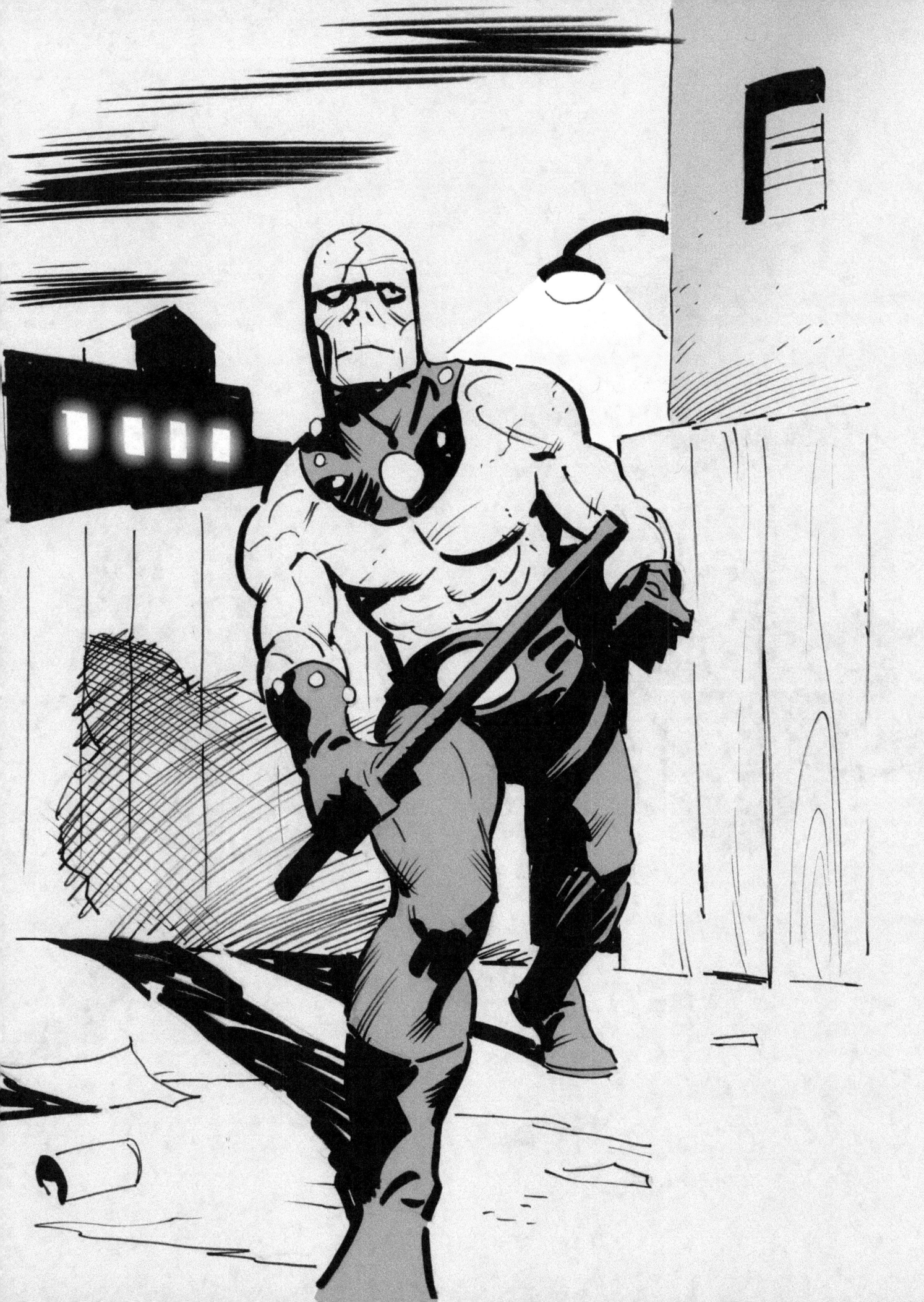

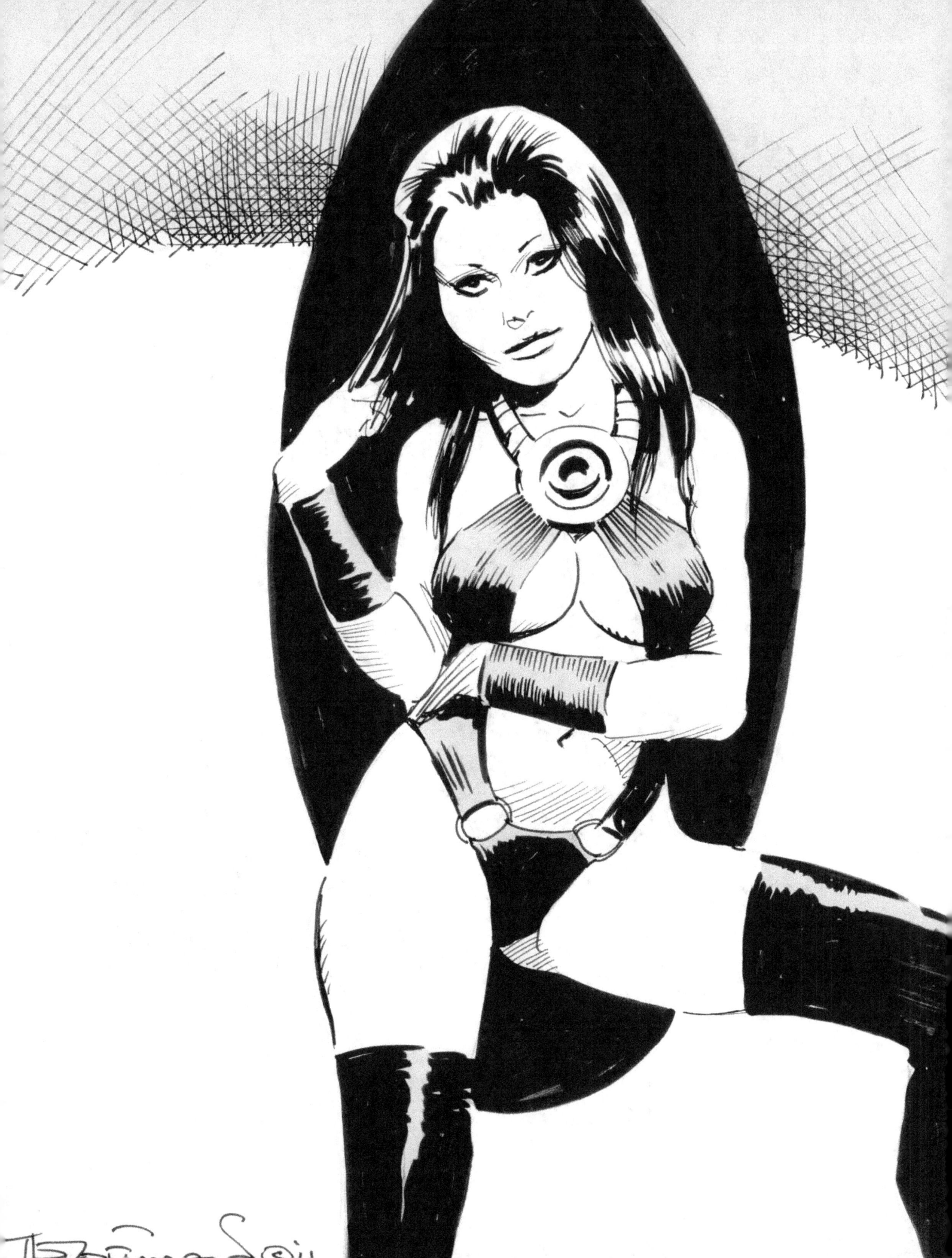

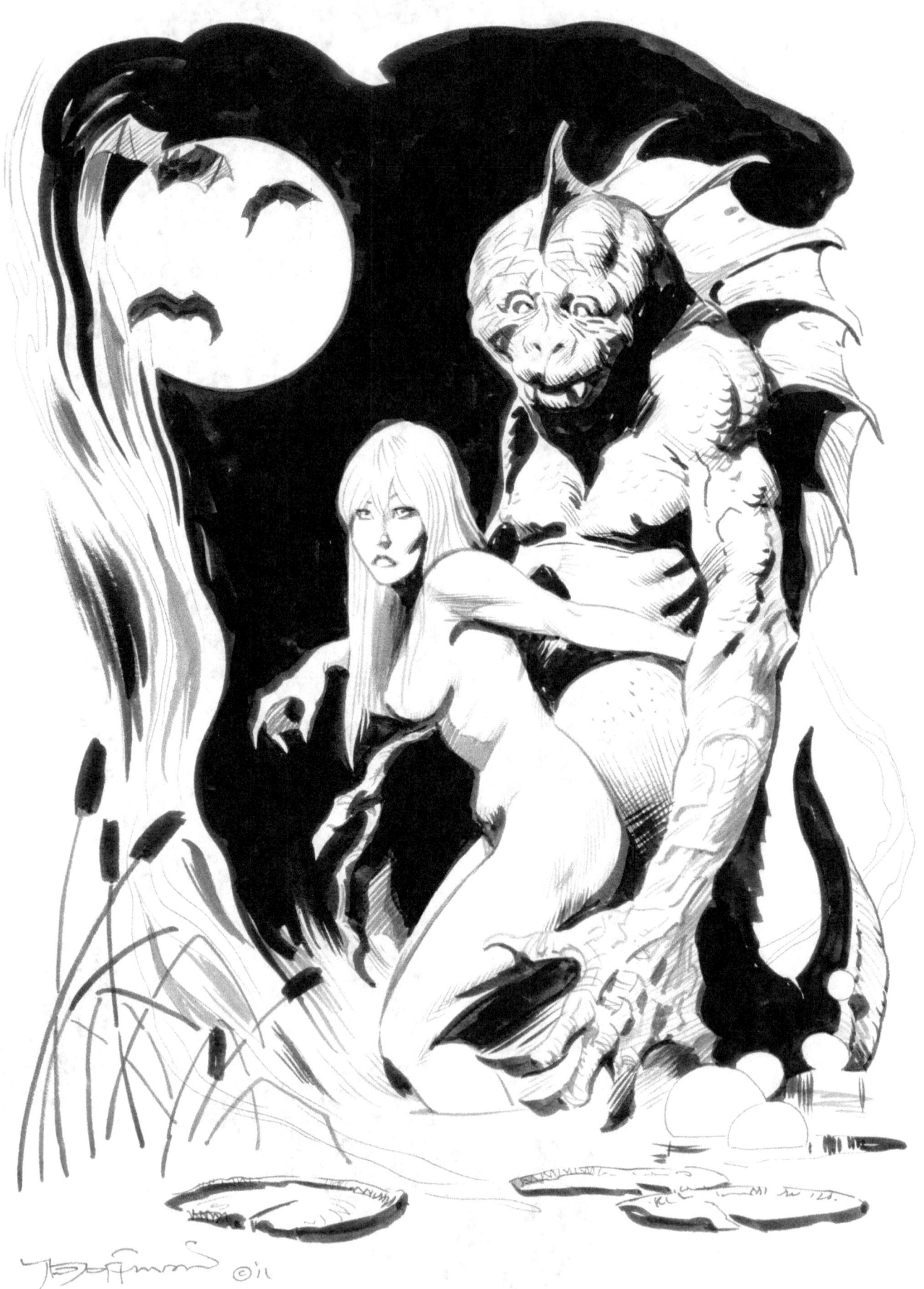

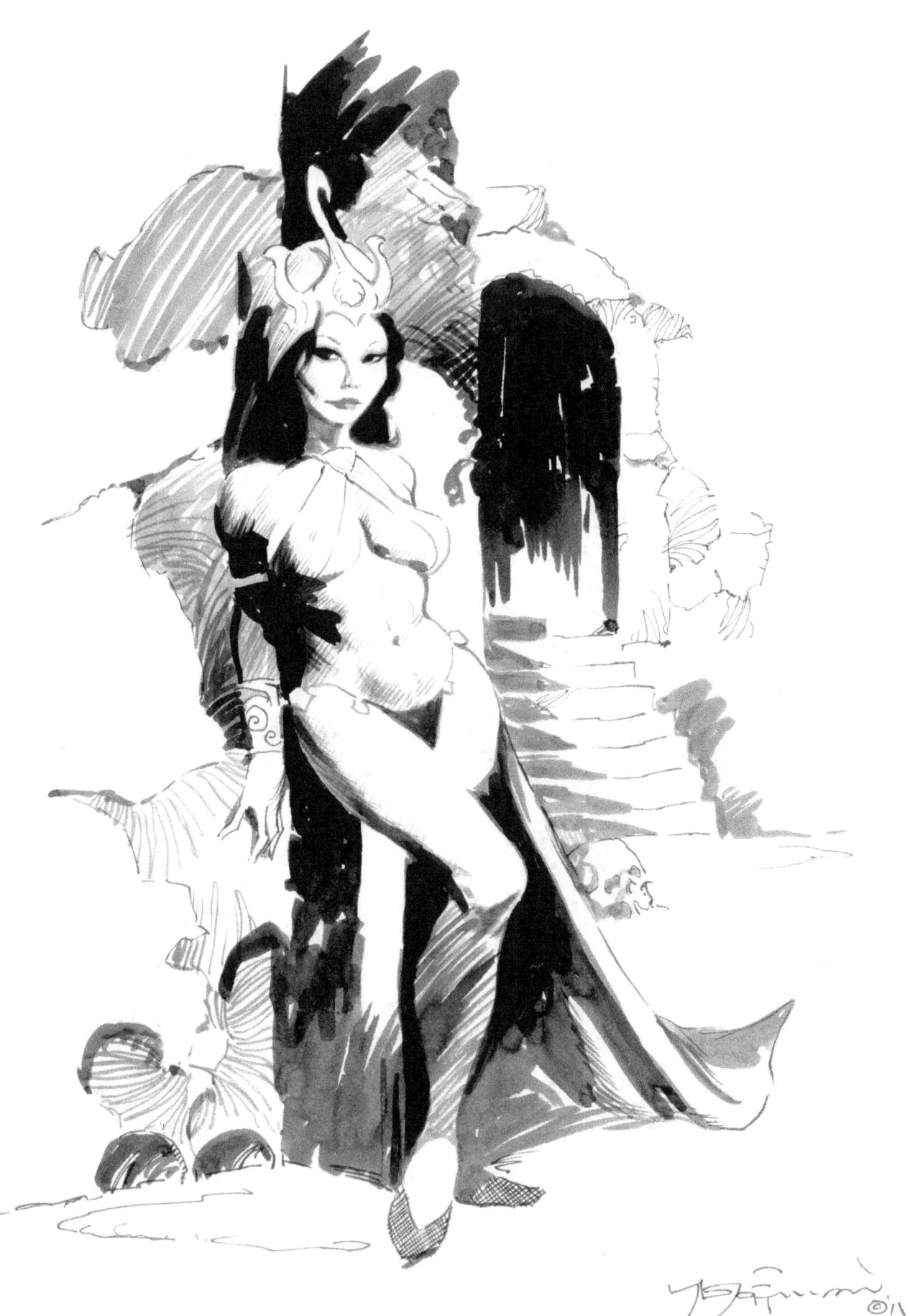

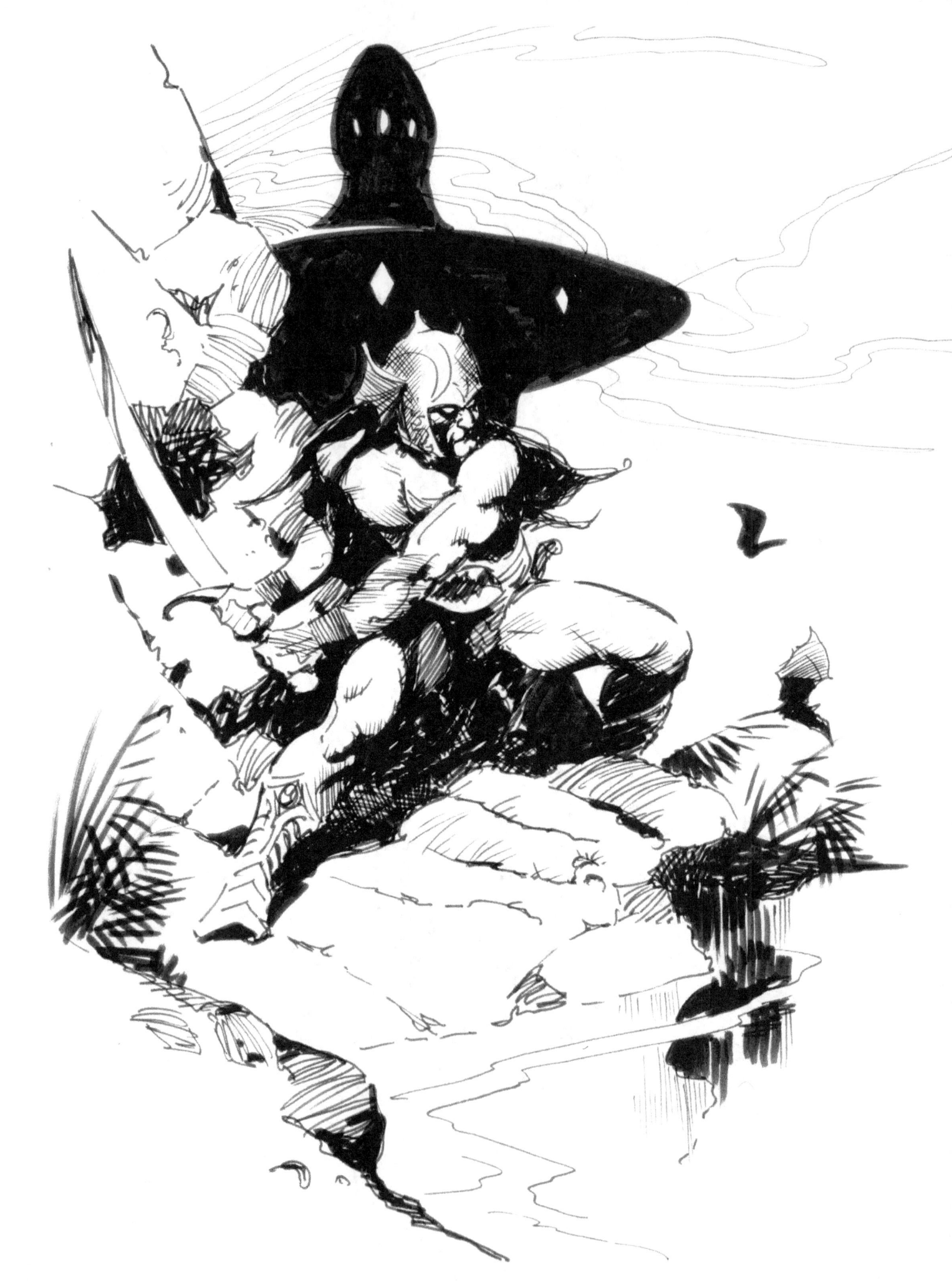

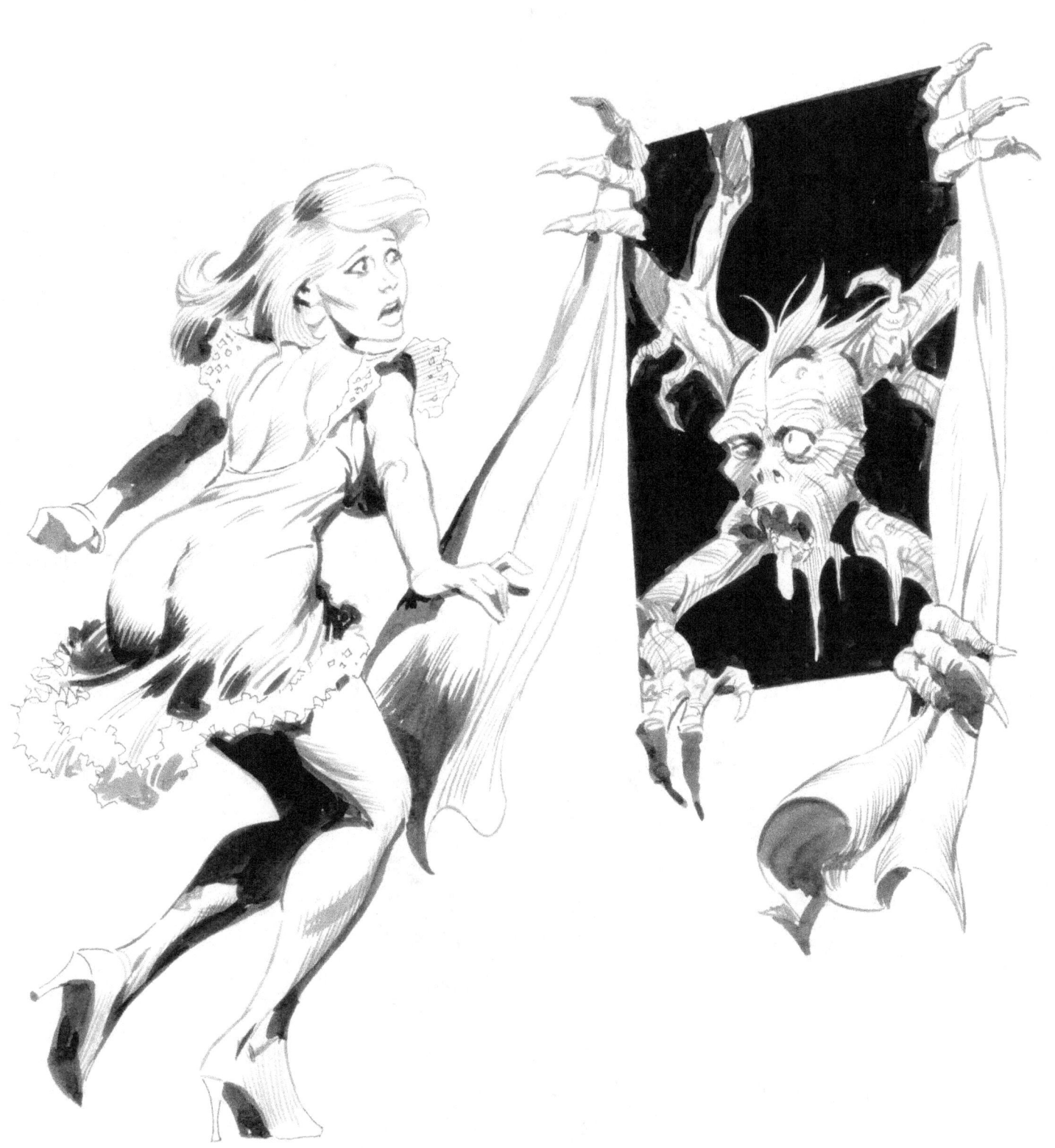

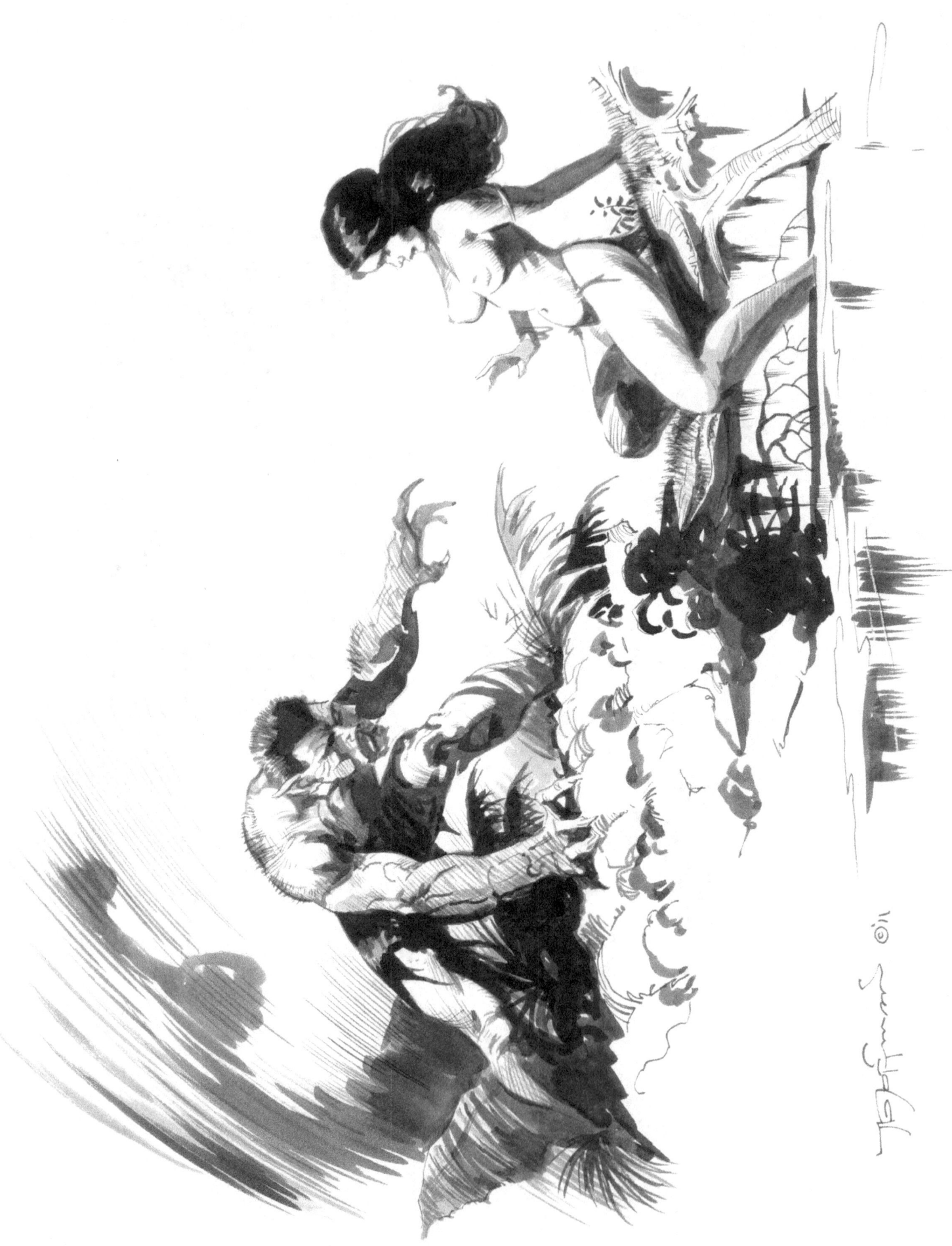

Ten Years After

This old ballpoint pen sketch fell out of a box recently and I liked it enough to add some years' worth of experience to it.

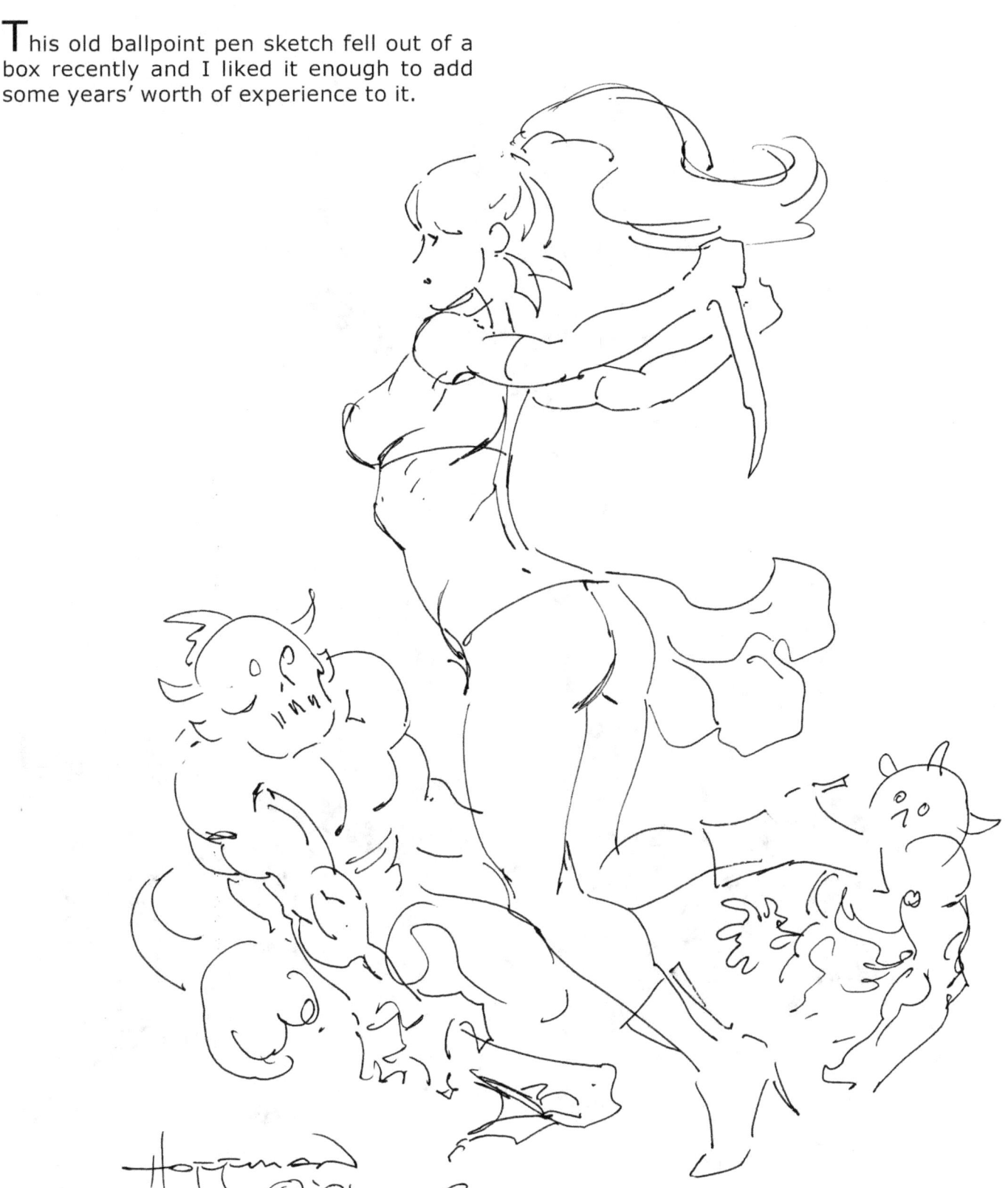

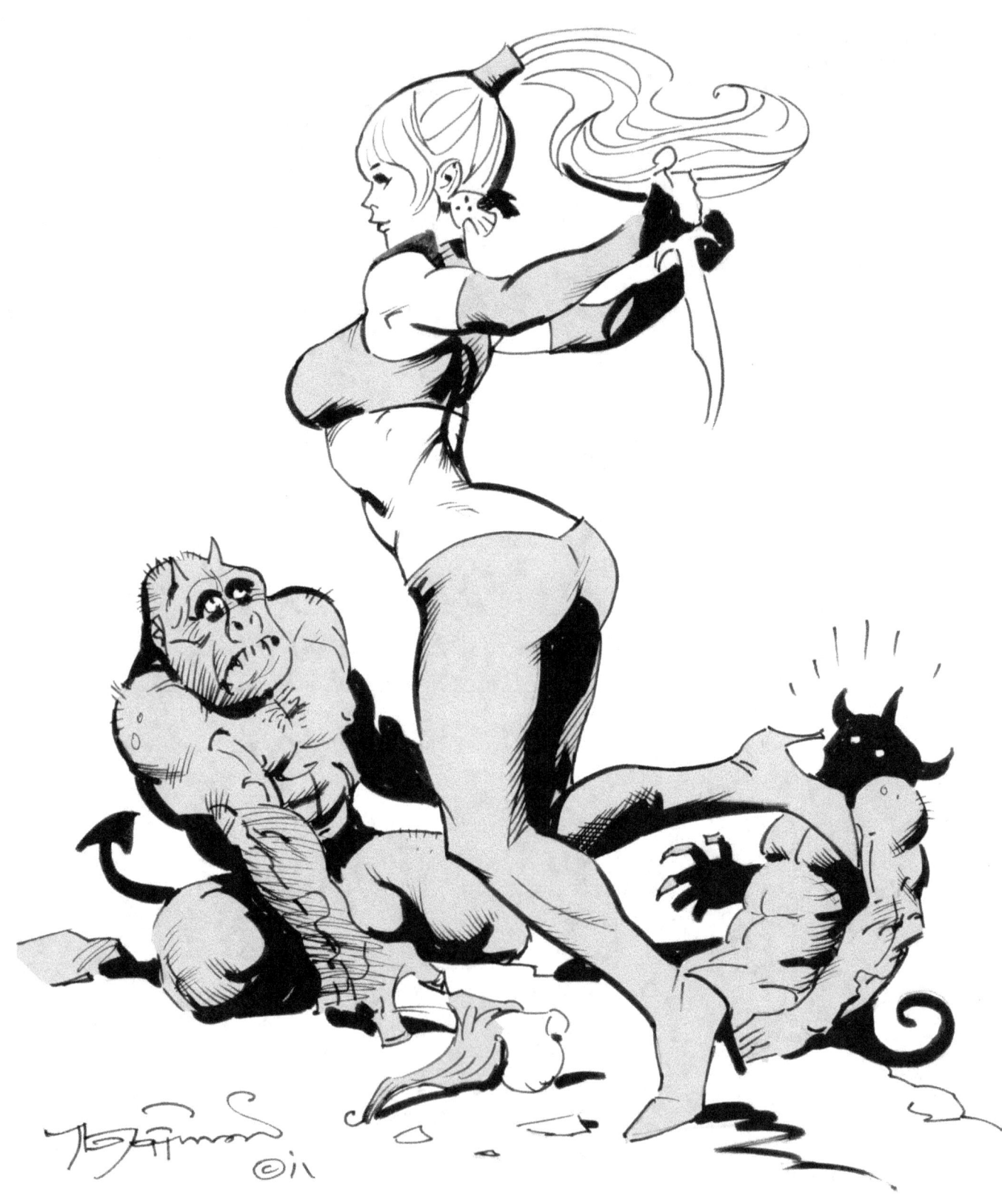

Same thing with this "Squid Girl" pencil drawing.

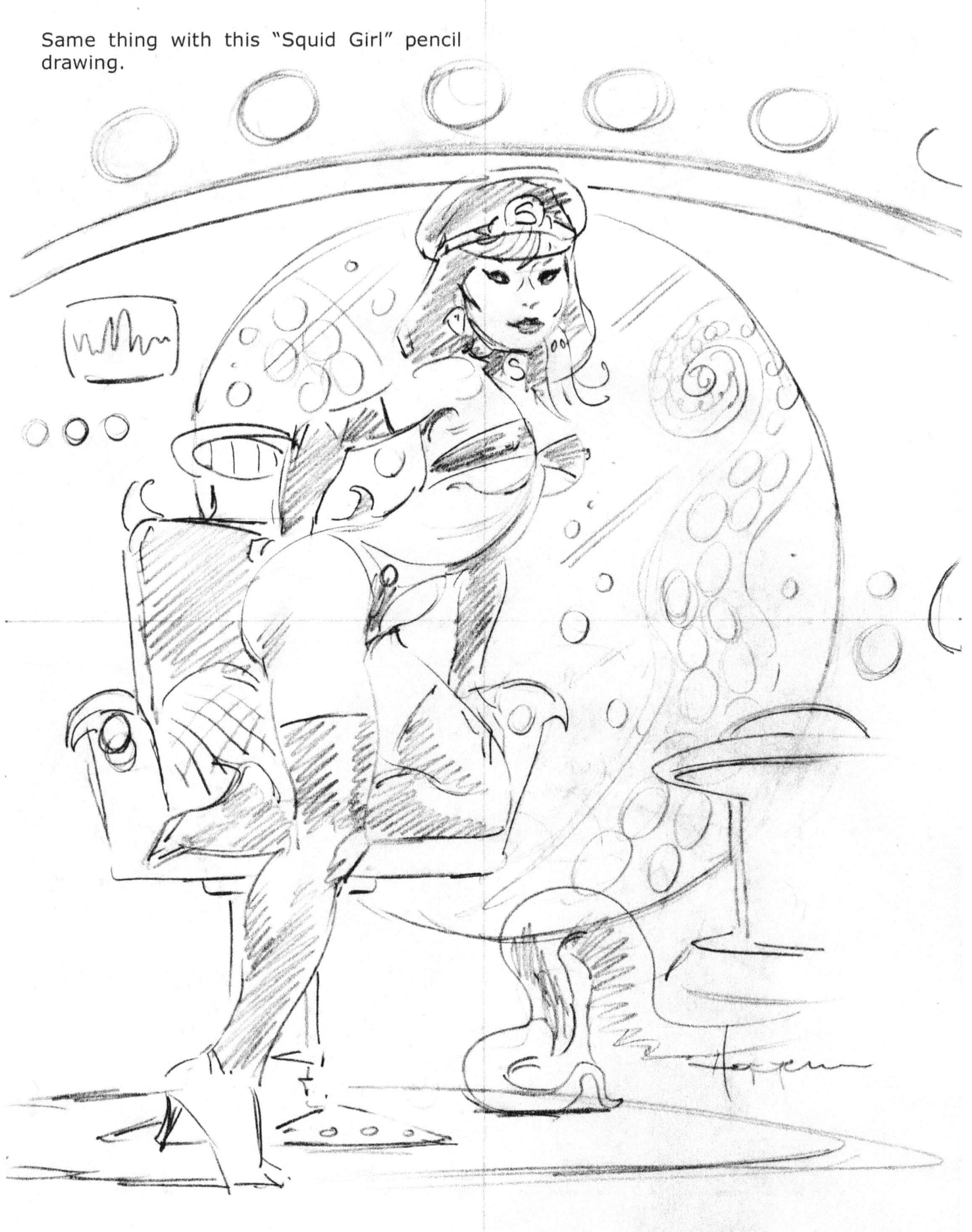

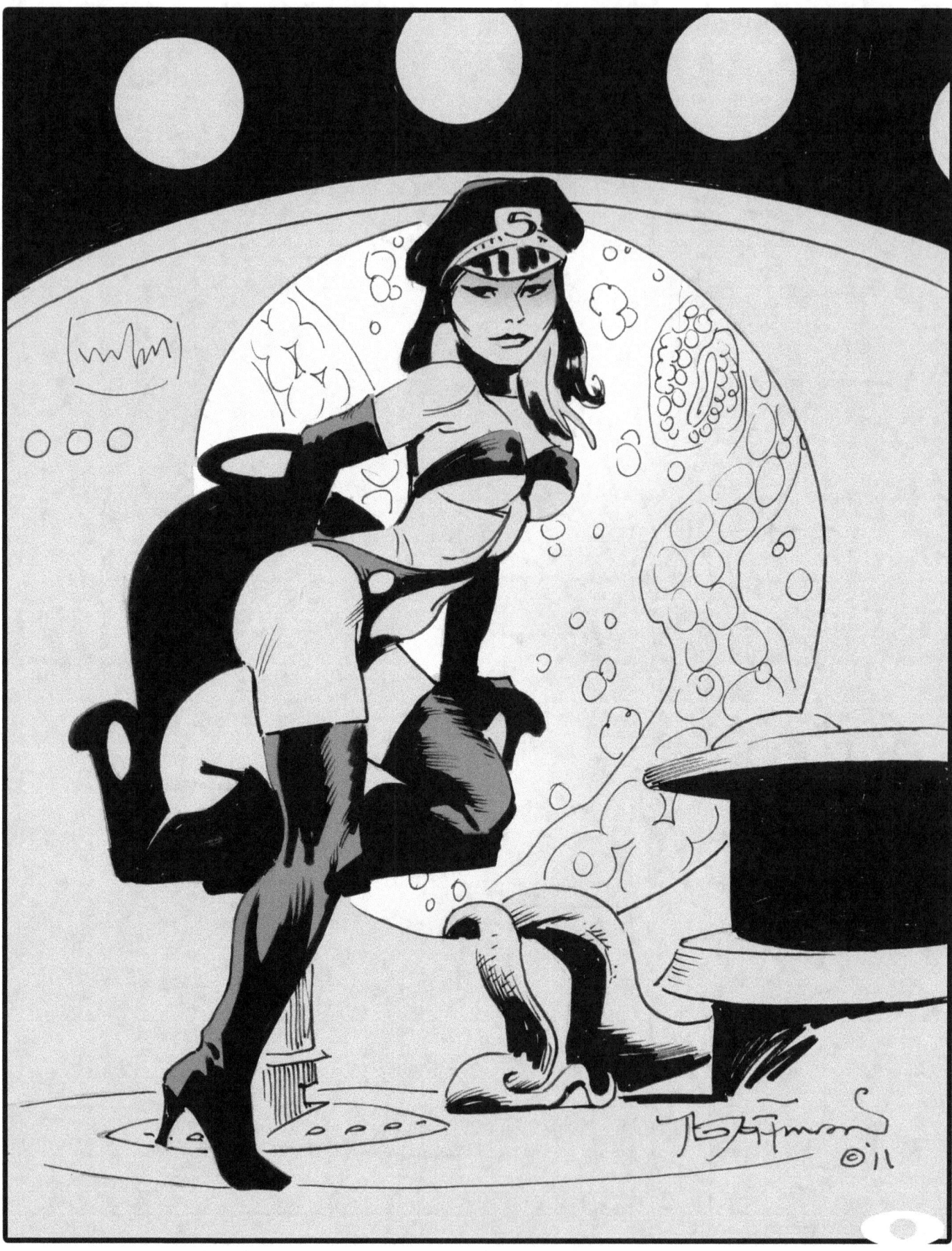

Zach's Back

When my pal Paul Russak asks for some Zacherley art for his *Zacherley at Large* newsletter, he always gets it, no matter what!

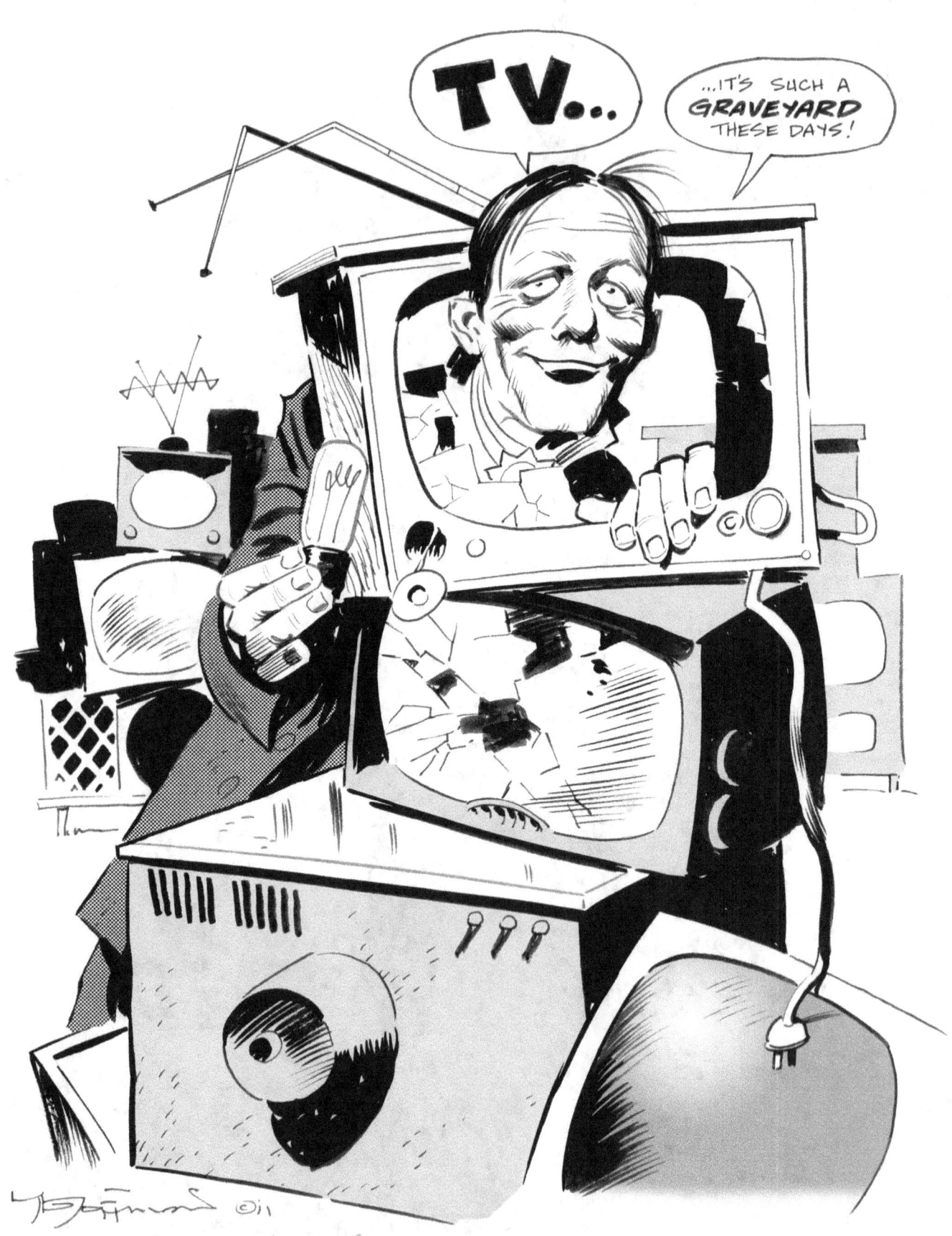

Weird Worlds Remarques

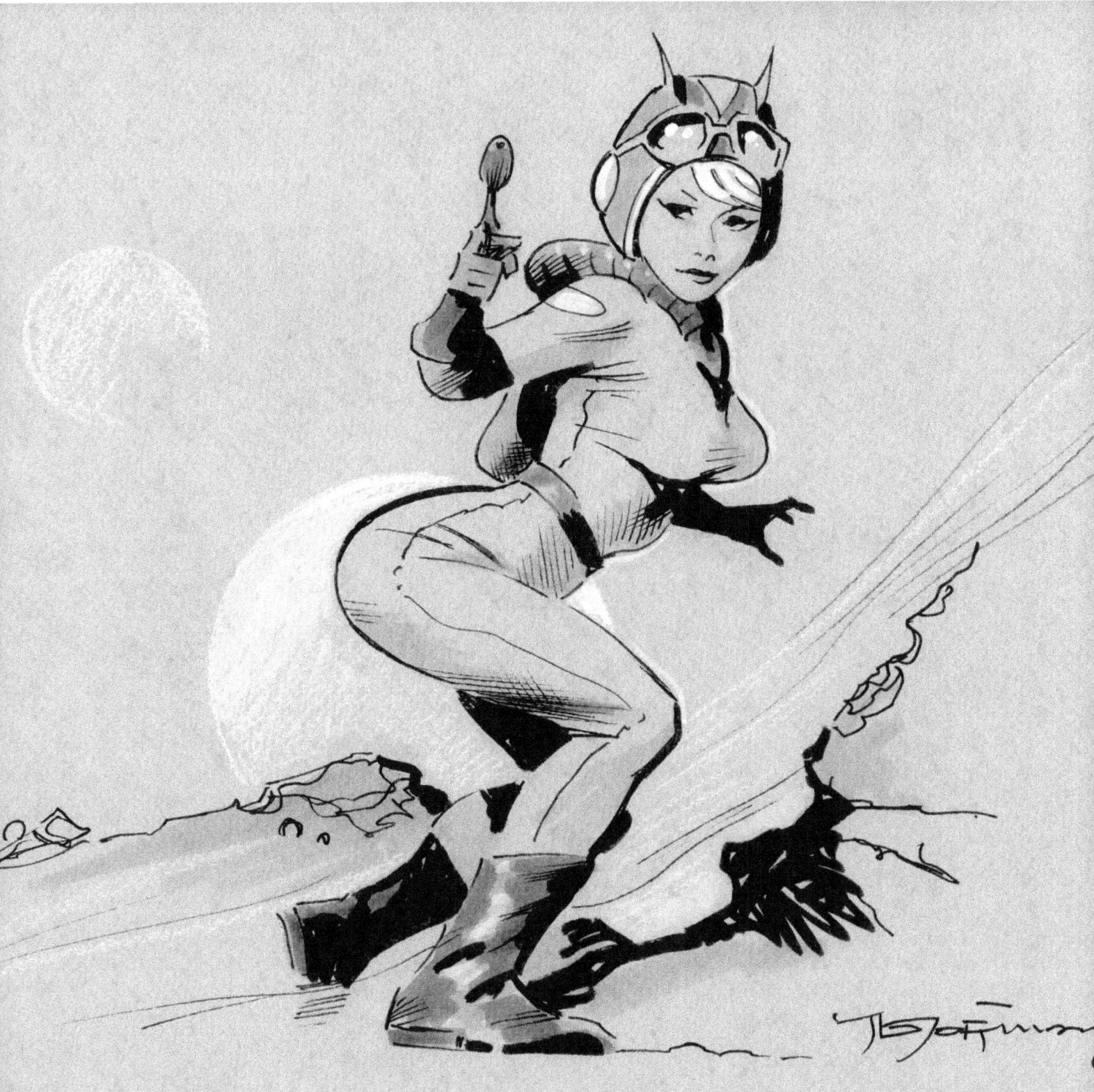

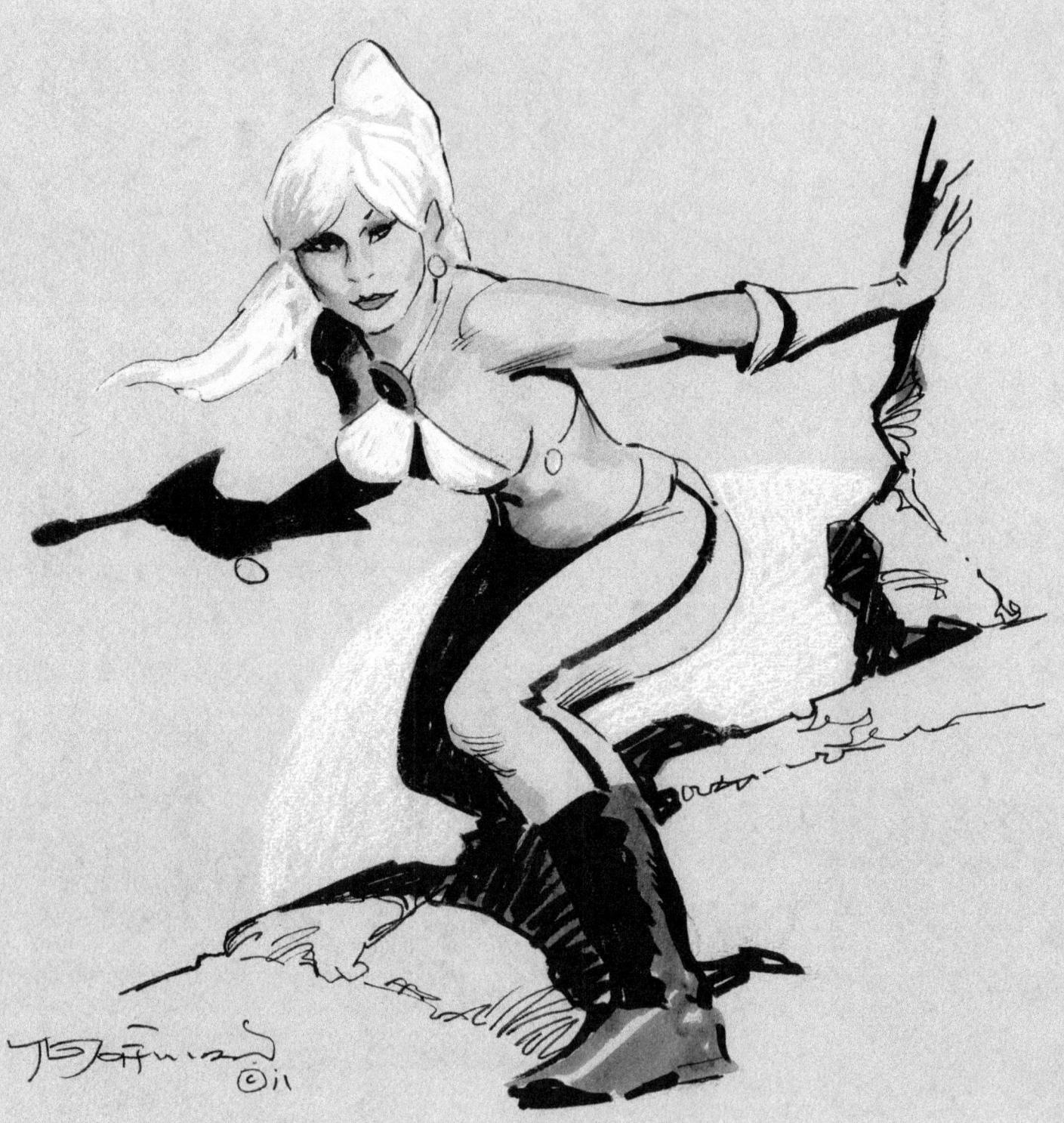

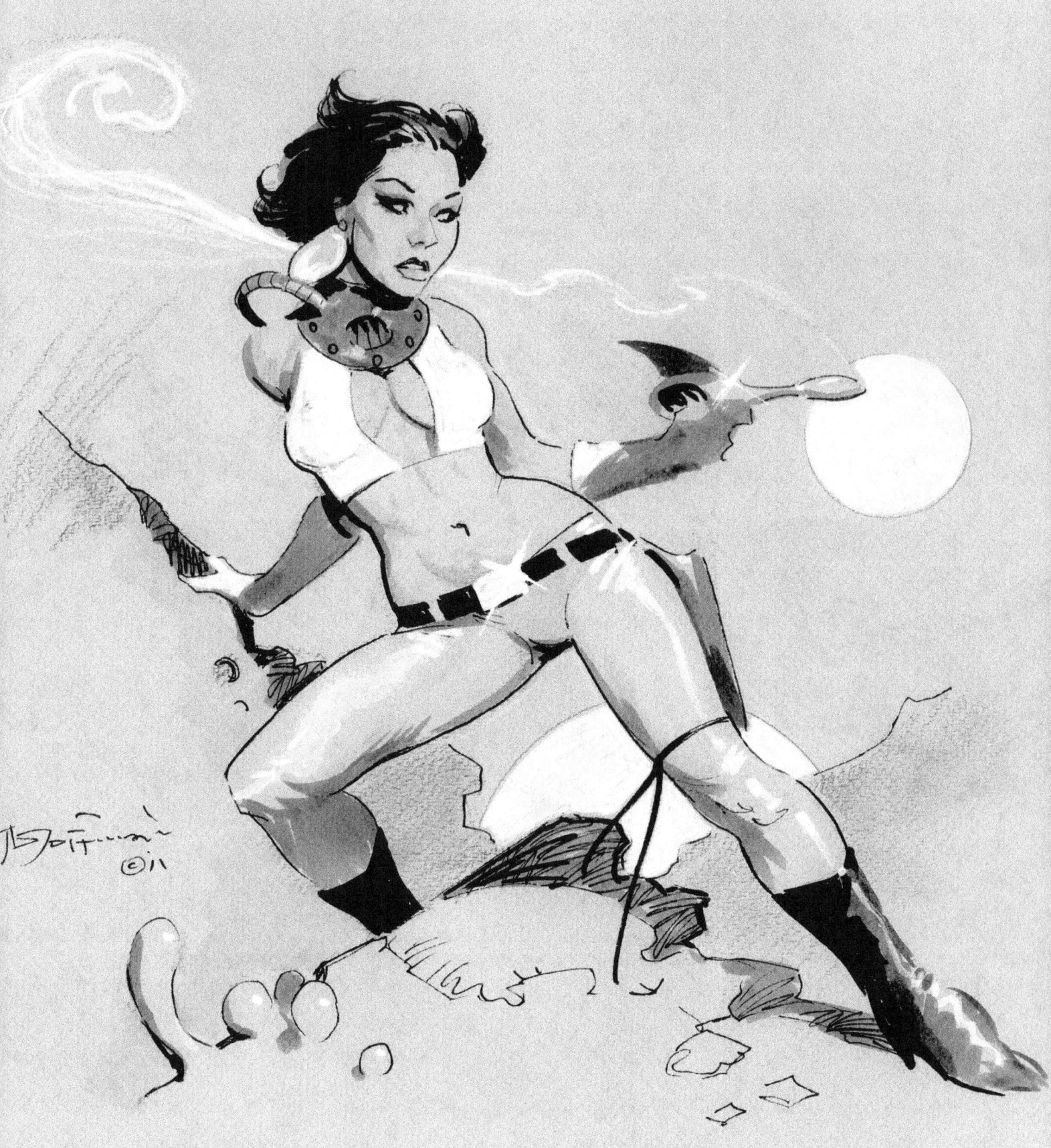

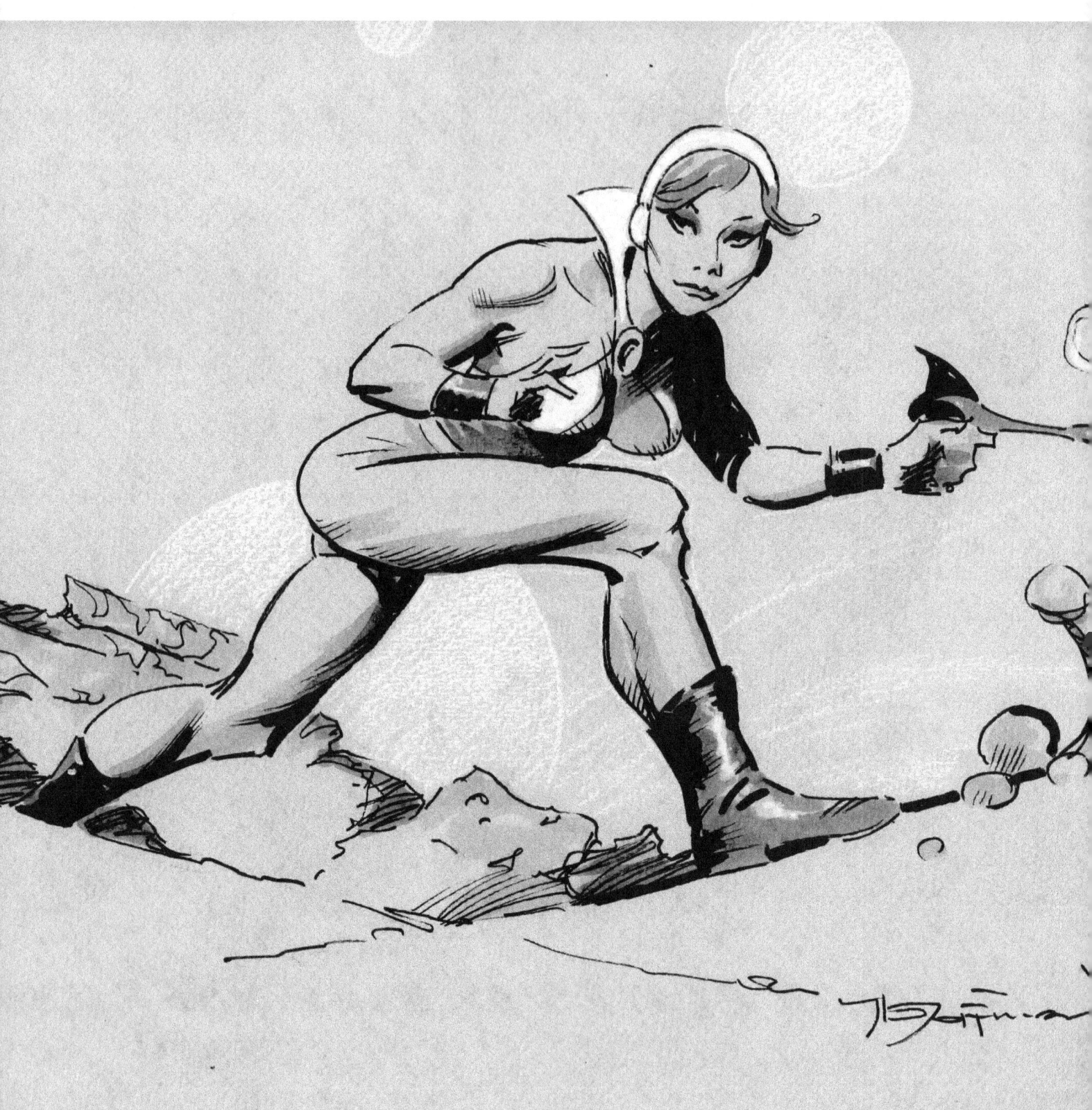

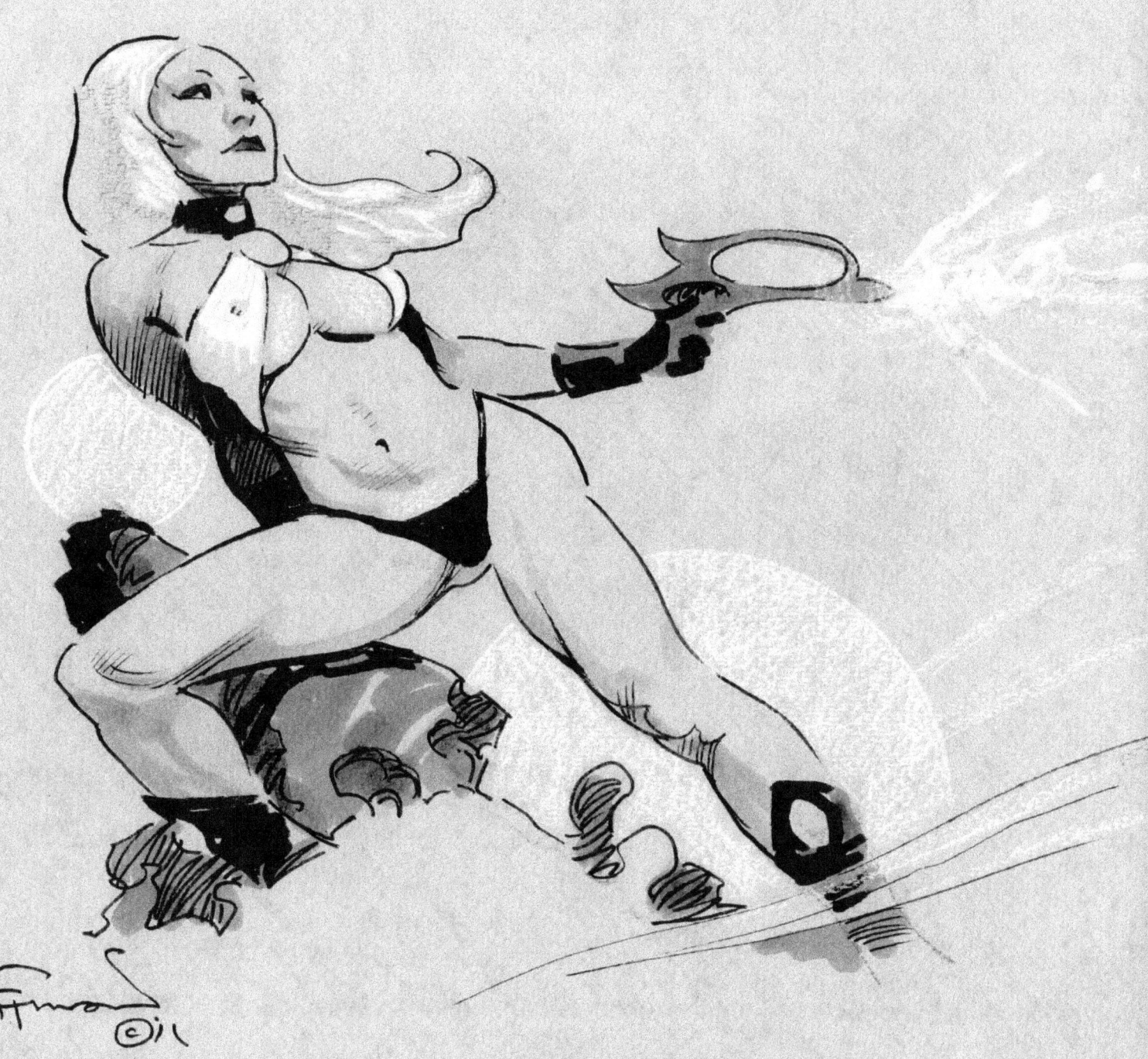

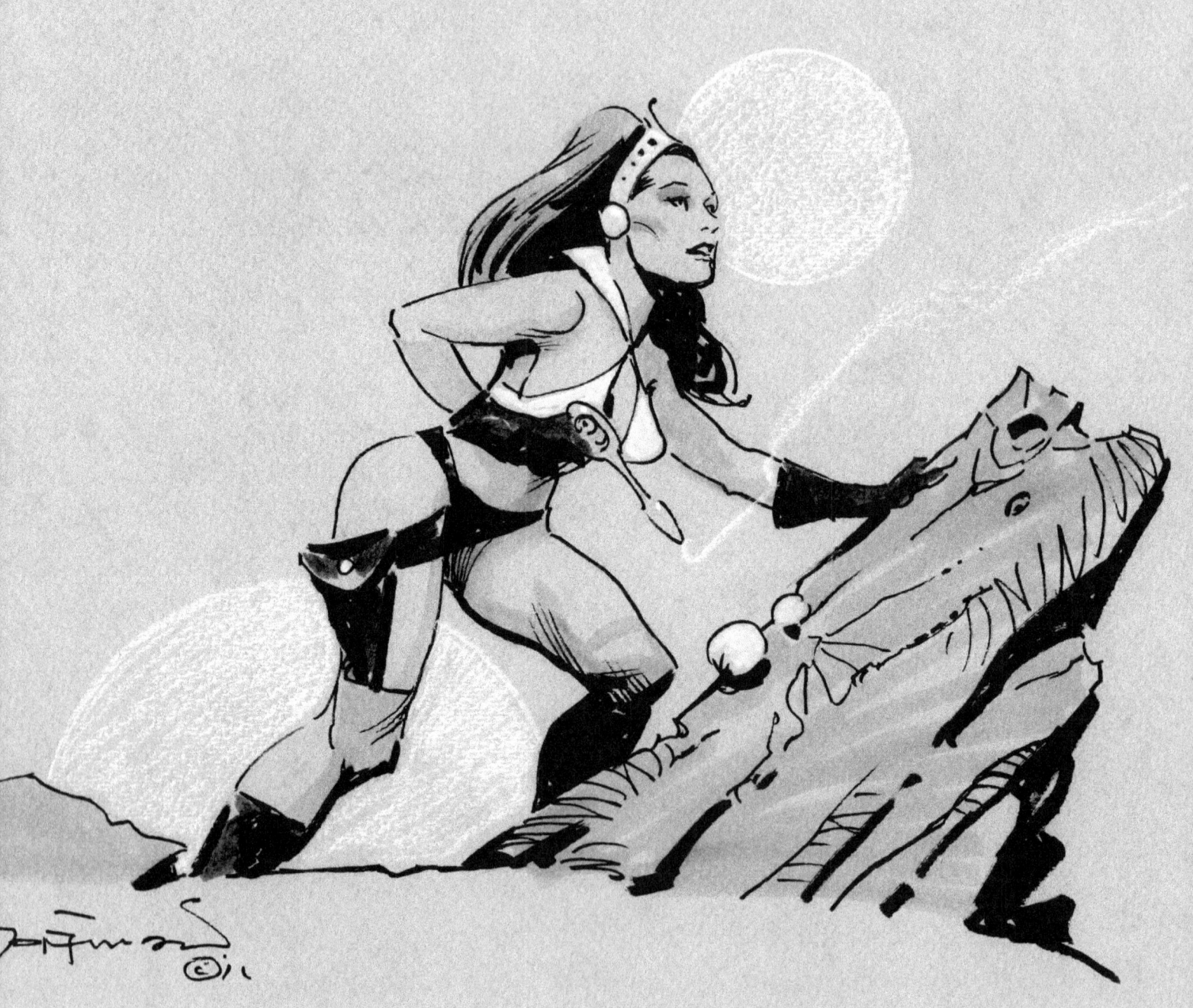

Ink Gallery 4

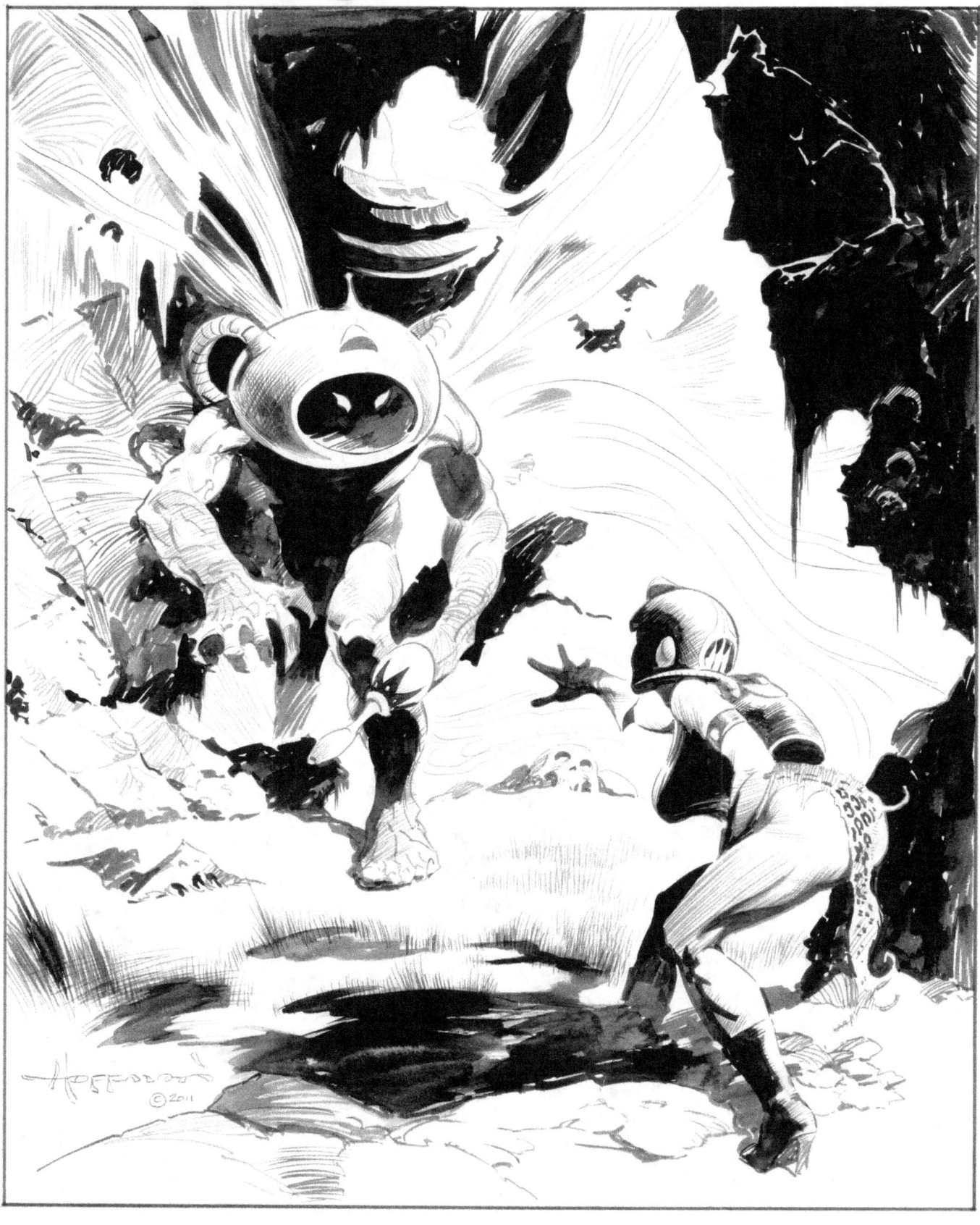

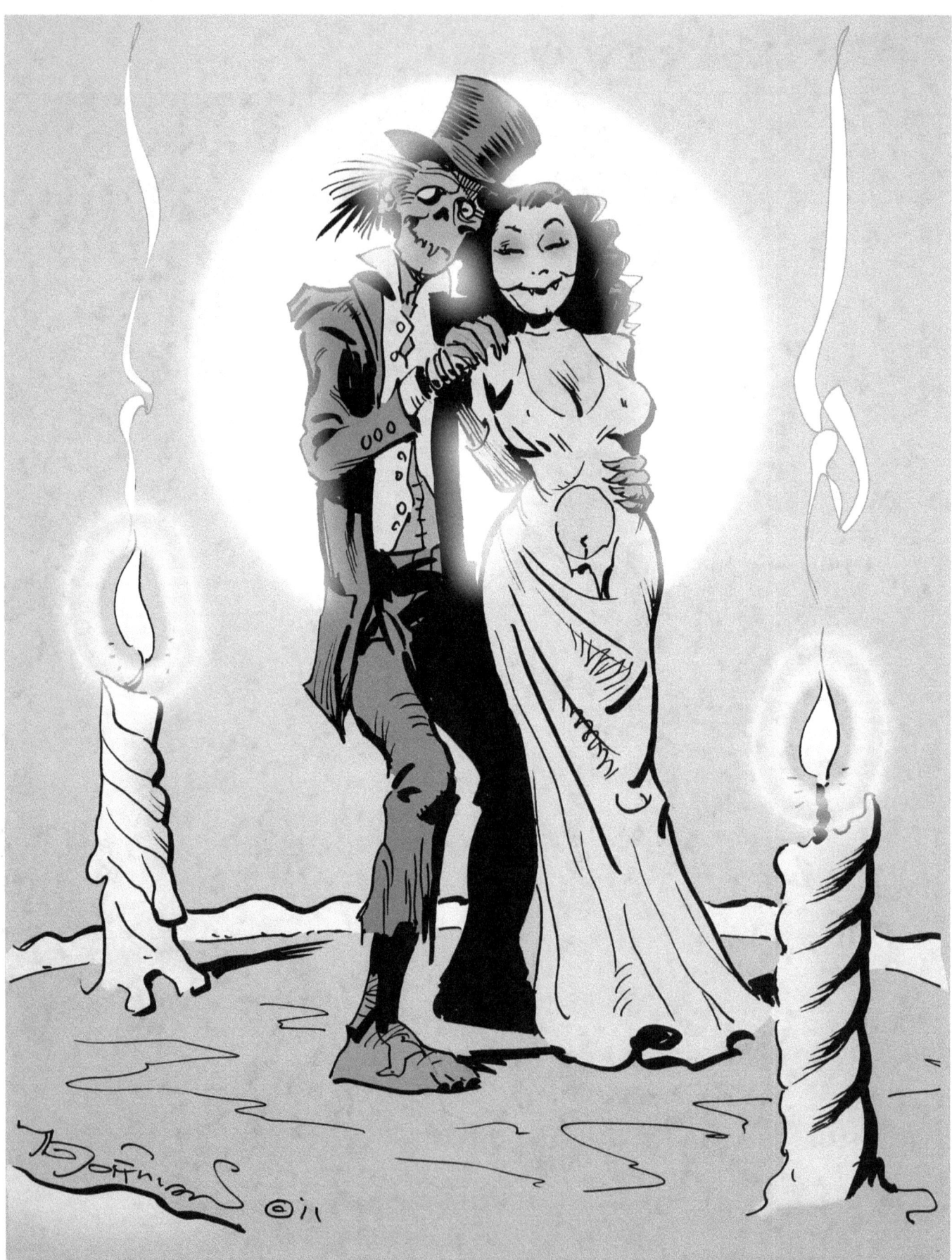

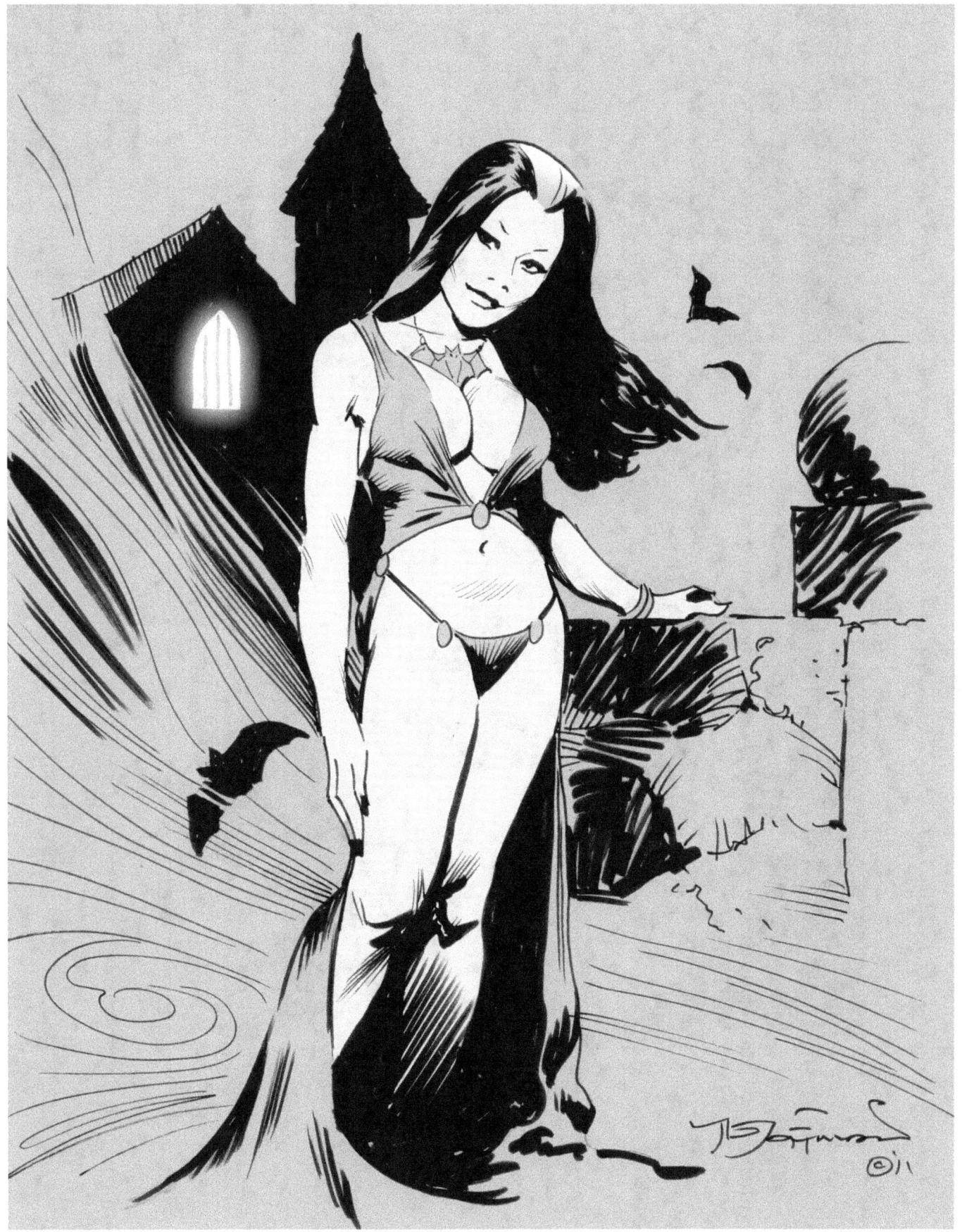

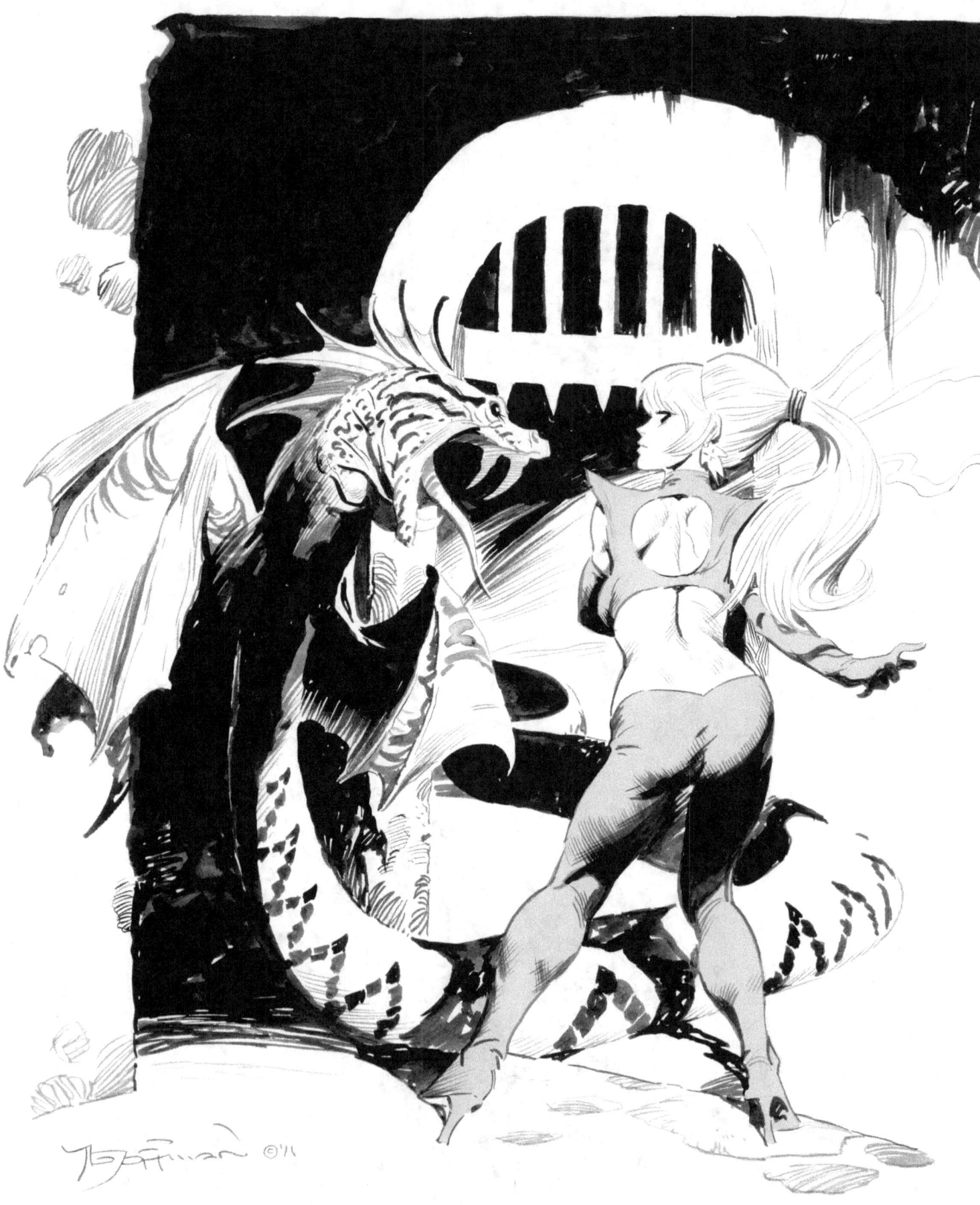

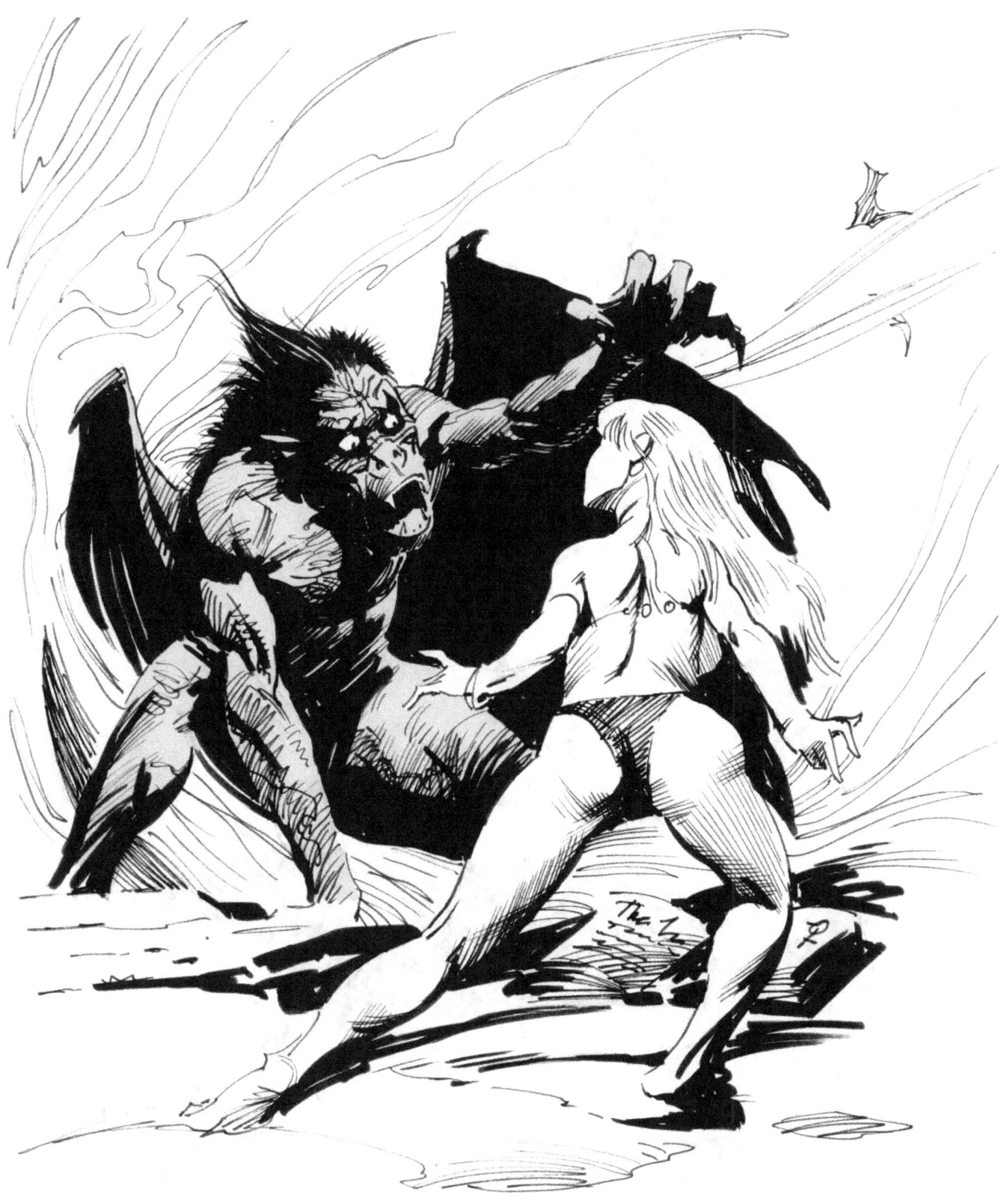

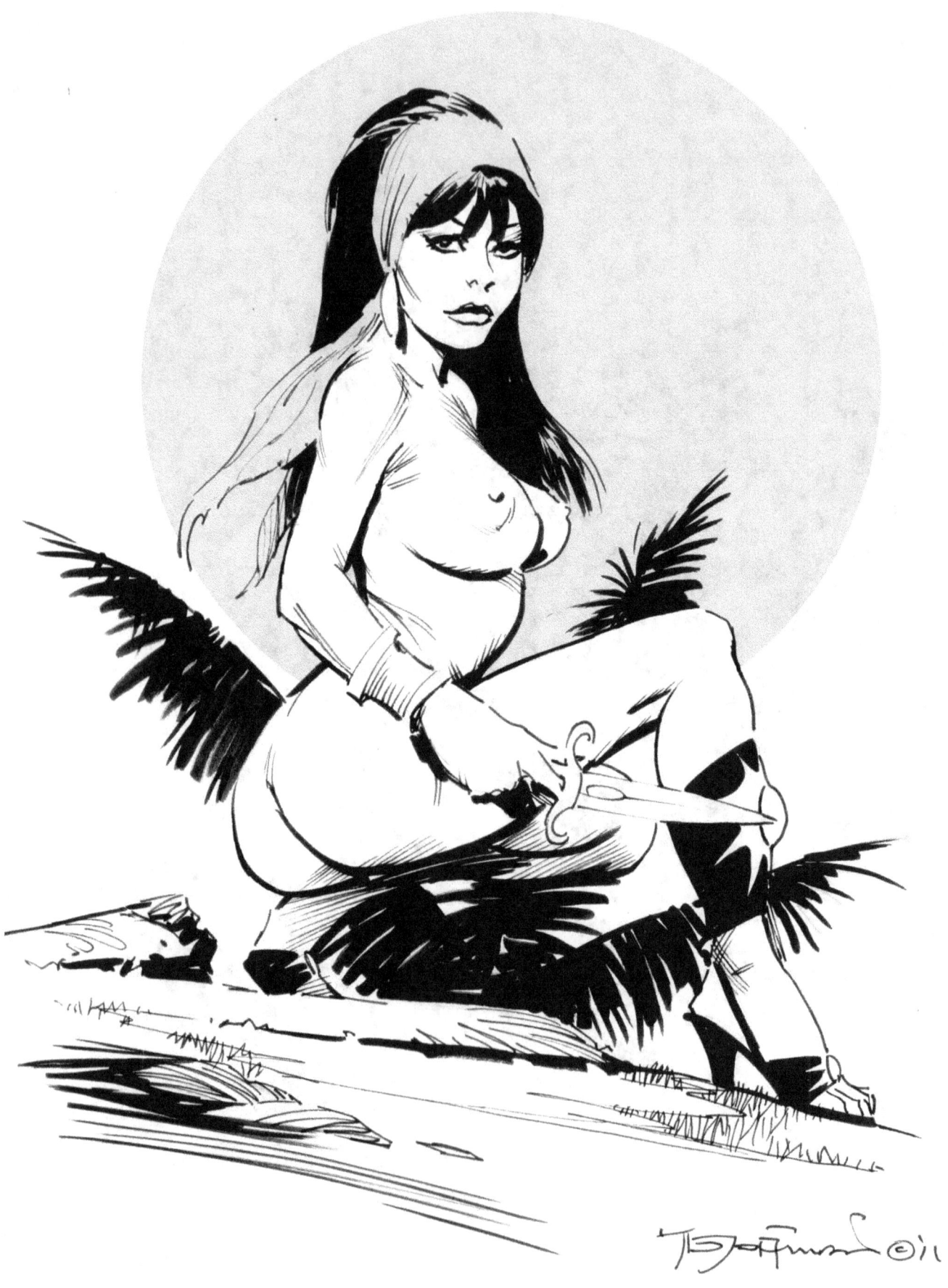

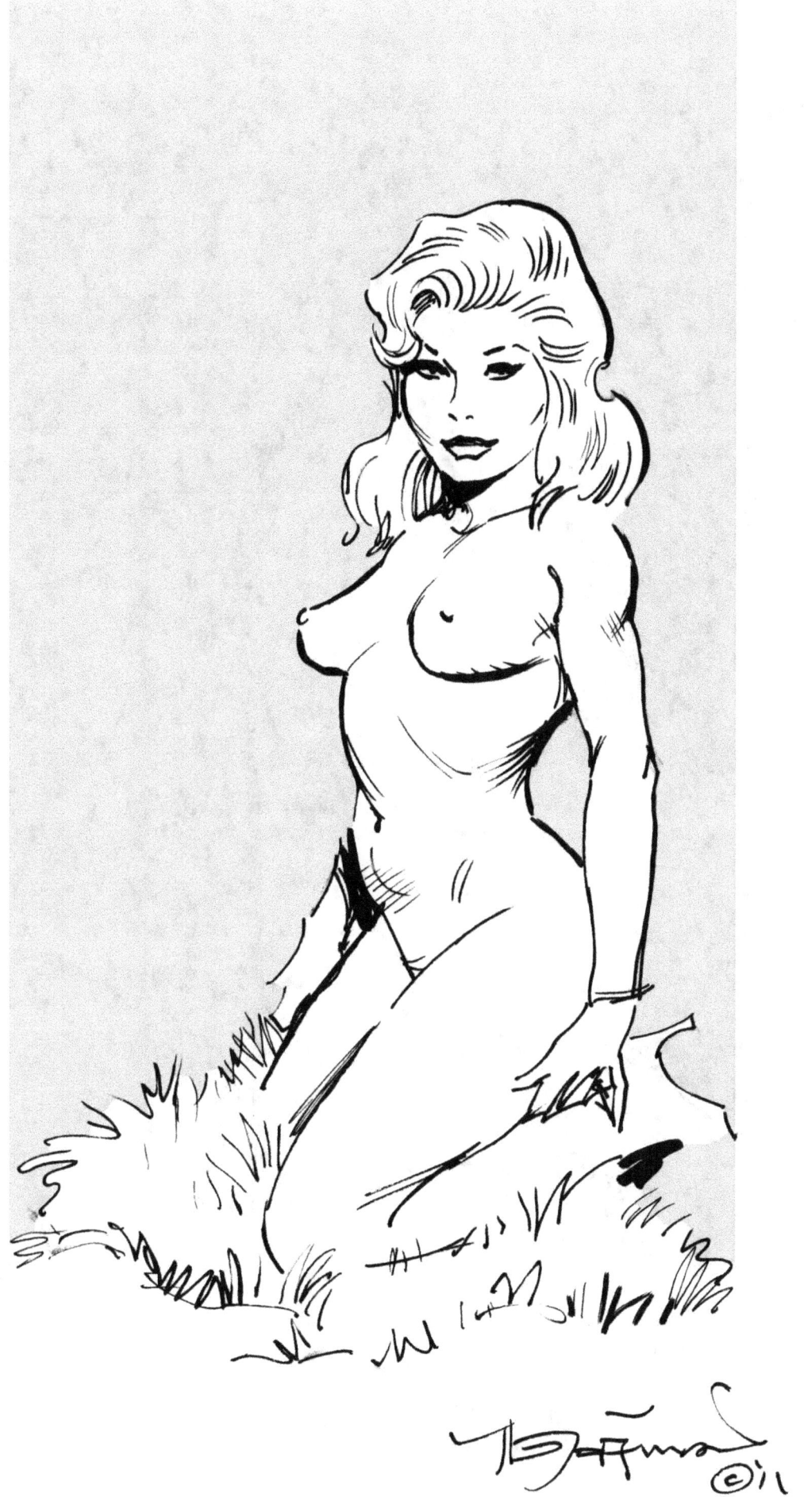

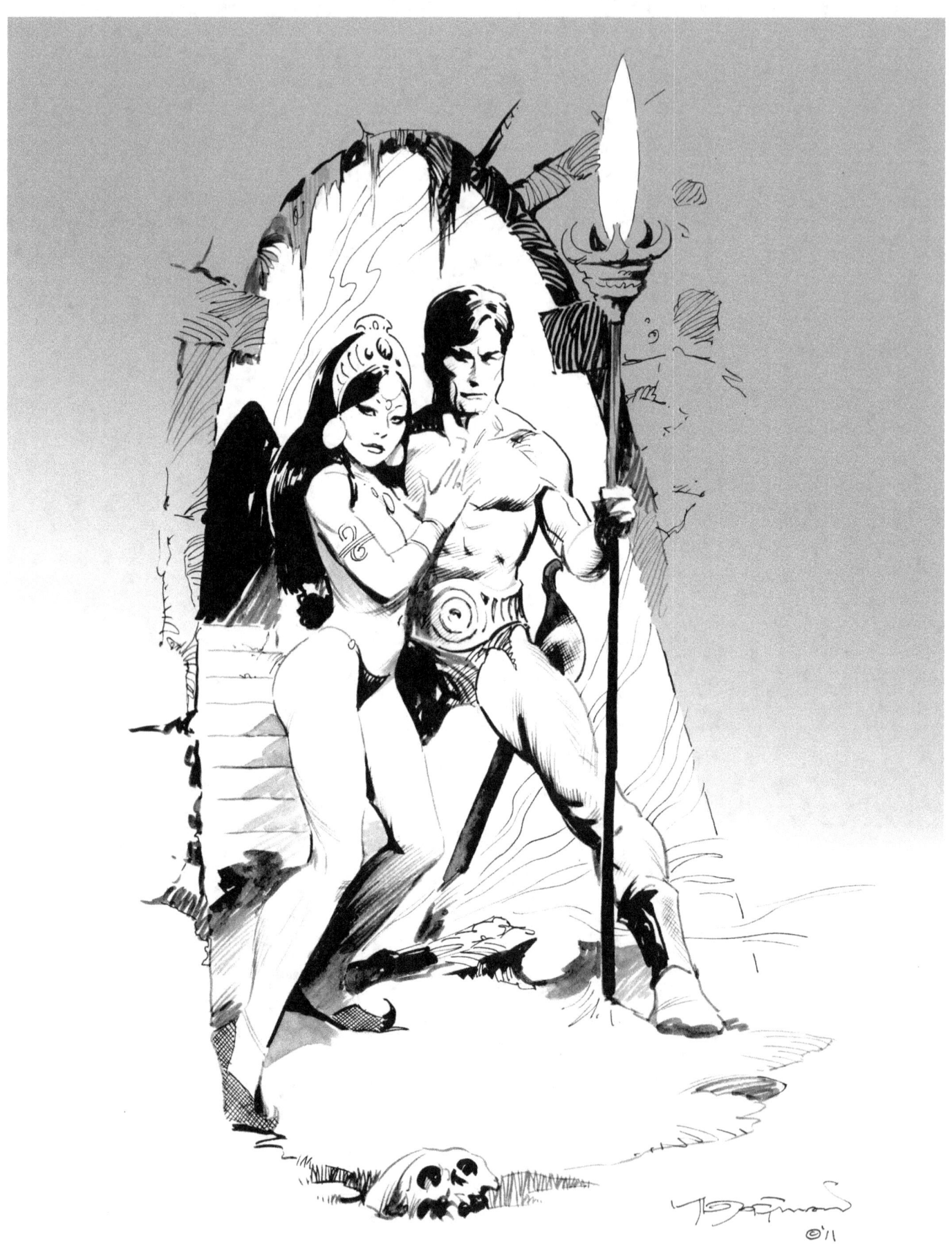

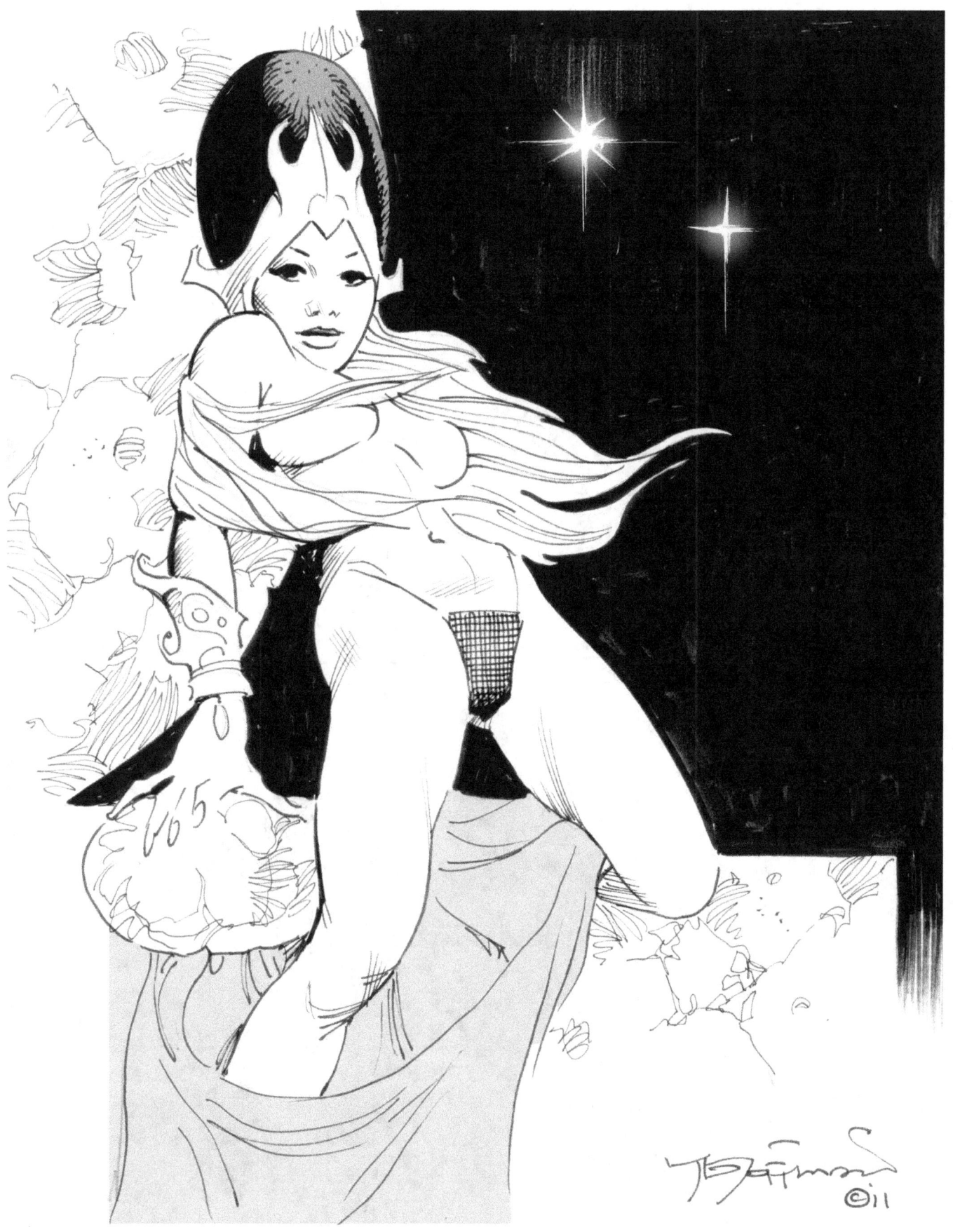

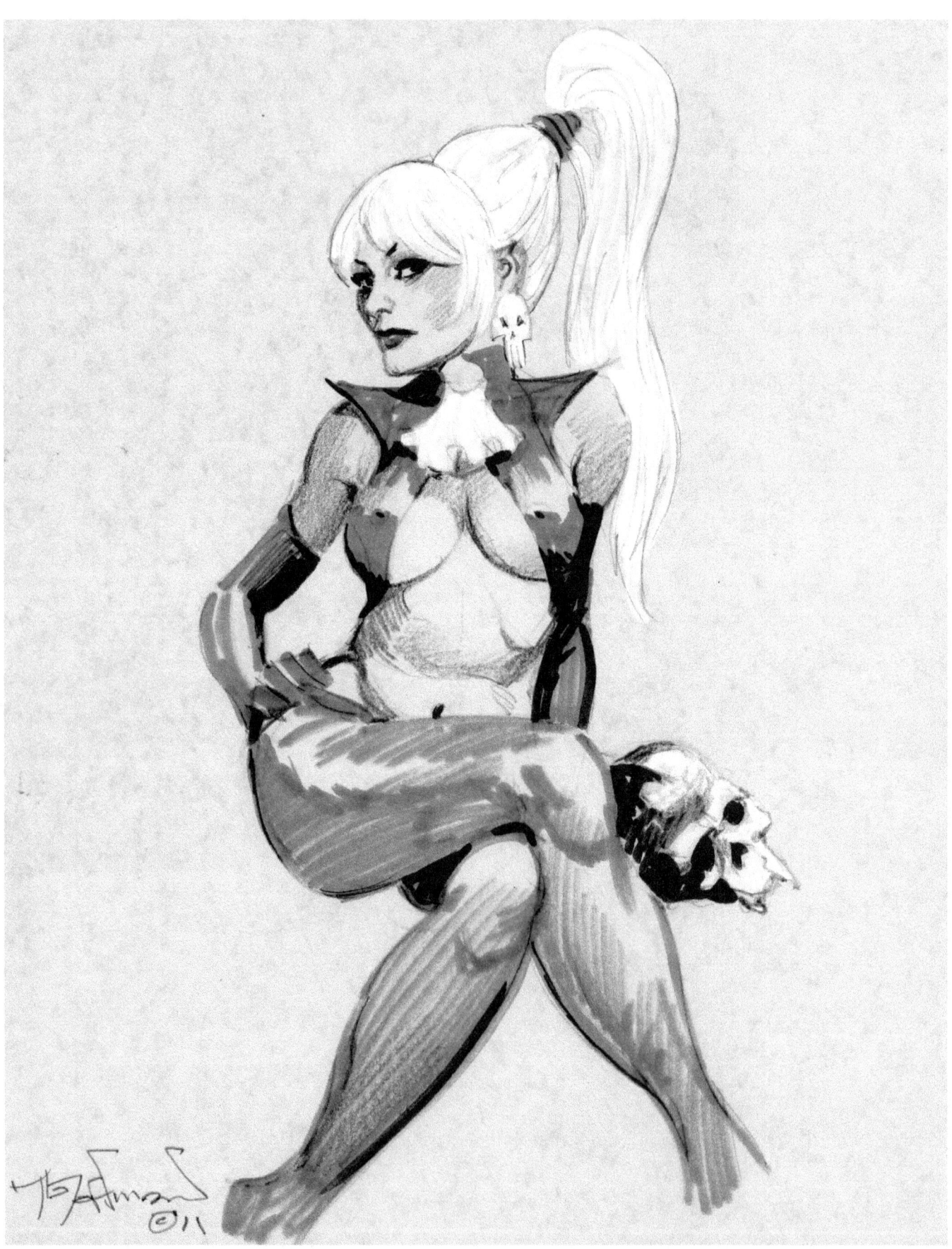

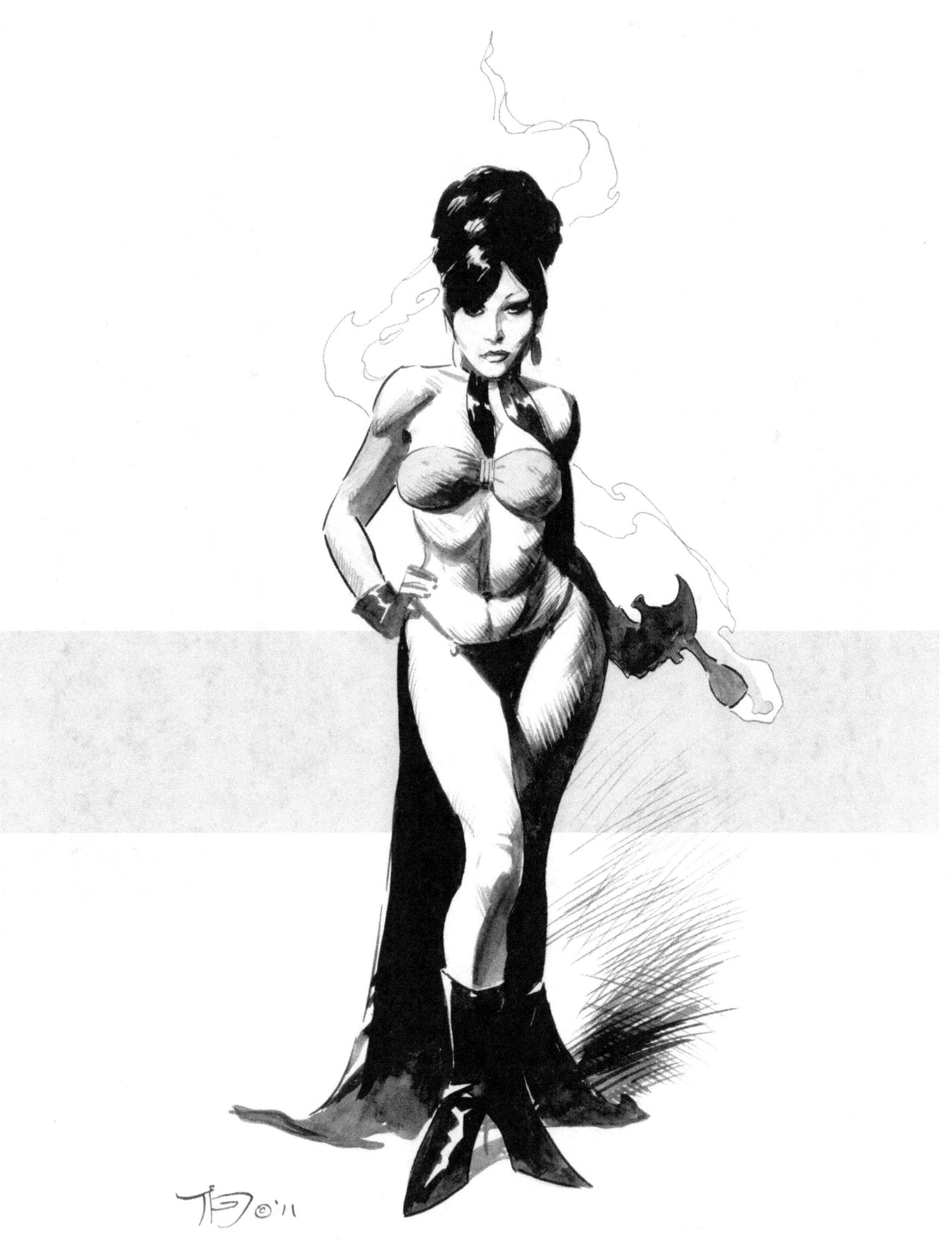

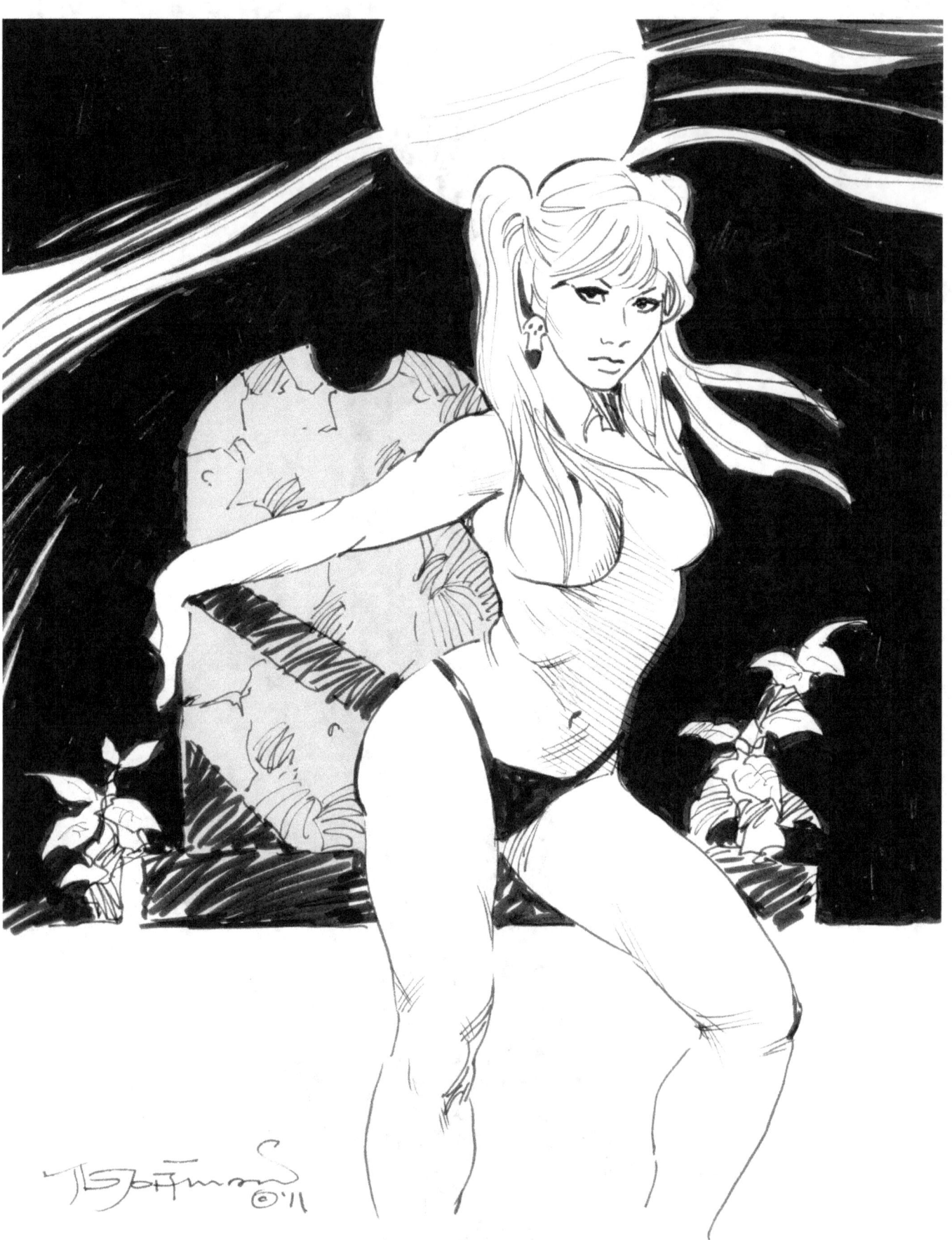

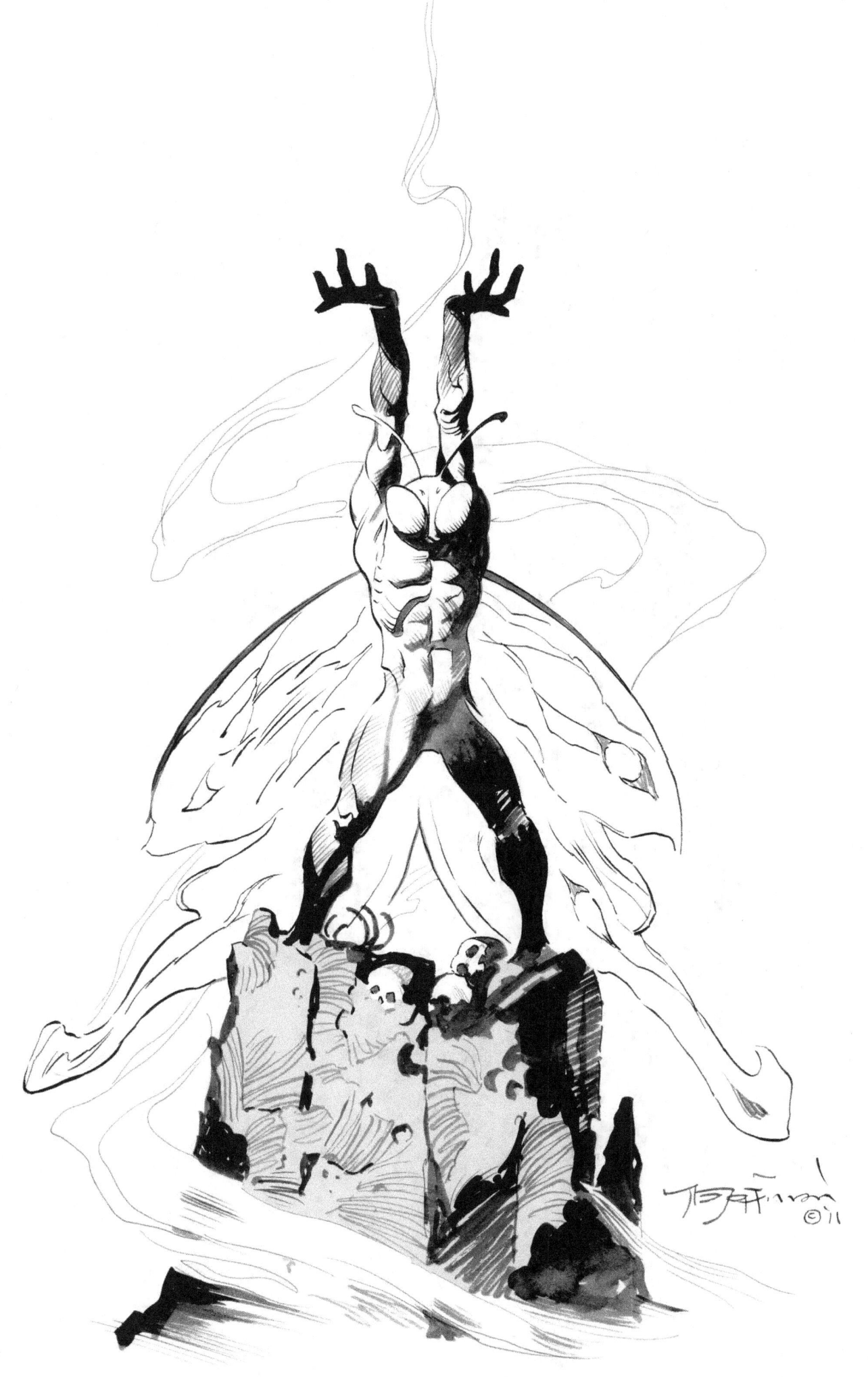

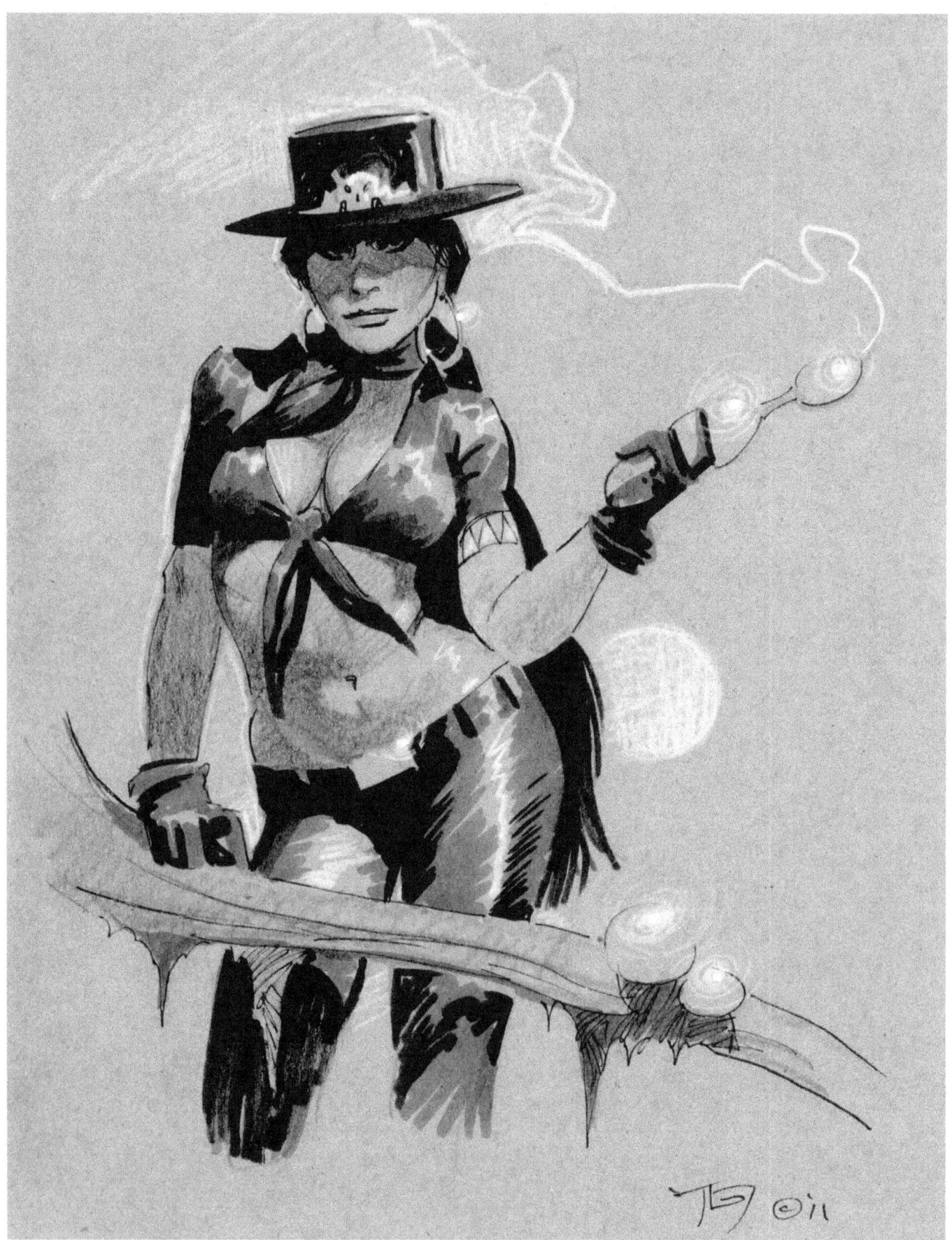

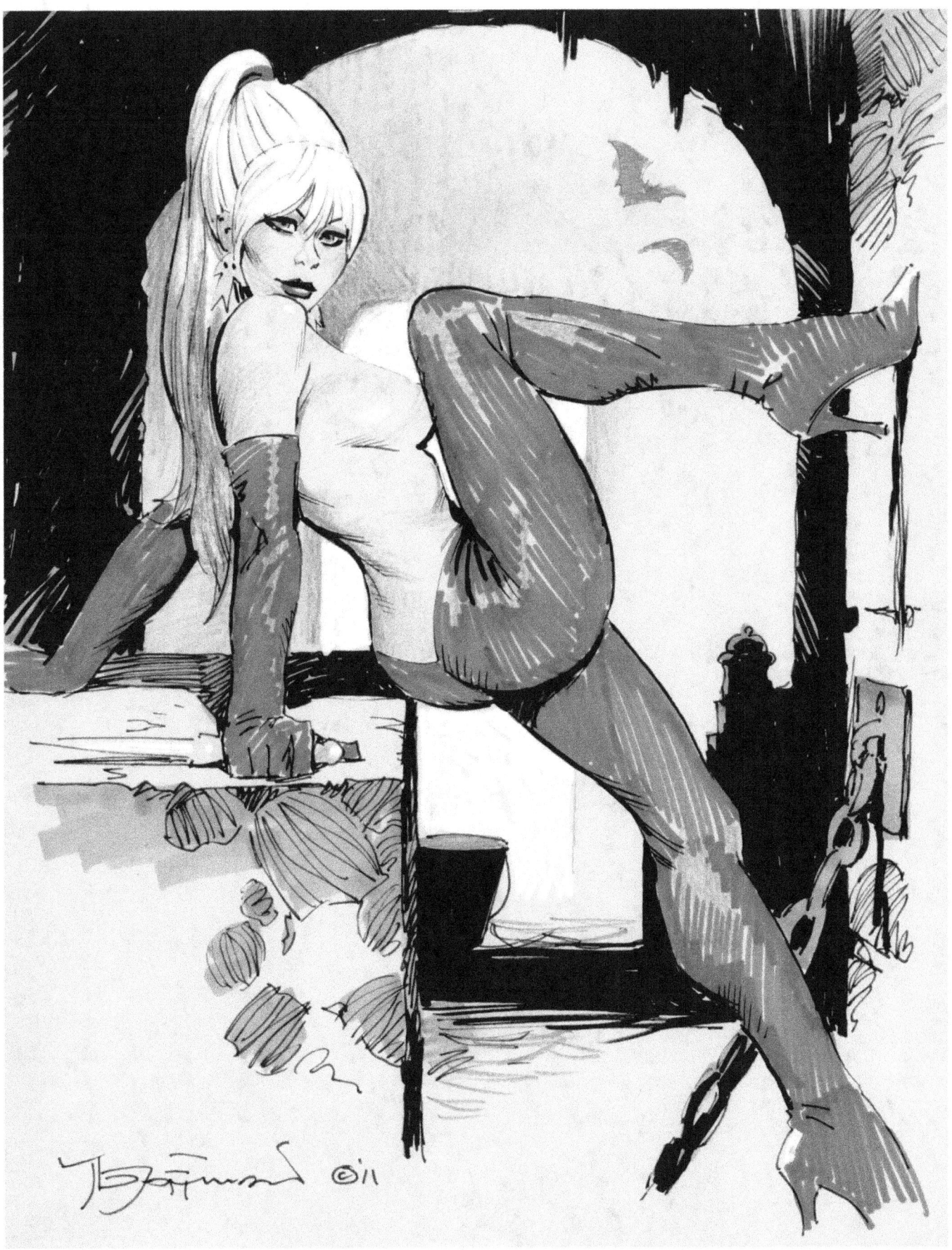

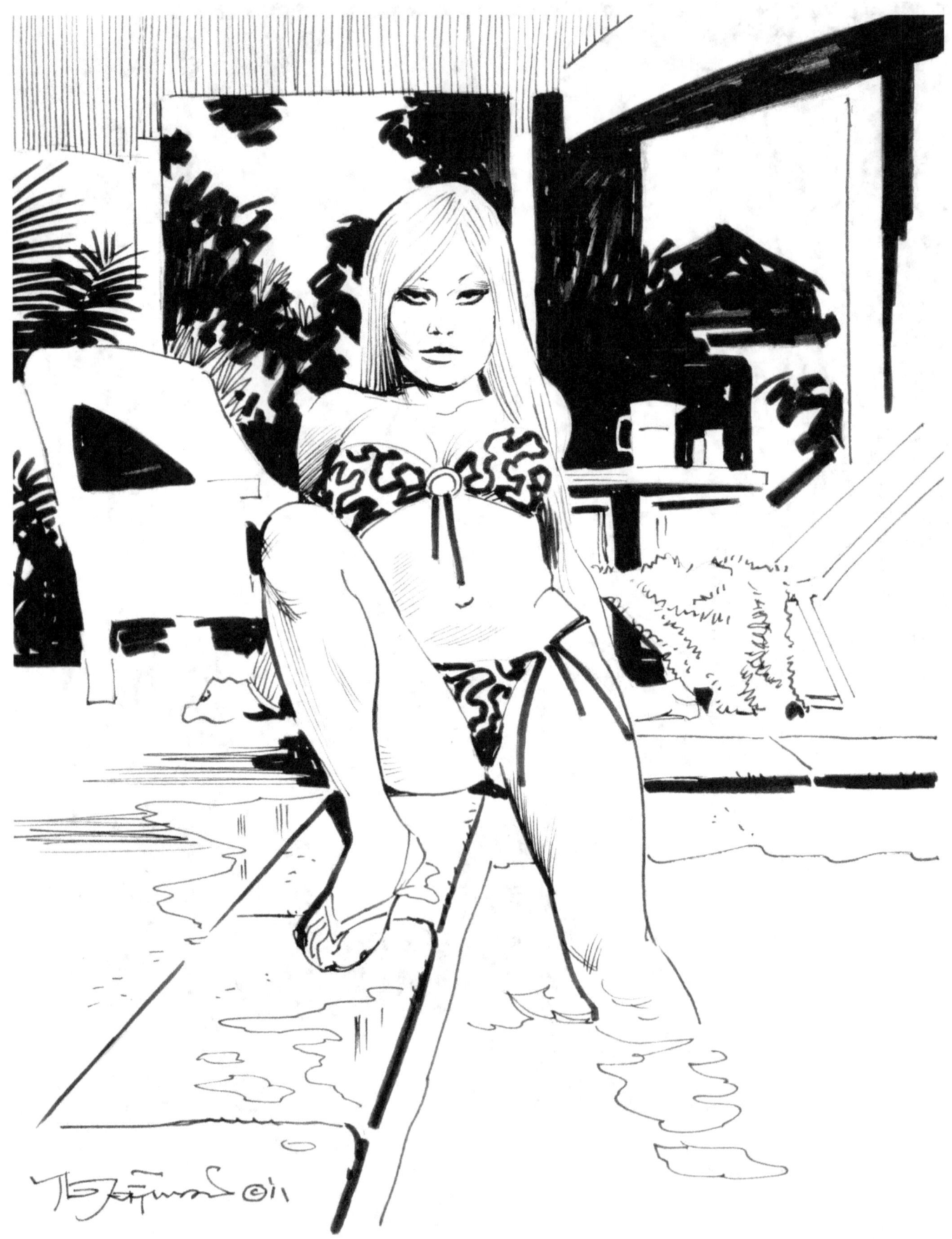

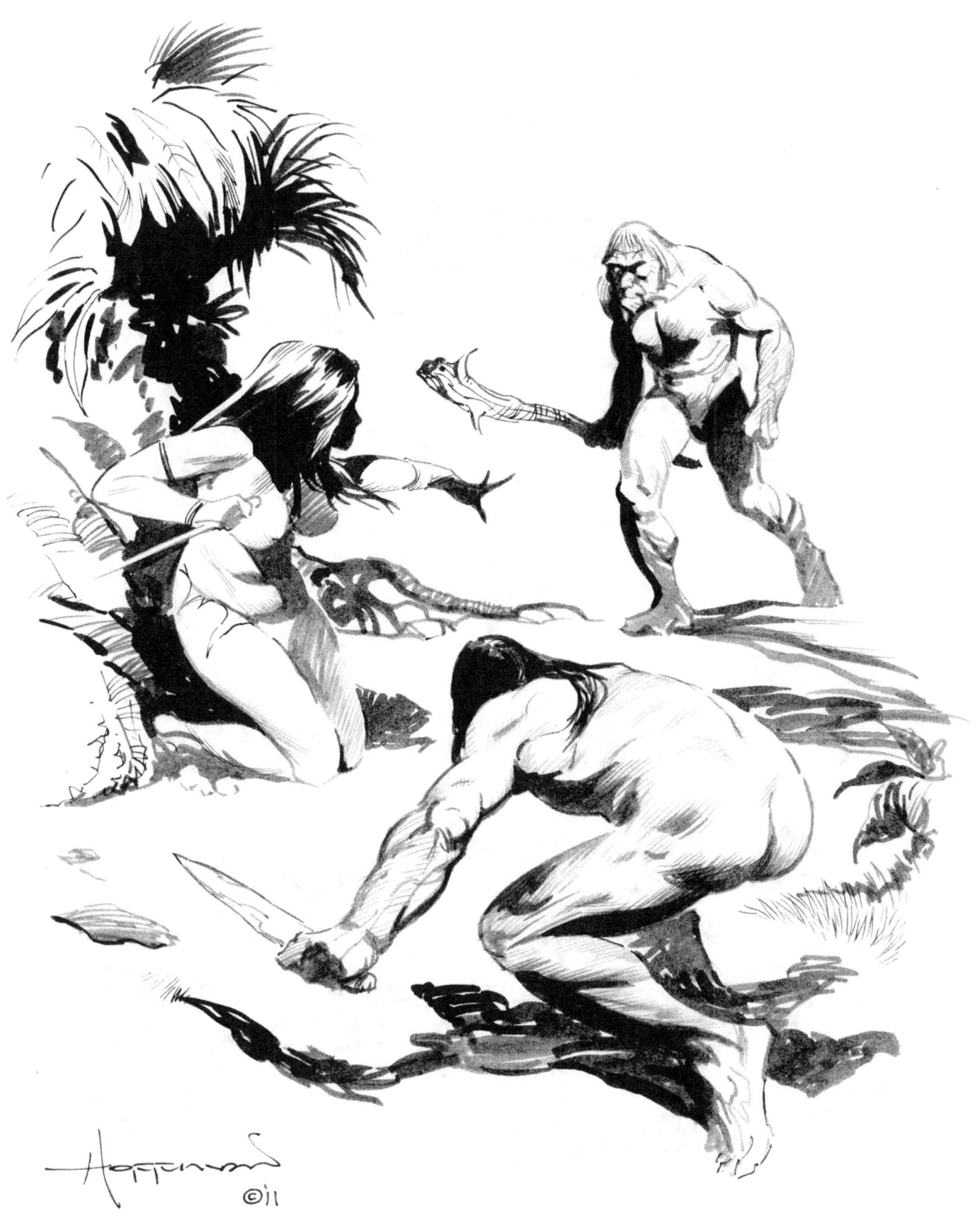

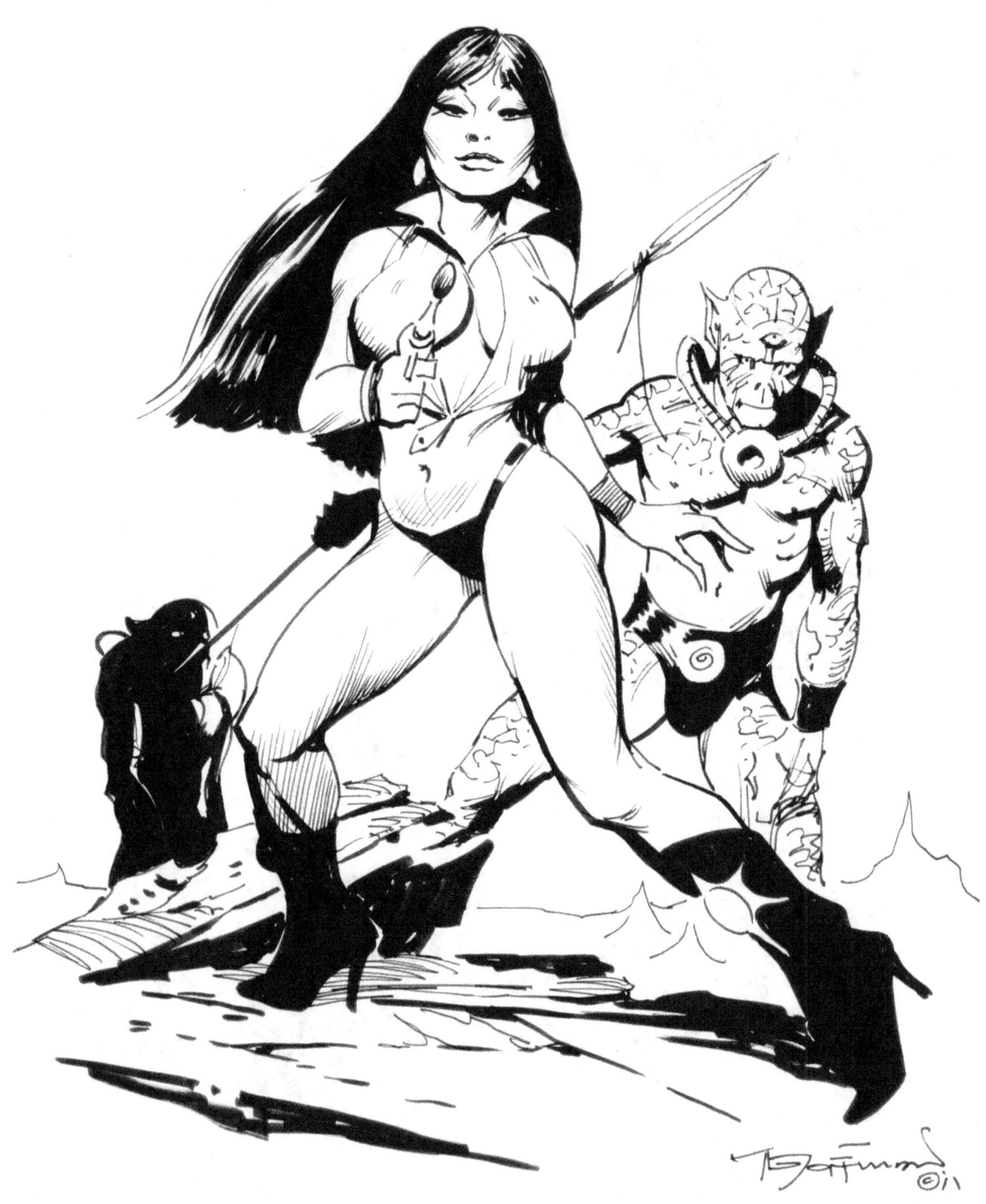

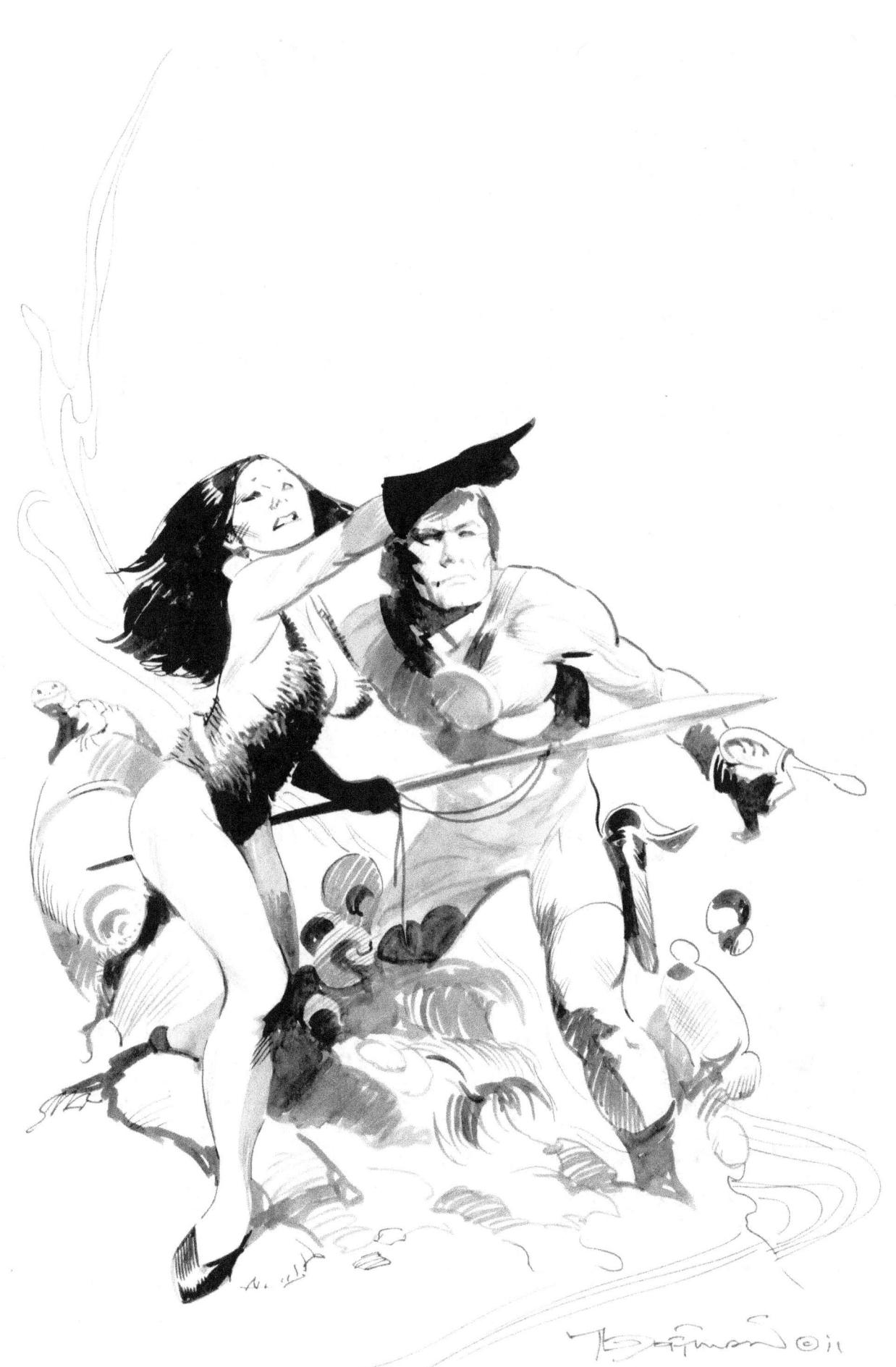

A Conversation Overheard

Another artist wrote to me recently about my *Secrets of Drawing* book, and we struck up a conversation online, which I share some my part with you here.

Dear ------,

I find that because I've been working as an artist for so long now the field has lost my interest somewhat. When I was a kid I loved Comics, but after having been in them forever it's pretty much killed it, also seeing what's happened to "the Industry" in recent years.

I get interested in some artists, but it's still technically "work related", and for my health and sanity I am trying to get away from work. I'm 53 and have already done 100 years worth of work.

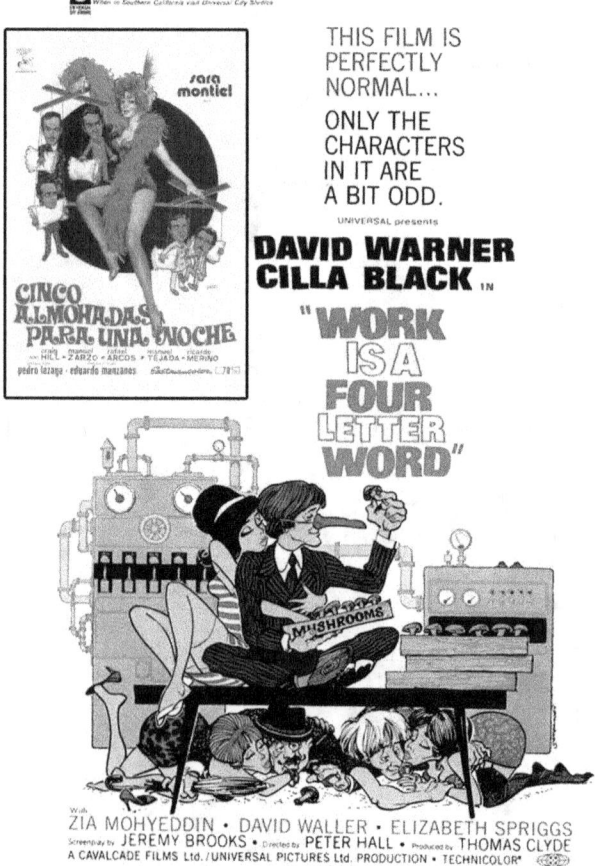

Lately I've bought some older movie posters for the art, one's by Bruce Steffenhagen, who used to draw for CARtoons magazine in the 1960s. This other one "Cinco Almohadas" is hanging in our bedroom now. I'd like to design large posters like these but can't find cheap enough printers to manufacture them.

I think what happens with conscientious training is that you tend to aim for perfection, but then you're forced to accept less. And, it's mainly about failure, ongoing failure, until mastery is achieved, if ever, and that failure is not good for morale or the pocketbook. So, most folks today just settle for a more modest toolbox of easier, more convenient styles. Like a kid with a guitar who wants to play right away.

Probably the best instructional Drawing book I think is Walt Reed's, it seems the most efficiently presented to me. Some can lead you around in circles forever--like Vilppu, who has people "sketching" at the same level for years and years. I have told pupils of his that endless "sketching" and "studies" should not be the goal.

I used Gregg Kreutz' "Problem Solving for Oil Painters" to iron out my final questions about painting, but now I find that same almost identiical info is coming out now from various people, all of whom seem to know each other. But, is "checklist" was invaluable to me.

Ultimately, I think artists of any kind are entertainers, and that's the ultimate goal and the measure of success. You can learn to paint sweat on a grape, but that's only the chrysalis stage. What comes next? Where will you take the audience and what will you show them?

M

Flooded Basement

An unfinished drawing that described as well as anything else where I was artistically and personally in the 1990s. Little did I know it woulod come to pass after moving to Milwaukee, where this drawing itself almost got the water-log treatment. Lens flare compliments of modern technological advancements.

Pencil Pushings

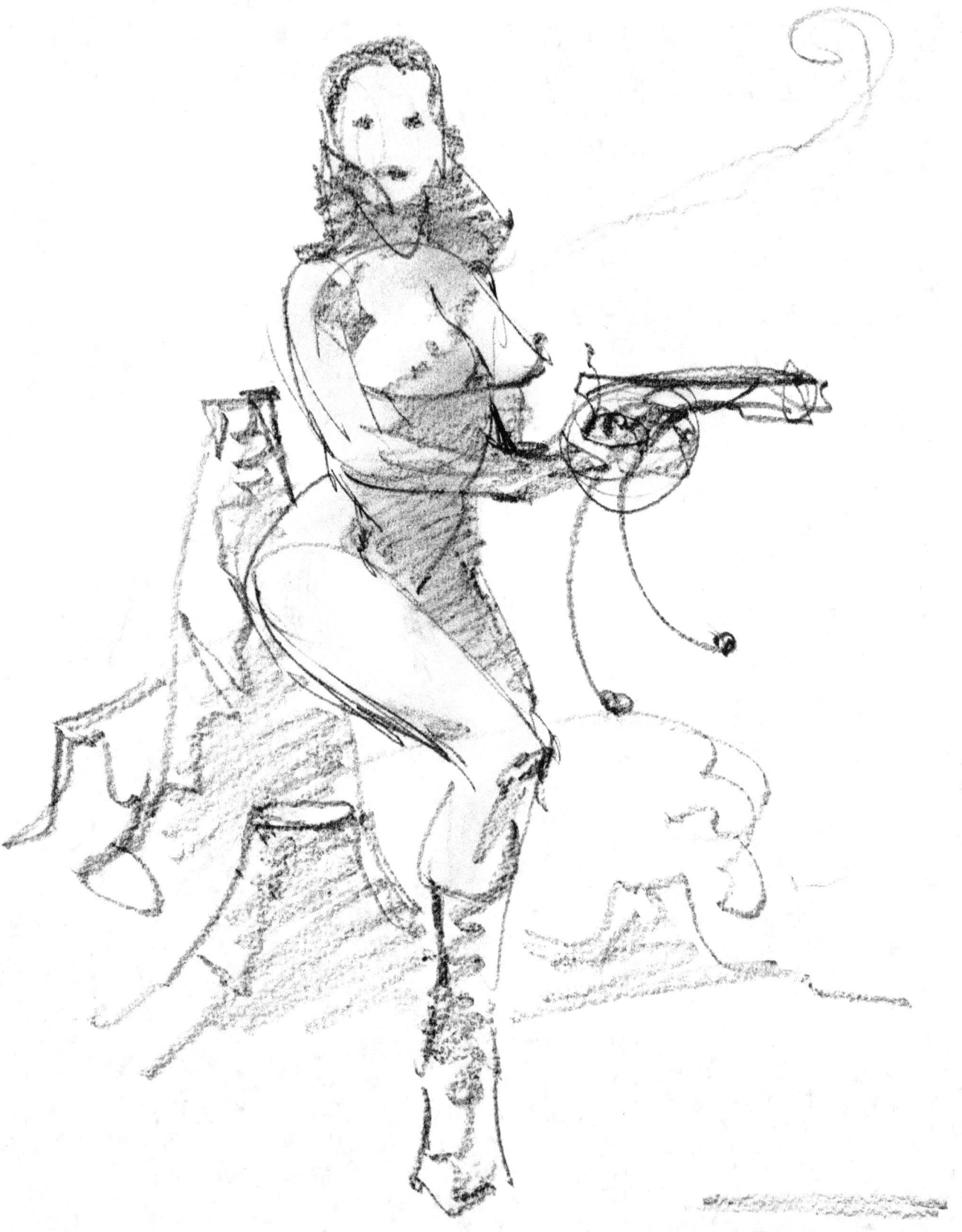

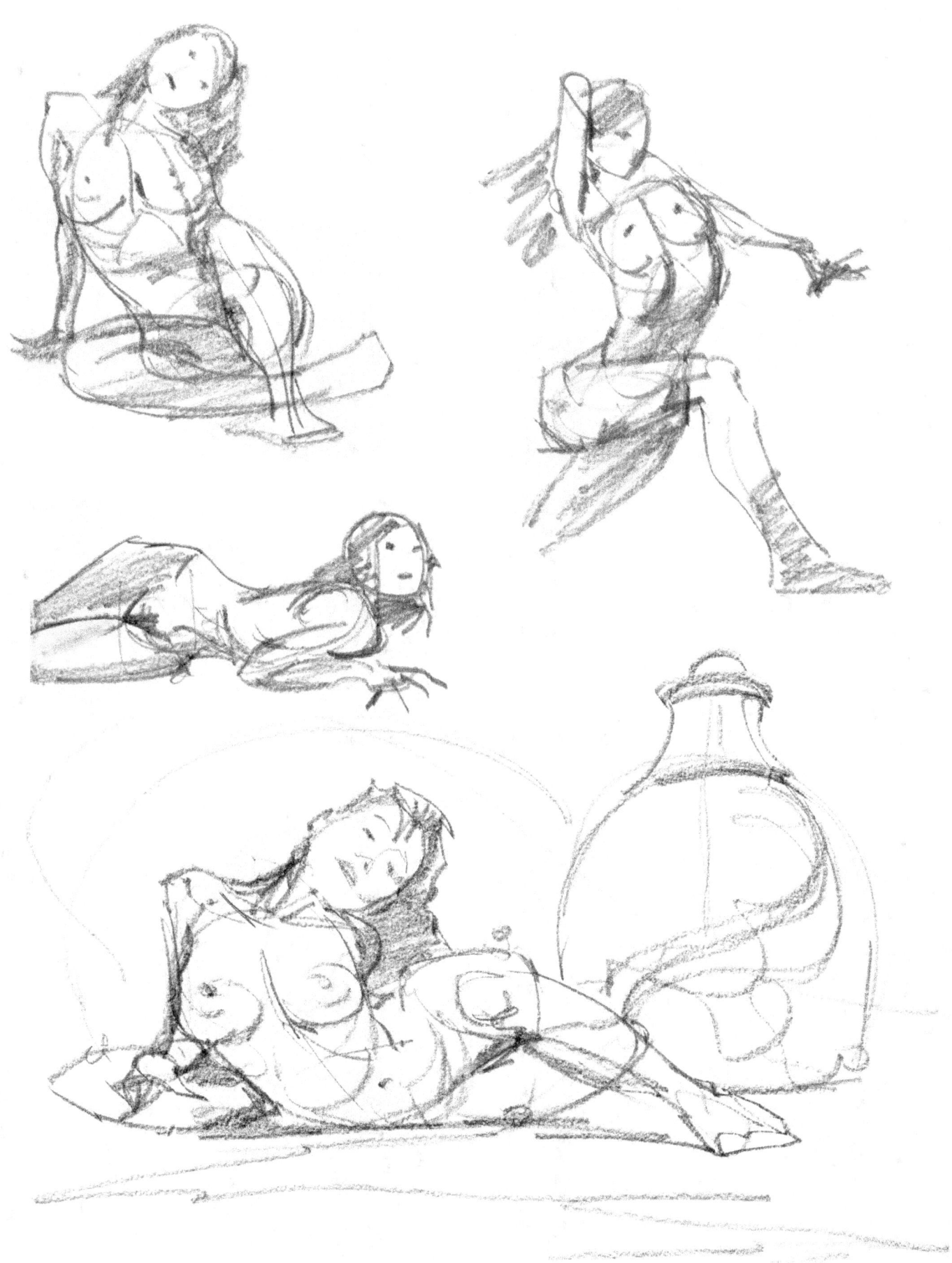

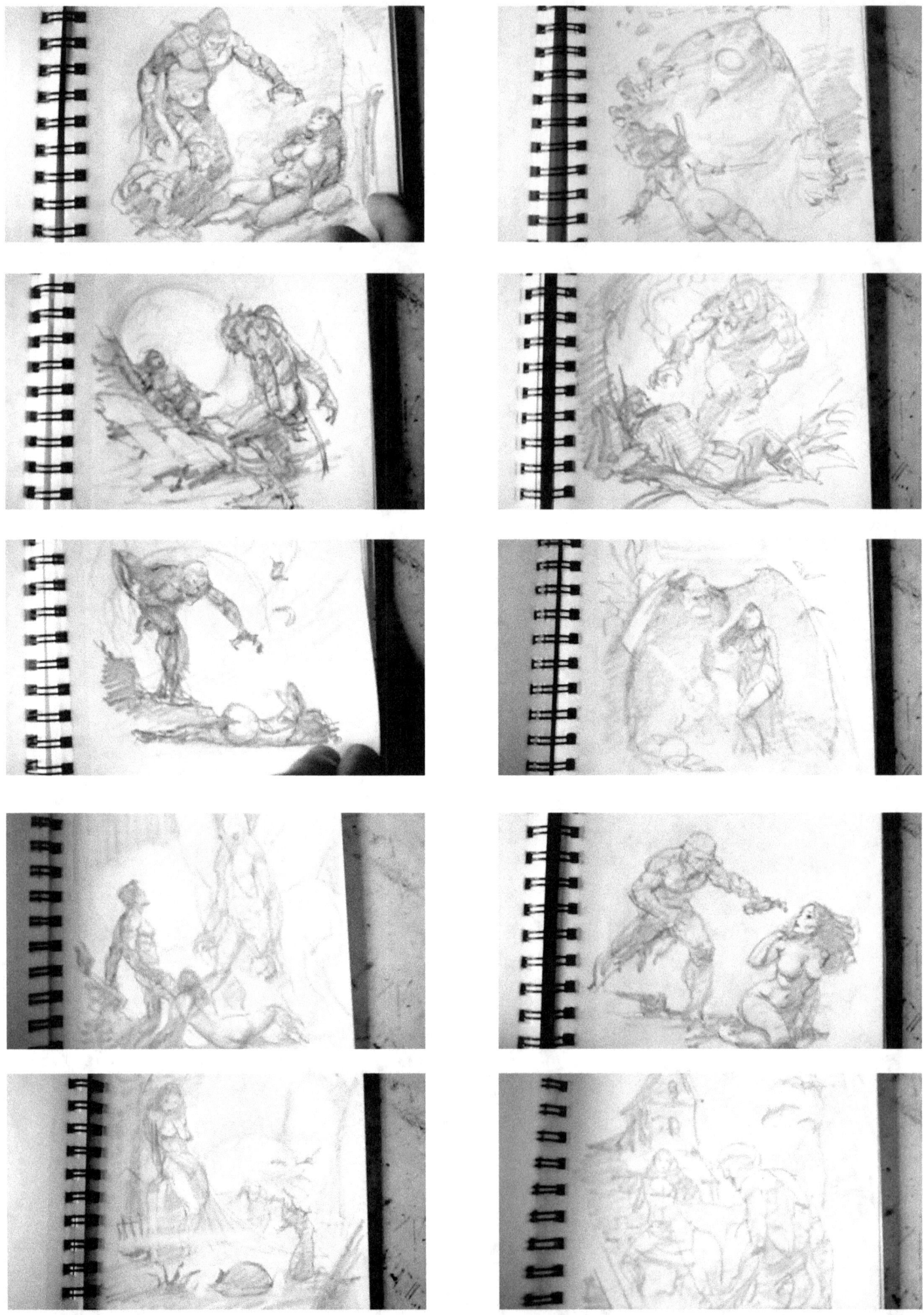

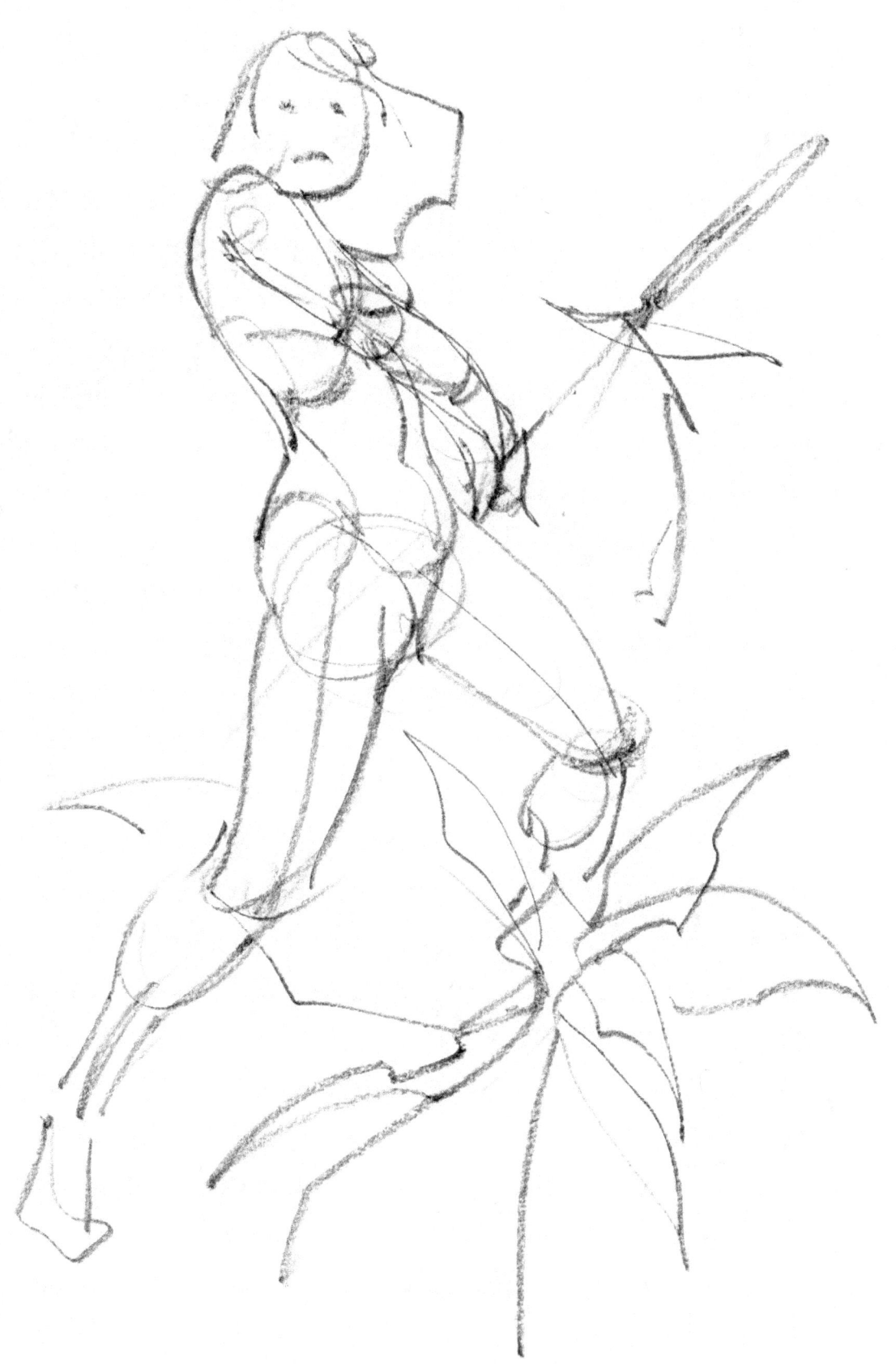

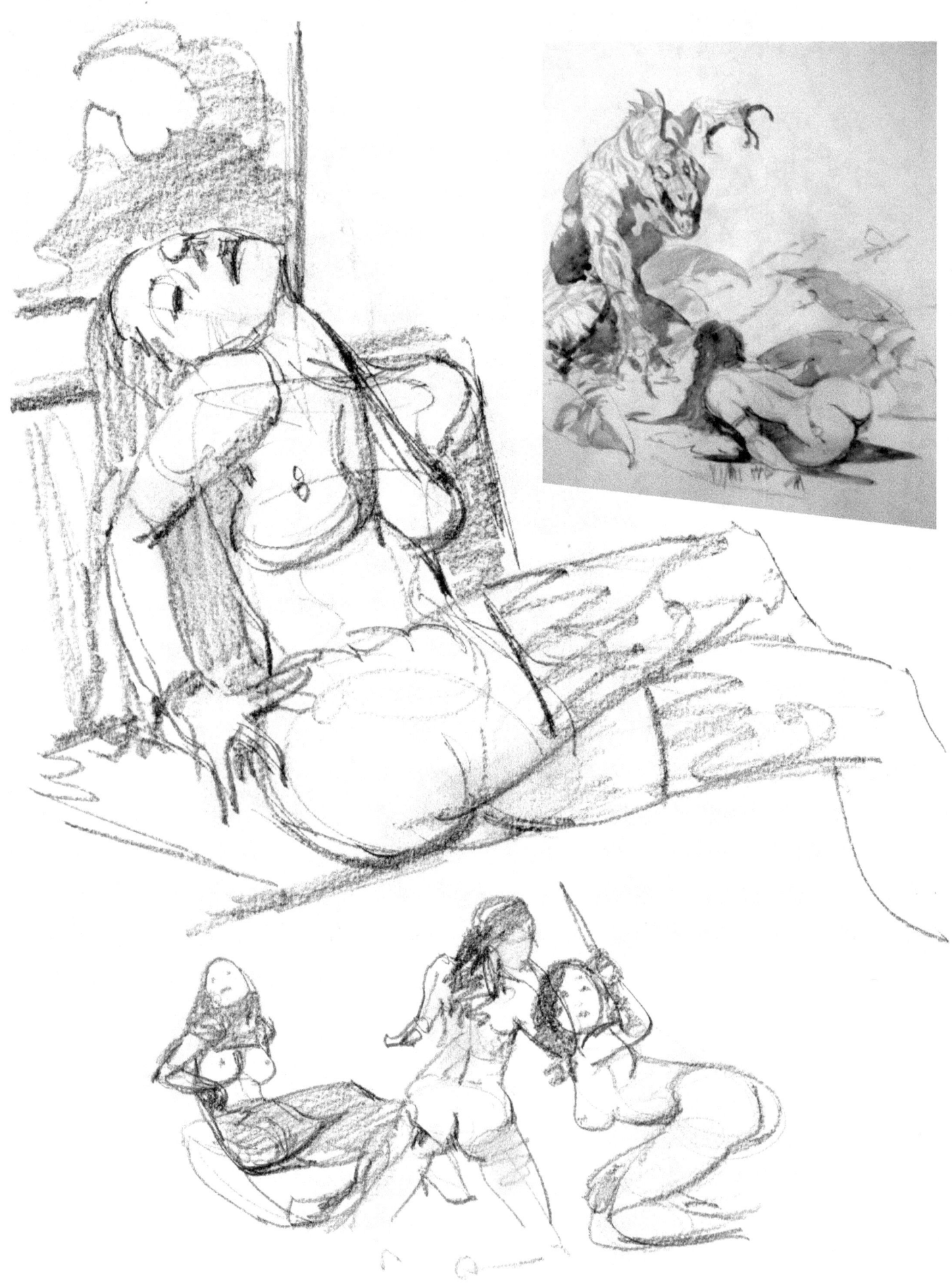

Hunger

The ascendance of Clive Barker's style of Horror in the 1980s was something that creeped some people out on a massive scale, as I recall. Folks were generally revolted by the imagery in the *Hellraiser* films, an effect which seemed to be their main goal. I know that around the old Main Street comic shop we referred to Barker as "Mister Icky".
I even wound up keeping it quiet that my own middle name is "Clive".

But I was a young artist looking for work and could hardly make choices between the jobs I was offered, and so I not only drew several "Hellraiser" comic stories but also designed two "Cenobite" characters, which I got royalties from for a while.
The world Barker created is so repulsive to me that I consider my contribution to it one of the lowest points of my career. Nowadays I would never do it. Not only did it have a theme that I can only consider anti-human, but also a distinct anti-woman bent as well.
As someone who has tried to elevate and protect women his whole life, Barker's misogynistic imagery makes me sick to my stomach.

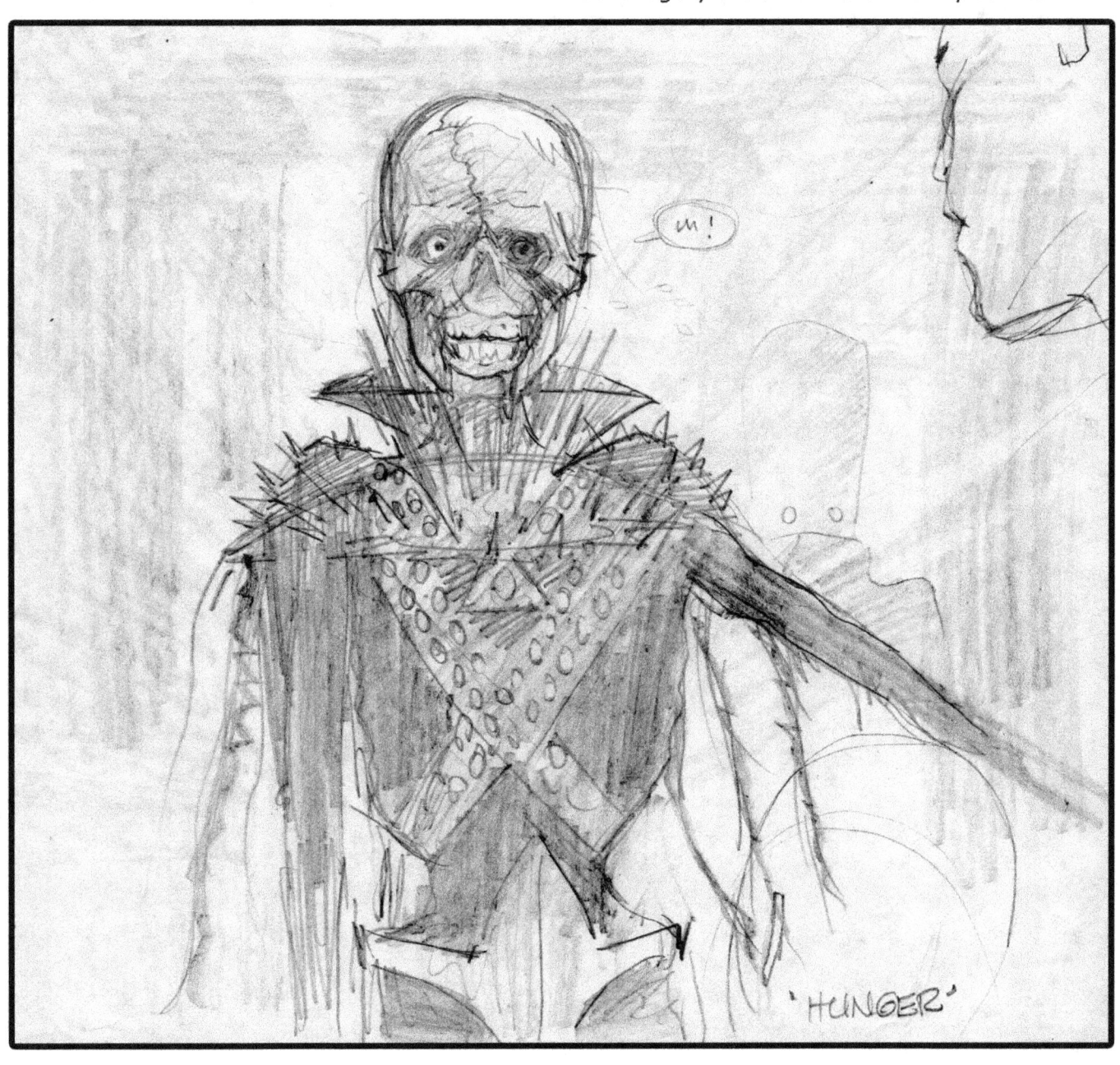

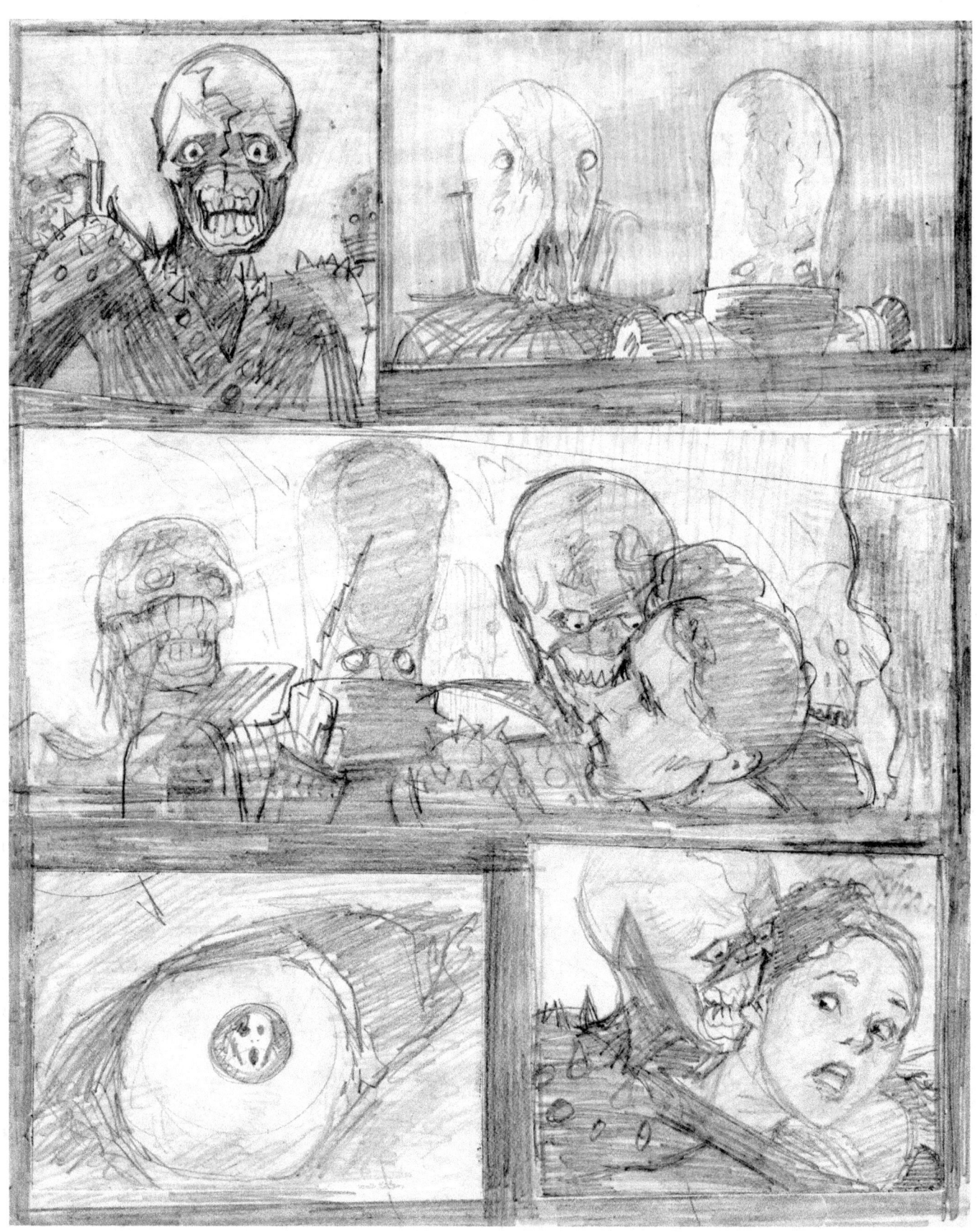

A sample of the cruel treatment of women, as described by the scriptwriter, that at the time I could only imagine as having come from the mind of a homosexual man whose twisted and diseased view of femininity via deformity and freakishness might as well have originated from some other planet altogether.

Pickled

Absolutely my earliest comic strip tale, read it in horror!

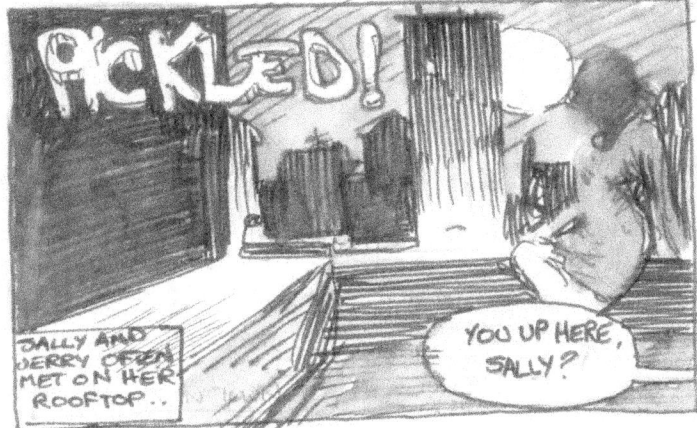
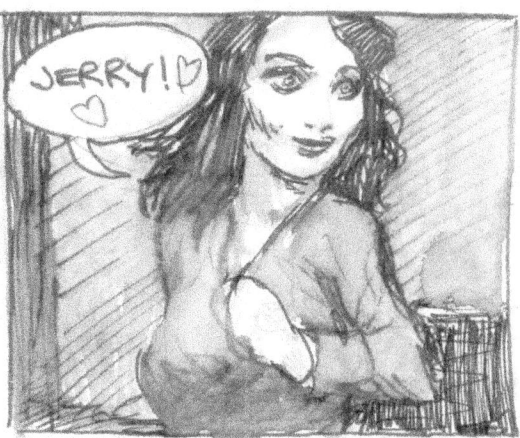
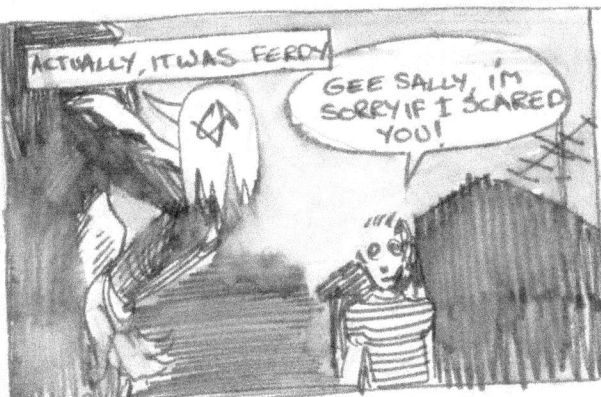

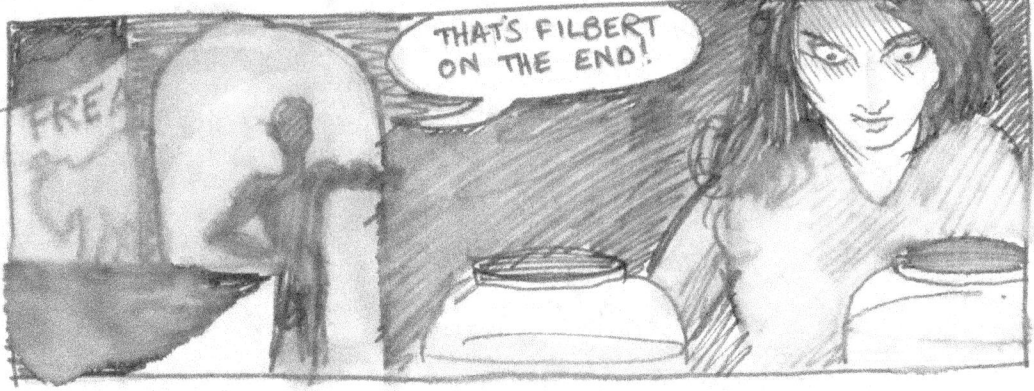

Ink Gallery 5

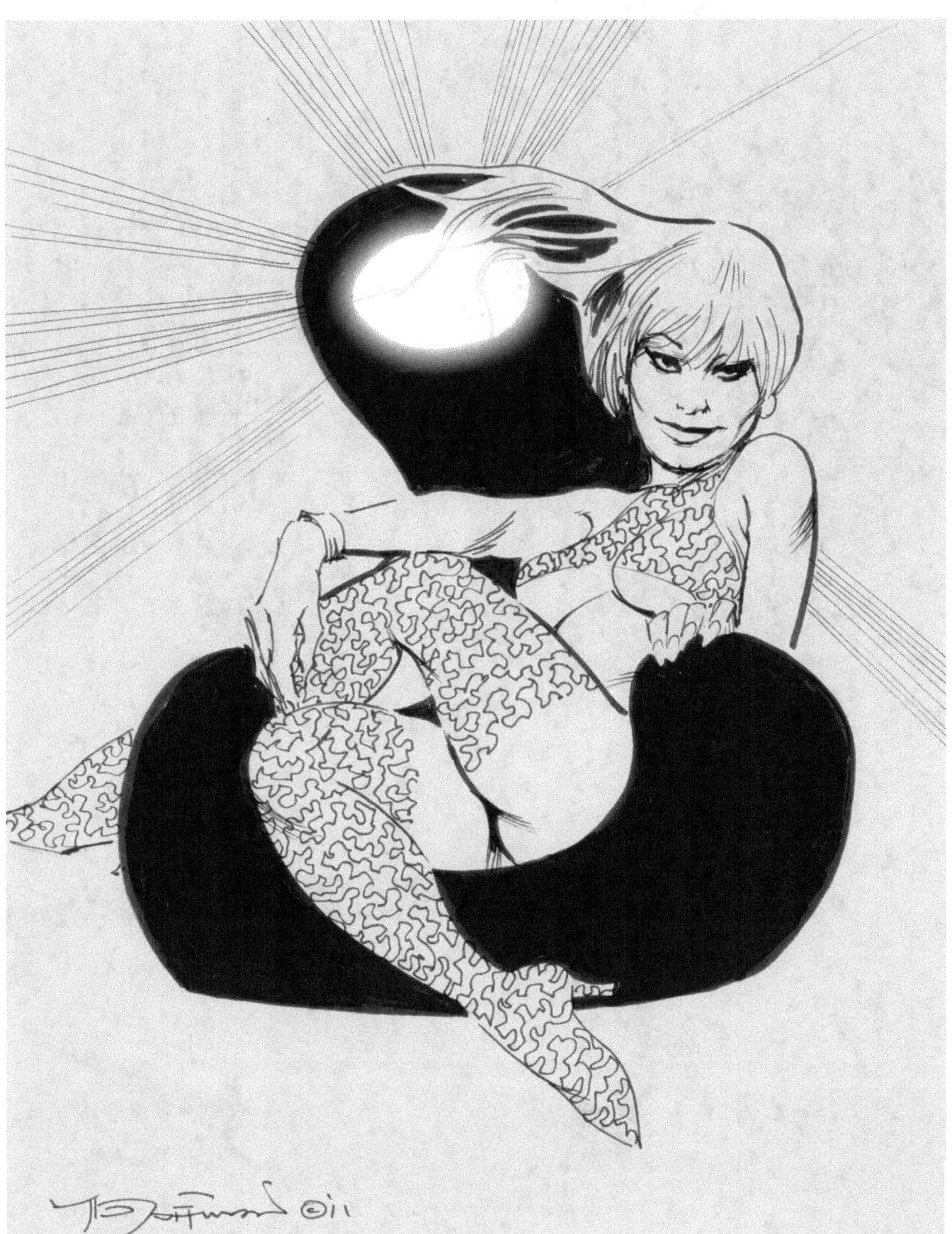

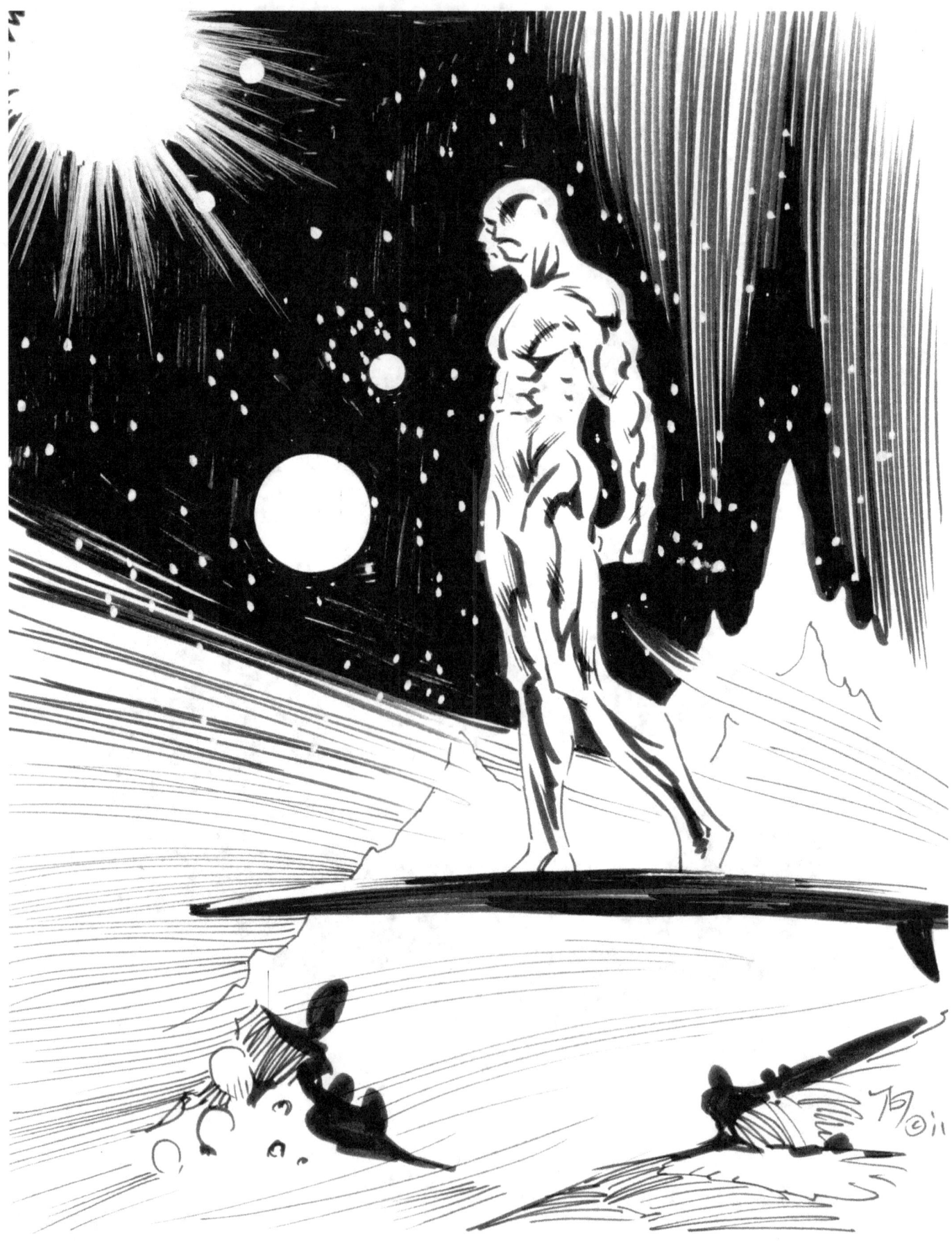

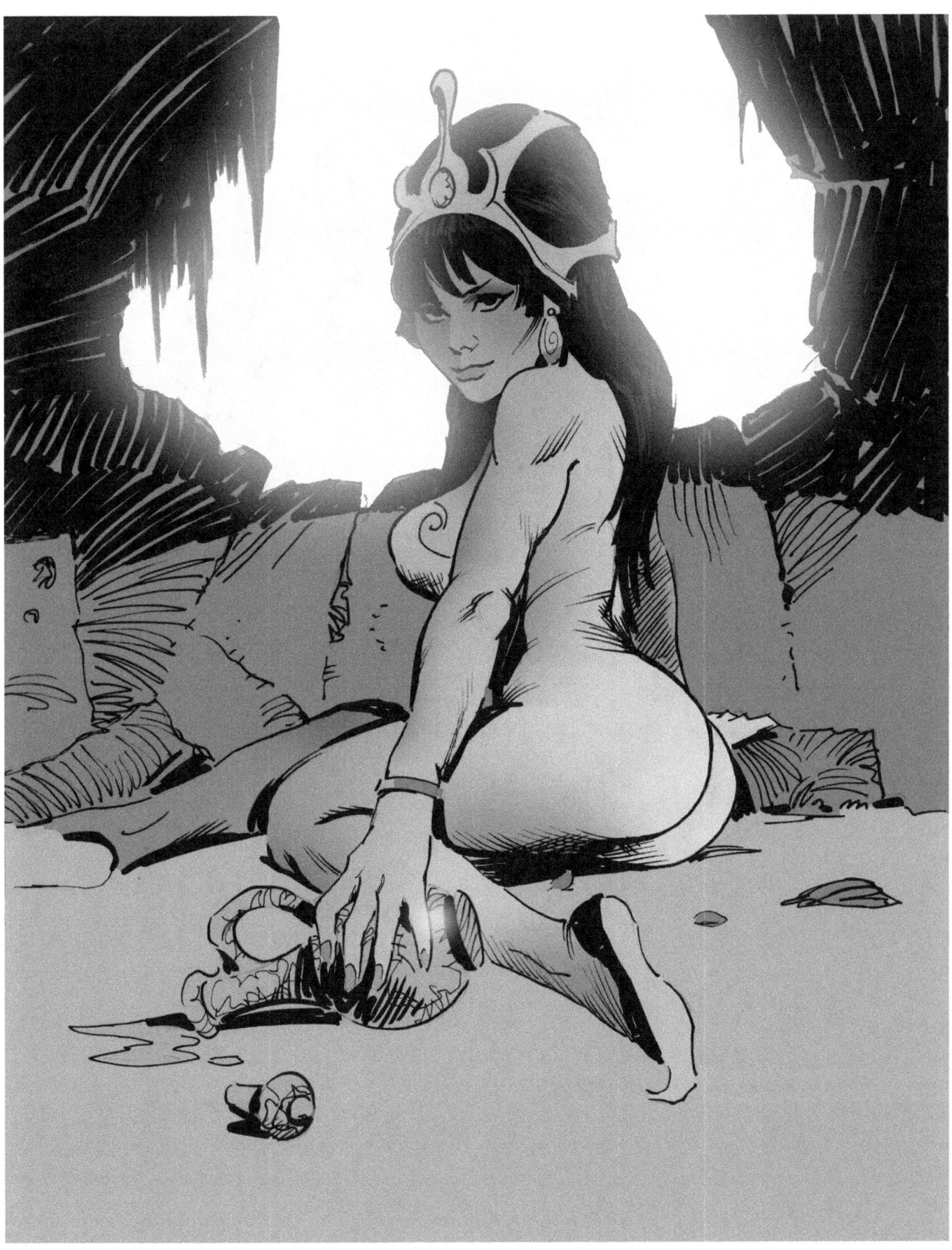

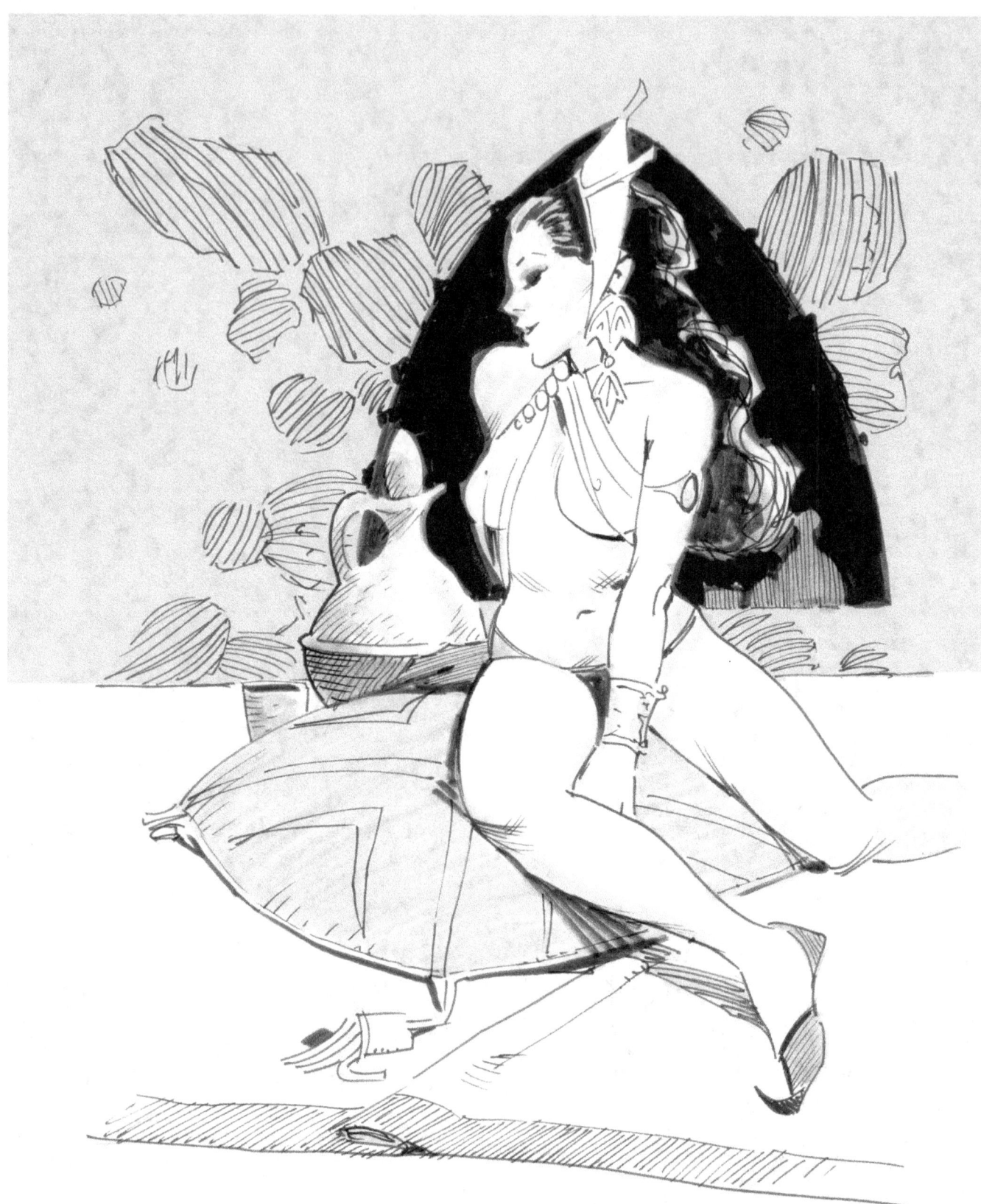

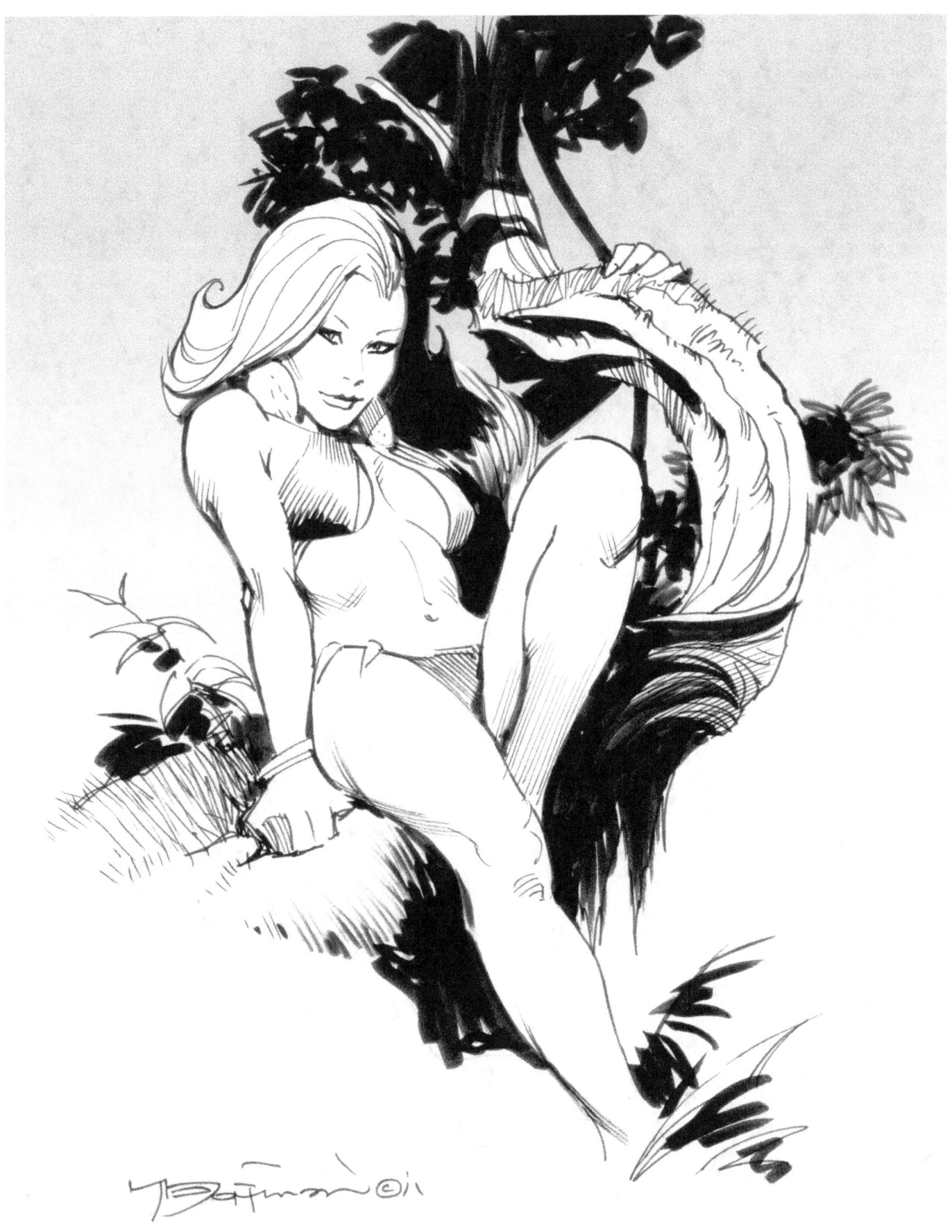

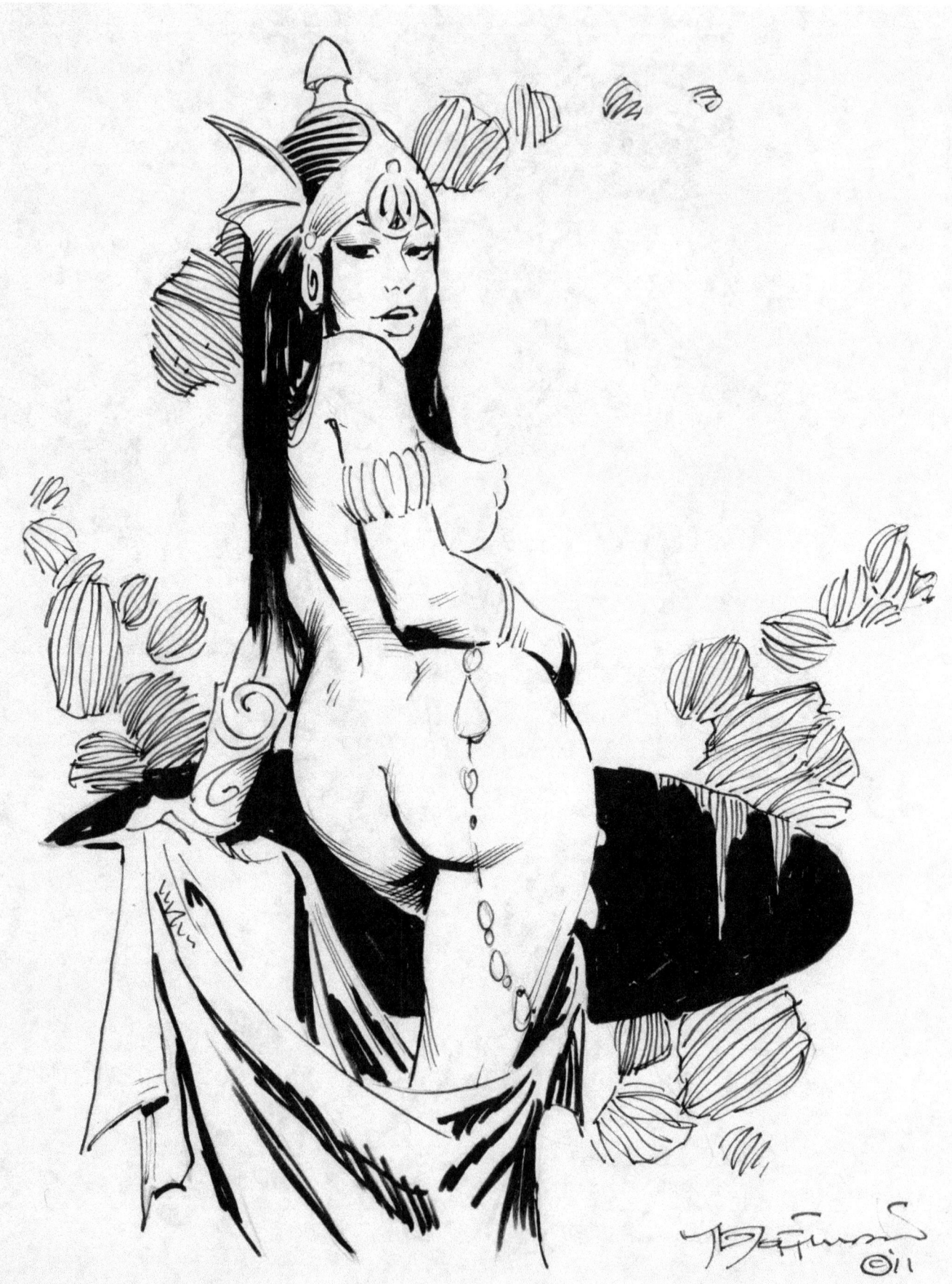

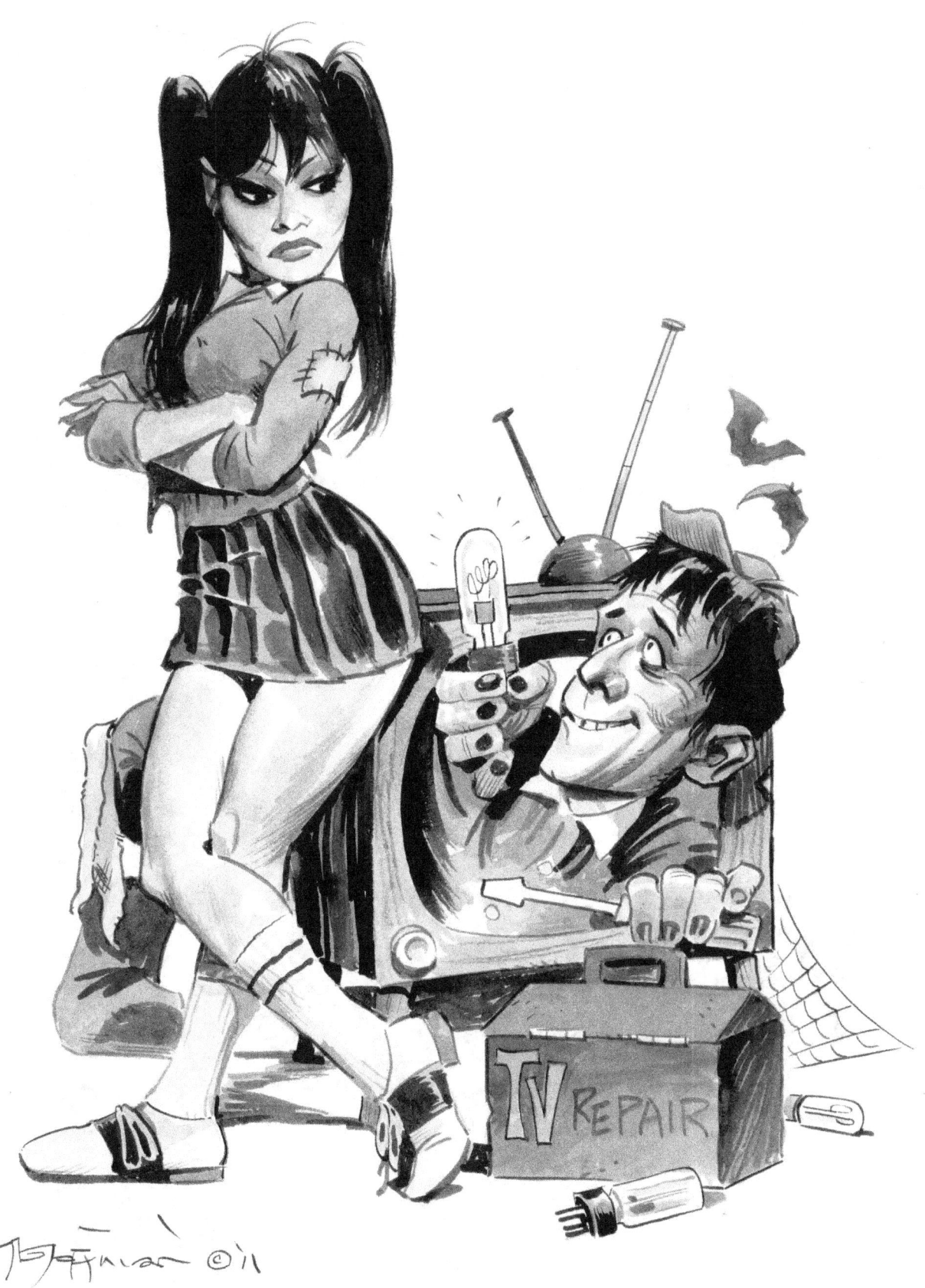

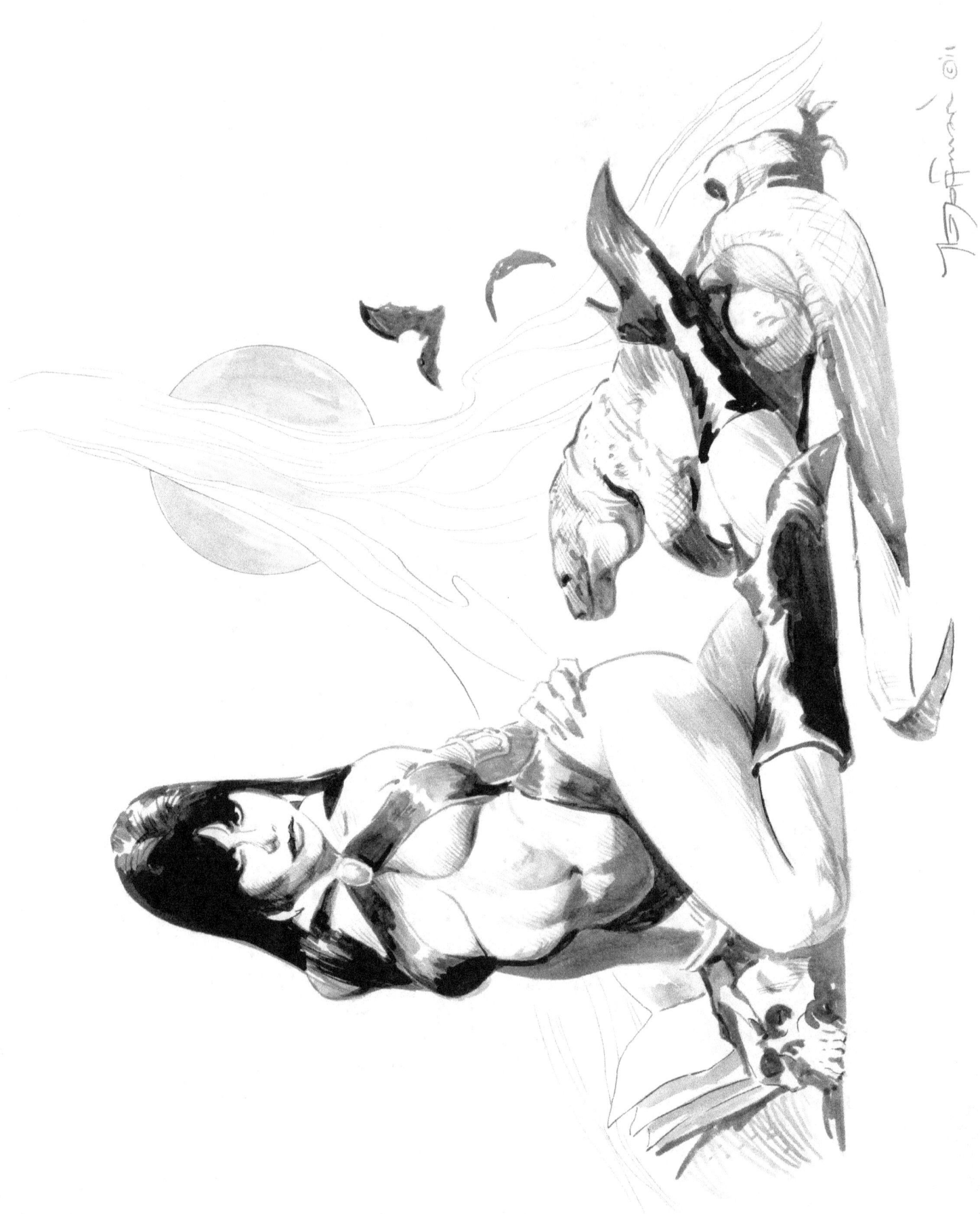

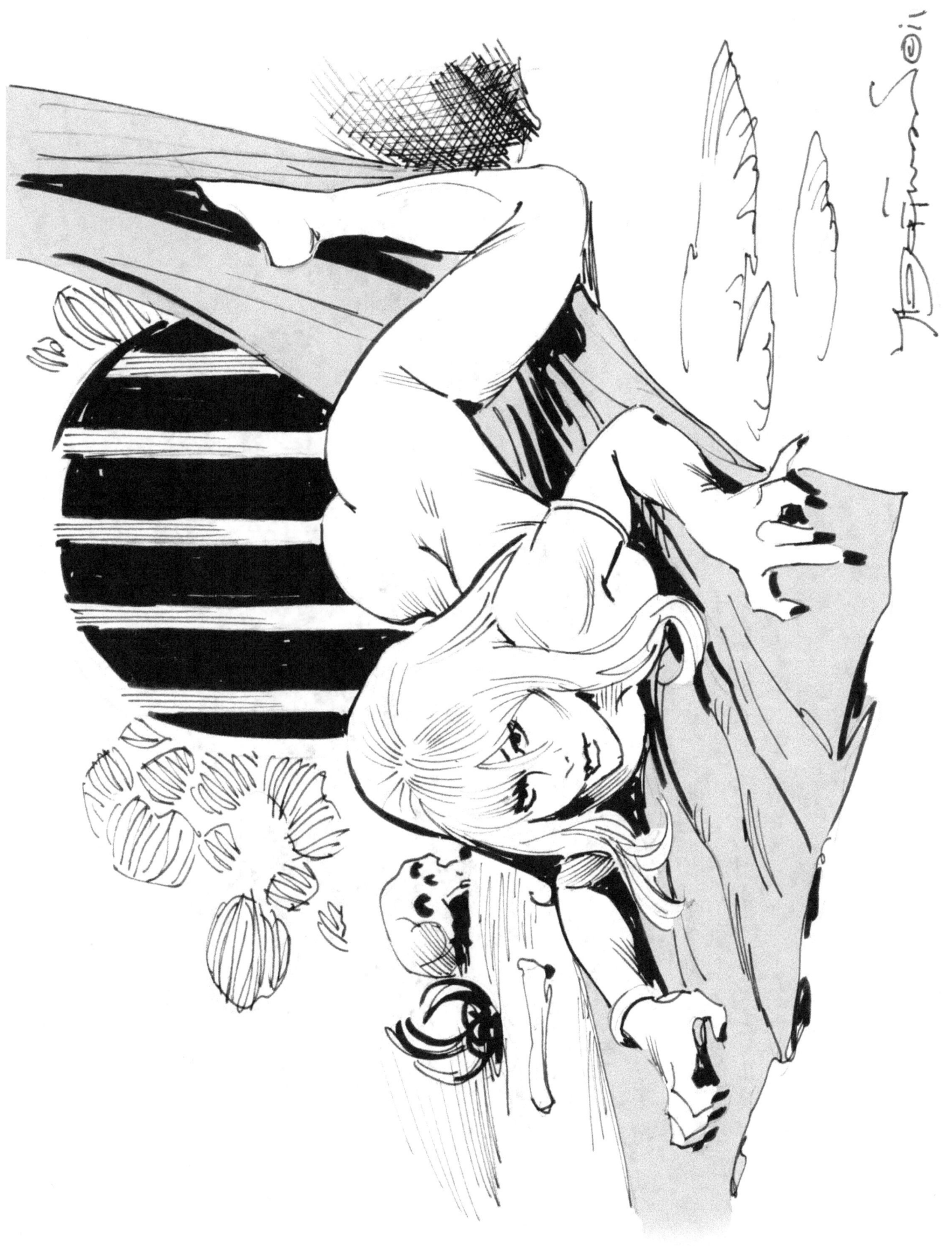

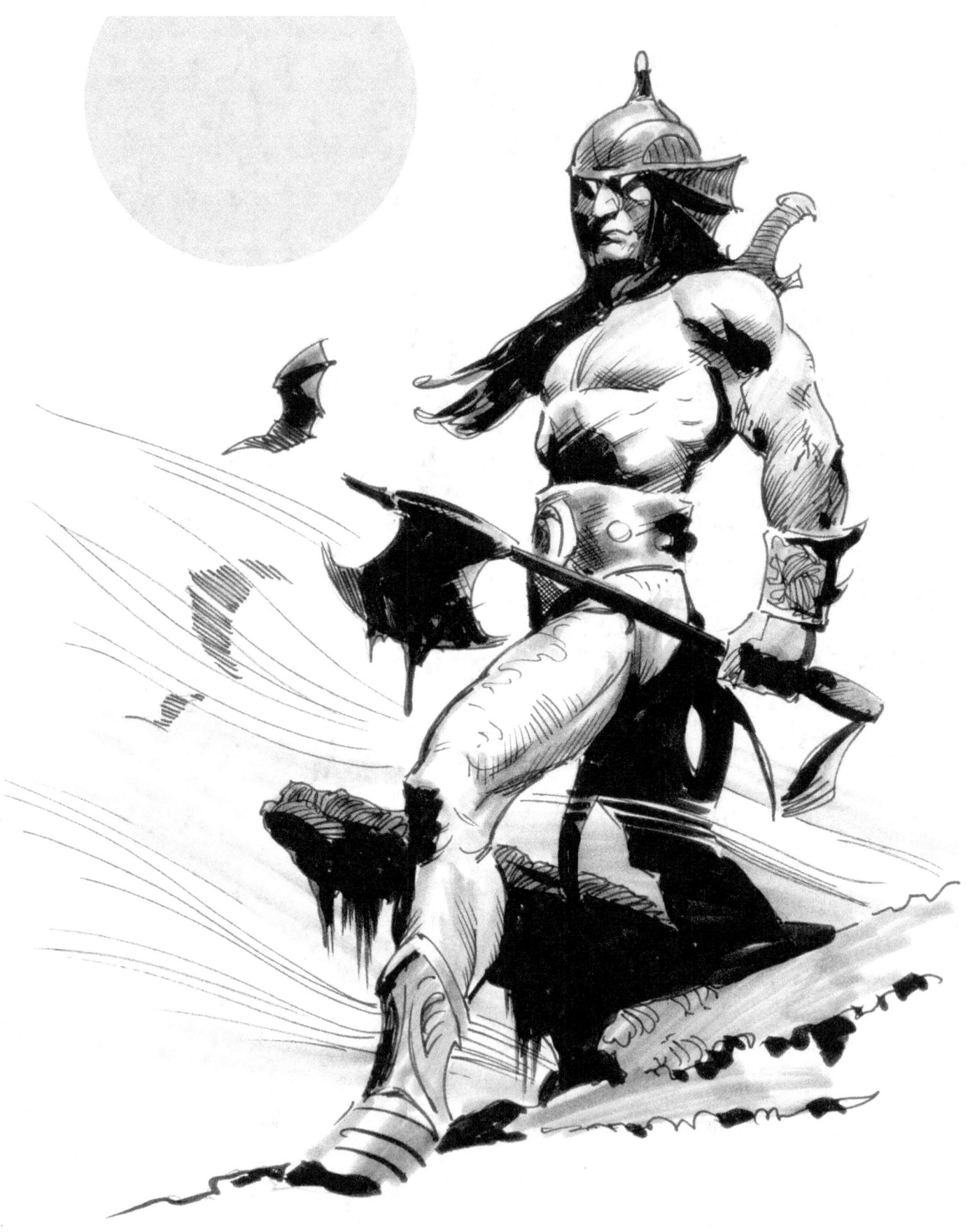

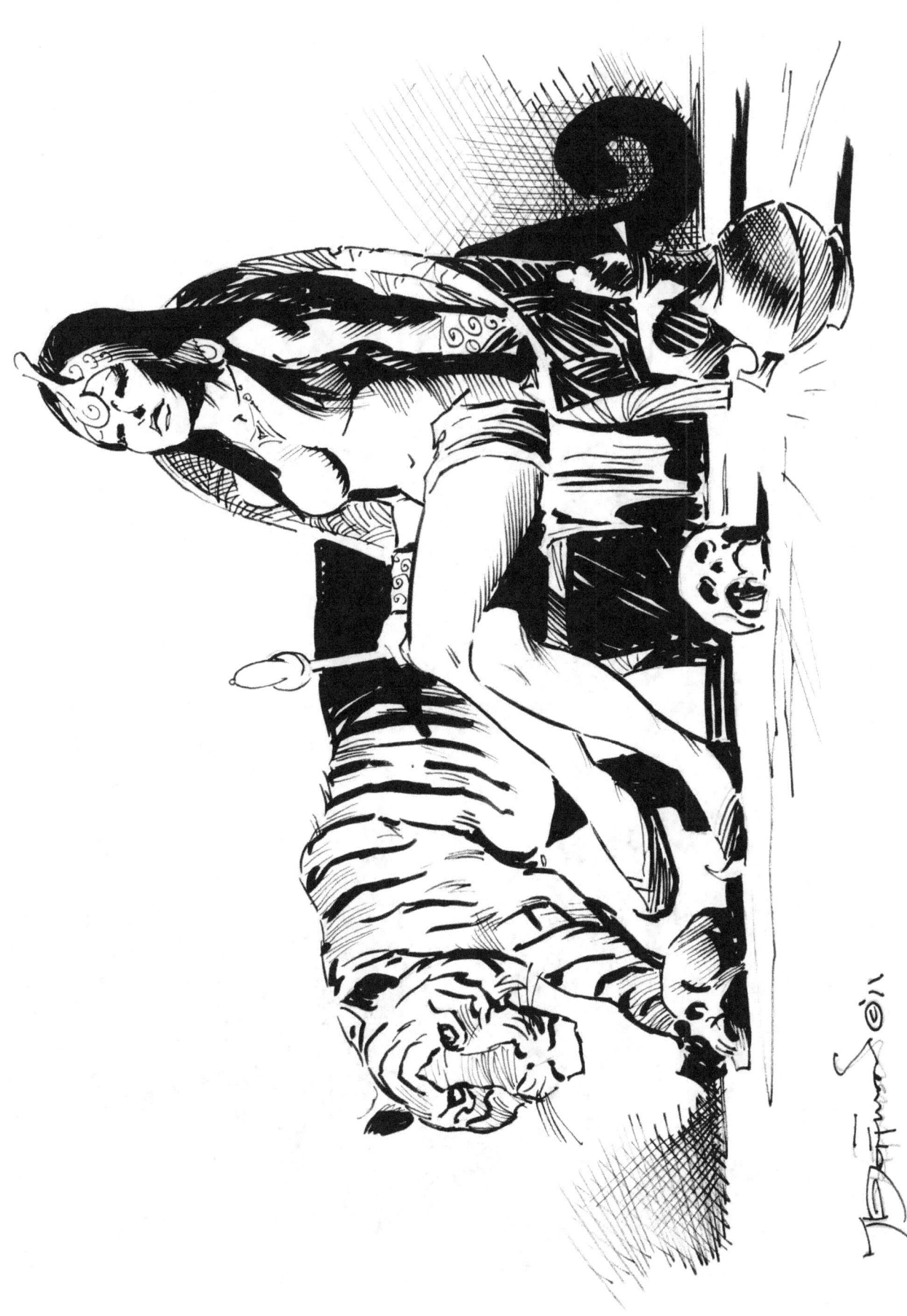

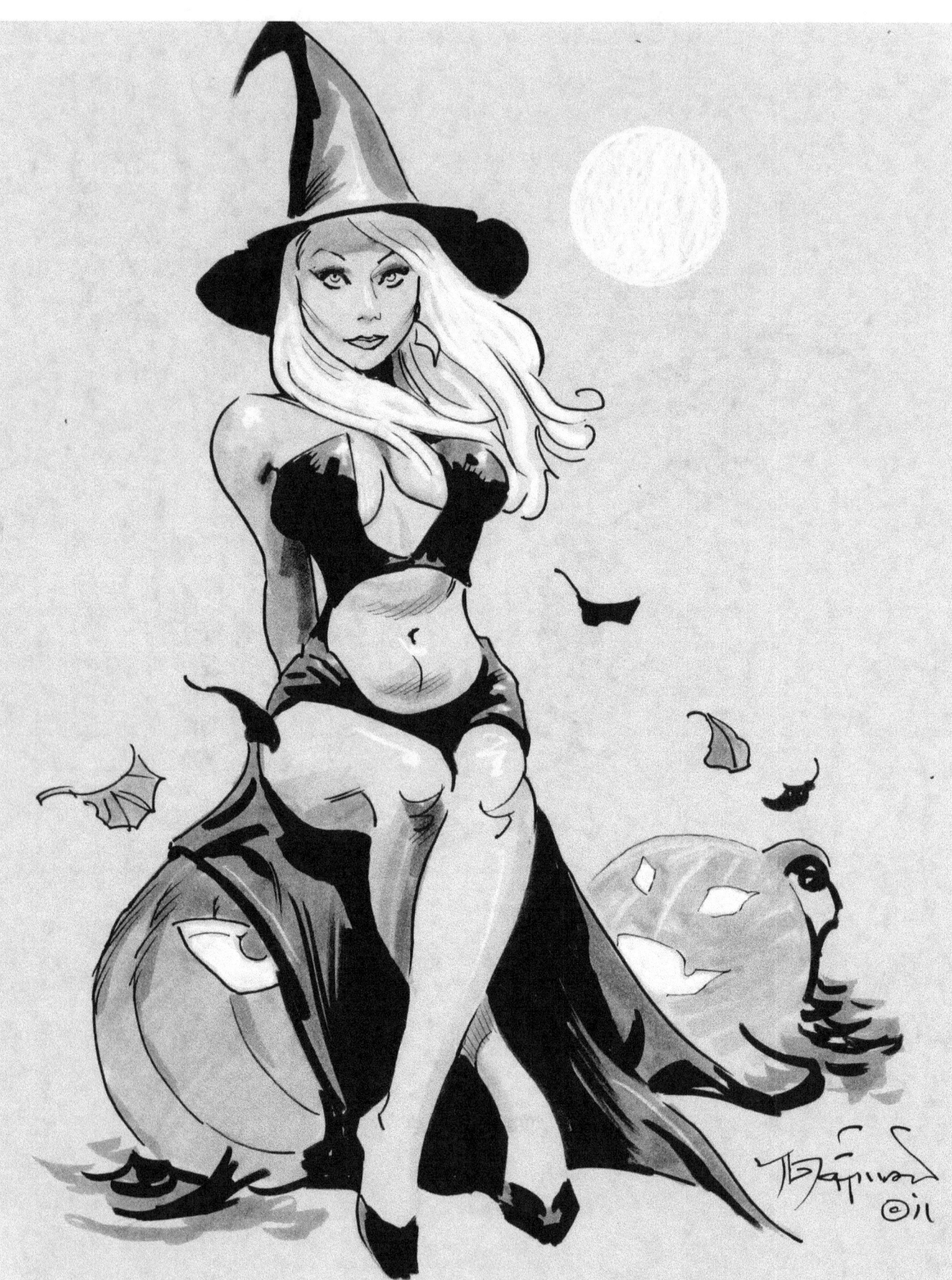

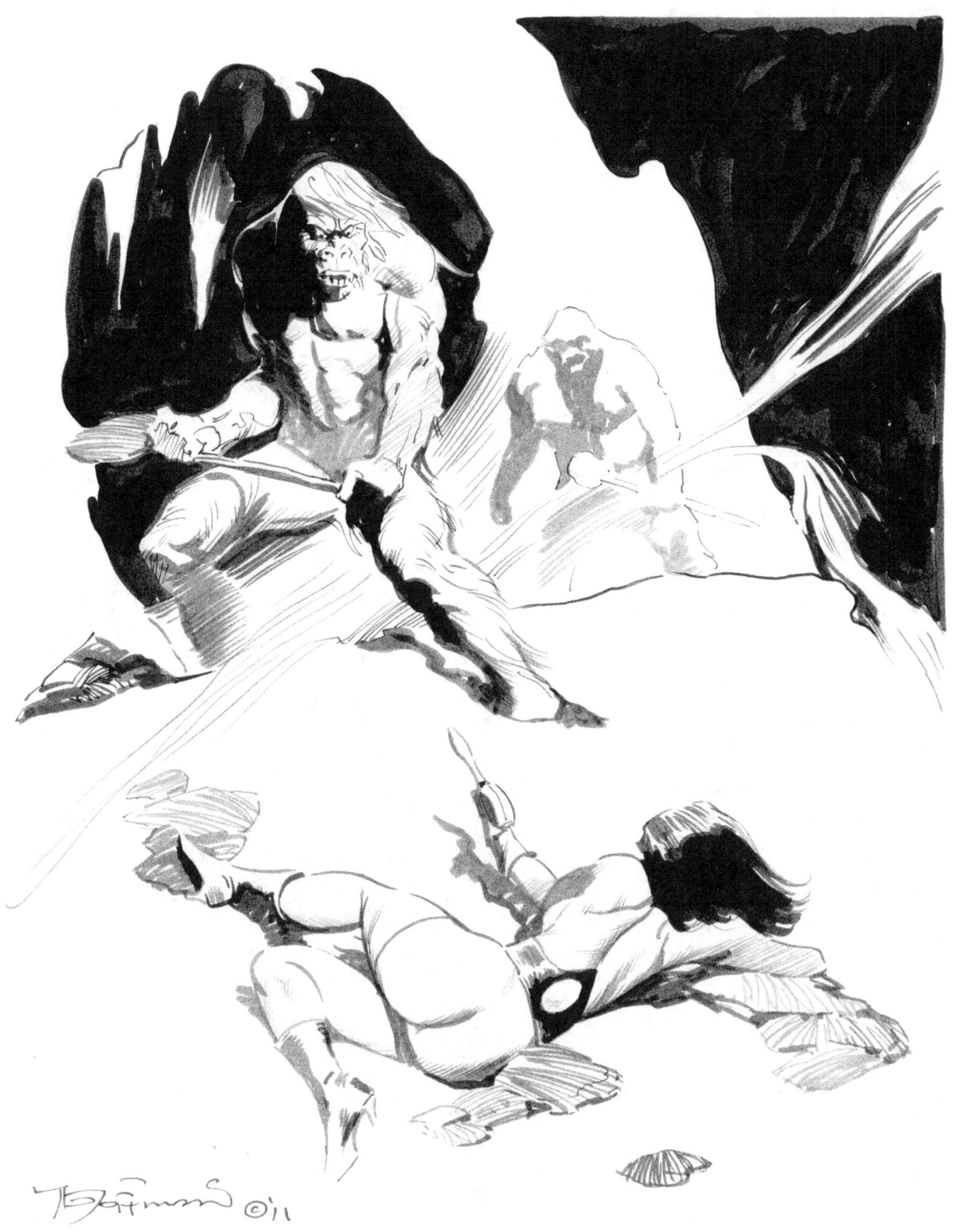

Bad Girl Craze

It was some time around 1992 when the so-called "bad Girl" craze hits comics, started off by one Everette Hartsoe with a $1200 tax refund check.

At the time I was struggling to find something rewarding in Comics myself, so I took a stab at creating a character, but never really put more into the idea that what you see here.

I eventually opted to go "Jungle Girl" with my *Tigress* character, and there was nothing especially "bad" about any of that.

What would a "Bayonette" comic have been like, with some sociopathic girl unrealistically bent on exacting some gory revenge, wielding bloody knives a la Hartsoe's *Razor* series?

No thanks--it starts and stops with this drawing right here.

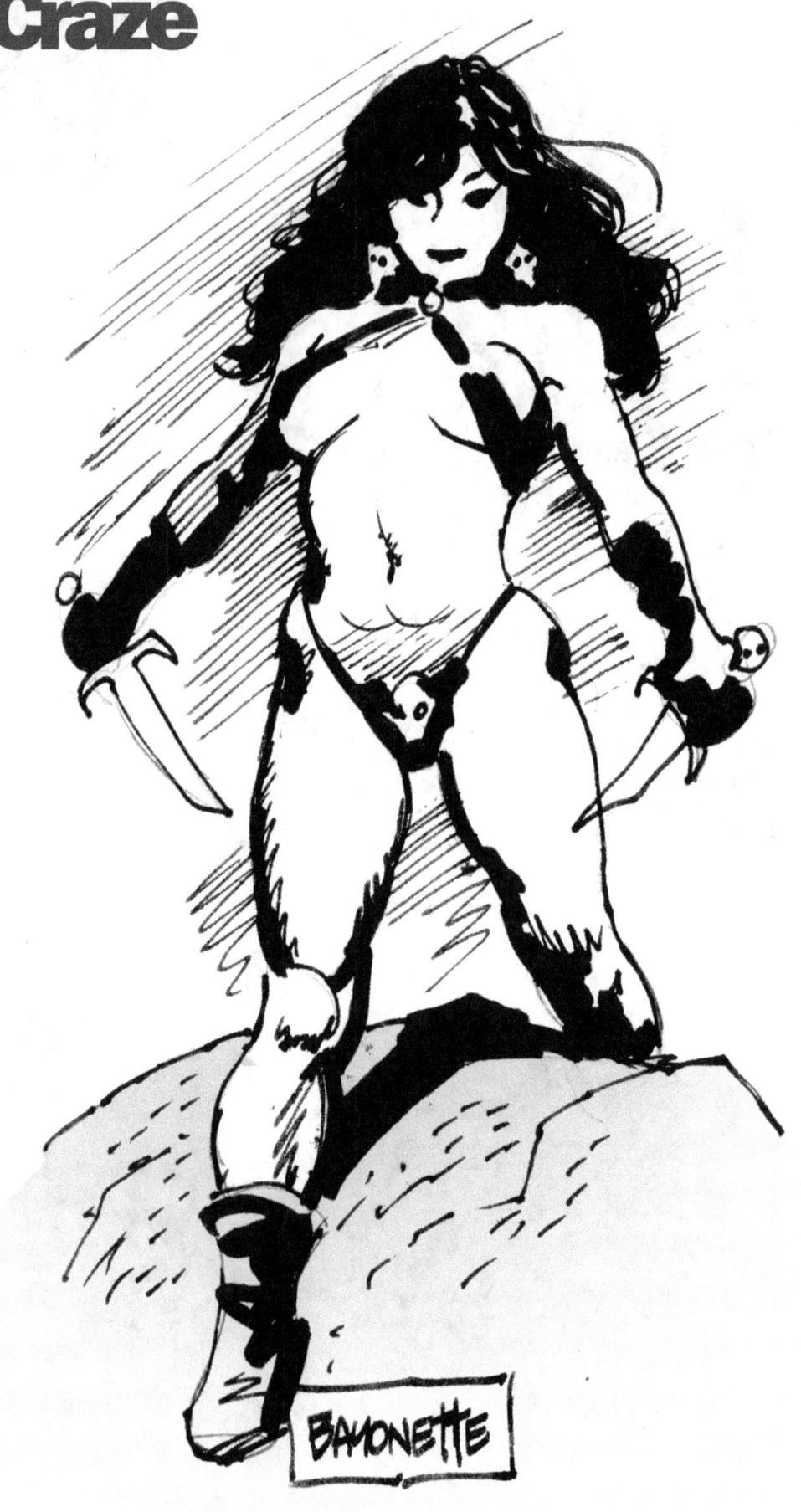

Nightmare Days

The art on these two pages resulted from a bad dream brought on by a late dinner of Liverwurst & onions, Japanese beer and German chocolate.

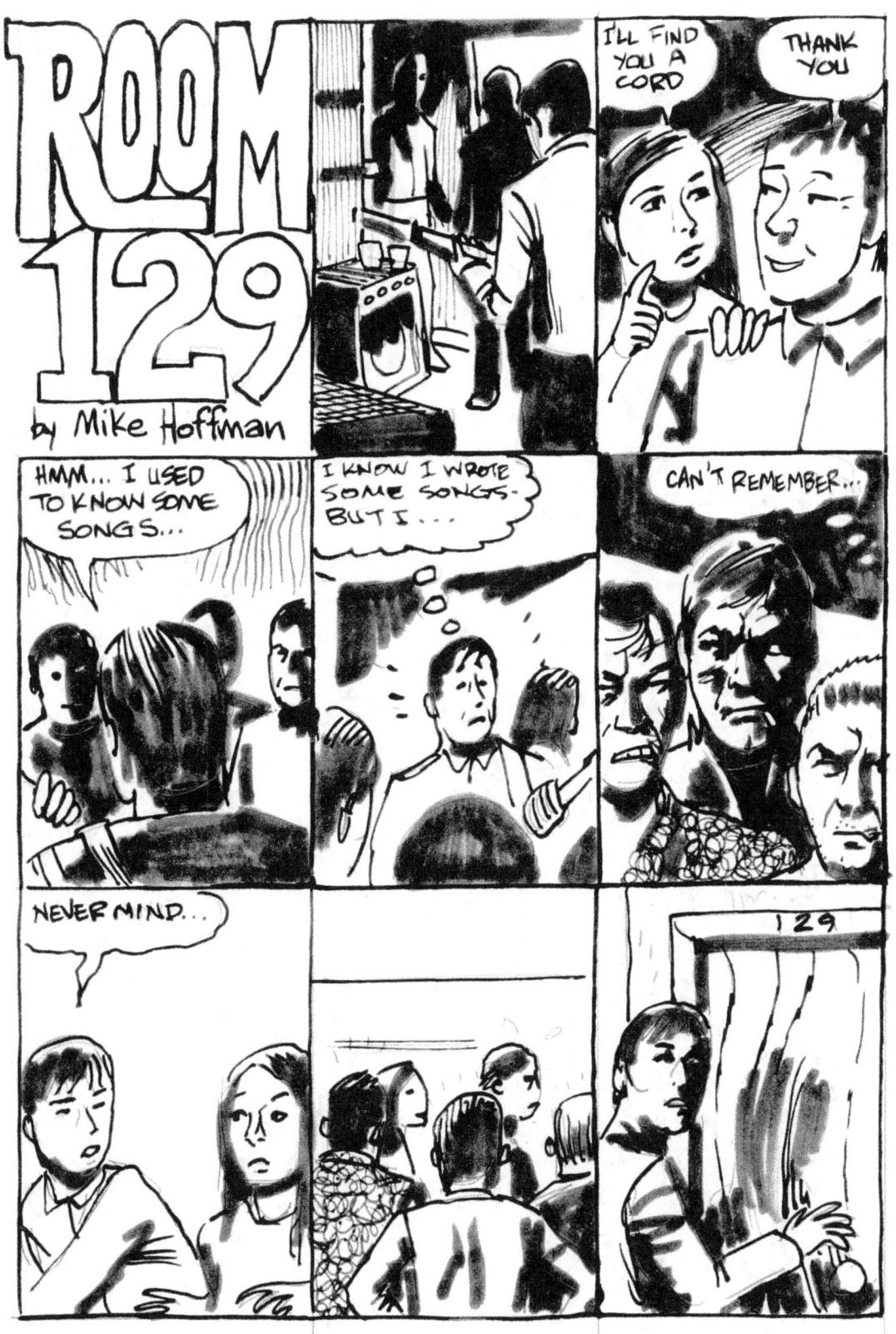

Sadhana

The following three drawings were created for the owner of a Columbia, SC Comic Book shop whose book attempted to explain his spiritual wanderings. I used real zip-a-tone for this one.

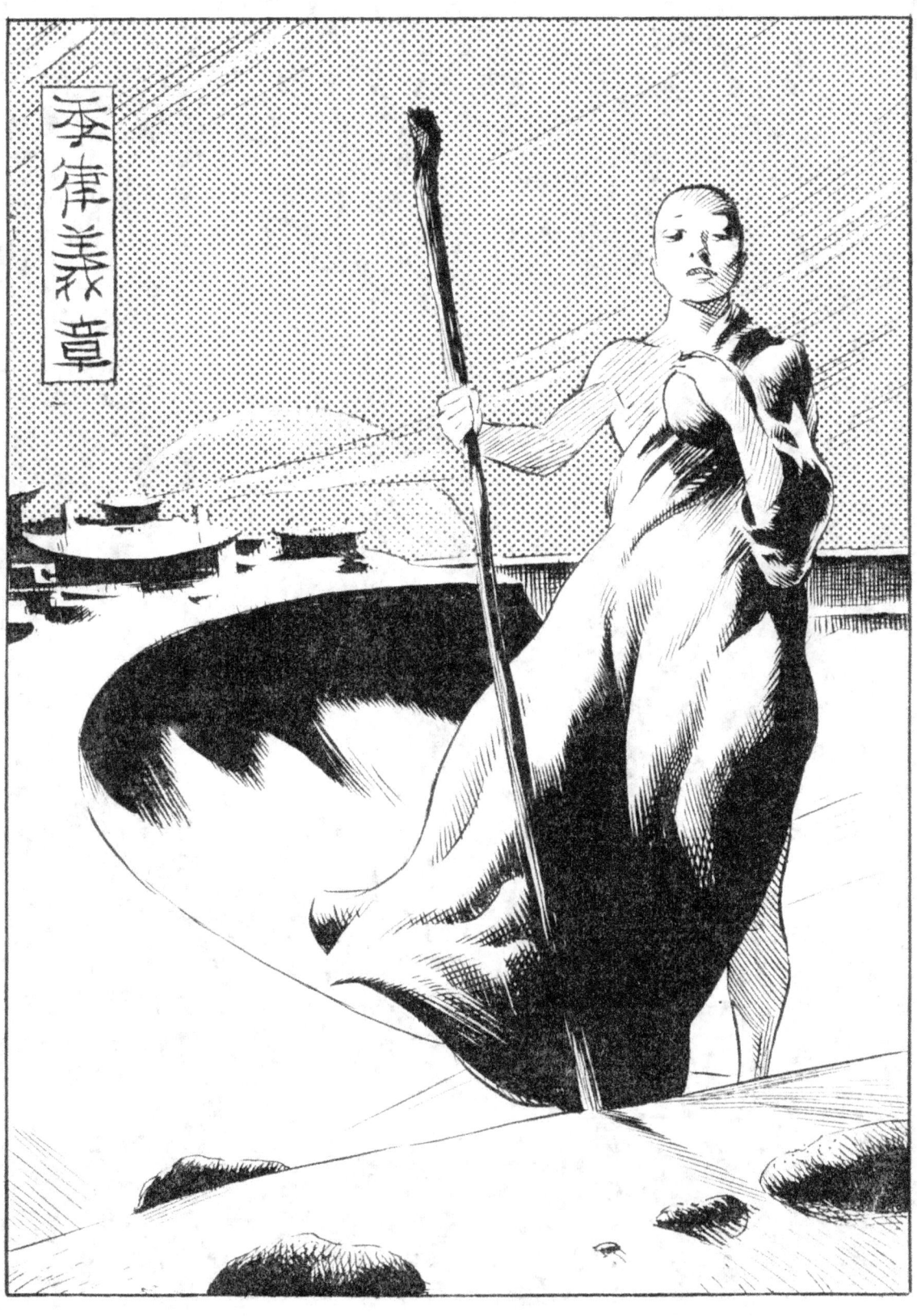

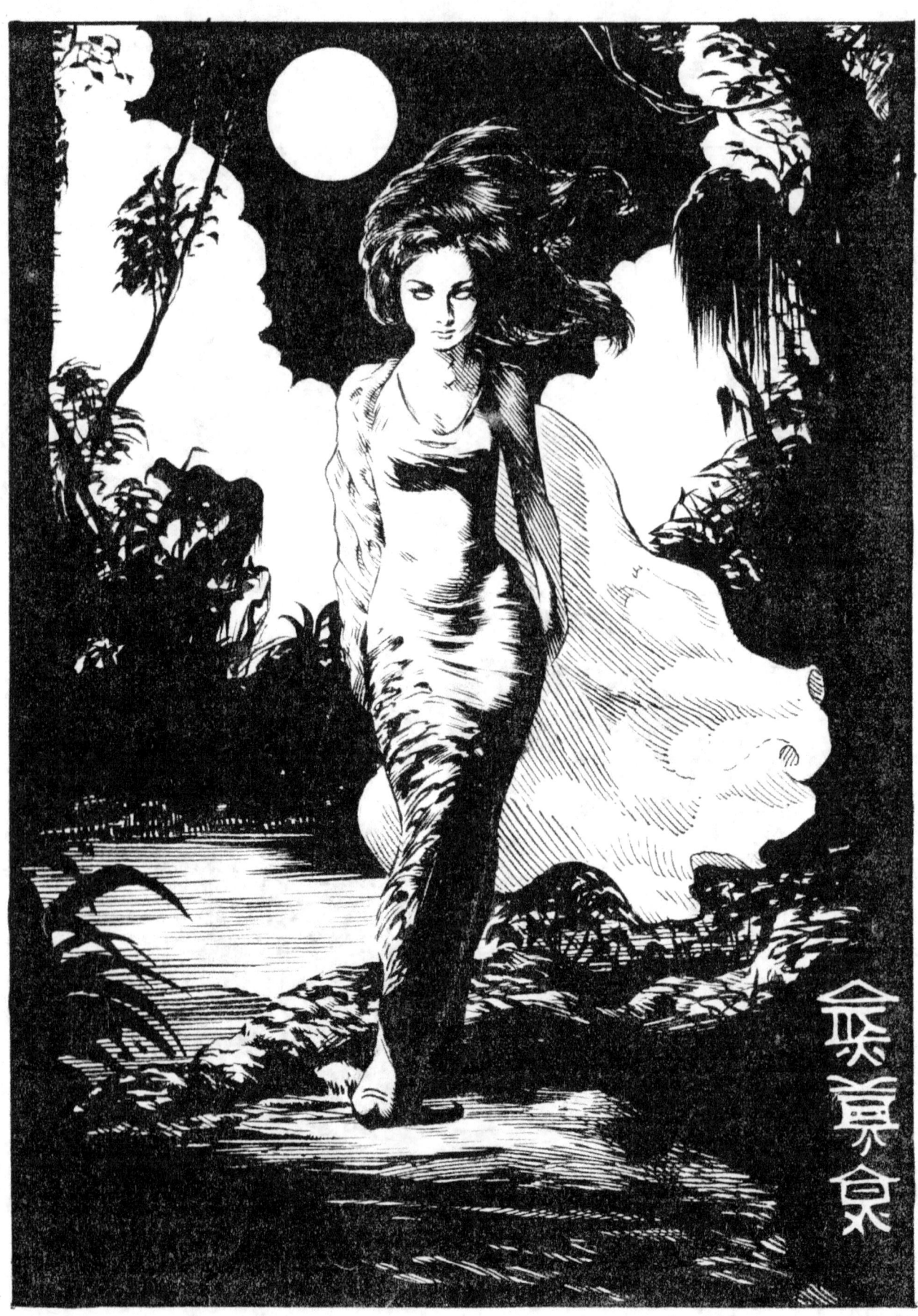

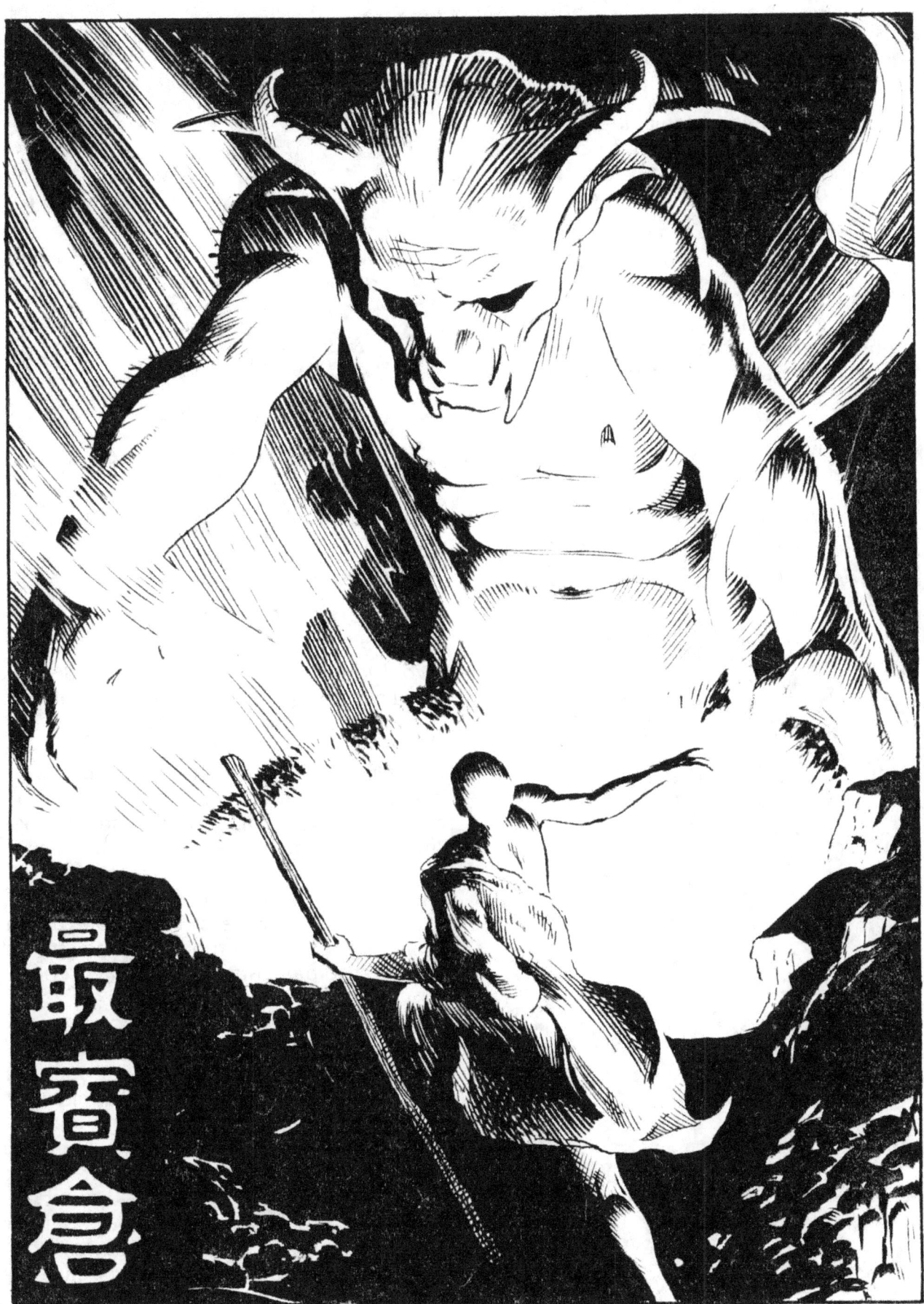

Santa Comic

There's rarely any shortage of ideas around here, and the idea of a Christmas Comic has been kicking about for many years. This year (2011) brought the most concerted effort to get the thing produced and out there.

What was concrete outside the basic idea? Not much, although I was already familiar with most of the "Giveaway" Xmas comics that department stores used to give out to kids. Many of those were nothing but glorified catalogs. But while there's a long History of holiday comics, those were to be just a departure point for me.

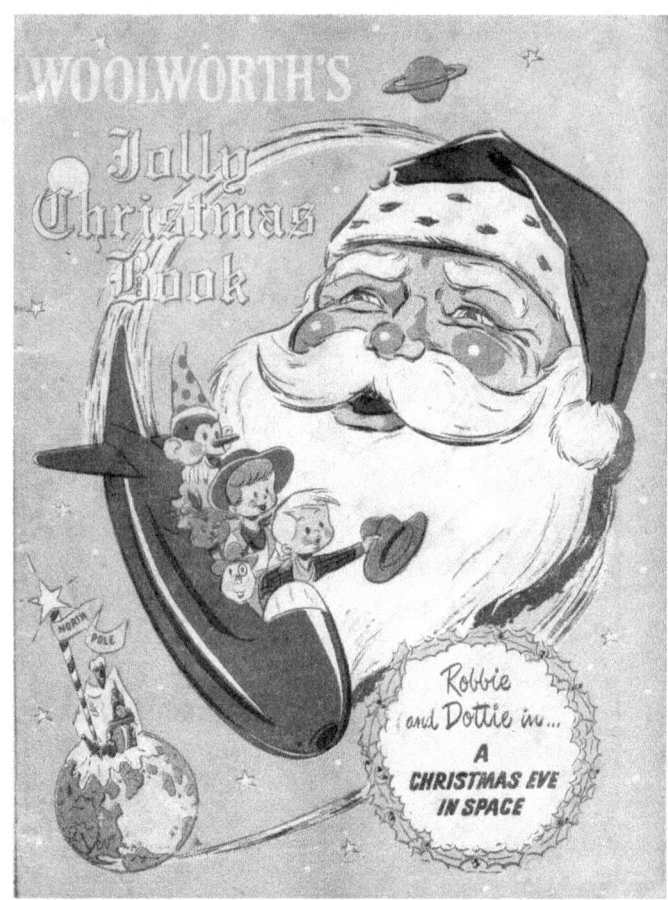

A Woolworth's Giveaway circa 1951, 36 pages, Marv Levy cover art. Five more like this would be published in the early 1950s.

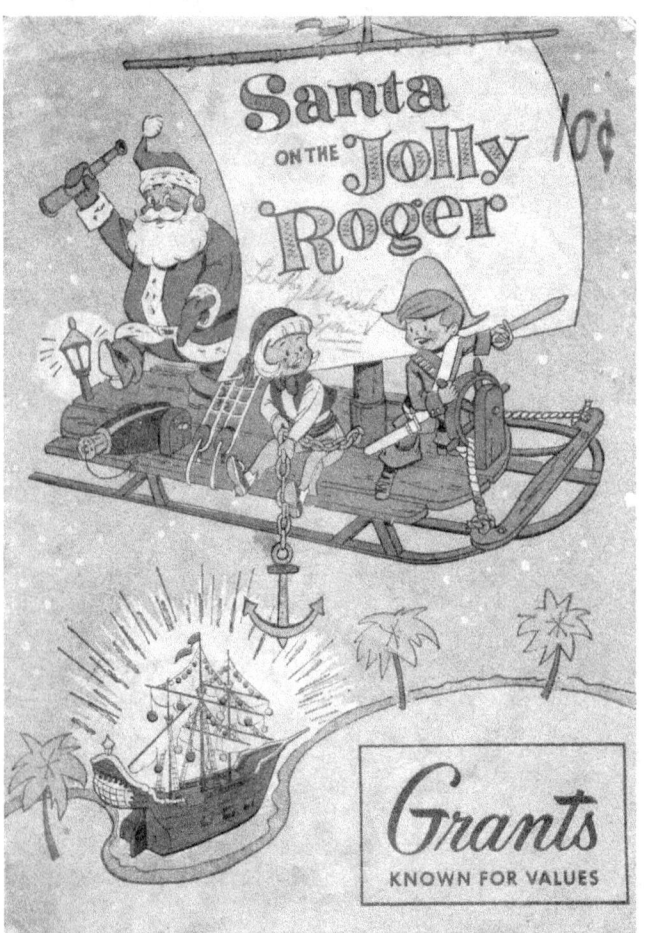

One of many free "Giveaway" Christmas comics from the 1950s, this one from 1951. 100% Newsprint comics like this were designed as an underhanded way to circumvent parents and get a toy catalog directly into kids' hands.

My feeling was that even a concept as over-used as Santa still had plenty of mileage in the right hands. There's been several Santa films lately, which I haven't seen.

I ruminated on ideas for several weeks and almost over-complicatd the whole process. Finally, armed with some notes and character designs, the day came when I was ready.

Basically, I made the whole thing up as I went along, but before you think that's just a slap-dash approach, I'd mention that Jack Kirby must've approached things in a simialr way.

Ultimately, you are telling a story in pictures, and to my mind producing "a script" first kills the process completely dead. At most, I like a synopsis, mainly to prevent plot holes. Admittedly, *The Santa Claus Christmas Chronicle* has a few of those, but I don't care if you don't.

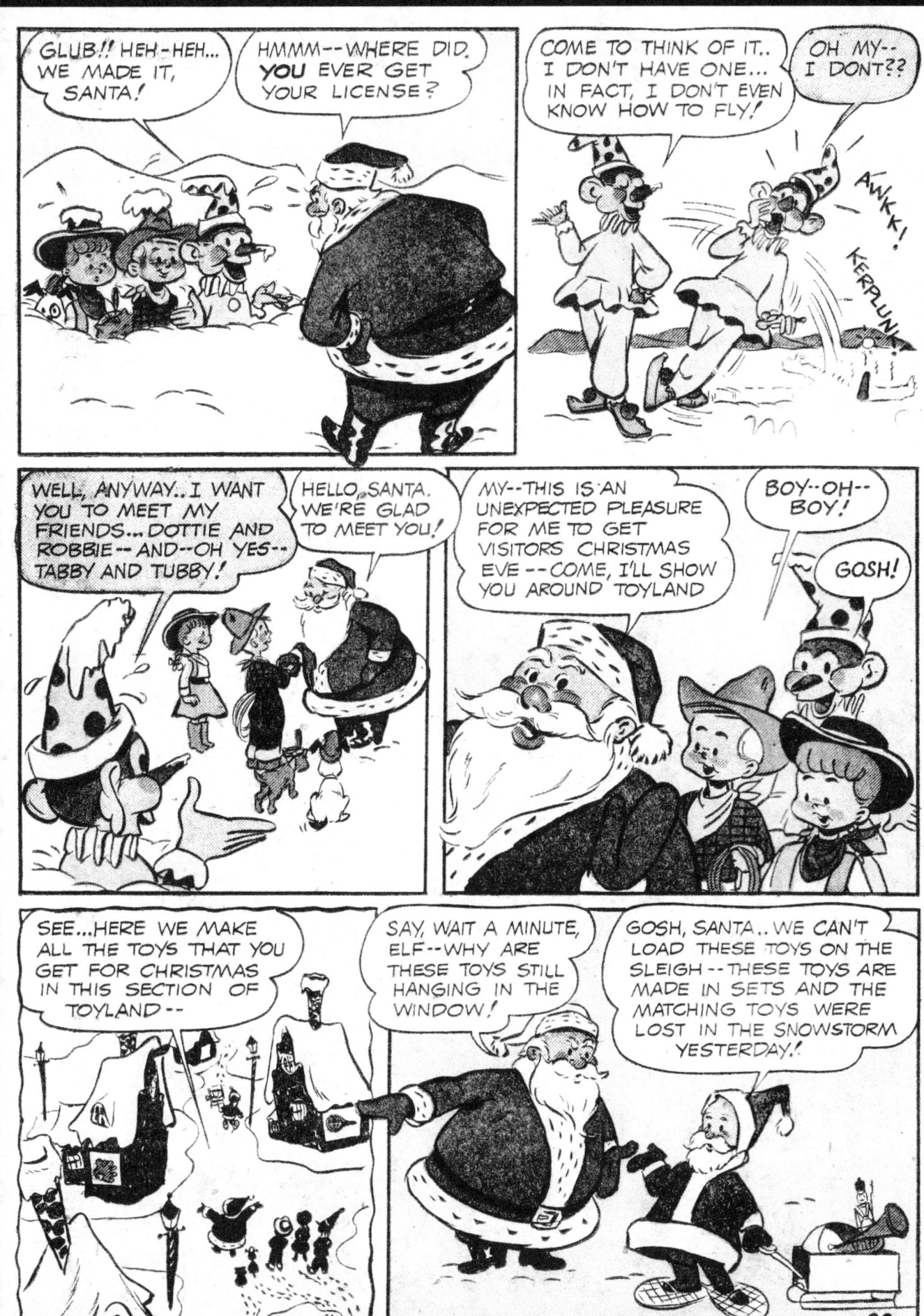

A sample page from the 1951 Woolworth's giveaway catalog/comic.

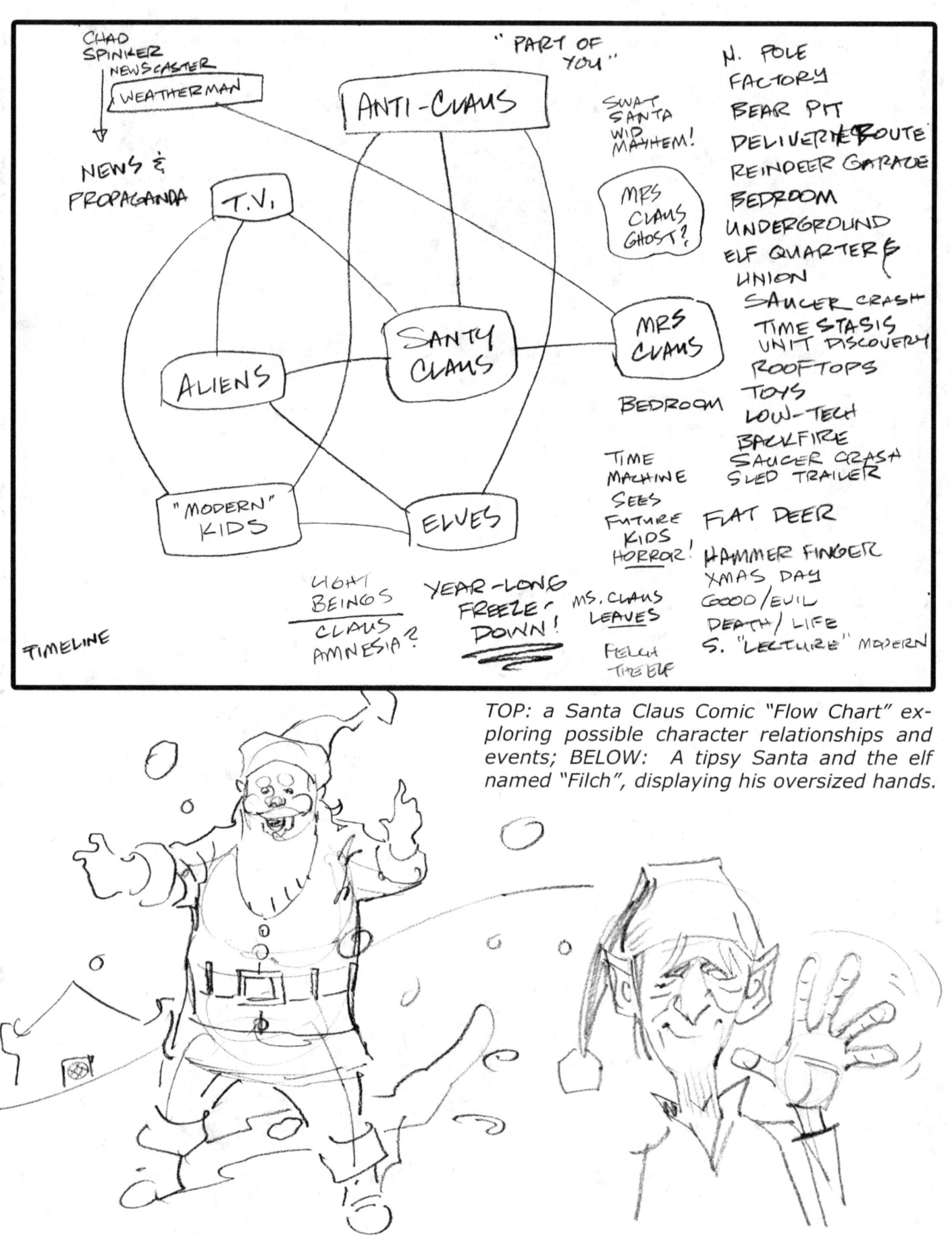

TOP: a Santa Claus Comic "Flow Chart" exploring possible character relationships and events; BELOW: A tipsy Santa and the elf named "Filch", displaying his oversized hands.

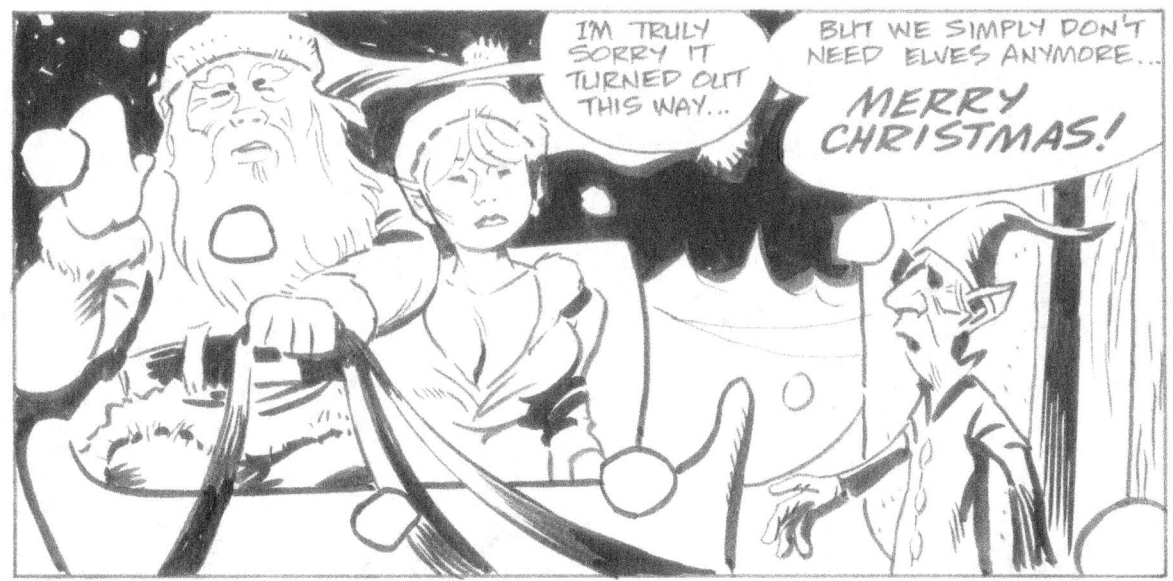

An inked page from the "Santa Claus Christmas Chronicle" oversized comic book.

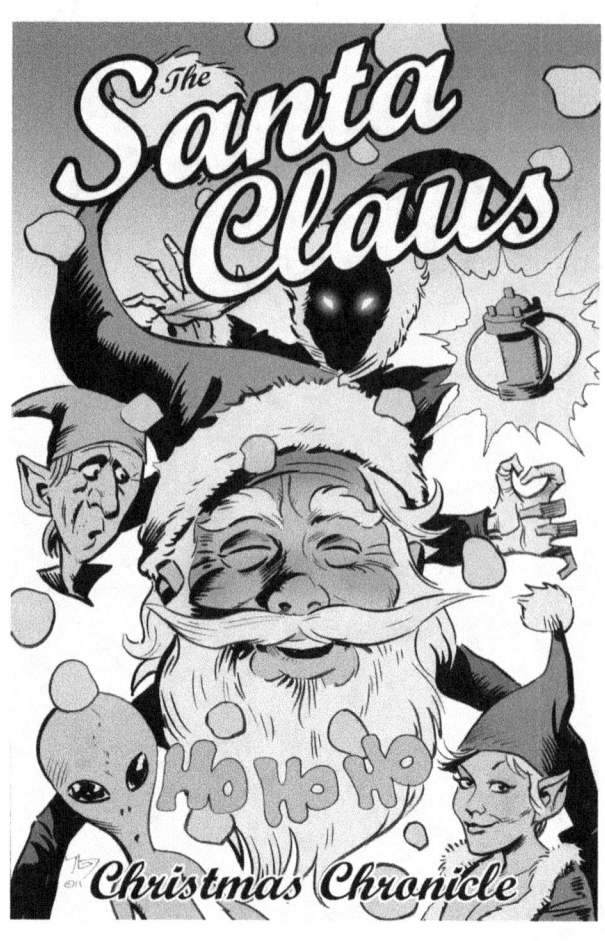
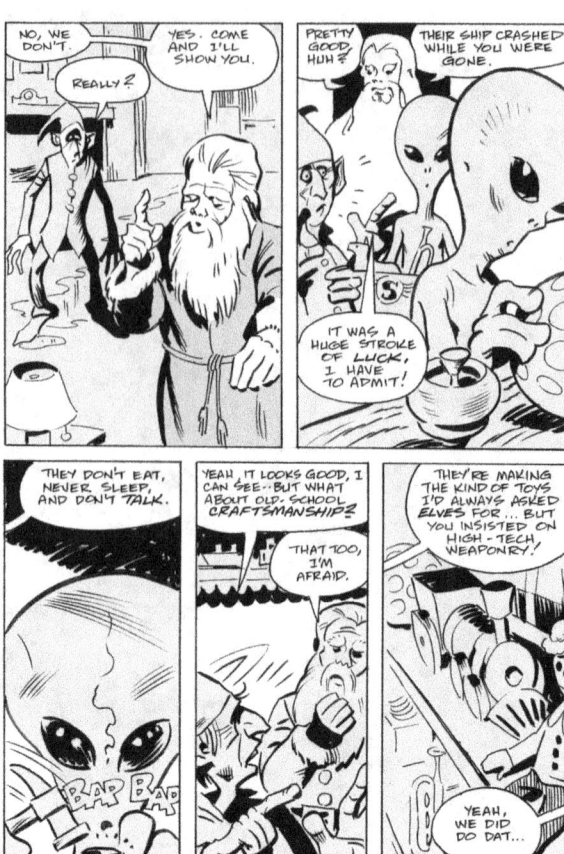

Cover and digitally-toned pages as published, Dec 2011.

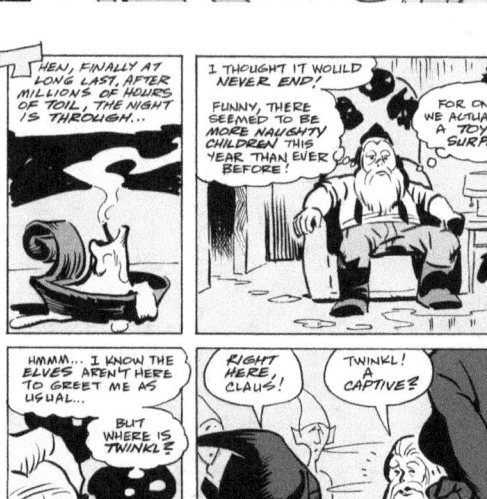
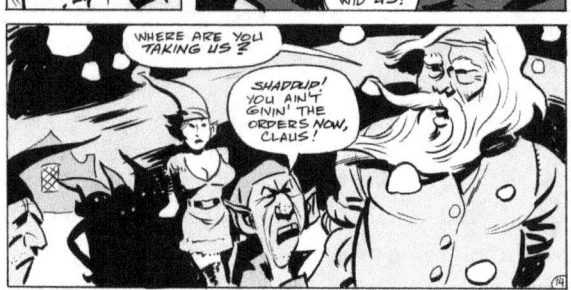
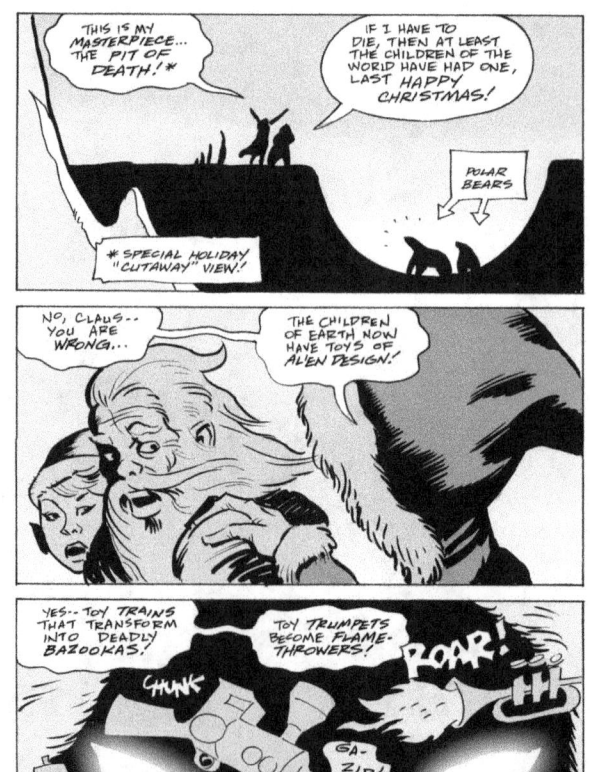

Tits for Tats

This is from "Radar" at the "Electric Rembrandt" tattoo shop outside Philadelphia, PA, based on a panel from my *Robin Screwso #1* comic. How do I feel about it? I'm not talkin'.

Bumper Sticker

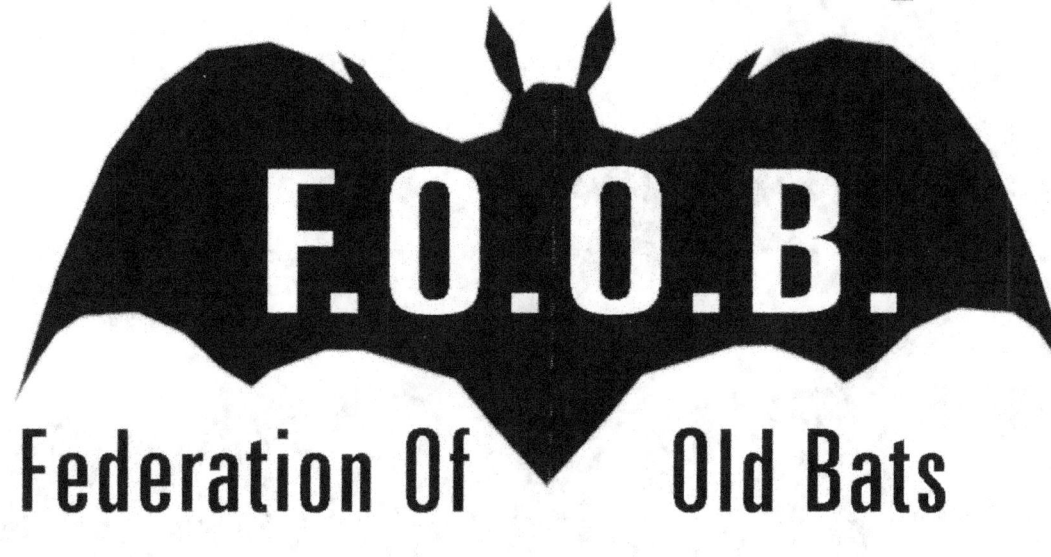

I designed this for my dear Mom many years ago, but later I had wanted to secretively go around sticking it on old ladies' cars in parking lots.
I still think Old Bats should organize, maybe even unionize.

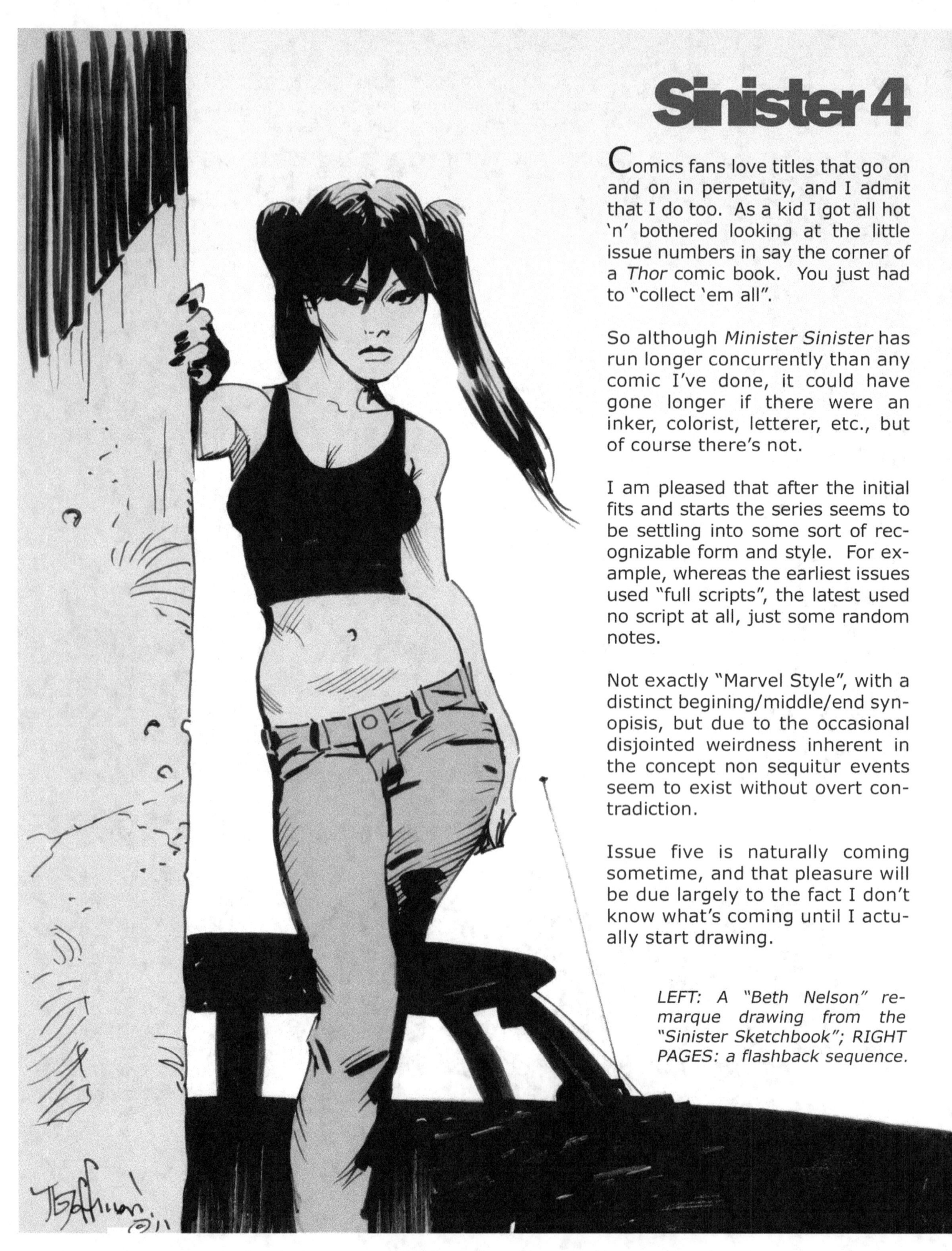

Sinister 4

Comics fans love titles that go on and on in perpetuity, and I admit that I do too. As a kid I got all hot 'n' bothered looking at the little issue numbers in say the corner of a *Thor* comic book. You just had to "collect 'em all".

So although *Minister Sinister* has run longer concurrently than any comic I've done, it could have gone longer if there were an inker, colorist, letterer, etc., but of course there's not.

I am pleased that after the initial fits and starts the series seems to be settling into some sort of recognizable form and style. For example, whereas the earliest issues used "full scripts", the latest used no script at all, just some random notes.

Not exactly "Marvel Style", with a distinct begining/middle/end synopisis, but due to the occasional disjointed weirdness inherent in the concept non sequitur events seem to exist without overt contradiction.

Issue five is naturally coming sometime, and that pleasure will be due largely to the fact I don't know what's coming until I actually start drawing.

LEFT: A "Beth Nelson" remarque drawing from the "Sinister Sketchbook"; RIGHT PAGES: a flashback sequence.

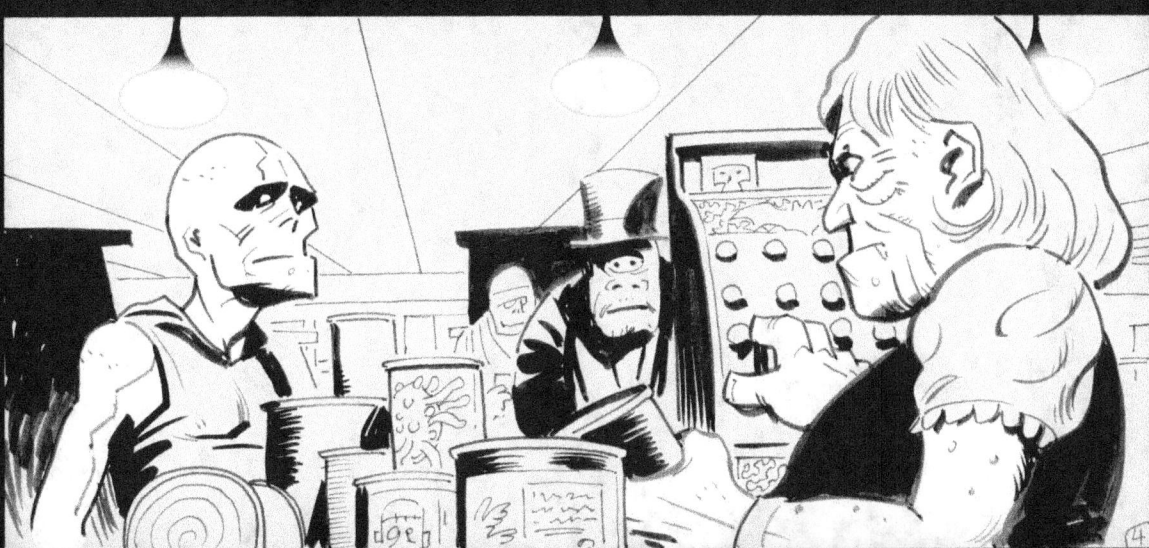

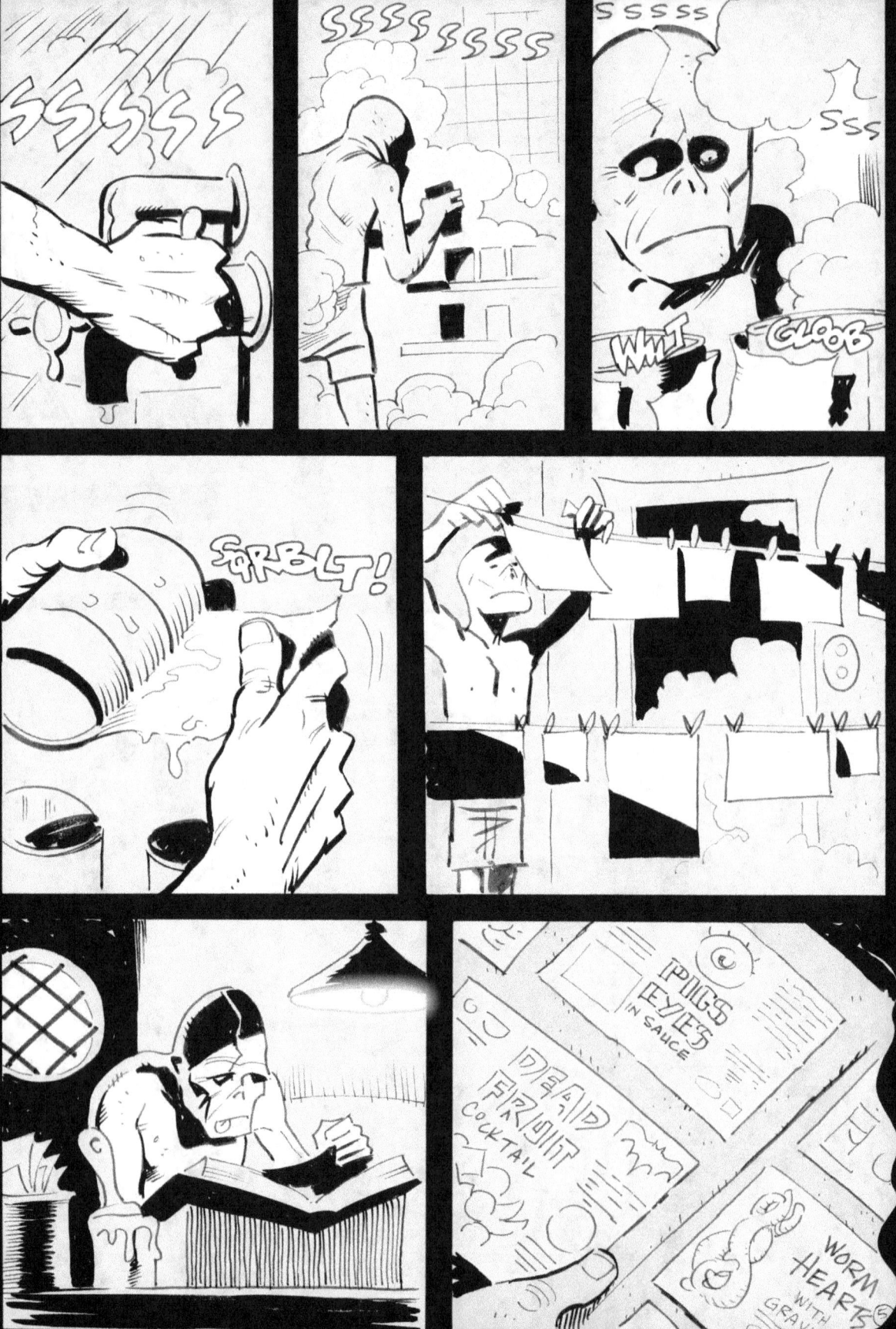

www.ingramcontent.com/pod-product-compliance
Lightning Source LLC
Chambersburg PA
CBHW080009210526
45170CB00015B/1956